THE MIRROR OF ART

The Mirror of Art

CRITICAL STUDIES BY

Charles Baudelaire

Translated and Edited
With Notes and Illustrations
By Jonathan Mayne

DOUBLEDAY ANCHOR BOOKS
DOUBLEDAY & COMPANY, INC.
GARDEN CITY, NEW YORK, 1956

Charles ⸺⸺⸺ ⸺⸺ ⸺⸺ ⸺ ⸺⸺⸺ ⸺ 1821. Upon receiving his degree in 1839 from the Collège Louis-le-Grand in Paris, he began his sensational literary career. After a life characterized by poverty, excesses, and controversy, he died in 1867.

Baudelaire first attracted public attention with two of his earliest writings on art—*The Salon of 1845* and *The Salon of 1846*. He wrote only one book of poetry, the famous *Fleurs du mal* (1857), whose successive revisions occupied him throughout his life. He was also the translator of such works of Edgar Allan Poe as *Histoires extraordinaires* (1857) and *Histoires grotesques et sérieuses* (1865).

Though *The Mirror of Art* is a title invented by Baudelaire himself, the book, first published in 1955, is composed of excerpts from two collections of Baudelaire's art criticism which were not compiled until after his death. These are *Curiosités esthétiques* (1868) and *L'Art romantique* (1869).

Cover design by Leonard Baskin
Typography by Edward Gorey

CONTENTS

vi CONTENTS

EDITOR'S NOTE
AND ACKNOWLEDGEMENTS

THE present translation has been made from the Conrad editions of *Curiosités esthétiques* (1923) and *L'Art romantique* (1925), both edited by the late Jacques Crépet. Reference has also been made to the Pléiade edition of the *Oeuvres complètes* (1951), edited by M. Y.-G. le Dantec, and to the late André Ferran's fully-annotated edition of the *Salon de 1845* (Toulouse 1933). To these editions I am indebted for much of the material contained in those footnotes which are preceded by a numerical reference. All footnotes, or parts of footnotes, included between an asterisk and the initials 'C.B.' are Baudelaire's own. To some of these I have added a further note after the initials.

Of the works of art mentioned in the text, I have identified as many as I have been able—though by no means as many as I should have liked—either by giving their present whereabouts, or by indicating where reproductions of them can be seen. In certain cases, where neither reproduction nor whereabouts were known to me, I have referred to standard *catalogues raisonnés* of the works of the artists concerned. In the matter of translating, or not translating, the titles of pictures, I have found absolute consistency impossible to secure. Where pictures, such as *Dante et Virgile* or *La Mort de Sardanapale*, are well known under their English titles, it is the English form that I have given. In the case of titles of obscure or unidentified pictures, of which so many are mentioned in the course of Baudelaire's *Salons*, I have generally left them in French, except in a few instances where the point of a criticism depends upon the literal understanding of a title. My guiding motive has been the avoidance of possible misidentification.

My greatest personal debts are owed to Miss Margaret Gilman, of Bryn Mawr College, whose *Baudelaire the Critic* has been an invaluable aid and whose kindness a constant encouragement; and to Mr Felix Leakey, of Glasgow University, who has been most patient and helpful with advice. Among those others who have assisted me in a variety of

ways, and whom I should like to take this opportunity of thanking once again, are: M. Jean Adhémar, of the Bibliothèque Nationale; Mr John Beckwith, of the Victoria and Albert Museum; M. de Broglie, of the Musée Condé, Chantilly; Mr Gordon Crocker; Miss Helen Darbishire; Miss Bernice Davidson, of the Frick Collection; M. Claude Ferment; Mr H. G. Fletcher, of the Cheltenham Art Gallery; M. Armand Godoy; Mrs Marie-Louise Hemphill; Mr Asa Lingard; Mrs Dora Lykiardopulo; Mrs F. J. Mather, Jr.; Mr Peter Mayne; Mr O'Hana; M. Claude Pichois; Mr Peter Quennell; Mr Graham Reynolds, of the Victoria and Albert Museum; M. Philippe Roberts-Jones; Mr Bryan Robertson; Mr Denys Sutton; and M. A. Veinstein, of the Bibliothèque de l'Arsénal, Paris. My thanks are also due to the authorities of the following Museums and Galleries who have kindly granted permission for works of art in their care to be reproduced here: the Victoria and Albert Museum, the Tate Gallery and the Wallace Collection, London; the Musée du Louvre, Paris; the Metropolitan Museum, and the Frick Collection, New York; the Fodor Museum, Amsterdam; the Musée d'Art Moderne, Brussels; the Smithsonian Institution, Washington; the Museum of Fine Arts, Boston; the Musée Fabre, Montpellier; the Musée Ingres, Montauban; the Musée Condé, Chantilly; the Museums at Autun, Bordeaux, Bourg-en-Bresse, Lille, Lyon, Metz, Nantes, Nîmes, Rouen, Saint-Lô, Toulouse and Versailles.

I wish to dedicate this edition to the memory of my friend Hallam Fordham.

<div style="text-align: right">J.M.</div>

EDITOR'S INTRODUCTION

IT IS probably true to say that the name *Baudelaire* has more suggestive power for the average English reader than that of any other French poet. Ever since Swinburne 'discovered' him to us in the 1860s, and the egregious Robert Buchanan anathematized him some ten years later as the accursed begetter of the 'Fleshly School of Poetry', he has had his more or less violent partisans and enemies. But in England and America at least it is only during the last generation or so that he has achieved his unquestioned status as one of the great archetypal figures—if not the greatest—in the moral and literary history of the nineteenth century. A considerable literature has grown up around him in English, ranging from biographical and interpretative studies to a whole shelf of translation of his poems and a volume or two of extracts from his prose-writings. It is therefore only the more remarkable that his works of criticism—and particularly his art-criticism, which is generally held to be his finest achievement in that field—should have remained largely unavailable to English readers. With the exception of Miss Margaret Gilman's excellent *Baudelaire the Critic*, no book in English, so far as I know, has been exclusively devoted to this subject; and I think that it would be fair to add that few professional art-writers, even, have given much evidence of having studied and profited by the works of one who has been called 'the father of modern art-criticism' and *'le premier esthéticien de son âge'*.

The present selection, therefore, should need no apology. It includes all three of Baudelaire's *Salons*, the articles on the *Exposition Universelle* of 1855, the essay on Laughter, with its accompanying articles on French and Foreign Caricaturists, and finally the great obituary panegyric on Delacroix. The well-known essay on Constantin Guys—*Le Peintre de la vie moderne*—has been regretfully omitted for reasons of space, and on the grounds that it alone of Baudelaire's art-critical studies has been translated, not

once only, but twice during the last twenty-five years.[1] It is certainly relevant, and therefore I hope not overpresumptuous, to add that this is the first edition of these writings to be published in any language, including French, with a substantial appendix of reproductions of paintings and prints discussed in the text. These include a number that have never before been reproduced, and one at least— Haussoullier's *Fontaine de jouvence*—which has long been believed to be lost.

'*Glorifier le culte des images (ma grande, mon unique, ma primitive passion)*', wrote Baudelaire in a famous passage of his autobiographical commonplace-book, *Mon cœur mis à nu*. And perhaps not the least rewarding approach to his art-critcism is to regard it as a kind of lifelong glorification of this chosen cult. Early in his *Salon of 1846* Baudelaire inserted a brief manifesto of what he meant by criticism; in this he was quick to reject a cold, mathematical, heartless type of criticism, and to require in its place a criticism which should be 'partial, passionate and political'—and, he added, 'amusing and poetic'. 'Thus,' he went on to say, 'the best account of a picture may well be a sonnet or an elegy'—a type of 'criticism' of which we find several examples among the *Fleurs du mal*.

But this, of course, is not all. To find the simplest and most revealing exposition of Baudelaire's critical attitude, it is best to turn to a long article which he wrote some fifteen years later in defence of Wagner. 'All great poets naturally and fatally become critics', he wrote there. 'I pity those poets who are guided by instinct alone: I regard them as incomplete. But in the spiritual life of the former [i.e. the great poets] a crisis inevitably occurs when they feel the need to reason about their art, to discover the obscure laws in virtue of which they have created, and to extract from this study a set of precepts whose divine aim is infallibility in poetic creation. It would be unthinkable for a

[1] By P. G. Konody, in *The Painter of Victorian Life* (London 1930), and by Norman Cameron, in *My Heart Laid Bare, and other essays by Charles Baudelaire* (London 1950).

critic to become a poet; and it is impossible for a poet not to contain within him a critic. Therefore the reader will not be surprised at my regarding the poet as the best of all critics.' The poet—that is, the creative artist, whatever his medium—is thus a double man who both feels and analyses his feelings; and the movement of his critical thought will be powered by the same central force which is also behind his creation. For Baudelaire, the distinction between criticism and creation in this way breaks down; they turn out to be merely different aspects of the same process.

Earlier in the same article he had written, '*Je résolus de m'informer du pourquoi, et de transformer ma volupté en connaissance*', and this, as several writers have already observed, is at the very core of Baudelaire's critical method. The starting-point is nearly always *volupté*—the shock of pleasure experienced in front of a work of art; the poet-critic then proceeds to examine and analyse the *pourquoi*—the why and the wherefore—until finally he is able to transform the initial shock of pleasure into knowledge—the *volupté* into *connaissance*. Knowledge gained in this way, however, is far from being the same thing as the cold, text-book knowledge which he had long ago rejected as a critical instrument; it is a knowledge charged and quickened by the pleasure which has logically preceded it, and, as we have seen, it is far more likely to take the form of a sonnet than an algebraic equation—a witty and suggestive interpretation than a piece of scientific, or pseudo-scientific, analysis.

Baudelaire made his literary début with a work of art-criticism—the *Salon of 1845*, with which this volume opens. In later years he became dissatisfied with this early and admittedly imperfect work, although we have the authority of Théodore de Banville that it made a striking effect on publication. Nevertheless it would certainly be worth preserving if only because it provides a kind of preliminary sketch—an *ébauche*, so to speak—for many of the critical attitudes that he was later to adopt and develop. Furthermore it contains his earliest tribute to the genius of Delacroix, whose art and ideas were to inform and interpenetrate

so much of what he was to write in the future on the subject
of art.

The *Salon of 1845* is set out in a conventional way, and
when it touches on general topics, it does so *en passant*.
Pictures are arranged neatly within their genres, and each
artist is dealt with in his place, with a paragraph or a series
of paragraphs to himself. The *Salon of 1846*, however, is
composed with great originality and brilliance. It begins
with a series of chapters on fundamental aesthetic ques-
tions, and by the time that we are presented with the first
artist (again Delacroix), a whole critical background has
been adumbrated. It is in this general introduction, and in
the further 'general' chapters and observations with which
this *Salon* is interspersed, that we find the first of the great
Baudelairean key-words, themselves defining key-positions
in his critical strategy. Individualism, Romanticism, *naïveté*,
the Ideal—all of them are paraded before the reader and
redefined in a new, exact and highly personal fashion. No-
where, indeed, could we have a better example of Baude-
laire's extraordinary gift for taking already-existing concepts
and reanimating them so that they are still recognizable,
but, in an essential sense, fresh and surprising. Take Ro-
manticism, for example. 'Few people today will want to
give a real and positive meaning to this word', we are told.
And then, after showing us the various ways in which the
idea of Romanticism has been misunderstood and per-
verted, Baudelaire proceeds, in a few short sentences, to
give his own definition. 'Romanticism is precisely situated
neither in choice of subject nor in exact truth. . . To say
the word Romanticism is to say modern art—that is, inti-
macy, spirituality, colour, aspiration towards the infinite,
expressed by every means available to the arts'. Or *naïveté*:
'By the *naïveté* of the genius', he writes, 'you must under-
stand a complete knowledge of technique combined with
the *Know thyself!* of the Greeks, but with knowledge mod-
estly surrendering the leading role to temperament.' Even
the old-fashioned, classic shibboleth of 'the Ideal' is given
an honoured and important place in this renovated vocabu-
lary of art. 'I am not claiming that there are as many funda-
mental ideals as there are individuals, for a mould gives

several impressions: but in the painter's soul there are just as many ideals as individuals, because a portrait is *a model complicated by an artist.*'

From this necessarily brief résumé of a few of the leading ideas to be encountered in the *Salon of 1846*, it will be apparent that Baudelaire was by no means setting out to make a sudden and shocking breach with the past. What he was doing was to take a series of dead or dying concepts and to breathe a new life into them; and if, in the process, he found it necessary (as he did) to denounce certain fashionable heresies by which, in his opinion, the integrity of art was endangered, this was not because his views were the views of a self-conscious *enfant terrible*. He was living at a time when artistic anarchy and its natural counterpart, artistic puritanism, were both rampant; when the 'great tradition' had got lost, and the new tradition had not yet been discovered; when 'wit' and 'anecdote' and 'erudition' were already beginning to flourish on the soil left vacant by 'history'—and his deeply serious aim was to attempt to call back the visual arts to what he held to be their proper functions. Hence his lifelong devotion to Delacroix who, by his indomitable adherence to classical values of order and artistic purity amid the turbulence of his Romantic imagination, was, in Baudelaire's view, the true painter of the age.

It has often been observed of Baudelaire's poetry that it reveals an extraordinary fusion of a lapidary, Classical permanence and an intimate, Romantic contingency—and this is only one of the striking parallels between Baudelaire and Delacroix as creative and critical artists. Both believed that every nation and every age possessed, and must possess, its own Beauty. Baudelaire analysed these various and varying manifestations of Beauty into two separate elements—the eternal, which was common to all, and the transitory, which resulted from the changing modes of feeling characteristic of different ages. In this, it may be argued, he showed no great originality; the idea was already implicit in Stendhal, and doubtless in other theorists too (for the successful tracing back of individual aspects of Baudelaire's thought to former authors has of recent

years become a minor industry of literary scholarship). But
in going a step further and asserting that without the co-
existence of both elements there could be no Beauty at all,
he was asserting something both new and significant. This
was but another way of saying that the 'ideal' had now
become a relative concept. And if we remember that, in a
mechanically progressive age, Baudelaire had the deepest
possible contempt for material 'progress', it will only make
his undertanding of the central aesthetic problem by so
much the more prophetic of our own.

It is in the articles on the *Exposition Universelle*, of some
nine years later, that we first encounter the concept which
may be said to epitomize and develop to their logical con-
clusion all those that we have already considered. This is
the concept of the 'imagination', which makes a brief but
telling début in the course of an analysis of the funda-
mental defects of Ingres. But it is not until the *Salon of
1859* that Baudelaire's idea of the imagination finds its full
statement. It is to some extent linked to his doctrine of 'cor-
respondences' (which is also first mentioned by name in the
Exposition Universelle articles), but it is not necessary to
accept that esoteric doctrine in all its implications in order
to appreciate the real value of the idea. As with all of
Baudelaire's key-words, the word 'imagination' has a very
special meaning attached to it. It is an all-informing faculty,
which must be allowed to dominate and to order all the
others. Furthermore, it is essentially creative—and here, as
Miss Gilman has pointed out, Baudelaire comes very close
to the doctrine of the creative imagination as developed by
Coleridge in the *Biographia Literaria*, though it is in a high
degree doubtful that he was aware of this relationship. (If
a literary parentage for Baudelaire's Imagination is re-
quired, we need look no further than Poe—although it is
now fashionable to deplore his influence—and Poe, as is
readily admitted even by his friends, owed much to the
ideas of Coleridge.)

But Imagination is also the 'most scientific of the facul-
ties'. By this seemingly paradoxical statement Baudelaire
meant that the Imagination alone is, by its nature, capable
of penetrating beneath the surface of appearances and of

detecting hidden analogies between different material man-
ifestations, different modes of perception, and different
levels of existence. The Imagination, in fact, is that capital
faculty of the creative artist whereby he is enabled to see
all in one synoptic glance, and thus to order his work in
such a way that the topical shall co-exist with the eternal,
the natural with the supernatural and the moral with the
metaphysical. It is through the Imagination, in short, that
the universal correspondences are discerned and the 'ideal'
brought to light. Baudelaire is nevertheless careful to insist
that the Imagination must have at its service a refined
sensibility and a practised technical equipment. He is, in-
deed, scornful of technical ineptitude (though, as in the
case of Corot, he does not always agree that criticism on
this score has been correctly applied); but he is, if any-
thing, even more contemptuous of a purely manual dex-
terity, undirected by Imagination or the 'Soul'—witness his
criticism of Troyon, for example.

There is one idea of fundamental importance, however,
which we have not yet touched on, although it runs through
all of Baudelaire's art-criticism, from the very first *Salon*
to the essay on Guys of almost twenty years later, and may
be said to emerge naturally from his doctrine of the Imagi-
nation and of Beauty. This is the idea of the 'Heroism of
Modern Life'. Starting with his definition of Romanticism
as intimacy, spirituality and the rest, and feeling (as we
know so well from his poetry that he felt) that modern life
was presenting a challenge and an obligation to the creative
artist which few of his contemporaries seemed willing to
meet, Baudelaire concluded his *Salon of 1845* with an im-
passioned appeal, which he took up again and developed
in the following year. This was an appeal for a painter who
could interpret the age to itself, with a complete imagina-
tive grasp of its occasional and paradoxical acts of a protest-
ing heroism amid a setting of moral and spiritual desolation.
Delacroix, for all that he was in other essentials the 'painter
of the age', had scarcely touched modern life, and even
though Baudelaire claimed to find a contemporary, sickly
type of beauty in his women (somewhat to the consterna-
tion of Delacroix himself, it must be admitted), this was

hardly enough to qualify him as the almost Messianic genius whom Baudelaire was crying in the wilderness. Courbet might perhaps suggest himself to us as a possible candidate; but this would be to forget that Baudelaire, after a brief flirtation with socialist ideas (and thus with the possibility of a popular, realist art), and in spite of a personal friendship with Courbet himself which lasted longer than is often supposed—Baudelaire, the sworn anti-materialist, had early declared his enmity for the realist ideal. Realism (associated by him with Positivism) was for Baudelaire a flat negation of the Imagination—it was little less than a blasphemy; hence his somewhat curious coupling of the names of Ingres and Courbet, both of whom he regarded as having sacrificed the imaginative faculty on the altars of other gods—'the great tradition' and 'external nature', respectively.

Another possibility might have been Daumier, for whom Baudelaire expressed a wholehearted admiration in his article on the French caricaturists; or the young Manet, whom he admired in private (if with certain reservations), but never, in fact, praised publicly, save on one occasion—in an article, not included here, in which he joined the name of Manet with that of Alphonse Legros (to the shocked surprise of posterity). When, however, the time came, it was none of these, but the modest, morbidly self-conscious Constantin Guys in whom Baudelaire discovered his 'painter of modern life'; it was around this delightfully gifted but essentially minor artist that he built his fully-developed theory of the relationship of art to modern life.

Whether or not we agree that Baudelaire was justified in glorifying Guys to this extent, it is generally conceded that the *Peintre de la vie moderne* is one of his prose masterpieces. For our present purpose, however, we may perhaps confine ourselves to a single one of the ideas of which it is composed—a crucial idea, nevertheless, not only in its context, but in the whole fabric of Baudelaire's aesthetic and metaphysical opinion. To reduce it to its fundamental statement, this was a passionately-held belief in the Fall of Man, and Original Sin. The essay, *On the Essence of Laughter*, had already made it clear that Baudelaire based

his whole theory of the Comic on this idea; and I think that it would be possible to maintain that in the final analysis his whole aesthetic was similarly founded. Good—whether in art or morality—can only be achieved by conscious (and, one might add, imaginative) effort; by striving after an ideal virtue or beauty, and constantly battling against the powerful, but senseless and undirected impulses of Nature. Hence the moving aphorisms of personal morality in *Mon cœur mis à nu;* and hence, as extreme statements, the glorification of the Dandy and the '*éloge du maquillage*' in the *Peintre de la vie moderne.* Transferred to the criticism of the arts in the mid-nineteenth century, the doctrine has a corollary of the greatest importance. For it is precisely this contempt (and also perhaps this fear) of Nature that explains Baudelaire's impatience with all current naturalistic trends—for the landscapes of the Barbizon painters no less than the realism of Courbet. The idea of copying nature, which was at that time more than usually in the air, was to Baudelaire an even greater artistic heresy than was the idea of adding something extraneous ('style', for example) to nature. He remained consistent from first to last in his belief that the immanent, individual ideal—whether expressed by the detachment of the Dandy, the make-up of the courtesan, or the imagination of the poet—was the only thing with which man should concern himself. In the sphere of art the realization of this ideal would always be the result of a collaboration—a sort of fusion, rather—of two separate entities. 'What is purt art, according to the modern conception?', asks Baudelaire in an unfinished article, *L'Art philosophique.* 'It is to create a suggestive magic containing at one and the same time the object and the subject, the external world and the artist himself.'

In the course of the preceding sketch of Baudelaire's general attitude towards the problems of art, several examples of his practical sympathies and antipathies have already been touched on. As has often been pointed out, Delacroix was from first to last his touchstone of greatness—the Turner to his Ruskin. It is very nearly true to say that Baudelaire's published criticism begins and ends with the name of Delacroix; and it is certain that the idea of Dela-

croix can almost always be felt hovering in the background through the intervening pages. Some modern critics have indeed come to reproach Baudelaire for this special and all-absorbing devotion, on the grounds that it blinded him to those progressive trends in contemporary painting which were already leading in the direction of Impressionism and thus of Modern Art as we now know it. They are shocked at his severe criticisms of Ingres and Courbet; they note his fundamentally imperfect sympathy for Rousseau, and his damaging dislike of Millet; and finally he is rebuked for omitting to 'discover' Manet at a time when he was in a position to do so, and instead for lavishing praise on a host of minor painters who are now almost entirely forgotten—and in most cases deservedly so.

Such is the case against him, as stated by M. Philippe Rebeyrol,[2] for example. But it is necessary first of all to view this kind of criticism in its historical context—to see it as a reaction from a modern devotion to Baudelaire no less fervent than was his own devotion to Delacroix. It has for some time indeed been conventional to hold that Baudelaire was the only art-critic of the nineteenth century who never made mistakes; and if by the phrase 'never made mistakes' we mean that he exactly anticipated the verdicts of posterity in all his judgements, it must at once be owned by anyone who has taken the trouble to read what he wrote that this conventional belief is not founded strictly on fact. Other critics of his time—the serious and business-like Thoré, for example, or even a gifted progressive like Champfleury—may be instanced as more accurate prophets of the dawn. Other critical attitudes than his belief in a purified and re-stated Romanticism may now seem to have been more in the mainstream of the theory of art as it has since developed.

But though such practical criticisms must indeed be admitted to have some force, it is legitimate to ask whether it is not perhaps a little crude to attempt to place a critic such as Baudelaire—or any critic, for that matter, who is

[2] See his article, 'Baudelaire et Manet' in Les Temps modernes, Oct. 1949.

also a creative artist—in accordance with a simple score-card of 'hits' and 'misses', and particularly when those hits and misses are themselves not so much verifiable facts as elements in a constantly changing complex of opinion. It is necessary at once to state that we do not read Baudelaire in order to dazzle ourselves with the shafts of his prophetic gaze; we may even perhaps allow ourselves to hazard the guess that, if he did look forward to a future art, it may well have been to that of Gustave Moreau rather than of Renoir or Cézanne, to that of Beardsley rather than of Toulouse-Lautrec. But against the enormous positive importance of his work, any such possible shortcomings are fundamentally insignificant. When we call Baudelaire the 'father of modern art-criticism' or the 'first aesthetician of his age' we are referring not to his anticipation of any one of our particular judgements and fashionable cults; we are thinking of his whole approach to the art of art-criticism. For Baudelaire was perhaps the first to detect the dangerous fallacy of a 'party-line' in art, to perceive the 'admirable, eternal and inevitable relationship between form and function' and to apprehend the delicate distinction between anarchy and autonomy in an artist of genius. Even his strictures on artists with whom he was naturally out of sympathy are more often than not conceived in such a way as to throw light on virtues no less than on vices; and in spite of M. Rebeyrol's carefully-arranged texts, he seldom failed to discern greatness, or even 'importance', where it existed, even though he may then have proceeded to enquire why it was not greater or more important still.

But it is above all to Baudelaire's passionately-held belief in the purity of art that we find ourselves returning. Just as his Romanticism transcends the historical reality of that movement (T. S. Eliot once called him a 'counter-Romantic'; in this context, perhaps 'post-Romantic' might be even more appropriate), so his belief in the purity or integrity of art transcends the concept of 'Art for Art's sake'. Painting (or poetry, or music) exists in its own right; it has nothing to do with politics (or philosophy, or archaeology), even though in certain conditions it may appeal, in a greater or a lesser degree, to a spectator who is con-

cerned with these things. 'Painting is an evocation, a magi-
cal operation' which makes its effect by means of a fusion
of colour and line, and which has its own principles of life,
to be found nowhere else but in the 'soul' of the artist. If
it were for nothing more than the constant re-affirmation
of this point of view, Baudelaire's criticism would remain
a landmark in the development of our understanding of the
arts. Add to it all those other qualities—the poetic insight,
the wit, the brilliance of description and the underlying
humanity—and the result is a critic with whom we may on
occasions disagree, but one whom we cannot forget once
we have read him.

A final note on the title and composition of this book.

Although Baudelaire had for long intended to assemble
and re-print his art-critical writings in one or more volumes,
this aim was not in fact accomplished until after his death
(in 1867). The following year there appeared, under the
editorship of Charles Asselineau and Théodore de Banville,
the volume entitled *Curiosités esthétiques*, containing all
three *Salons*, the articles on the *Exposition Universelle*, the
Laughter and Caricature articles, and a shorter piece en-
titled *Le Musée classique du Bazar Bonne-nouvelle* (not
included here). This was followed in 1869 by *L'Art roman-
tique* (a title, it seems, of the editors' own choosing) which
contained the articles on Delacroix and Guys, and two other
shorter art-critical studies; the remainder of the volume was
devoted to articles of literary and other criticism. The pres-
ent book is therefore neither one nor the other, being com-
posed for the greater part of elements from *Curiosités
esthétiques*, but with one important extract from *L'Art
romantique*. The title, *The Mirror of Art*, has been chosen
because it was invented (but not used) by Baudelaire him-
self when he was meditating the publication of the book
that was finally issued as *Curiosités esthétiques*. Other titles,
such as *Bric-à-brac esthétique* and *Le Cabinet esthétique*
were also discussed, but of the various available possibili-
ties, *Le Miroir de l'Art* has seemed by far the most appropri-

ate—not least because it alone can be happily transformed into English. 'J'aime les titres mystérieux et les titres pétards', wrote Baudelaire to his publisher Poulet-Malassis; and in default of anything more mysterious or explosive, *The Mirror of Art*, suggesting as it does Baudelaire's conviction that art-criticism should be the reflection of a work of art in the mind of a critic, seems to sum up his attitude and express his intentions with the maximum of authenticity.

JONATHAN MAYNE

ABBREVIATIONS USED IN THE FOOTNOTES

Delteil Loys Delteil. *Honoré Daumier* (in the series 'Le peintre-graveur illustré'). 10 volumes. Paris, 1925–30

Escholier Raymond Escholier. *Delacroix*. 3 volumes. Paris, 1926–9

Gilman Margaret Gilman. *Baudelaire the Critic*. New York, 1943

Illustr. *L'Illustration. Journal universel*

Journal *The Journal of Eugène Delacroix*. London, 1951

Robaut Alfred Robaut. *L'Oeuvre complet d'Eugène Delacroix*. Paris, 1885

Wildenstein Georges Wildenstein. *The Paintings of J.A.D. Ingres*. London, 1954

BIBLIOGRAPHICAL NOTE

Margaret Gilman's *Baudelaire the Critic* (New York 1943) contains a list of works on Baudelaire's criticism. To this may be added Nino Barbantini's important article 'Baudelaire Critico d'Arte' in his *Scritti d'Arte* (Venice 1953). Martin Turnell's *Baudelaire* (London 1953) contains a good general bibliography. For a detailed examination of the art-criticism of the period 1848–70, see Joseph C. Sloane's *French Painting between the Past and the Present* (Princeton 1951).

The most convenient source of information concerning the Salon-exhibits of 19th century French artists is Bellier de la Chavignerie's *Dictionnaire général des artistes de l'école française* (2 vols., Paris 1882–5).

THE SALON OF 1845[1]

I

A FEW WORDS OF INTRODUCTION

WE CAN claim with at least as much accuracy as a well-known writer claims of his little books, that no newspaper would dare print what we have to say. Are we going to be very cruel and abusive, then? By no means; on the contrary, we are going to be impartial. We have no friends—that is a great thing—and no enemies. Ever since the days of M. Gustave Planche,[2] a rough diamond whose learned and commanding eloquence is now silent to the great regret of all right-thinking minds, the lies and the shameless favouritisms of newspaper criticism, which is sometimes silly, sometimes violent, but never independent, have inspired the bourgeois with a disgust for those useful handbooks which go by the name of Salon-reviews.*

And at the very outset, with reference to that impertinent designation, 'the bourgeois', we beg to state that we in no way share the prejudices of our great confrères in the world of art, who for some years now have been striving their utmost to cast anathema upon that inoffensive being whom nothing would please better than to love good painting, if only those gentlemen knew how to make it understandable

[1] The exhibition opened on 15th March at the Musée Royal (Louvre). Baudelaire's review appeared in the form of a booklet. Although it was officially recorded as published on 24th May, Baudelaire himself wrote to his mother that it was appearing on his birthday, 9th April. The present translation of this *Salon* is somewhat abridged. Omissions are indicated where they occur.

[2] Gustave Planche (1808–57), who had written regularly for the *Revue des Deux-Mondes*, had been absent in Italy for the last few years.

* Let us record a fine and honourable exception in M. Delécluze, whose opinions we do not always share, but who has always managed to preserve his integrity, and, without roaring or ranting, has often been responsible for bringing new and unknown talents to light. (C.B.)

to him and if the artists themselves showed it him more often.

That word, which smells of studio-cant from a mile off, should be expunged from the dictionary of criticism.

The 'bourgeois' ceased to exist the moment he himself adopted the word as a term of abuse—which only goes to prove his sincere desire to become artistic, in relation to the art-critics.

In the second place, the bourgeois—since he does, in fact, exist—is a very respectable personage; for one must please those at whose expense one means to live.

And finally, the ranks of the artists themselves contain so many bourgeois that it is better, on the whole, to suppress a word which does not define any particular vice of caste, seeing that it is equally applicable to those who ask no more than that they should cease to incur it, as to those who have never suspected that they deserved it.

It is with the same contempt for all systematic nagging and opposition—opposition and nagging which have become banal and commonplace;* it is with the same orderliness, the same love of good sense, that we are banishing far from this little booklet all discussion both of juries[3] in general and of the paintings-jury in particular; of the reform of the jury, which we are told has become necessary, and of the manner and frequency of exhibitions, etc. . . . First of all, a jury is necessary—so much is clear; and as for the annual recurrence of the exhibition,[4] which we owe to the enlightened and liberally paternal mind of a king to whom both public and artists owe also the enjoyment of six museums,** a fair-minded man will always see that the

* The complaints are perhaps justified, but they count as nagging, because they have become systematic. (C.B.)

[3] i.e. selection-committees, about which there was much current dissatisfaction. Under the Empire and the Restoration, the works of new exhibitors only were subject to the jury; in 1831 new rules were formed according to which all were so subject.

[4] It was not until 1833 that the Salon became an annual event. In recent years there had never been less than two years between each, and often more (viz. 1817, 1819, 1822, 1824, 1827, 1831).

** The Galerie des Dessins, the extension to the Galerie Fran-

great artist cannot fail to gain by it, considering his natural productiveness, and that the mediocre artist will only find his deserved punishment therein.

We shall speak about everything that attracts the eye of the crowd and of the artists; our professional conscience obliges us to do so. Everything that pleases has a reason for pleasing, and to scorn the throngs of those that have gone astray is no way to bring them back to where they ought to be.

Our method of address will consist simply in dividing our work into categories—History-paintings and Portraits—Genre-paintings and Landscape—Sculpture—Engravings and Drawings; and in arranging the artists in accordance with the rank and order which the estimation of the public has assigned to them.

8th May 1845

II

HISTORY-PAINTINGS

DELACROIX.—M. Delacroix is decidedly the most original painter of ancient or of modern times. That is how things are, and what is the good of protesting? But none of M. Delacroix's friends, not even the most enthusiastic of them, has dared to state this simply, bluntly and impudently, as we do. Thanks to the tardy justice of the years, which blunt the edge of spite and shock and ill-will, and slowly sweep away each obstacle to the grave, we are no longer living at a time when the name of Delacroix was a signal for the reactionaries to cross themselves, and a rallying-symbol for every kind of opposition, whether intelligent or not. Those fair days are past. M. Delacroix will always re-

çaise, the *Musée Espagnol*, the *Musée Standish*, the *Musée de Versailles*, and the *Musée de Marine* (C.B.). The first two and the last two of these exist today. The *Musée Espagnol* comprised Spanish pictures belonging to the Orléans family. The *Musée Standish* consisted of works bequeathed by Lord Standish to King Louis-Philippe.

main a somewhat disputed figure—just enough to add a
little lustre to his glory. And a very good thing too! He has
a right to eternal youth, for he has not betrayed us, he has
not lied to us like certain thankless idols whom we have
borne into our pantheons. M. Delacroix is not yet a member
of the Academy, but morally he belongs to it.[1] A long time
ago he said everything that was required to make him the
first among us—that is agreed. Nothing remains for him but
to advance along the right road—a road that he has always
trodden. Such is the tremendous feat of strength demanded
of a genius who is ceaselessly in search of the new.

This year M. Delacroix has sent four pictures:[2]

1. *La Madeleine dans le désert.*[3] A head of a woman, up-
turned, in a very narrow frame. High up to the right, a
little scrap of sky or rock—a touch of blue. The Magdalen's
eyes are closed, her mouth soft and languid, her hair
dishevelled. Short of seeing it, no one could imagine the
amount of intimate, mysterious and romantic poetry that
the artist has put into this simple head. It is painted almost
entirely in visible brush-strokes, like many of M. Delacroix's
pictures. Far from being dazzling or intense, it is very
gentle and restrained in tone; its general effect is almost
grey, but of a perfect harmony. This picture demonstrates
a truth which we have long suspected, and which is made
clearer still in another work of which we shall shortly speak;
it is that M. Delacroix is stronger than ever, and on a path
of progress which ceaselessly renews itself—that is to say
that he is more than ever of a harmonist.

2. *Dernières paroles de Marc-Aurèle.*[4] Marcus Aurelius
commits his son to the Stoics. A half-draped figure, on his
death-bed, he is presenting the young Commodus—a young,
pink, soft voluptuary, seemingly a little bored—to his aus-
tere friends grouped around him in attitudes of dejection.

A splendid, magnificent, sublime and misunderstood pic-

[1] In fact Delacroix had already sought election to the Institut in
1837, but he was not finally elected until 1857.

[2] A fifth, his *Education de la Vierge,* was rejected by the jury.

[3] Robaut 921.

[4] Now in the Lyons Museum; see pl. 68.

ture. A well-known critic has sung the painter's praises for having placed Commodus—that is to say, the future—in the light; and the Stoics—that is to say, the past—in the shade. What a brilliant thought! But in fact, except for two figures in the half-shadow, all the characters have their share of illumination. This reminds us of the admiration of a republican man of letters who could seriously congratulate the great Rubens for having painted Henri IV with a slovenly boot and hose, in one of his official pictures in the Médicis gallery.[5] To him it was a stroke of independent satire, a liberal thrust at the royal excesses. Rubens the revolutionary! Oh criticism! Oh you critics! . . .

With this picture we are in mid-Delacroix—that is to say, we have before us one of the most perfect specimens of what genius can achieve in painting.

Its colour is incomparably scientific; it does not contain a single fault. And yet what is it but a series of triumphs of skill—triumphs which are invisible to the inattentive eye, for the harmony is muffled and deep? And far from losing its cruel originality in this new and completer science, the colour remains sanguinary and terrible. This equilibrium of green and red delights our heart. M. Delacroix has even introduced into this picture some tones which he had not habitually employed before—at least, so it seems to us. They set one another off to great advantage. The background is as serious as such a subject requires.

Finally—let us say it, since no one else does—this picture is faultless both in draughtsmanship and in modelling. Has the public any idea of how difficult it is to model in colour? It is a double difficulty. In modelling with a single tone—that is with a stump—the difficulty is simple; modelling with colour, however, means first discovering a logic of light and shade, and then truth and harmony of tone, all in one sudden, spontaneous and complex working. Put in another way, if the light is red and the shadow green, it means discovering at the first attempt a harmony of red and green, one luminous, the other dark, which together produce the effect of a monochrome object in relief.

[5] The paintings executed by Rubens for the Palais du Luxembourg are now in the Louvre.

'This picture is faultless in drawing.' With reference to this vast paradox, this impudent piece of blasphemy, must I repeat, must I re-explain what M. Gautier gave himself the trouble of explaining in one of his articles[6] last year, on the subject of M. Couture—for when a work is well suited to his literary temperament and education, M. Gautier expounds well what he feels finely? I mean, that there are two kinds of draughtsmanship—the draughtsmanship of the colourists, and that of the draughtsmen. Their procedures are contrary; but it is perfectly possible to draw with untrammelled colour, just as it is possible for an artist to achieve harmonious colour-masses while remaining an exclusive draughtsman.

Therefore when we say that this picture is well drawn, we do not wish it to be understood that it is drawn like a Raphael. We mean that it is drawn in an extempore and *graphic* manner; we mean that this kind of drawing, which has something analogous with that of all the great colourists, Rubens, for example, perfectly renders the movement, the physiognomy, the hardly perceptible tremblings of nature, which Raphael's drawing never captures. We only know of two men in Paris who draw as well as M. Delacroix—one in an analogous and the other in a contrary manner. The first is M. Daumier, the caricaturist; the second M. Ingres, the great painter, the artful adorer of Raphael. This is certainly something calculated to astound both friends and enemies, both partisans and antagonists of each one of them; but anyone who examines the matter slowly and carefully will see that these three kinds of drawing have this in common, that they perfectly and completely render the aspect of nature that they mean to render, and that they say just what they mean to say. Daumier draws better, perhaps, than Delacroix, if you would prefer healthy, robust qualities to the weird and amazing powers of a great genius sick with genius; M. Ingres, who is so much in love with detail, draws better, perhaps, than either of them, if you prefer laborious niceties to a total harmony, and the nature of the fragment to the nature of the composition, but . . . let us love them all three.

[6] In *La Presse*, 28th March, 1844.

3. *Une Sibylle qui montre le rameau d'or.*[7] Once more the colour is fine and original. The head reminds one a little of the charming hesitancy of the Hamlet designs. As a piece of modelling and texture it is incomparable: the bare shoulder is as good as a Correggio.

4. *Le Sultan de Maroc entouré de sa garde et de ses officiers.*[8] This is the picture to which we were referring a moment ago when we declared that M. Delacroix had advanced in the science of harmony. In fact, has anyone ever shown a greater musical seductiveness, at any time? Was ever Veronese more enchanting? Were melodies more fanciful ever set to sing upon a canvas? or a concord more wondrous of new, unknown, delicate and charming tones? We appeal to the honesty of anyone who knows his Louvre to mention a picture by a great colourist in which the colour is as *suggestive* as in M. Delacroix's picture. We know that we shall only be understood by a small number, but that is enough. In spite of the splendour of its hues, this picture is so harmonious that it is grey—as grey as nature, as grey as the summer atmosphere when the sun spreads over each object a sort of twilight film of trembling dust. Therefore you do not notice it at first; its neighbours kill it. The composition is excellent; it has an element of the unexpected, because it is true and natural . . .

P.S. It is said that praises can be compromising, and that it is better a wise enemy, etc. . . . We, however, do not believe that it is possible to compromise genius by explaining it.

HORACE VERNET. This African painting[9] is colder than a fine winter's day. Everything in it is of a heart-breaking whiteness and brightness. Unity, none; rather, a crowd of interesting little anecdotes—a vast tavern mural. These

[7] See pl. 69.

[8] Now in the Toulouse Museum; see pl. 67.

[9] The *Prise de la Smalah d'Abd-el-Kader*, now in the Versailles Museum. The colossal size of this painting (over sixty feet long) ensured it overwhelming critical and popular attention. The military operation which it illustrated took place in 1843; see pl. 15.

kinds of decoration are generally divided up as though into
compartments or acts, by a tree, a great mountain, a cavern,
etc. M. Horace Vernet has followed the same method—
that of a serialist—thanks to which the spectator's memory
duly finds its landmarks; namely a huge camel, some deer,
a tent, etc. . . . It is truly painful to see an intelligent man
floundering about in such a mess of horror. Good Heavens,
has M. Horace Vernet never seen the works of Rubens,
Veronese, Tintoretto, Jouvenet?

WILLIAM HAUSSOULLIER. M. Haussoullier must not be sur-
prised, first of all, at the violence of the praises which we
are about to heap upon his picture, for we have only de-
cided to do so after having conscientiously and minutely
analysed it; nor, in the second place, at the brutal and un-
mannerly reception which a French public is according it
—at the passing bursts of laughter which it occasions. We
have seen more than one important newspaper-critic toss-
ing it his little meed of mockery, over his shoulder. Let the
artist take no notice. It is a fine thing to have a success like
St. Symphorian.[10]

There are two ways of becoming famous—by the accu-
mulation of annual successes, or by a bolt from the blue.
The second way is certainly the more original. Let M.
Haussoullier remember the outcries which greeted *Dante
and Virgil,*[11] and then persevere along his own path. A lot
of miserable catcalls are yet in store for this work, but it will
abide in the memory of anyone with eyes and feelings. May
its success continue ever widening—for success it ought to
have.

After M. Delacroix's wonderful pictures, this is truly the
capital work of the exhibition. Let us rather say, it is, in a
certain sense at least, the unique picture of this year's Salon.
For M. Delacroix has for long been an illustrious genius, a
granted and accepted glory; and this year he has given us
four pictures. Whereas M. William Haussoullier was un-
known yesterday; and he has only sent one.

[10] Ingres' *Martyre de saint Symphorian,* painted for the Cathe-
dral of Autun and exhibited at the 1834 Salon, was the centre
of violent controversy.

[11] By Delacroix; exhibited at the 1822 Salon.

To begin with, we cannot deny ourselves the pleasure of describing it—such a joyful and delicious task does it seem. The subject is the Fountain of Youth.[12] In the foreground are three groups. At the left a young, or rather a rejuvenated couple, gazing into one another's eyes and talking close together—they appear to be practising Platonic love. In the middle, a half-nude woman, with skin white as snow, and brown crimped hair—she too is smiling and chatting with her partner; there is a greater air of sensuality about her, and she still holds a mirror in which she has just been looking at herself. Finally, in the right-hand corner, a robust and elegant man—a ravishing head, this, with forehead a trifle low and lips a shade forceful; he smiles as he puts down his glass on the turf, while his companion is pouring some wondrous elixir into the glass of a long, thin young man standing in front of her.

Behind them, on the second plane, is another group, lying at full length on the greensward, in one another's arms. In the middle stands a nude woman; she is wringing from her hair the last drops of the health-giving and fertilizing stream. A second woman, also nude, and half recumbent, seems like a chrysalis still clothed in the last shift of its metamorphosis. Delicate of form, these two women are vapourously, outrageously white; they are just beginning to re-emerge, so to speak, into life. The standing figure is in the strong position of dividing the picture symmetrically in two. This almost-living statue is admirably effective, and, by contrasting with them, stresses the violent hues of the foreground, which thereby acquire an added vigour. The fountain itself, which will doubtless strike some critics as a little too 'Séraphin'[13] in style—this

[12] This painting, long believed lost, was acquired in London shortly before the war by Mr. Graham Reynolds; see pl. 12. A preliminary drawing for it was published by J. Crépet in the *Figaro*, 15th Nov. 1924. The painting itself had been exhibited at the Royal Academy in London a year before being shown in Paris. As well as Baudelaire, Théodore de Banville was much struck by it and described it in a poem of the same title (dated May 1844), which was later published in *Les Stalactites* (1846).

[13] The 'Théâtre du sieur Séraphin', a marionette-theatre for children, was well known for its sensational production-effects.

fairy-tale fountain is much to our liking; it divides into
two sheets of water, and is tapered, or cleft, into wavering
fringes, thin as air. Along a winding pathway, which leads
the eye right into the background of the picture, come
happy sixty-year-olds, bent and bearded. The background
to the right consists of a grove in which a kind of joyful
ballet is taking place.

The sentiment of this picture is exquisite; it shows us
people making love and drinking—a sight that thrills the
senses—but they are drinking and making love in a deeply
serious, almost a melancholy manner. Far from the storms
and ferments of youth, this is a second youth which knows
the value of life and can enjoy it in tranquillity.

In our opinion this picture has one very important
quality, especially in a Museum—it is very showy. There is
no chance of not seeing it. Its colour is of a terrible, an
unrelenting rawness, which might even be accounted rash,
if the artist were a weaker man; but . . . it is *distinguished*
—a merit so sought after by the gentlemen of the school of
Ingres. Moreover it contains some happy tonal combina-
tions; it is possible that the artist will one day become a
genuine colourist. This painting possesses another pro-
digious quality, and one which makes men—true men; it
has faith—faith in its own beauty; this is absolute, self-
convinced painting, which cries aloud 'I will, I will be
beautiful, and beautiful according to my own lights; and
I know that I shall not lack an audience to please!'

The drawing, too, suggests great determination and
finesse; the facial expressions are pretty. All the attitudes
are felicitous. Elegance and *distinction* are the particular
mark of this picture throughout.

Will it have a swift success? We cannot tell. It is true that
every public possesses a conscience and a fund of good
will which urge it towards the true; but a public has to be
put on a slope and given an impetus, and our pen is even
more unknown than M. Haussoullier's talent.

If it were possible to re-exhibit the same work at different
times, and on different occasions, we could guarantee the
justice of the public towards this artist.

Nevertheless his painting is quite bold enough to sup-

port attack, and it suggests a man who can assume responsibility for his works; so he has only to go off and paint a new picture.

Now that we have so openly displayed our sympathies, dare we . . . ?—but our wretched duty compels us to think of everything!—dare we, I say, admit that after our sweet contemplation the names of Giovanni Bellini and of one or two other early Venetian painters crossed our mind? Is M. Haussoullier perhaps one of those who know too much about their art? That is a truly dangerous scourge, and one that represses the spontaneity of many an excellent impulse. Let him beware of his erudition, let him beware even of his taste—but that is a glorious failing—and this picture still contains enough originality to promise a happy future.

DECAMPS. Let us hurry on quickly—for Decamps kindles the curiosity in advance—you can always promise yourself a surprise—you count on something new. This year M. Decamps has contrived for us a surprise which surpasses all those on which he worked for so long and with so much love in the past—I mean the *Crochets* and the *Cimbres*.[14] This year M. Decamps has given us a bit of Raphael and Poussin. Yes, by Heaven, he has!

Let us hasten to correct any exaggeration in that sentence by saying that never was imitation better concealed, nor more skilful; it is perfectly permissible, it is praiseworthy, even, to imitate thus.

But frankly—in spite of all the pleasure it gives us to peruse an artist's works for the various transformations of his art and the successive preoccupations of his mind— frankly, we miss the old Decamps a little.

With the sense of choice which particularly distinguishes him, he has hit upon that one among all biblical subjects which best suits with the nature of his talent; it is the strange, epic, fantastic, baroque, mythological story of Samson, the man of impossible labours, who could overturn houses with a push of his shoulder—Samson, that antique cousin of Hercules and the Baron von Münchausen.

[14] The *Supplice des crochets* (Wallace Collection) was exhibited in 1839, and the *Défaite des Cimbres* (Louvre) in 1834.

The first of these designs[15]—the sudden appearance of the angel in the midst of a wide landscape—makes the mistake of recalling things that we know too well; that raw sky, those rocky boulders, those horizons of granite have for long been familiar to the whole of the younger school, and although it is true to say that it was M. Decamps who first taught them, nevertheless it pains us to be reminded of M. Guignet when we are in front of a Decamps.

Several of these drawings have, as we have already said, a very Italian cast to them; and this mingling of the spirit of the great masters with that of M. Decamps himself—a very Flemish intelligence, in certain respects—has produced a most curious result. For example, you will find figures comporting themselves happily enough in the grand manner, side by side with an effect of an open window and the sun streaming through it to light up the floor, such as would rejoice the heart of the most industrious Fleming. In the drawing, however, which represents the overturning of the temple—a drawing composed like a great and magnificent picture, with gestures and attitudes of historical grandeur—you will find the purest essence of this artist's genius in a flying silhouette of a figure who is taking several steps in his stride and remains eternally suspended in mid-air. How many others would have dreamt of this detail? or if they had, would not have realized it in a different way? But M. Decamps loves to capture nature in the very act, in her simultaneous moments of fantasy and reality—in her most sudden and most unexpected aspects.

The finest of all is undeniably the last, in which the broad-shouldered and invincible Samson is condemned to turn a mill-stone—his head of hair, or rather his mane, is no

[15] Decamps' *Histoire de Samson* in nine drawings was unanimously praised by the critics. The drawings were dispersed at the Delessert sale in May 1911, but a set of lithographic reproductions by Eugène le Roux exists. Decamps himself made a set of reduced replicas, of which one is now in the Lyons Museum. Pierre du Colombier (*Decamps*, 1928) reproduces three of the set, including that which shows Samson at the mill; the same three are reproduced in the Delessert sale catalogue. The statement in Bénézit's dictionary that such a set is in the Musée des Arts Décoratifs, Paris, is incorrect.

more—his eyes are blinded—the hero is bending to his toil
like a draft-animal—trickery and treachery have mastered
that terrible strength which was capable of overturning the
very laws of nature. Here, then, at last is a true bit of
Decamps, and of the best vintage; here at last we find that
sense of irony, of fantasy, I was just about to say that sense
of the comic, which we missed so much in the earlier
drawings. Samson is turning the wheel like a draft-horse;
he walks ponderously, stooping with a rude naïveté—the
naïveté of a dispossessed lion, the resigned sadness, the
almost brute abasement of the king of the forests made to
drag a cartload of manure or of offal for cats.

In the shadowed foreground an overseer—a jailor, no
doubt—is silhouetted against the wall, in an attentive atti-
tude, and is watching him work. What could be more
complete than these two figures and the mill-stone? And
what more interesting? There was no need even to intro-
duce those inquisitive onlookers behind a grill in the wall
—the thing was already fine, and fine enough.

And so we may say that M. Decamps has produced a
magnificent illustration, a set of heroic vignettes, to the
strange and poetic story of Samson. And although one
might perhaps find fault with the over-literal treatment of
a wall here and an object there, or with the meticulous and
artful mixture of painting and pencil, nevertheless, just be-
cause of the new aims which it reveals, this series of de-
signs constitutes one of the finest surprises which this prodi-
gious artist has yet produced. But no doubt he is already
getting some new ones ready for us.[16]

ACHILLE DEVÉRIA. And now for a fair name; now for a true
and noble artist, to our way of thinking.

The word has gone round among critics and journalists
to start intoning a charitable *De Profundis* over the defunct
talent of his brother, M. Eugène Devéria;[17] and each time

[16] *Paragraphs on* Robert-Fleury *and* Granet *are omitted here.*
[17] This probably refers to the article by Gautier in *La Presse*
(28th March 1844), in which Eugène Devéria's *Naissance de
Henri IV* (1827; now in the Louvre) was praised at the ex-
pense of his most recent work.

the fancy takes that glorious old veteran of romanticism to show his face, they devoutly enshroud him in the *Birth of Henri IV*, and burn a few candles in honour of his ruined genius. So far so good; it proves that those gentlemen have a conscientious love of beauty, and it does honour to their feelings. But how comes it that no one thinks of tossing a few sincere blossoms, of plaiting a few loyal tributes to the name of M. Achille Devéria? For long years, and all for our pleasure, this artist poured forth from the inexhaustible well of his invention a stream of ravishing vignettes, of charming little interior-pieces, of graceful scenes of fashionable life, such as no Keepsake—in spite of the pretensions of the new names—has since published. He was skilled at colouring the lithographic stone; all his drawings were distinguished, full of feminine charms, and distilled a strangely pleasing kind of reverie. All those fascinating and sweetly sensual women of his were idealizations of women that one had seen and desired in the evening at the *café-concerts*, at the Bouffes, at the Opera, or in the great Salons. Those lithographs, which the dealers buy for three sous and sell for a franc, are the faithful representatives of that elegant, perfumed society of the Restoration, over which there hovers, like a guardian angel, the blond, romantic ghost of the duchesse de Berry.[18]

But what ingratitude! People speak of them no longer, and today all our routine-minded and anti-poetic asses have turned their loving eyes towards the virtuous asininities and ineptitudes of M. Jules David,[19] or the pedantic paradoxes of M. Vidal.[20]

We are not going to say that M. Achille Devéria has painted an *excellent* picture in his *Sainte Anne instruisant la Vierge,* but he has painted a picture whose great value consists in qualities of elegance and clever composition. It is more a patchwork of colour than a painting, it is true, and

[18] The duchesse de Berry (1798–1870), daughter-in-law of Charles X, and mother of the comte de Chambord.

[19] In 1837 Jules David had published a set of moralistic lithographs entitled *Vice et Vertu.* He exhibited three water-colours at the 1845 Salon.

[20] See p. 34.

in these days of *pictorial criticism*, of *Catholic art* and of *bold handling*, a work like this must of necessity seem somewhat naïve and out of its element. But if the works of a famous man who was once your joy seem today to be naïve and out of their element, then at least you might bury him to the accompaniment of a chord or two on the orchestra, you mob of egotists!

BOULANGER's *Sainte famille*[21] is detestable.

His *Bergers de Virgile*—mediocre.

His *Baigneuses*—a little better than Duval Lecamuses or Maurins;[22] but his *Portrait d'homme* is a good piece of painting.

Here we have the last ruins of the old romanticism—this is what it means to come at a time when it is the accepted belief that inspiration is enough and takes the place of everything else; this is the abyss to which the unbridled course of Mazeppa has led.[23] It is M. Victor Hugo that has destroyed M. Boulanger—after having destroyed so many others; it is the poet that has tumbled the painter into the ditch. And yet M. Boulanger can paint decently enough—look at his portraits. But where on earth did he win his diploma as history-painter and inspired artist? Can it have been in the prefaces and odes of his illustrious friend?

BOISSARD. It is to be regretted that M. Boissard,[24] who possesses the qualities of a good painter, has not been able to show us this year an allegorical picture of his representing Music, Painting and Poetry. The jury, who doubtless found its irksome task too fatiguing that day, did not deem it proper to admit it. M. Boissard has always contrived to

[21] Now in the church of Saint-Médard, Paris.

[22] The Duval Lecamuses (father and son) were pupils of David and Delaroche respectively; Antoine Maurin was a pupil of Ary Scheffer.

[23] Boulanger achieved his first great success in 1827 with *Le Supplice de Mazeppa* (Rouen Museum).

[24] Boissard de Boisdenier, painter, musician, writer and dandy, was a friend of Baudelaire's in the days of the Club des Haschischins.

keep his head above the troubled waters of that bad period of which M. Boulanger prompted us to speak, and thanks to the serious and what one might call the *naïve* qualities of his painting, he has preserved himself from danger. His *Christ en croix* is solidly painted and its colour is good.

SCHNETZ. Alas! what is to be done with these vast Italian pictures? We are in 1845—but we are very afraid that Schnetz will still be giving us the same kind of thing ten years from now.

CHASSÉRIAU. *Le Kalife de Constantine suivi de son escorte*.[25] The immediate attraction of this picture lies in its composition. This procession of horses and noble riders has something that suggests the spontaneous boldness of the great masters. But to anyone who has carefully followed M. Chassériau's studies, it must be obvious that many a revolution is still going on in this youthful mind, and that the struggle is not yet over.

The position which he wants to create for himself between Ingres, whose pupil he is, and Delacroix, whom he is seeking to plunder, has an element of ambiguity for everybody—and of embarrassment for himself. That M. Chassériau should find his quarry in Delacroix is simple enough; but that, in spite of all his talent and of all the precocious experience that he has acquired, he should make the fact so obvious—that is where the evil lies. And so this picture contains contradictions. Here and there it already achieves *colour;* elsewhere it is still only a patchwork of *colouring*. Nevertheless its general effect is pleasing, and its composition, we are glad to repeat, is excellent.

As early as the Othello illustrations[26] everyone had noticed how concerned he was with imitating Delacroix. But given tastes as distinguished and a mind as active as those of M. Chassériau, there is every ground for hoping that he will become a painter, and an eminent one.[27]

[25] Now in the Versailles Museum; see pl. 17.
[26] A series of fifteen etchings which appeared in 1844.
[27] A *paragraph on* Debon *is omitted here.*

VICTOR ROBERT. Here is a picture which has been very unlucky. We think, however, that it has been quite sufficiently *roasted* by the pundits of the press, and that the time has now come to right its wrongs. And yet what a curious idea it was to show these gentlemen *Europe being enlightened by Religion, Philosophy, the Sciences and the Arts*,[28] and to represent each European people by a figure occupying its geographical position in the picture! How could one hope to make something bold acceptable to those scribblers, or to make them understand that allegory is one of the noblest branches of art?

The colour of this enormous composition is good—in bits, at least; it even reveals a search after fresh tones. The attitudes of some of the beautiful women who symbolize the various nations are elegant and original.

It is unfortunate that the eccentric idea of assigning its geographical position to each people should have damaged the ensemble of the composition and the charm of the groups, and that the figures should thus have been spilt all over the canvas, as in a picture by Claude whose little manikins are allowed to tumble about as they like.

Is M. Victor Robert a consummate artist, or a crack-brained genius? There are things to be said for either view —expert intentions side by side with the blunders of youth. But on the whole this is one of the most interesting pictures in the Salon, and one of the most worthy of attention.[29]

PLANET is one of those rare pupils of Delacroix who brilliantly reflect certain of their master's qualities.[30]

There is no joy so sweet, in the miserable business of writing a Salon-review, than to come upon a genuinely good and original picture whose name has already been made— by hoots and catcalls.

[28] The catalogue contained a lengthy explanation of this picture. Gautier described it as 'cet immense tableau humanitaire et palingénésique'.

[29] *Paragraphs on* Brune, Glaize, Lépaulle, Mouchy, Appert *and* Bigand *are omitted here.*

[30] Planet's *Souvenirs* (published long after his death, in 1929) contain much useful information concerning Delacroix's methods, as well as information about the present picture.

And in fact this picture really *has* been jeered at. We can perfectly well understand the hatred of architects, masons, sculptors and modellers towards anything that looks like painting; but how comes it that artists can be blind to such things in this picture as its originality of composition, and even its simplicity of colour?

We were charmed at the very start by some hint which it contains of an almost Spanish voluptuousness. M. Planet has done what all first-rate colourists do—that is, he has achieved colour with a small quantity of tones—with red, white, and brown; and the result is delicate and caressing to the eye. St. Teresa,[31] as the painter has represented her here—St. Teresa, sinking, falling, thrilling at the point of the dart with which Divine Love is about to pierce her, is among the happiest inventions in modern painting. The hands are charming. The attitude, for all its naturalness, is as poetic as could be. This picture distills an atmosphere of extreme sensuous rapture and marks its author as a man who is capable of thoroughly understanding a subject—for we are told that St. Teresa was 'afire with so great a love of God that its violence caused her to cry out aloud . . . And her pain was not bodily but spiritual, although her body had its share in it, even a large one'.[32]

Are we going to speak about the mystical little cupid, hanging in mid-air and about to transfix her with his javelin? No. What is the point? M. Planet is obviously talented enough to paint a *complete* picture another time.[33]

GLEYRE. He it was that captured the heart of the sentimental public with his picture, *Le Soir*.[34] And that was all very well, so long as it was only a question of painting women warbling romantic ballads in a boat—in the same way as a poor opera can triumph over its music with the

[31] *La Vision de sainte Thérèse*, now in a private collection, is reproduced on pl. 18.

[32] Quoted, in the catalogue, from St. Teresa's *Life* (ch. XXIX, § 17).

[33] *A paragraph on* Dugasseau *is omitted here.*

[34] Now in the Louvre; otherwise known as *Les Illusions perdues*. See pl. 42.

delightful aid of undraped bosoms—or rather *behinds*. But this year M. Gleyre has taken it into his head to paint apostles[85]—*apostles*, M. Gleyre! and alas! he has not proved capable of triumphing over his own painting.[36]

JOSEPH FAY. M. Joseph Fay has sent only drawings, like M. Decamps—which is our reason for including him among the history-painters. We are not concerned here with the *technique*, but with the *manner* in which an artist works.

M. Joseph Fay[37] has sent six drawings representing the life of the ancient Germans—they are the cartoons for a frieze executed in fresco in the town hall at Elberfeld in Prussia.

And as a matter of fact these things did strike us as more than a little *Germanic*, and while we were scrutinizing them with the pleasure that any honest work will always afford, we found ourselves thinking of all those modern celebrities from the other side of the Rhine, who are published by the dealers on the Boulevard des Italiens.

These drawings, of which some represent the great struggle between Arminius and the invading Romans, and others the serious and ever-martial games of Peace, bear a noble family likeness to the excellent compositions of Peter Cornelius. Their draughtsmanship is adroit and skilful, and tends towards the neo-Michelangelesque. Every movement is happily conceived and denotes a mind which sincerely loves form, if it be not actually in love with it. We were attracted to these drawings because of their beauty; and it is for that that we like them. But on the whole, despite the beauty of this array of intellectual power, we still yearn and cry aloud for *originality*: we should like to see this same talent arrayed in support of ideas more modern—or rather, in support of a new way of seeing and of understanding the arts. By this we do not mean to refer to choice of subject— for in that respect artists are not always free—but rather to

[85] This painting is now in the church at Montargis; it is reproduced, after an engraving, in Clément, *Gleyre*, 1878, pl. IV.

[36] *Paragraphs on* Pilliard *and* Auguste Hesse *are omitted here.*

[37] A German artist, Joseph Fay was in Paris in 1845-6. He studied for a time with Delaroche.

the manner in which subjects are comprehended and de-
picted.

In a word, what is the point of all this erudition when a
man has talent?[38]

JANMOT. We were only able to find a single figure-subject
by M. Janmot—it is of a woman, seated, with flowers on her
knee.[39] This simple figure, which is both serious and melan-
choly, and whose fine draughtsmanship and slightly raw
colour remind one of the old German masters—this graceful
Dürer made us excessively curious to find the others; but
we were not successful. Here, however, we certainly have a
fine painting; and quite apart from the fact that the model
is very beautiful, well chosen and well attired, there is in
the colour itself, and in this slightly distressing combination
of green, pink and red tones, a certain mystical quality
which is in keeping with the rest; there is a natural har-
mony here between colour and drawing.

To complete the idea that one should form of M. Jan-
mot's talent, it will be enough to read the subject of another
of his pictures in the catalogue:—'*The Assumption of the
Virgin;* in the upper part, the Blessed Virgin surrounded by
angels, of which the two chief ones represent Chastity and
Harmony; in the lower part, *The Rehabilitation of Woman*
—an angel breaking her chains.'

ETEX. Oh sculptor! you who have been known to give us
good statues—are you unaware, then, that there is a great
difference between designing upon a canvas and modelling
with clay, and that colour is a melodious science whose
secrets are not revealed by merely knowing how to cope
with marble? It would be possible to understand a *musician*
wanting to ape Delacroix—but a *sculptor*, never! Oh great
hewer of stone, why do you want to play the fiddle?[40]

[38] *Paragraphs on* Jollivet, Laviron *and* Matout *are omitted here.*
[39] Janmot's *Fleurs des champs* is now in the Lyons Museum; see
pl. 16. Besides his *Assumption* (mentioned below), he also ex-
hibited two portraits.
[40] Etex's painting was entitled *La Délivrance.* On his sculpture
see pp. 36–7 below.

III

PORTRAITS

LEON COGNIET has a very fine portrait of a woman, in the *Salon carré*.

This artist occupies a very high position in the middle reaches of taste and invention. If he does not aspire to the level of genius, his is one of those talents which defy criticism by their very completeness within their own moderation. M. Cogniet is as unacquainted with the reckless flights of fantasy as with the rigid systems of the absolutists. To fuse, to mix and to combine, while exercising choice, have always been his role and his aim; and he has perfectly fulfilled them. Everything in this excellent portrait—the flesh-tones, the millinery, the background—is handled with an equal felicity.

DUBUFE. For several years now M. Dubufe has been the victim of every art-journalist. If it is a far cry from M. Dubufe to Sir Thomas Lawrence, at any rate it is not without a certain justice that he has inherited some of that artist's urbane popularity. In our opinion the *bourgeois* is quite right to idolize the man who provides him with such pretty women—and almost always such elegantly attired ones.

M. Dubufe has a son who has declined to walk in the steps of his father, and has blundered into serious painting.

MLLE. EUGÉNIE GAUTIER. Fine colour—firm and elegant drawing. This woman knows her old masters—there is a touch of Van Dyck about her—she paints like a man. Every connoisseur of painting will remember the modelling of two bare arms in a portrait which she showed at the last Salon. Mlle. Eugénie Gautier's painting has nothing to do with *woman's painting*, which usually makes us think of the domestic precepts of the excellent Chrysale.[1]

[1] The protesting husband, and father, of Molière's *Femmes Savantes*.

BELLOC. M. Belloc has sent several portraits. That of
M. Michelet struck us with the excellence of its colour.
M. Belloc, who is not well enough known, is among the
most skilful of present-day artists. He has turned out some
remarkable pupils—Mlle. Eugénie Gautier is one of them,
we believe. Last year at the Bonne-Nouvelle galleries we
saw a child's head of his which reminded us of the very
best of Lawrence.[2]

HAFFNER. Another new name, for us at least. Very badly
hung in the little gallery, he has a strikingly effective por-
trait of a woman. It is difficult to find, which is a real pity.
This portrait betokens a colourist of the first order. There is
nothing dazzling, sumptuous or vulgar about its colour; it
is excessively distinguished and remarkably harmonious.
The whole thing is carried out within a very grey tonal
scale. Its effect is very skilfully contrived, so that it is at
once both soft and striking. The head, which is romantically
conceived and of a delicate pallor, stands out against a grey
background, which is paler still at this stage, and which,
by growing darker towards the edges, gives the impression
of forming a halo around it. As well as this, M. Haffner has
painted a landscape which is very daring in colour—it shows
a waggon with a man and some horses, almost silhouetted
against the uncertain brilliance of a twilight sky. Another
conscientious seeker . . . how rare they are!

PERIGNON[3] has sent nine portraits, of which six are of
women. M. Pérignon's heads are as hard and polished as in-
animate objects. A real waxwork show.

HORACE VERNET. M. Horace Vernet, the portrait-painter, is
inferior to M. Horace Vernet, the heroic painter. His colour
surpasses that of M. Court in rawness.

HIPPOLYTE FLANDRIN. Did not M. Flandrin once give us a
graceful portrait of a woman leaning against the front of

[2] *Paragraphs on* Tissier, Riesener *and* Dupont *are omitted here.*
[3] According to the critic of *l'Illustration*, Pérignon was 'le por-
traitiste à la mode'.

a theatre-box, with a bunch of violets at her bosom?[4] But alas! he has come to grief in his portrait of M. Chaix-d'Est-Ange.[5] This is but the semblance of serious painting; he has quite failed to catch the well-known expression of that fine-drawn, sardonic and ironical face. It is heavy and dull.

Nevertheless it has just given us the keenest pleasure to find a female portrait by M. Flandrin—a simple head—which reminded us once more of his best works. Its general effect may be a little too gentle, and perhaps it makes the mistake of not rivetting the eye, like M. Lehmann's portrait of the Princess Belgiojoso.[6] Nevertheless, as this picture is a small one, M. Flandrin has been able to carry it through to perfection. The modelling is beautiful, and the whole thing has the merit, which is rare among these gentlemen, of seeming to have been done all in one breath and at the first attempt.[7]

HENRI SCHEFFER. To give this artist his proper due, we dare not suppose that this portrait of His Majesty was done from the life. There are but few faces in contemporary history which are so strongly marked as that of Louis-Philippe. Toil and fatigue have printed some goodly wrinkles upon it—but of these the artist shows no knowledge. It pains us that France should not possess a single portrait of her King. One man alone is worthy of that task—it is M. Ingres.

All of M. Henri Scheffer's portraits are painted with the same blind and meticulous honesty, the same monotonous and patient conscientiousness.[8]

[4] Presumably the portrait of Mme. Oudiné, exhibited at the 1840 Salon; repro. facing p. 166 in Louis Flandrin's *Hippolyte Flandrin, Sa Vie et son Oeuvre* (Paris 1902).

[5] Jurist, statesman and barrister (1800–76), the father of Baudelaire's counsel in the lawsuit over *Les Fleurs du Mal* (Aug. 1857).

[6] Henri Lehmann's portrait of the Princess Belgiojoso was one of the great successes of the 1844 Salon. Reproduced in R. Barbiera's *La Principessa Belgioioso* (edition of 1914), as the property of the Marchese Franco Dal Pozzo.

[7] *Paragraphs on* Richardot *and* Verdier *are omitted here.*

[8] *A paragraph on* Leiendecker *is omitted here.*

DIAZ. M. Diaz usually paints little pictures whose magical colour surpasses even the fantastic visions of the kaleido-scope. This year he has sent some small full-length portraits. But it is not only colour, but lines and modelling, that go to make a portrait. No doubt our genre-painter will get his own back for this year's aberration.

IV

GENRE-PAINTINGS

BARON has taken his *Oies du père Philippe*[1] from one of La Fontaine's tales.

He has made it an excuse for introducing pretty women, shady trees, and variegated colours, for all that.

Its general effect is most engaging, but it must be ac-counted the *rococo* of Romanticism. It contains elements of Couture, a little of Célestin Nanteuil's technique, and a lot of tints borrowed from Roqueplan and Clément Boulanger. Stand in front of this picture and reflect how cold an ex-cessively expert and brilliantly-coloured painting can still remain when it lacks an individual temperament.

ISABEY. *Un Intérieur d'alchimiste.*[2] These scenes always contain crocodiles, stuffed birds, vast morocco-bound tomes, fiery braziers, and an old man in a dressing-gown—that is to say, a great diversity of tints. This explains the partiality of certain colourists for so commonplace a subject.

M. Isabey is a true colourist—always brilliant, frequently subtle. He has been one of the most justly fortunate of the men of the new movement.

LECURIEUX. *Salomon de Caus, à Bicêtre.*[3] We are in a popular playhouse that has gone in for real literature for a

[1] Repro. *Moniteur des Arts* (I, 96).

[2] Repro. *Illustr.*, vol. 5 (1845), p. 57.

[3] Repro. *Illustr.*, vol. 5 (1845), p. 41. Salomon de Caus was an engineer who in his writings foreshadowed the theory of steam-power. The story of his confinement in the asylum at Bicêtre is

change. The curtain has just risen, and all the actors are facing the public.

A great lord, with Marion Delorme leaning sinuously upon his arm, is turning a deaf ear to the complaints of Salomon, who is gesticulating like a maniac in the background.

The production is well-staged; all the lunatics are charming, picturesque, and know their parts perfectly.

Indeed, we cannot understand Marion Delorme's dismay at the sight of such charming lunatics.

The uniform effect created by this picture is one of *café au lait*. It is as russet in colour as a wretched, dust-ridden day.

The drawing—that of a vignette, an illustration. What is the point of attempting what is called serious painting when one is neither a colourist nor a draughtsman?[4]

TASSAERT. A little devotional picture, done almost like a love-scene. The Virgin is suckling the infant Jesus, beneath a coronet of flowers and little cupids. We had already taken note of M. Tassaert last year. He combines good, moderately bright colour with a great deal of taste.[5]

GUILLEMIN. Though his execution certainly has merit, M. Guillemin wastes too much talent supporting a bad cause— the cause of *wit in painting*. By this I mean providing the catalogue-printer with captions aimed at the Sunday public.

MULLER. Can it be the *Saturday* public, on the other hand, that M. Muller thinks to please when he chooses his subjects from Shakespeare and Victor Hugo?[6] Enormous 'Empire' cupids in the guise of sylphs. So it is not enough to be a colourist in order to have taste. His *Fanny*, however, is better.[7]

related in a letter from Marion Delorme, the famous 17th century courtesan, which is quoted in the catalogue.

[4] *A paragraph on* Mme. Céleste Pensotti *is omitted here.*

[5] *Paragraphs on* Leleux frères *and* Lepoitevin *are omitted here.*

[6] Muller's *Sylphe endormi* was supported with a quotation from Victor Hugo, and his *Lutin Puck* with one from Shakespeare.

[7] *Paragraphs on* Duval Lecamus (père) *and* Duval Lecamus (Jules) *are omitted here.*

GIGOUX. M. Gigoux has given us the pleasant task of re-reading the account of the death of Manon Lescaut[8] in the catalogue. But his picture is bad; it has no style, and its composition and colour are bad. It lacks all character, it lacks all feeling for its subject. Whatever is this Desgrieux? I would not recognize him.

No more can I recognize M. Gigoux himself in this picture—the M. Gigoux who several years ago was acclaimed by the public as the equal of the most serious innovators in art. . . . Can it be that he is embarrassed today by his reputation as a painter?

RUDOLPHE LEHMANN.[9] His Italian women this year make us regret those of last year.[10]

PAPETY showed great promise, they say. On his return from Italy (which was heralded by some injudicious applause), he exhibited an enormous canvas[11] in which, although the recent usages of the Academy of Painting were too clearly discernible, he had nevertheless hit upon some felicitous poses and several compositional *motifs;* and in spite of its fan-like colour, there was every ground for predicting the artist a serious future. Since then he has remained in the secondary class of the men who paint well and have portfolios full of scraps of ideas all ready to be used. His two pictures this year (*Memphis* and *Un Assaut*)[12] are commonplace in colour. Nevertheless their general appearance

[8] Repro. *l'Artiste*, 4th series, vol. IV, and Ferran's edition of the *Salon of 1845*, facing p. 178.

[9] Rudolphe Lehmann is not to be confused with his brother Henri Lehmann, to whose portrait of the Princess Belgiojoso there is reference above. Of the former's paintings of Italian peasant women, one is reproduced *Illustr.*, vol. 5 (1845), p. 137, and another *Moniteur des Arts* (II, p. 41).

[10] *Paragraphs on* De la Foulhouse, Pérèse, De Dreux *and* Mme. Calamatta *are omitted here.*

[11] Presumably his *Rêve de bonheur,* exhibited in 1843.

[12] *Memphis,* repro. *Illustr.*, vol. 5 (1845), p. 137. *Un Assaut* (correct title, *Guillaume de Clermont défendant Ptolémais*) is in the Versailles Museum.

differs considerably, which leads us to imagine that M.
Papety has not yet discovered his manner.

ADRIEN GUIGNET. There is no doubt that M. Adrien Gui-
gnet has talent; he knows how to compose and arrange. But
why, then, this perpetual *doubt?* One moment it is De-
camps, and the next, Salvator. This year you would think
that he had taken some motives from Egyptian sculpture or
antique mosaics, and then had coloured them, on papyrus
(*Les Pharaons*).[13] And yet if Salvator or Decamps were
painting Psammenit or Pharaoh, even so they would do them
in the manner of Salvator or Decamps. Why then does M.
Guignet . . . ?

MEISSONIER. Three pictures: *Soldats jouant aux dés—Jeune
homme feuilletant un carton*[14]—*Deux buveurs jouant aux
cartes.*

Times change—and with them, manners; fashions change
—and with them, schools. In spite of ourselves, M. Meis-
sonier makes us think of M. Martin Drolling. All reputa-
tions, even the most deserved ones, contain a mass of little
secrets. Thus, when the celebrated Monsieur X. was asked
what he had seen at the Salon, he replied that the only
thing he had seen was a Meissonier—in order to avoid
speaking about the equally famous Monsieur Y., who, for
his part, said exactly the same thing! See what a good
thing it is to act as a club for two rivals to beat one another
with!

On the whole M. Meissonier executes his little figures
admirably. He is a Fleming, minus the fantasy, the charm,
the colour, the naïveté—and the pipe![15]

HORNUNG. '*Le plus têtu des trois n'est pas celui qu'on
pense.*'[16]

[13] *Joseph expliquant les songes du Pharaon* is now in the Rouen
Museum. See pl. 14.

[14] Repro. (*Jeune homme regardant des dessins*), *Illustr.*, vol. 5
(1845), p. 184.

[15] *Paragraphs on* Jacquand, Roehn, Rémond *and* Henri Scheffer
are omitted here.

[16] 'The most stubborn of the three is not the one you think', was

BARD. See above.

GEFFROY. See above.

V

LANDSCAPES

COROT. At the head of the modern school of landscape stands M. Corot. If M. Théodore Rousseau[1] were to exhibit, his supremacy would be in some doubt, for to a *naïveté*, an originality which are at least equal, M. Rosseau adds a greater charm and a greater sureness of execution. It is *naïveté* and originality, in fact, which constitute M. Corot's worth. Obviously this artist loves Nature sincerely, and knows how to look at her with as much knowledge as love. The qualities by which he excels are so strong—because they are qualities of heart and soul—that M. Corot's influence is visible today in almost all the works of the young landscape-painters—in those, above all, who already had the good sense to imitate him and to profit by his manner before he was famous and at a time when his reputation still did not extend beyond the world of the studios. From the depths of his modesty, M. Corot has acted upon a whole host of artists. Some have devoted themselves to combing nature for the themes, the views and the colours for which he has a fondness—to fostering the same subjects; others have even tried to paraphrase his awkwardness. Now, on the subject of this pretended *awkwardness* of M. Corot's, it seems to us that there is a slight misconception to clear up. After having conscientiously admired and faithfully praised a picture by Corot, our fledgling connoisseurs always end by declaring that it comes to grief in its execution; they agree in this, that decidedly M. Corot

the title of Hornung's painting; it showed a boy and a girl sitting on a donkey, and served Baudelaire with a convenient riddle with which to dismiss his last three genre-painters. See La Fontaine, *Le Meunier, son fils, et l'âne*, l. 37.

[1] See *n.*, p. 117.

does not know how to paint. Splendid fellows! who first of
all are unaware that a work of genius (or if you prefer, a
work of the soul), in which every element is well seen, well
observed, well understood and well imagined, will always
be very well executed when it is *sufficiently* so. Next, that
there is a great difference between a work that is *complete*
and a work that is *finished;* that in general what is *complete*
is not *finished,* and that a thing that is highly *finished* need
not be *complete* at all; and that the value of a telling, ex-
pressive and well-placed touch is enormous, etc., etc.,—
from all of which it follows that M. Corot paints like the
great masters. We need look no further for an example
than to his picture of last year,[2] which was imbued with
an even greater tenderness and melancholy than usual. That
verdant landscape, in which a woman was sitting playing
the violin—that pool of sunlight in the middle distance,
which lit up and coloured the grass in a different manner
from the foreground, was certainly a most successful stroke
of aesthetic daring. M. Corot is quite as strong this year as
in the past—but the eye of the public has become so ac-
customed to neat, glistening and industriously polished
morsels that the same criticism is always levelled at him.

Another proof of M. Corot's powers, be it only in the
sphere of technique, is that he knows how to be a colourist
within a scarcely varied tonal range—and that he is always
a harmonist even when he uses fairly raw and vivid tones.
His composition is always impeccable. Thus in his *Homère
et les bergers*[3] there is nothing unnecessary, nothing to be
pruned—not even the two little figures walking away in
conversation down the path. The three little shepherds with
their dog are enchanting, like those excellent little scraps
of bas-relief which are sometimes to be found on the
pedestals of antique statues. But is not Homer himself a
little too much like Belisarius, perhaps?

Daphnis et Chloe[4] is another picture full of charms; its

[2] Exhibited in 1844 as *Paysage avec figures*, this picture was ex-
tensively repainted by the artist and exhibited again thirteen
years later; it is now in the Chantilly Museum (*Le Concert*).

[3] Now in the Saint-Lô Museum. See pl. 20.

[4] Repro. *Moniteur des Arts* (I, 152).

composition, like all good compositions—as we have often observed—has the merit of the unexpected.

FRANÇAIS is another landscape-painter of the highest merit —a merit somewhat like that of Corot, and one that we should be inclined to characterize as 'love of nature'; but it is already less naïve, more artful—it smacks much more of its painter—and it is also easier to understand. His painting, *Le Soir*,[5] is beautiful in colour.

PAUL HUET. *Un vieux château sur des rochers.* Can it be that M. Paul Huet is seeking to modify his manner?
 But it was already excellent as it was.

HAFFNER. Prodigious originality—above all in colour. This is the first time that we have seen works by M. Haffner, so we do not know if he is by rights a landscape-painter or a portrait-painter—all the more so because he excels in both genres.

TROYON always paints beautiful, luxuriant landscapes, and he paints them in the role of colourist and even that of *observer*—but he always wearies the eye by the unshakeable self-confidence of his manner and the restless flicker of his brush-strokes. It is not pleasant to see a man so sure of himself.

CURZON has painted a highly original view called *Les Houblons*. It is quite simply a horizon, framed in the leaves and branches of the foreground. As well as this, M. Curzon has produced a very fine drawing of which we shall shortly have occasion to speak.[6]

CALAME AND DIDAY.[7] For a long time people were under the impression that this was one and the same artist, suffering from a *chronic dualism;* but later it was observed that

[5] Repro. *Moniteur des Arts* (I, 64).

[6] *Paragraphs on* Flers *and* Wickemberg *are omitted here.*

[7] Calame was the pupil of Diday. This year Calame exhibited *Un Orage* and Diday *La Suite d'un orage dans les Alpes.*

he had a preference for the name Calame on the days when he was painting well.[8]

BORGET. Eternal views of India and China.[9] Doubtless it is all very well done, but they are too much like travel-essays or accounts of manners and customs. There are people, however, who sigh for what they have never seen—such as the boulevard du Temple, or the galeries de Bois![10] M. Borget's pictures make us sigh for that China where the very breeze, according to M. Heine,[11] takes on a comic sound as it slips past the little hanging bells, and where nature and man cannot look at one another without laughing.

PAUL FLANDRIN. It is understandable that a man should damp down the reflected lights on a head in order to make the modelling more visible—and above all so when his name is Ingres. But who on earth was the weird eccentric who first took it into his head to 'ingrize' the countryside?[12]

BRASCASSAT. Without doubt too much fuss is being made of M. Brascassat, who, man of sense and talent as he is, must really know that the Flemish gallery contains a lot of pictures of the same kind as his[13]—quite as fully realized, more broadly painted—and of a better colour.—Similarly too much fuss is made of

[8] *Paragraphs on Dauzats, Frère, Chacaton, Loubon, Garnerey and* Joyant *are omitted here.*

[9] His *Pont Chinois* was repro. *Illustr.*, vol. 5 (1845), p. 136. He had been exhibiting Chinese and Indian views since 1836.

[10] A favourite rendezvous in the Palais-Royal: it had already been demolished when Baudelaire wrote, and the site is now occupied by the Galerie d'Orléans.

[11] The allusion is to a passage in Heine's *Die romantische Schule* (Bk. III, ch. 1, § 1).

[12] *Paragraphs on Blanchard, Lapierre and Lavieille are omitted here.*

[13] Of five landscapes exhibited, one, *Vache attaquée par des loups*, was repro. *Illustr.*, vol. 5 (1845), p. 39, and another, *Paysage*, repro. *Moniteur des Arts* (I, 112).

SAINT-JEAN, who is of the school of Lyons, the penitentiary of painting, the corner of the known world in which the infinitely minute is wrought the best. We prefer the flowers and fruits of Rubens; they seem to us more natural. Moreover the general effect of M. Saint-Jean's picture[14] is most wretched—it is monotonously yellow. On the whole, however well executed they may be, M. Saint-Jean's pictures are dining-room pictures—not cabinet or gallery-pictures, but real *dining-room* pictures.[15]

ARONDEL.[16] A great heap of game of every kind. This ill-composed picture—more a hotch-potch than a composition, as though it was aiming above all at *quantity*—has nevertheless what is a very rare quality these days; it is painted with a great *naïveté*, without any dogmatism of school or pedantry of studio. And from this it follows that parts of it are really well painted. Unhappily some others are of a muddy brown colour, which gives the picture a certain effect of dinginess—but all the clear or rich tones are thoroughly effective. What therefore struck us in this picture was its mixture of clumsiness and skill—blunders suggesting a man who had not painted for years, and assurance suggesting a man who had painted a great deal.

CHAZAL has painted the *Yucca gloriosa* which flowered last year in the park at Neuilly. It would be a good thing if all those people who cling so desperately to microscopic truth, and believe themselves to be painters, could see this little picture; and if the following little observations could be pumped into their ears through an ear-trumpet:—'This picture is a success not because everything is there and you can count each leaf, but because at the same time it cap-

[14] *Fruits et Fleurs,* a copy of which is now in the Dijon Museum.
[15] *Paragraphs on* Kiörboe, Philippe Rousseau *and* Béranger *are omitted here.*
[16] This obscure artist was twice mentioned by Baudelaire in his salon-reviews (see p. 119 below). He is generally identified with the dealer Arondel who sold Baudelaire false Bassanos and in whose debt Baudelaire long remained. His address is given in the catalogue as the Hôtel Pimodan, quai d'Anjou, where Baudelaire also had lived.

tures the general character of nature; because it conveys well the raw greenness of a park beside the Seine and the effect of our cold sun; in short, because it is done with a profound *naïveté,* whereas all of you spend far too much of your time being . . . *artists!'* (Sic).

VI

DRAWINGS—ENGRAVINGS

BRILLOUIN has sent five pencil-drawings which are a little like those of M. de Lemud; these, however, have more firmness and perhaps more character. Their composition on the whole is good. 'Tintoretto giving a drawing-lesson to his daughter' is certainly an excellent thing. What chiefly distinguishes these drawings is their nobility of structure, their seriousness and the characterization of the heads.

CURZON. *Une sérénade dans un bateau* is one of the most distinguished things in the Salon. The arrangement of all those figures is most happy, and the old man lying amid his garlands at the end of the boat is a most delightful idea. There is some affinity between M. Curzon's composition and those of M. Brillouin; they have this above all in common—they are well drawn, and drawn with a vivid touch.[1]

MARÉCHAL. Without doubt *La Grappe*[2] is a fine pastel, and good in colour. But we must criticize all those gentlemen of the school of Metz[3] for only as a rule achieving a *conventional* seriousness, an *imitation* of real mastery. We would say this without wishing in the very least to detract from the honour of their efforts . . .[4]

[1] *A paragraph on* De Rudder *is omitted here.*

[2] Repro. *Illustr.,* vol. 5 (1845), p. 185.

[3] The *Société des Amis des Arts* at Metz was founded in 1834, and it was from this that the *Ecole de Metz* sprang. Maréchal was one of its leaders. See Ferran's edition of the *Salon de 1845* (pp. 272–3) for further details. See also p. 90 below.

[4] *Paragraphs on* Tourneux, Pollet, Chabal, Alphonse Masson *and* Antonin Moine *are omitted here.*

VIDAL. It was last year, to the best of our belief, that the
parrot-cry about Vidal's drawings began to be raised.[5] It
would be a good thing to be finished with it once and for
all. Every effort is now being made to present M. Vidal to
us as a serious draughtsman. His are *very finished* drawings
—but they are *incomplete;* nevertheless it must be admitted
that they have more elegance than those of Maurin and
Jules David. We beg forgiveness for insisting so strongly
on this point—but we know a critic who took it into his
head to speak about Watteau in connection with M. Vidal.[6]

JACQUE. Here we have a new name which will continue, let
us hope, to grow greater. M. Jacque's[7] etching is very bold
and he has grasped his subject admirably. There is a
directness and a freedom about everything that M. Jacque
does upon his copper which reminds one of the old masters.
He is known, besides, to have executed some remarkable
reproductions of Rembrandt's etchings.

VII

SCULPTURES

BARTOLINI.[1] We in Paris have a right to be suspicious of
foreign reputations. Our neighbours have so often beguiled

[5] Baudelaire seems to be confusing two artists of this name. *Victor* Vidal, who exhibited five drawings this year (one of them, *L'Amour de soi-même,* repro. *Illustr.,* vol. 5 [1845], p. 152), had not exhibited since 1841, whereas *Vincent* Vidal, who showed nothing in 1845, had exhibited five pastels in the previous year. It seems, therefore, that the 'préjugé Vidal', to which Baudelaire again referred in 1846 (see pp. 91–2 below), originated with Vincent, and not Victor, Vidal.

[6] Gautier had invoked the name of Watteau (and of Chardin) in *La Presse,* 16th April; and Thoré added Boucher and Fragonard. *Paragraphs on* Mme. de Mirbel *and* Henriquel-Dupont *are omitted here.*

[7] This was Jacque's first Salon.

[1] Lorenzo Bartolini (1777–1850) was one of the most admired Italian sculptors of his day. His portrait had been painted by Ingres in 1806, and again in 1820.

our credulous admiration with masterpieces which they
never showed—or which, if at last they consented to reveal
them, were an object of embarrassment for them, as for us
—that we always remain on our guard against new traps.
Thus it was only with an excessive feeling of suspicion that
we approached the *Nymphe au scorpion*. But this time we
have found it quite impossible to withhold our admiration
from a foreign artist. Certainly our sculptors have more
skill—an excessive preoccupation with technique engrosses
them just as it does our painters; but it is precisely because
of the qualities which our artists have to some extent for-
gotten—namely taste, nobility, grace—that we regard M.
Bartolini's exhibit as the capital work of the Salon of
sculpture. We know that more than one of the *sculpturizers*
of whom we are about to speak are very well fitted to pick
out the several faults of execution which this statue con-
tains—a little too much softness here, a lack of firmness
there; in short, certain flabby passages, and a touch of
meagreness about the arms—but not one of them has man-
aged to hit upon such a pretty *motif;* not one of them has
this fine taste, this purity of aim, this chastity of line which
by no means excludes originality. The legs are charming,
the head graceful and coquettish; it is probable that it is
quite simply a well-chosen model.* The less a workman
obtrudes himself in his work and the purer and clearer its
aims, the more charmed we are.

DAVID. This is far from the case with M. David, for ex-
ample, whose works always make us think of Ribera. And
yet our comparison is not entirely just, for Ribera is only
a man of technique *into the bargain*, so to speak—in addi-
tion to that, he is full of fire, originality, rage and irony.

Certainly it would be difficult to model or to trace a
contour better than M. David. His child hanging on to a
bunch of grapes,[2] which was already familiar to us from

* What makes us only the prouder of our opinion is that we
know it to be shared by one of the greatest painters of the mod-
ern school. (C.B.)

[2] *L'Enfant à la grappe*, now in the Louvre. Sainte-Beuve's poem,
'Sur une statue d'enfant, à David, statuaire', is included in his
Pensées d'Août.

a few charming lines by Sainte-Beuve, is an intriguing thing; admittedly it is real flesh and blood, but it is *as senseless* as nature—and surely it is an uncontested truth that it is no part of the aim of sculpture to go into rivalry with plaster-casts. Having made this point, let us stand back and admire its beauty of workmanship.[3]

PRADIER. You would think that M. Pradier had wanted to get away from himself and to mount up, in one leap, towards the supernal regions. We do not know how to praise his statue;[4] it is incomparably skilful; it is pretty from every angle, though doubtless one could trace some of its detail to the Museum of antique sculpture, for it is a prodigious mixture of hidden borrowings. Beneath this new skin the old Pradier still lives, to give an exquisite charm to this figure. Certainly it is a noble *tour de force;* but M. Bartolini's Nymph, with all its imperfections, seems to us to be more original.

FEUCHÈRE. More cleverness—but Good Heavens! shall we never get any further?

This young artist has already had his good years at the Salon; his statue is evidently destined for a success. Quite apart from the fact that its subject is a happy one (for virgin purity can generally count on a public, like everything that touches the popular affections), this Joan of Arc, which we had already seen in plaster,[5] gains much by being enlarged. The fall of the drapery is good—not at all like that of the generality of sculptors; the arms and the feet are very finely wrought; the head is perhaps a little commonplace.[6]

ETEX. M. Etex has never been able to produce anything complete. His conceptions are often happy—he possesses a certain pregnancy of thought which reveals itself quickly enough and which we find pleasing; but his work is always

[3] *A paragraph on Bosio is omitted here.*
[4] *Phryné,* repro. *Illustr.,* vol. 5 (1845), p. 173.
[5] At the 1835 Salon.
[6] *A paragraph on Daumas is omitted here.*

spoiled by quite considerable passages. Thus, when seen from behind, his group 'Hero and Leander' seems heavy, and the lines do not unfold harmoniously. Hero's shoulders and back are unworthy of her hips and legs.[7]

DANTAN has done several good busts[8]—noble, and obviously lifelike—as has

CLESINGER, who has put a great deal of distinction and elegance into his portraits of the duc de Nemours and Mme. Marie de M . . .

CAMAGNI has done a romantic bust of Cordelia, original enough in type to be a portrait . . .

We do not think that we have been guilty of any serious omissions. This Salon, on the whole, is like all previous Salons, except for the sudden, unexpected and dazzling appearance of M. William Haussoullier, and several very fine things, by Delacroix and Decamps. For the rest, let us record that everyone is painting better and better—which seems to us a lamentable thing; but of invention, ideas or temperament there is no more than before. No one is cocking his ear to to-morrow's wind; and yet the heroism of *modern life* surrounds us and presses upon us. We are quite sufficiently choked by our true feelings for us to be able to know them. There is no lack of subjects, nor of colours, to make epics. The painter, the true painter for whom we are looking, will be he who can snatch its epic quality from the life of today and can make us see and understand, with brush or with pencil, how great and poetic we are in our cravats and our patent-leather boots. Next year let us hope that the true seekers may grant us the extraordinary delight of celebrating the advent of the *new!*[9]

[7] *Paragraphs on* Garraud, Debay, Cumberworth, Simart, Forceville-Duvette *and* Millet *are omitted here.*

[8] One of them, of Soufflot, is at Versailles. The reference is to Dantan the younger; Dantan *aîné* did not exhibit this year.

[9] This conclusion is taken up and developed in the closing section of the *Salon of 1846.*

THE SALON OF 1846[1]

TO THE BOURGEOIS

You ARE the majority—in number and intelligence; therefore you are the force—which is justice.

Some are scholars, others are owners; a glorious day will come when the scholars shall be owners and the owners scholars. Then your power will be complete, and no man will protest against it.

Until that supreme harmony is achieved, it is just that those who are but owners should aspire to become scholars; for knowledge is no less of an enjoyment than ownership.

The government of the city is in your hands, and that is just, for you are the force. But you must also be capable of feeling beauty; for as not one of you today can do without power, so not one of you has the right to do without poetry.

You can live three days without bread—without poetry, never! and those of you who say the contrary are mistaken; they are out of their minds.

The aristocrats of thought, the distributors of praise and blame, the monopolists of the things of the mind, have told you that you have no right to feel and to enjoy—they are Pharisees.

For you have in your hands the government of a city whose public is the public of the universe, and it is necessary that you should be worthy of that task.

Enjoyment is a science, and the exercise of the five senses calls for a particular initiation which only comes about through good will and need.

Very well, you need art.

Art is an infinitely precious good, a draught both refreshing and cheering which restores the stomach and the mind to the natural equilibrium of the ideal.

You understand its function, you gentlemen of the bour-

[1] The exhibition opened on 16th March at the Musée Royal. Baudelaire's review appeared as a booklet on 13th May. See pl. 2.

geoisie—whether lawgivers or business-men—when the
seventh or the eighth hour strikes and you bend your tired
head towards the embers of your hearth or the cushions
of your arm-chair.

That is the time when a keener desire and a more active
reverie would refresh you after your daily labours.

But the monopolists have decided to keep the forbidden
fruit of knowledge from you, because knowledge is their
counter and their shop, and they are infinitely jealous of it.
If they had merely denied you the power to create works
of art or to understand the processes by which they are
created, they would have asserted a truth at which you
could not take offence, because public business and trade
take up three quarters of your day. And as for your leisure
hours, they should be used for enjoyment and pleasure.

But the monopolists have forbidden you even to enjoy,
because you do not understand the technique of the arts,
as you do those of the law and of business.

And yet it is just that if two thirds of your time are
devoted to knowledge, then the remaining third should be
occupied by *feeling*—and it is by feeling alone that art is to
be understood; and it is in this way that the equilibrium
of your soul's forces will be established.

Truth, for all its multiplicity, is not two-faced; and just
as in your politics you have increased both rights and
benefits, so in the arts you have set up a greater and more
abundant communion.

You, the bourgeois—be you king, lawgiver or business-
man—have founded collections, museums and galleries.
Some of those which sixteen years ago were only open to
the monopolists have thrown wide their doors to the multi-
tude.

You have combined together, you have formed com-
panies and raised loans in order to realize the idea of the
future in all its varied forms—political, industrial and
artistic. In no noble enterprise have you ever left the
initiative to the protesting and suffering minority,[2] which
anyway is the natural enemy of art.

For to allow oneself to be outstripped in art and in

[2] i.e. the Republicans.

politics is to commit suicide; and for a majority to commit suicide is impossible.

And what you have done for France, you have done for other countries too. The Spanish Museum[3] is there to increase the volume of general ideas that you ought to possess about art; for you know perfectly well that just as a national museum is a kind of communion by whose gentle influence men's hearts are softened and their wills unbent, so a foreign museum is an international communion where two peoples, observing and studying one another more at their ease, can penetrate one another's mind and fraternize without discussion.

You are the natural friends of the arts, because you are some of you rich men and the others scholars.

When you have given to society your knowledge, your industry, your labour and your money, you claim back your payment in enjoyments of the body, the reason and the imagination. If you recover the amount of enjoyments which is needed to establish the equilibrium of all parts of your being, then you are happy, satisfied and well-disposed, as society will be satisfied, happy and well-disposed when it has found its own general and absolute equilibrium.

And so it is to you, the bourgeois, that this book is naturally dedicated; for any book which is not addressed to the majority—in number and intelligence—is a stupid book.

1st May 1846

I

WHAT IS THE GOOD OF CRITICISM?

WHAT is the good?—A vast and terrible question-mark which seizes the critic by the throat from his very first step in the first chapter that he sits down to write.

At once the artist reproaches the critic with being unable to teach anything to the bourgeois, who wants neither to paint nor to write verses—nor even to art itself, since it is from the womb of art that criticism was born.

[3] See pp. 2-3.

And yet how many artists today owe to the critics alone their sad little fame! It is there perhaps that the real reproach lies.

You will have seen a Gavarni which shows a painter bending over his canvas; behind him stands a grave, lean, stiff gentleman, in a white cravat, holding his latest article in his hand. 'If art is noble, criticism is holy.'—'Who says that?'—'The critics!'[1] If the artist plays the leading role so easily, it is doubtless because his critic is of a type which we know so well.

Regarding technical means and processes taken from the works themselves,* the public and the artist will find nothing to learn here. Things like that are learnt in the studio, and the public is only concerned about the result.

I sincerely believe that the best criticism is that which is both amusing and poetic: not a cold, mathematical criticism which, on the pretext of explaining everything, has neither love nor hate, and voluntarily strips itself of every shred of temperament. But, seeing that a fine picture is nature reflected by an artist, the criticism which I approve will be that picture reflected by an intelligent and sensitive mind. Thus the best account of a picture may well be a sonnet or an elegy.

But this kind of criticism is destined for anthologies and readers of poetry. As for criticism properly so-called, I hope that the philosophers will understand what I am going to say. To be just, that is to say, to justify its existence, criticism should be partial, passionate and political, that is to say, written from an exclusive point of view, but a point of view that opens up the widest horizons.

To extol line to the detriment of colour, or colour at the expense of line, is doubtless a point of view, but it is neither very broad nor very just, and it indicts its holder of a great ignorance of individual destinies.

[1] No. 4 of Gavarni's series of lithographs entitled *Leçons et Conseils,* published in *Le Charivari,* 27 Nov. 1839. See pl. 3.

* I know quite well that criticism today has other pretensions; that is why it will always recommend drawing to colourists, and colour to draughtsmen. Its taste is in the highest degree rational and sublime! (c.b.)

You cannot know in what measure Nature has mingled
the taste for line and the taste for colour in each mind, nor
by what mysterious processes she manipulates that fusion
whose result is a picture.

Thus a broader point of view will be an orderly in-
dividualism—that is, to require of the artist the quality of
naïveté and the sincere expression of his temperament,
aided by every means which his technique provides.* An
artist without temperament is not worthy of painting pic-
tures, and—as we are wearied of imitators and, above all,
of eclectics—he would do better to enter the service of a
painter of temperament, as a humble workman. I shall
demonstrate this in one of my later chapters.[2]

The critic should arm himself from the start with a sure
criterion, a criterion drawn from nature, and should then
carry out his duty with passion; for a critic does not cease
to be a man, and passion draws similar temperaments to-
gether and exalts the reason to fresh heights.

Stendhal has said somewhere 'Painting is nothing but a
construction in ethics!'[3] If you will understand the word
'ethics' in a more or less liberal sense, you can say as much
of all the arts. And as the essence of the arts is always the
expression of the beautiful through the feeling, the pas-
sion and the dreams of each man—that is to say a variety
within a unity, or the various aspects of the absolute—so
there is never a moment when criticism is not in contact
with metaphysics.

As every age and every people has enjoyed the expres-
sion of its own beauty and ethos—and if, by *romanticism,*
you are prepared to understand the most recent, the most
modern expression of beauty—then, for the reasonable and

* With reference to the proper ordering of individualism, see
the article on William Haussoullier, in the *Salon of 1845* (pp. 8–
11). In spite of all the rebukes that I have suffered on this sub-
ject, I persist in my opinion; but it is necessary to understand
the article. (C.B.)

[2] See p. 123.

[3] *Histoire de la Peinture en Italie,* ch. 156 (edition of 1859,
p. 338, n. 2). Stendhal's phrase is 'de la morale construite', and
he explains that he is using the past participle in the geometric
sense.

passionate critic, the great artist will be he who will combine with the condition required above—that is, the quality of *naïveté*—the greatest possible amount of romanticism.

II

WHAT IS ROMANTICISM?

FEW people today will want to give a real and positive meaning to this word; and yet will they dare assert that a whole generation would agree to join a battle lasting several years for the sake of a flag which was not also a symbol?

If you think back to the disturbances of those recent times, you will see that if few romantics have survived, it is because few of them discovered romanticism, though all of them sought it sincerely and honestly.

Some applied themselves only to the choice of subjects; but they had not the temperament for their subjects. Others, still believing in a Catholic society, sought to reflect Catholicism in their works. But to call oneself a romantic and to look systematically at the past is to contradict oneself. Some blasphemed the Greeks and the Romans in the name of romanticism: but you can only make Romans and Greeks into romantics if you are one yourself. Many others have been misled by the idea of truth in art, and local colour. Realism had already existed for a long time when that great battle took place, and besides, to compose a tragedy or a picture to the requirements of M. Raoul Rochette is to expose yourself to a flat contradiction from the first comer if he is more learned than M. Raoul Rochette.[1]

Romanticism is precisely situated neither in choice of subjects nor in exact truth, but in a mode of feeling.

They looked for it outside themselves, but it was only to be found within.

[1] A well-known archaeologist (1789–1854), who held several important positions, and published many books on his subject.

For me, Romanticism is the most recent, the latest expression of the beautiful.

There are as many kinds of beauty as there are habitual ways of seeking happiness.*

This is clearly explained by the philosophy of progress; thus, as there have been as many ideals as there have been ways in which the peoples of the earth have understood ethics, love, religion, etc., so romanticism will not consist in a perfect execution, but in a conception analogous to the ethical disposition of the age.

It is because some have located it in a perfection of technique that we have had the *rococo* of romanticism, without question the most intolerable of all forms.

Thus it is necessary, first and foremost, to get to know those aspects of nature and those human situations which the artists of the past have disdained or have not known.

To say the word Romanticism is to say modern art—that is, intimacy, spirituality, colour, aspiration towards the infinite, expressed by every means available to the arts.

Thence it follows that there is an obvious contradiction between romanticism and the works of its principal adherents.

Does it surprise you that colour should play such a very important part in modern art? Romanticism is a child of the North, and the North is all for colour; dreams and fairy-tales are born of the mist. England—that home of fanatical colourists, Flanders and half of France are all plunged in fog; Venice herself lies steeped in her lagoons. As for the painters of Spain, they are painters of contrast rather than colourists.

The South, in return, is all for nature; for there nature is so beautiful and bright that nothing is left for man to desire, and he can find nothing more beautiful to invent than what he sees. There art belongs to the open air; but several hundred leagues to the north you will find the deep

* Stendhal. (c.b.) Baudelaire seems to have in mind a footnote in ch. 110 of the *Histoire de la Peinture en Italie*, where Stendhal wrote 'La beauté est l'expression d'une certaine manière habituelle de chercher le bonheur . . .'

dreams of the studio and the gaze of the fancy lost in horizons of grey.

The South is as brutal and positive as a sculptor even in his most delicate compositions; the North, suffering and restless, seeks comfort with the imagination, and if it turns to sculpture, it will more often be picturesque than classical.

Raphael, for all his purity, is but an earthly spirit ceaselessly investigating the solid; but that scoundrel Rembrandt is a sturdy idealist who makes us dream and guess at what lies beyond. The first composes creatures in a pristine and virginal state—Adam and Eve; but the second shakes his rags before our eyes and tells us of human sufferings.

And yet Rembrandt is not a pure colourist, but a harmonizer. How novel then would be the effect, and how matchless his romanticism, if a powerful colourist could realize our dearest dreams and feelings for us in a colour appropriate to their subjects!

But before passing on to an examination of the man who up to the present is the most worthy representative of romanticism, I should like to give you a series of reflections on colour, which will not be without use for the complete understanding of this little book.

III

ON COLOUR

LET us suppose a beautiful expanse of nature, where there is full licence for everything to be as green, red, dusty or iridescent as it wishes; where all things, variously coloured in accordance with their molecular structure, suffer continual alteration through the transposition of shadow and light; where the workings of latent heat allow no rest, but everything is in a state of perpetual vibration which causes lines to tremble and fulfils the law of eternal and universal movement. An immensity which is sometimes blue, and often green, extends to the confines of the sky; it is the sea. The trees are green, the grass and the moss are green; the tree-trunks are snaked with green, and the unripe stalks

are green; green is nature's ground-bass, because green marries easily with all the other colours.* What strikes me first of all is that everywhere—whether it be poppies in the grass, pimpernels, parrots, etc.—red sings the glory of green; black (where it exists—a solitary and insignificant cipher) intercedes on behalf of blue or red. The blue—that is, the sky—is cut across with airy flecks of white or with grey masses, which pleasantly temper its bleak crudeness; and as the vaporous atmosphere of the season—winter or summer—bathes, softens or engulfs the contours, nature seems like a spinning-top which revolves so rapidly that it appears grey, although it embraces within itself the whole gamut of colours.

The sap rises, and as the principles mix, there is a flowering of *mixed tones;* trees, rocks and granite boulders gaze at themselves in the water and cast their *reflections* upon them; each transparent object picks up light and colour as it passes from nearby or afar. According as the daystar alters its position, tones change their values, but, always respecting their natural sympathies and antipathies, they continue to live in harmony by making reciprocal concessions. Shadows slowly shift, and colours are put to flight before them, or extinguished altogether, according as the light, itself shifting, may wish to bring fresh ones to life. Some colours cast back their reflections upon one another, and by modifying their own qualities with a *glaze* of transparent, borrowed qualities, they combine and recombine in an infinite series of melodious marriages which are thus made more easy for them. When the great brazier of the sun dips beneath the waters, fanfares of red surge forth on all sides; a harmony of blood flares up at the horizon, and green turns richly crimson. Soon vast blue shadows are rhythmically sweeping before them the host of orange and rose-pink tones which are like a faint and distant echo of the light. This great symphony of today, which is an

* Except for yellow and blue, its progenitors: but I am only speaking here of pure colours. For this rule cannot be applied to transcendent colourists who are thoroughly acquainted with the science of counterpoint. (c.b.)

eternal variation of the symphony of yesterday, this suc-
cession of melodies whose variety ever issues from the
infinite, this complex hymn is called *colour*.

In colour are to be found harmony, melody and counter-
point.

If you will examine the detail within the detail in an
object of medium dimensions—for example, a woman's hand,
rosy, slender, with skin of the finest—you will see that there
is perfect harmony between the green of the strong veins
with which it is ridged and the ruby tints which mark the
knuckles; pink nails stand out against the topmost-joints,
which are characterized by several grey and brown tones.
As for the palm of the hand, the life-lines, which are pinker
and more wine-coloured, are separated one from another
by the system of green or blue veins which run across them.
A study of the same object, carried out with a lens, will
afford, within however small an area, a perfect harmony
of grey, blue, brown, green, orange and white tones,
warmed by a touch of yellow—a harmony which, when
combined with shadows, produces the colourist's type of
modelling, which is essentially different from that of the
draughtsman, whose difficulties more or less boil down to
the copying of a plaster-cast.

Colour is thus the accord of two tones. Warmth and
coldness of tone, in whose opposition all theory resides, can-
not be defined in an absolute manner; they only exist in a
relative sense.

The lens is the colourist's eye.

I do not wish to conclude from all this that a colourist
should proceed by a minute study of the tones commingled
in a very limited space. For if you admit that every mole-
cule is endowed with its own particular tone, it would
follow that matter should be infinitely divisible; and be-
sides, as art is nothing but an abstraction and a sacrifice of
detail to the whole, it is important to concern oneself above
all with *masses*. I merely wished to prove that if the case
were possible, any number of tones, so long as they were
logically juxtaposed, would fuse naturally in accordance
with the law which governs them.

Chemical affinities are the grounds whereby Nature cannot make mistakes in the arrangement of her tones; for with Nature, form and colour are one.

No more can the true colourist make mistakes; everything is allowed him, because from birth he knows the whole scale of tones, the force of tone, the results of mixtures and the whole science of counterpoint, and thus he can produce a harmony of twenty different reds.

This is so true that if an anti-colourist landowner took it into his head to repaint his property in some ridiculous manner and in a system of cacophonous colours, the thick and transparent varnish of the atmosphere and the learned eye of Veronese between them would put the whole thing right and would produce a satisfying ensemble on canvas—conventional, no doubt, but logical.

This explains how a colourist can be paradoxical in his way of expressing colour, and how the study of nature often leads to a result quite different from nature.

The air plays such an important part in the theory of colour that if a landscape-painter were to paint the leaves of a tree just as he sees them, he would secure a false tone, considering that there is a much smaller expanse of air between the spectator and the picture than between the spectator and nature.

Falsifications are continually necessary, even in order to achieve a *trompe-l'œil*.

Harmony is the basis of the theory of colour.

Melody is unity within colour, or over-all colour.

Melody calls for a cadence; it is a whole, in which every effect contributes to a general effect.

Thus melody leaves a deep and lasting impression in the mind.

Most of our young colourists lack melody.

The right way to know if a picture is melodious is to look at it from far enough away to make it impossible to understand its subject or to distinguish its lines. If it is melodious, it already has a meaning and has already taken its place in your store of memories.

Style and feeling in colour come from choice, and choice comes from temperament.

Colours can be gay and playful, playful and sad, rich and gay, rich and sad, commonplace and original.

Thus Veronese's colour is tranquil and gay. Delacroix's colour is often plaintive, and that of M. Catlin[1] is often terrible.

For a long time I lived opposite a drinking-shop which was crudely striped in red and green; it afforded my eyes a delicious pain.

I do not know if any *analogist* has ever established a complete scale of colours and feelings, but I remember a passage in Hoffmann which expresses my idea perfectly and which will appeal to all those who sincerely love nature: 'It is not only in dreams, or in that mild delirium which precedes sleep, but it is even awakened when I hear music—that perception of an analogy and an intimate connexion between colours, sounds and perfumes. It seems to me that all these things were created by one and the same ray of light, and that their combination must result in a wonderful concert of harmony. The smell of red and brown marigolds above all produces a magical effect on my being. It makes me fall into a deep reverie, in which I seem to hear the solemn, deep tones of the oboe in the distance.'[*]

It is often asked if the same man can be at once a great colourist and a great draughtsman.

Yes and no; for there are different kinds of drawing.

The quality of pure draughtsmanship consists above all in precision, and this precision excludes *touch*; but there are such things as happy touches, and the colourist who undertakes to express nature through colour would often lose more by suppressing his happy touches than by studying a greater austerity of drawing.

Certainly colour does not exclude great draughtsmanship —that of Veronese, for example, which proceeds above all by ensemble and by mass; but it does exclude the meticulous drawing of detail, the contour of the tiny fragment, where touch will always eat away line.

[1] On Catlin, see pp. 72–3.

[*] Kreisleriana. (C.B.) It is the third of the detached observations entitled *Höchst zerstreute Gedanken*.

The love of air and the choice of subjects in movement call for the employment of flowing and fused lines.

Exclusive draughtsmen act in accordance with an inverse procedure which is yet analogous. With their eyes fixed upon tracking and surprising their line in its most secret convolutions, they have no time to see air and light—that is to say, the effects of these things—and they even compel themselves *not* to see them, in order to avoid offending the dogma of their school.

It is thus possible to be at once a colourist and a draughtsman, but only in a certain sense. Just as a draughtsman can be a colourist in his broad masses, so a colourist can be a draughtsman by means of a total logic in his linear ensemble; but one of these qualities always engulfs the detail of the other.

The draughtsmanship of colourists is like that of nature; their figures are naturally bounded by a harmonious collision of coloured masses.

Pure draughtsmen are philosophers and dialecticians.

Colourists are epic poets.

IV

EUGÈNE DELACROIX

ROMANTICISM and colour lead me straight to Eugène Delacroix. I do not know if he is proud of his title of 'romantic', but his place is here, because a long time ago—from his very first work, in fact—the majority of the public placed him at the head of the *modern* school.

As I enter upon this part of my work, my heart is full of a serene joy, and I am purposely selecting my newest pens, so great is my desire to be clear and limpid, so happy do I feel to be addressing my dearest and most sympathetic subject. But in order to make the conclusions of this chapter properly intelligible, I must first go back some little distance in the history of this period, and place before the eyes of the public certain documents of the case which have already been cited by earlier critics and historians, but which are

necessary to complete my demonstration. Nevertheless, I do not think that true admirers of Eugène Delacroix will feel anything but a keen pleasure in re-reading an extract from the *Constitutionnel* of 1822, taken from the Salon of M. Thiers,[1] journalist.

'In my opinion no picture is a clearer revelation of future greatness than M. Delacroix's *Dante et Virgile aux Enfers*.[2] Here above all you can recognize that spurt of talent, that burst of dawning mastery which revives our hopes, already a trifle dashed by the too moderate worth of all the rest.

'Dante and Virgil are being ferried across the infernal stream by Charon; they cleave their way with difficulty through the mob which swarms round the barque in order to clamber aboard. Dante, pictured alive, bears the dreadful taint of the place: Virgil, crowned with gloomy laurel, wears the colours of death. The hapless throng, doomed eternally to crave the opposite bank, are clinging to the boat: one is clutching at it in vain, and, thrown backwards by his precipitate effort, plunges once more into the waters; another has hold, and is kicking back those who, like himself, are struggling to get on board; two others are gripping at the elusive timber with their teeth. There you have all the egoism of misery, the despair of Hell. In a subject which borders so closely on exaggeration, you will yet find a severity of taste, a propriety of setting, so to say, which enhances the design, though stern judges—*in this case, ill-advised*—might perhaps criticize it for a lack of nobility. It is painted with a broad, firm brush, and its colour is simple and vigorous, if a trifle raw.

'Apart from that poetic imagination which is common both to painter and writer, the author of this picture has another, *artistic* imagination, which one might almost call 'the graphic imagination',[3] and which is quite dif-

[1] Adolphe Thiers (1797–1877), later famous as statesman and historian, was at that time at the very outset of his career.

[2] In the Louvre; see pl. 63.

[3] *L'imagination du dessin.*

ferent from the first. He throws his figures on to the canvas, he groups and bends them at will, with the boldness of Michelangelo and the abundance of Rubens. Some strange recollection of the great masters seized hold of me at the sight of this picture; once more I found that power—wild, ardent, but natural—which yields without effort to its own impulse . . .

'I do not believe that I am mistaken when I say that M. Delacroix has been given genius. Let him forward this assurance, let him devote himself to immense tasks, an indispensable condition of talent; and let him take still further confidence when I say that the opinion which I am expressing here is shared by one of the great masters of the school.'[4]

A. T . . . rs

These enthusiastic paragraphs are truly staggering, as much for their precocity as for their boldness. If, as is to be presumed, the editor of the journal had pretensions himself as a connoisseur of painting, the young Thiers must have struck him as a trifle mad.

To obtain a proper idea of the profound confusion into which the picture of Dante and Virgil must have thrown contemporary minds—of the amazement, the dumbfoundedness, the rage, the shouts of praise and of abuse, the enthusiasm and the peals of offensive laughter which beset this fine picture (a true signal of revolution)—you must remember that in the studio of M. Guérin (a man of great worth, but a despot and absolutist, like his master David) there was only a small group of pariahs who devoted themselves in secret to the old masters and who dared shyly to conspire beneath the wing of Raphael and Michelangelo. There was as yet no question of Rubens.

M. Guérin, who was harsh and severe towards his young pupil, only looked at the picture because of the clamour that raged around it.

Géricault, who was back from Italy (where he was said to have renounced several of his almost original qualities before the great frescoes of Rome and Florence) com-

4 According to Silvestre (*Histoire des artistes vivants*, 1856, p. 62), this was Gérard.

plimented the new and still bashful painter so warmly that
he was almost overcome.[5]

It was in front of this painting, or, some time afterwards,
in front of the *Pestiférés de Scio*,* that Gérard himself, who,
as it seems, was more a wit than a painter, cried 'A painter
has just been revealed to us, but he is a man who runs along
the roof-tops!'—To run along the roof-tops you need a firm
step and an eye illumined by an interior light.

Let glory and justice be accorded to MM. Thiers and
Gérard!

It is doubtless a lengthy interval that separates the *Dante
and Virgil* from the paintings in the Palais Bourbon;[6] but
the biography of Eugène Delacroix is poor in incident. For
a man like this, endowed with such courage and such pas-
sion, the most interesting struggles are those which he has
to maintain against himself; horizons need not be vast for
battles to be important, and the most curious events and
revolutions take place beneath the firmament of the skull,
in the close and mysterious laboratory of the brain.

Now that the man had been duly revealed and was con-
tinuing to reveal himself more and more (in the allegorical
picture *La Grèce*,[7] *Sardanapalus*,[8] *La Liberté*,[9] etc.), and
now that the contagion of the new gospel was spreading
from day to day, even academic disdain found itself forced
to take this new genius into account. One fine day M.
Sosthènes de la Rochefoucauld, then *Directeur des Beaux-
Arts*, sent for Eugène Delacroix, and, after lavishing com-
pliments upon him, told him that it was vexing that a man
of so rich an imagination and so fine a talent, a man, more-

[5] Géricault is elsewhere recorded as saying that it was a picture
that he would have been glad to have signed himself.

* I write *pestiférés* instead of *massacre* in order to explain to the
critics those flesh-tones to which they have so often and so
stupidly objected. (C.B.) The picture is now in the Louvre. It
was painted in 1824.

[6] On which Delacroix was still engaged in 1846.

[7] Painted in 1827: first exhibited the following year, and now in
the Bordeaux Museum.

[8] Painted in 1827, and now in the Louvre; repro. *Journal*, pl. 8.

[9] Painted in 1830, and now in the Louvre; repro. *Journal*, pl. 13.

over, to whom the government was favourably disposed, should not be prepared to add a little water to his wine; he asked him once and for all if it would not be possible for him to modify his manner. Eugène Delacroix, vastly surprised at this quaint condition and these ministerial counsels, replied with almost a parody of rage that evidently if he painted thus, it was because he had to and because he could not paint otherwise. He fell into complete disgrace and was cut off from any kind of official work for seven years. He had to wait for 1830. Meanwhile M. Thiers had written a new and very lofty article in *Le Globe*.[10]

A journey to Morocco[11] seems to have left a deep impression on his mind; there he could study at leisure both man and woman in their independence and native originality of movement, and could comprehend antique beauty in the sight of a race pure of all base-breeding and adorned with health and the free development of its muscles. The composition of *The Women of Algiers*[12] and a mass of sketches probably date from this period.

Up to the present, Eugène Delacroix has met with injustice. Criticism, for him, has been bitter and ignorant; with one or two noble exceptions, even the praises of his admirers must often have seemed offensive to him. Generally speaking, and for most people, to mention Eugène Delacroix is to throw into their minds goodness knows what vague ideas of ill-directed fire, of turbulence, of hazardous inspiration, of confusion, even; and for those gentlemen who form the majority of the public, pure chance, that loyal and obliging servant of genius, plays an important part in his happiest compositions. In that unhappy period of revolution of which I was speaking a moment ago and whose numerous errors I have recorded, people used often to compare Eugène Delacroix to Victor Hugo. They had their romantic poet; they needed their painter. This necessity of going to any length to find counterparts and analogues in the different arts often results in strange blunders; and this one proves once again how little people knew what

[10] On the Salon of 1824.

[11] In 1832.

[12] Painted in 1834, and now in the Louvre; see pl. 64.

they were about. Without any doubt the comparison must have seemed a painful one to Eugène Delacroix, if not to both of them; for if my definition of romanticism (intimacy, spirituality and the rest) places Delacroix at its head, it naturally excludes M. Victor Hugo. The parallel has endured in the banal realm of accepted ideas, and these two preconceptions still encumber many feeble brains. Let us be done with these rhetorical ineptitudes once and for all. I beg all those who have felt the need to create some kind of aesthetic for their own use and to deduce causes from their results, to make a careful comparison between the productions of these two artists.

M. Victor Hugo, whose nobility and majesty I certainly have no wish to belittle, is a workman far more adroit than inventive, a labourer much more correct than *creative*. Delacroix is sometimes clumsy, but he is essentially creative. In all his pictures, both lyric and dramatic, M. Victor Hugo lets one see a system of uniform alignment and contrasts. With him even eccentricity takes symmetrical forms. He is in complete possession of, and coldly employs, all the modulations of rhyme, all the resources of antithesis and all the tricks of apposition. He is a composer of the decadence or transition, who handles his tools with a truly admirable and curious dexterity. M. Hugo was by nature an academician even before he was born, and if we were still living in the time of fabulous marvels, I would be prepared to believe that often, as he passed before their wrathful sanctuary, the green lions of the Institut would murmur to him in prophetic tones, 'Thou shalt enter these portals'.

For Delacroix justice is more sluggish. His works, on the contrary, are poems—and great poems, *naïvely** conceived and executed with the usual insolence of genius. In the works of the former there is nothing left to guess at, for he takes so much pleasure in exhibiting his skill that he omits not one blade of grass nor even the reflection of a street-lamp. The latter in his works throws open immense vistas

* By the *naïveté* of the genius you must understand a complete knowledge of technique combined with the γνῶθι σεαυτόν of the Greeks, but with knowledge modestly surrendering the leading role to temperament. (C.B.) The word *naïveté*, used in this special sense, is one of the keywords of this *Salon*.

to the most adventurous imaginations. The first enjoys a certain calmness, let us rather say a certain detached egoism, which causes an unusual coldness and moderation to hover above his poetry—qualities which the dogged and melancholy passion of the second, at grips with the obstinacies of his craft, does not always permit him to retain. One starts with detail, the other with an intimate understanding of his subject; from which it follows that one only captures the skin, while the other tears out the entrails. Too earth-bound, too attentive to the superficies of nature, M. Victor Hugo has become a painter in poetry; Delacroix, always respectful of his ideal, is often, without knowing it, a poet in painting.

As for the second preconception, the preconception of pure chance, it has no more substance than the first. Nothing is sillier or more impertinent than to talk to a great artist, and one as learned and as thoughtful as Delacroix, about the obligations which he may owe to the god of chance. It quite simply makes one shrug one's shoulders in pity. There is no pure chance in art, any more than in mechanics. A happy invention is the simple consequence of a sound train of reasoning whose intermediate deductions one may perhaps have skipped, just as a fault is the consequence of a faulty principle. A picture is a machine, all of whose systems of construction are intelligible to the practised eye; in which everything justifies its existence, if the picture is a good one; where one tone is always planned to make the most of another; and where an occasional fault in drawing is sometimes necessary, so as to avoid sacrificing something more important.

This intervention of chance in the business of Delacroix's painting is all the more improbable since he is one of those rare beings who remain original after having drunk deep of all the true wells, and whose indomitable individuality has borne and shaken off the yokes of all the great masters in turn. Not a few of you would be quite astonished to see one of his studies after Raphael—patient and laborious masterpieces of imitation; and few people today remember his lithographs after medals and engraved gems.[13]

[13] Delacroix made six such lithographs in 1825.

Here are a few lines from Heinrich Heine which explain Delacroix's method rather well—a method which, like that of all robustly-framed beings, is the result of his temperament:

'In artistic matters, I am a supernaturalist. I believe that the artist cannot find all his forms in nature, but that the most remarkable are revealed to him in his soul, like the innate symbology of innate ideas, and at the same instant. A modern professor of aesthetics, the author of *Recherches sur l'Italie*,[14] has tried to restore to honour the old principle of the *imitation of nature*, and to maintain that the plastic artist should find all his forms in nature. The professor, in thus setting forth his ultimate principle of the plastic arts, had only forgotten one of those arts, but one of the most fundamental—I mean architecture. A belated attempt has now been made to trace back the forms of architecture to the leafy branches of the forest and the rocks of the grotto; and yet these forms were nowhere to be found in external nature, but rather in the soul of man.'[15]

Now this is the principle from which Delacroix sets out—that a picture should first and foremost reproduce the intimate thought of the artist, who dominates the model as the creator dominates his creation; and from this principle there emerges a second which seems at first sight to contradict it—namely that the artist must be meticulously careful concerning his material means of execution. He professes a fanatical regard for the cleanliness of his tools and the preparation of the elements of his work. In fact, since painting is an art of deep ratiocination, and one that demands an immediate contention between a host of different qualities, it is important that the hand should encounter the least possible number of obstacles when it gets down to business, and that it should accomplish the divine orders of the brain with a slavish alacrity; otherwise the ideal will escape.

[14] The reference is to Carl Friedrich von Rumohr (1785–1843); his book, *Italienische Forschungen*, was published in three volumes between 1827 and 1831.
[15] From Heine's *Salon of 1831*, which was published in a French translation in his *De la France*, 1833.

The process of conception of this great artist is no less slow, serious and conscientious than his execution is nimble. This moreover is a quality which he shares with the painter whom public opinion has set at the opposite pole from him—I mean M. Ingres. But travail is by no means the same thing as childbirth, and these great princes of painting, though endowed with a seeming indolence, exhibit a marvellous agility in covering a canvas. *St. Symphorian*[16] was entirely re-painted several times, and at the outset it contained far fewer figures.

Nature, for Eugène Delacroix, is a vast dictionary whose leaves he turns and consults with a sure and searching eye; and his painting which issues above all from the memory, speaks above all to the memory. The effect produced upon the spectator's soul is analogous to the artist's means. A picture by Delacroix—*Dante and Virgil*, for example—always leaves a deep impression whose intensity increases with distance. Ceaselessly sacrificing detail to whole, and hesitating to impair the vitality of his thought by the drudgery of a neater and more calligraphic execution, he rejoices in the full use of an inalienable originality, which is his searching intimacy with the subject.

The employment of a dominant note can only rightfully take place at the expense of the rest. An excessive taste makes sacrifices necessary, and masterpieces are never anything but varied extracts from nature. That is the reason why it is necessary to submit to the consequences of a grand passion (whatever it may be), to accept the destiny of a talent, and not to try and bargain with genius. This is a thing never dreamt of by those people who have jeered so much at Delacroix's draughtsmanship—particularly the sculptors, men more partial and purblind than they have a right to be, whose judgement is worth no more than half that of an architect, at the most. Sculpture, to which colour is impossible and movement difficult, has nothing to discuss with an artist whose chief preoccupations are movement, colour and atmosphere. These three elements necessarily demand a somewhat undecided contour, light and floating

[16] Ingres' *St. Symphorian* was commissioned for Autun cathedral in 1824: it was not completed until ten years later.

lines, and boldness of touch. Delacroix is the only artist
today whose originality has not been invaded by the tyran-
nical system of straight lines; his figures are always restless
and his draperies fluttering. From Delacroix's point of view
the line does not exist; for, however tenuous it may be, a
teasing geometrician may always suppose it thick enough
to contain a thousand others; and for colourists, who seek
to imitate the eternal throbbings of nature, lines are never
anything else but the intimate fusion of two colours, as in
the rainbow.

Moreover there are several kinds of drawing, as there are
of colour:—the exact or silly, the physiognomic and the
imaginative.

The first is negative, incorrect by sheer force of reality,
natural but absurd; the second is a naturalistic, but ideal-
ized draughtsmanship—the draughtsmanship of a genius
who knows how to choose, arrange, correct, rebuke, and
guess at nature; lastly the third, which is the noblest and
strangest, and can afford to neglect nature—it realizes
another nature, analogous to the mind and the temper-
ment of the artist.

Physiognomic drawing is generally the domain of the
fanatical, like M. Ingres; creative drawing is the privilege
of genius.*

The great quality of the drawing of supreme artists is
truth of movement; and Delacroix never violates this
natural law.

But let us pass on to an examination of still more general
qualities. Now one of the principal characteristics of the
great painter is his universality. Take an epic poet, Homer
or Dante, for example: he can write an idyll, a narrative,
a speech, a description, an ode, etc., all equally well.

In the same way, if Rubens paints fruit, he will paint
finer fruit than any specialist that you care to name.

Eugène Delacroix is universal. He has painted genre-
pictures full of intimacy, and historical pictures full of
grandeur. He alone, perhaps, in our unbelieving age has
conceived religious paintings which were neither empty

* This is what M. Thiers called 'l'imagination du dessin'. (C.B.)
See p. 51.

and cold, like competition works, nor pedantic, mystical or neo-Christian, like the works of all those philosophers of art who make religion into an archaistic science, and who believe that not until they have made themselves masters of the traditions and symbology of the early church, can they strike and sound the chords of religion.

This is easy to understand if you are prepared to consider that Delacroix, like all the great masters, is an admirable mixture of science—that is to say, he is a complete painter; and of *naïveté*—that is to say, a complete man. Go to St. Louis au Marais[17] and look at his *Pietà*, in which the majestic Queen of Sorrows is holding the body of her dead Son on her knees, with her two arms extended horizontally in an access of despair, a mother's paroxysm of grief. One of the two figures, who is supporting and soothing her anguish, is sobbing like the most pitiful characters in his *Hamlet*—a work with which, moreover, this painting has no little affinity. Of the two holy women, the first, still decked with jewels and tokens of luxury, is crouching convulsively on the ground; the other, fair and golden-haired, sinks more feebly beneath the enormous weight of her despair.

The group is spread out and disposed entirely against a background of a dark, uniform green which suggests a tempest-ridden sea no less than massed boulders. This background is fantastic in its simplicity, for, like Michelangelo, Eugène Delacroix seems to have suppressed the accessories in order not to damage the clarity of his idea. This masterpiece leaves a deep furrow of melancholy upon the mind. But this was not the first time that he had tackled religious subjects. His *Agony in the Garden*[18] and his *St. Sebastian*[19] had already testified to the seriousness and deep sincerity with which he can stamp them.

But to explain what I declared a moment ago—that only Delacroix knows how to paint religious subjects—I would

[17] Baudelaire is mistaken here. Delacroix's *Pietà* was painted (in 1844) for the church of Saint-Denis-du-Saint-Sacrement, Paris, where it is now to be seen.

[18] Exhibited in 1827, and now in the church of Saint-Paul-Saint-Denis.

[19] Painted in 1836 and bought for the church of Nantua.

have the spectator note that if his most interesting pictures are nearly always those whose subjects he chooses himself —namely, subjects of fantasy—nevertheless the grave sadness of his talent is perfectly suited to our religion which is itself profoundly sad—a religion of universal anguish, and one which, because of its very catholicity, grants full liberty to the individual and asks no better than to be celebrated in each man's own language—so long as he knows anguish and is a painter.

I remember a friend of mine—a lad of some merit, too, and an already fashionable colourist; one of those precocious young men who give promise all their lives, and who is far more academic than he himself believes—I remember him calling this 'cannibal's painting'.

It is perfectly true that our young friend will look in vain among the niceties of a loaded palette or in the dictionary of rules for a blood-soaked and savage desolation such as this, which is only just offset by the sombre green of hope.

This terrible hymn to anguish affected his classical imagination in just the same way as the formidable wines of Anjou, Auvergne or the Rhine affect a stomach which is used to the pale violets of Médoc.

So much for universality of feeling—and now for universality of knowledge!

It is a long time since our painters *unlearnt,* so to speak, the genre called 'decoration'. The *Hemicycle*[20] at the Beaux-Arts is a puerile, clumsy work whose intentions contradict one another; it is hardly more than a collection of historical portraits. The *Plafond d'Homère*[21] is a fine picture which makes a bad ceiling. Most of the chapels executed in recent times and distributed among the pupils of Ingres were done according to the methods of the Italian

[20] Painted by Paul Delaroche, 1838–41. It represents the most celebrated artists of all nations, up to the end of the 17th century.

[21] Painted by Ingres in 1827 for the ceiling in one of the galleries of the Louvre. It was removed in 1855 in order to be shown at the *Exposition Universelle,* and some years later was replaced by a copy. The original now hangs as a picture in the Louvre. See pl. 61.

primitives—that is, they aim at achieving unity by the suppression of effects of light and by a vast system of softened colourings. This method, which is doubtless more reasonable, nevertheless evades the difficulties. Under Louis XIV, XV and XVI, painters produced decorations of dazzling brilliance, but they lacked unity in colour and composition.

Eugène Delacroix had decorations to paint, and he solved the great problem. He discovered pictorial unity without doing hurt to his trade as a colourist.

We have the Palais Bourbon[22] to bear witness to this extraordinary *tour de force*. There the light is dispensed economically, and it spreads evenly across all the figures, without tyrannically catching the eye.

The circular ceiling in the library of the Luxembourg[23] is a still more astonishing work, in which the painter has arrived not only at an even blander and more unified effect, while suppressing nothing of the qualities of colour and light which are the characteristic feature of all his pictures —but he has gone further and revealed himself in an altogether new guise: Delacroix the landscape-painter!

Instead of painting Apollo and the Muses, the invariable decoration for a library, Eugène Delacroix has yielded to his irresistible taste for Dante, whom Shakespeare alone, perhaps, can challenge in his mind, and he has chosen the passage where Dante and Virgil meet with the principal poets of antiquity in a mysterious place:

> We ceased not to go, though he was speaking; but passed the wood meanwhile, the wood, I say, of crowded spirits. Our way was not yet far since my slumber, when I saw a fire which conquered a hemisphere of the darkness. We were still a little distant from it; yet not so distant that I did not in part discern what honourable people occupied that place.
>
> 'O thou that honourest every science and art; who are these, who have such honour that it separates them from the manner of the rest?'

[22] Delacroix made twenty allegorical paintings for the library of the *Chambre des Députés* between 1838 and 1847.

[23] Delacroix was nearing the end of his work at the Luxembourg at the time that this was written.

And he to me: 'The honoured name, which glorifies them in that life of thine, gains favour in Heaven which thus advances them'.

Meanwhile a voice was heard by me: 'Honour the great Poet! His shade returns that was departed.'

After the voice had paused and was silent, I saw four great shadows come to us; they had an aspect neither sad nor joyful.

The good Master began to speak: 'Mark him with that sword in hand, who comes before the three as their lord: that is Homer, the sovereign poet; the next who comes is Horace the satirist; Ovid is the third, and the last is Lucan. Because each agrees with me in the name which the one voice sounded, they do me honour; and therein they do well.'

Thus I saw assembled the goodly school of that lord of highest song, who like an eagle soars above the rest. After they had talked a space together, they turned to me with a sign of salutation; and my Master smiled thereat. And greatly more besides they honoured me; for they made me of their number, so that I was a sixth amid such intelligences.[24]

I shall not pay Eugène Delacroix the insult of an exaggerated panegyric for having so successfully mastered the concavity of his canvas, or for having placed his figures upright upon it. His talent is above these things. I am concentrating above all upon the *spirit* of this painting. It is impossible to express in prose all the blessed calm which it breathes, and the deep harmony which imbues its atmosphere. It makes you think of the most luxuriant pages of *Télémaque*, and brings to life all the memories which the mind has ever gathered from tales of Elysium. From the point of view at which I took up my position a short while ago, the landscape, which is nevertheless no more than an accessory—such is the universality of the great masters!—is a thing of the greatest importance. This circular landscape, which embraces an enormous area, is painted with the assurance of a history-painter, and the delicacy and love of

[24] Dante, *Inferno*, canto iv. ll. 64 sqq.

a painter of landscape. Clumps of laurel and considerable patches of shade dissect it harmoniously; pools of gentle, uniform sunlight slumber on the greensward; mountains, blue or forest-girt, form a perfect horizon *for the eyes' pleasure*.[25] The sky is blue and white—an amazing thing with Delacroix; the clouds, which are spun and drawn out in different directions, like a piece of gauze being rent, are of a wonderful airiness; and the deep and luminous vault of the sky recedes to a prodigious height. Even Bonington's water-colours are less transparent.

This masterpiece, which, in my opinion, is superior to the finest of Veronese, needs a great tranquillity of mind and a very gentle light to be properly comprehended. Unfortunately the brilliant daylight which will burst through the great window of the façade, as soon as it is cleared of its tarpaulins and scaffolding, will make this task more difficult.

Delacroix's pictures this year are *The Abduction of Rebecca*, taken from *Ivanhoe*, the *Farewell of Romeo and Juliet*, *Marguerite in Church*, and *A Lion*, in water-colour.

The admirable thing about *The Abduction of Rebecca*[26] is the perfect ordering of its colours, which are intense, close-packed, serried and logical; the result of this is a thrilling effect. With almost all painters who are not colourists, you will always be noticing vacuums, that is to say great holes produced by tones which are below the level of the rest, so to speak. Delacroix's painting is like nature; it has a horror of a vacuum.

Romeo and Juliet[27] are shown on the balcony, in the morning's cold radiance, holding one another devoutly clasped by the waist. In the violence of this farewell embrace, Juliet, with her hands laid on the shoulders of her lover, is throwing back her head as though to draw breath, or in a movement of pride and joyful passion. This unwonted attitude—for almost all painters glue their lovers'

[25] The phrase italicized (by Baudelaire) is an exact verbal echo from Fénelon's description of Calypso's island (*Télémaque*, Bk. 1).

[26] In the Metropolitan Museum, New York; repro. *Journal*, pl. 39.

[27] See pl. 66.

lips together—is nevertheless perfectly natural; this vigorous movement of the neck is typical of dogs and cats in the thrill of a caress. This scene, with the romantic landscape which completes it, is enveloped in the purplish mists of the dawn.

The general success which this picture has achieved, and the interest which it inspires, only go to show what I have already said elsewhere—that Delacroix is *popular*, whatever the painters may say; and that it will be enough not to keep the public away from his works for him to be as much so as inferior painters are.

Marguerite in Church[28] belongs to that already numerous class of charming genre-pictures, by which Delacroix seems to be wanting to explain his lithographs,[29] which have been so bitterly criticized.

The water-colour *Lion* has a special merit for me, quite apart from its beauty of drawing and attitude; this is because it is painted with a great simplicity. Water-colour is restricted here to its own modest role; it has no desire to rival oil-paint in stature.

To complete this analysis, it only remains for me to note one last quality in Delacroix—but the most remarkable quality of all, and that which makes him the true painter of the nineteenth century; it is the unique and persistent melancholy with which all his works are imbued, and which is revealed in his choice of subject, in the expression of his faces, in gesture and in style of colour. Delacroix has a fondness for Dante and Shakespeare, two other great painters of human anguish: he knows them through and through, and is able to translate them freely. As you look through the succession of his pictures, you might think that you were assisting at the celebration of some dolorous mystery; *Dante and Virgil, The Massacre of Scio, Sar-*

[28] Repro. *Escholier,* vol. II, facing p. 308.
[29] Delacroix's *Faust* lithographs were first published in book form in 1828. Goethe had seen some of them two years before, and spoke of them with great admiration to Eckermann (see *Conversations of Goethe with Eckermann,* Everyman ed., pp. 135–6). Between 1834 and 1843 Delacroix made sixteen lithographs of scenes from *Hamlet.*

danapalus, Christ in the Garden of Olives, St. Sebastian, Medea,[30] *The Shipwreck of Don Juan,*[31] and the *Hamlet,*[32] which was so much mocked at and so misunderstood. In several of them, by some strange and recurring accident, you will find one figure which is more stricken, more crushed than the others; a figure in which all the surrounding anguish is epitomized—for example, the kneeling woman, with her hair cast down, in the foreground of the *Crusaders at Constantinople,*[33] or the old woman, so wrinkled and forlorn, in *The Massacre of Scio.* This aura of melancholy surrounds even *The Women of Algiers,*[34] that most engaging and showy of his pictures. That little poem of an interior, all silence and repose, and crammed with rich stuffs and knick-knacks of the toilet, seems somehow to exhale the heady scent of a house of ill-fame, which quickly enough guides our thoughts towards the fathomless limbo of sadness. Generally speaking he does not paint pretty women—not at any rate from the point of view of the fashionable world. Almost all of them are sick, and gleaming with a sort of interior beauty. He expresses physical force not by bulk of muscle, but by nervous tension. He is unrivalled at expressing not merely suffering, but above all *moral* suffering—and here lies the prodigious mystery of his painting! This lofty and serious melancholy of his shines with a gloomy brilliance, even in his colour, which is broad, simple and abundant in harmonious masses, like that of all the great colourists; and yet it is as plaintive and deep-toned as a melody by Weber.[35]

Each one of the old masters has his kingdom, his prerogative, which he is often constrained to share with illustrious rivals. Thus Raphael has form, Rubens and Veronese

[30] Painted in 1838, and now in the Lille Museum.

[31] Painted in 1840, and now in the Louvre; repro. *Journal,* pl. 30.

[32] Delacroix painted several versions of *Hamlet and the Grave-digger:* that of 1839 is in the Louvre; see pl. 65.

[33] Painted in 1841, and now in the Louvre; repro. *Journal,* pl. 25.

[34] Painted in 1834, and now in the Louvre; see pl. 64.

[35] The simile recurs in the stanza devoted to Delacroix in Baudelaire's poem *Les Phares.* See p. 217, where Baudelaire analyses this stanza.

colour, Rubens and Michelangelo the 'graphic imagination'. There remained one province of the empire in which Rembrandt alone had carried out a few raids; I mean drama, natural and living drama, the drama of terror and melancholy, expressed often through colour, but always through gesture.

In the matter of sublime gestures, Delacroix's only rivals are outside his art. I know of scarcely any others but Frédérick Lemaître[36] and Macready.[37]

It is because of this entirely modern and novel quality that Delacroix is the latest expression of progress in art. Heir to the great tradition—that is, to breadth, nobility and magnificence in composition—and a worthy successor of the old masters, he has even surpassed them in his command of anguish, passion and gesture! It is really this fact that establishes the importance of his greatness. Suppose, indeed, that the baggage of one of the illustrious departed were to go astray; he will almost always have his counterpart, who will be able to explain him and disclose his secret to the historian's scrutiny. But take away Delacroix, and the great chain of history is broken and slips to the ground.

In an article which must seem more like a prophecy than a critique, what is the object of isolating faults of detail and microscopic blemishes? The whole is so fine that I have not the heart. Besides it is such an easy thing to do, and so many others have done it! Is it not a pleasant change to view people from their good side? M. Delacroix's defects are at times so obvious that they strike the least trained eye. You have only to open at random the first paper that comes your way, and you will find that they have long followed the opposite method from mine, in persistently not seeing the glorious qualities which con-

[36] Frédérick Lemaître (1800–1876) was one of the great French actors of the Romantic generation. He made his first great success as Robert Macaire in L'Auberge des Adrets (1823), and later created the title-rôle in Victor Hugo's Ruy Blas.

[37] William Charles Macready (1793–1873), the notable English tragedian of the same generation as Edmund Kean. His grand, impassioned style greatly impressed the French when he acted in Paris in 1828 (twice) and again in 1844.

stitute his originality. Need I remind you that great geniuses never make mistakes by halves, and that they have the privilege of enormity in every direction?

Among Delacroix's pupils there are some who have happily appropriated whatever elements of his talent could be captured—that is, certain parts of his method—and who have already earned themselves something of a reputation. Nevertheless their colour has, generally speaking, this flaw —that it scarcely aims above picturesqueness and 'effect'; the ideal is in no sense their domain, although they readily dispense with nature, without having earned the right to do so by dint of their master's intrepid studies.

This year we must regret the absence of M. Planet, whose *Sainte Thérèse*[38] attracted the eyes of the connoisseurs at the last Salon—and of M. Riesener, who has often given us broadly-coloured pictures, and by whom you can see some good ceilings at the Chambre des Pairs— and see them with pleasure, too, in spite of the terrible proximity of Delacroix.

M. Léger-Chérelle has sent *Le Martyre de Sainte Irène*.[39] The composition consists of a single figure and a pike, which makes a somewhat unpleasant effect. Nevertheless the colour and the modelling of the torso are generally good. But I rather think that M. Léger-Chérelle had already shown the public this picture before, with some minor variations.

A somewhat surprising feature of *La Mort de Cléopâtre*,[40] by M. Lassale-Bordes, is that the artist does not seem to be uniquely preoccupied with colour; and this is perhaps a merit. Its tints are, so to speak, equivocal, and this sourness of taste is not without its charms.

Cleopatra is dying, on her throne, while Octavius's envoy stoops forward to gaze at her. One of her handmaidens has

[38] See pp. 18–19.

[39] The note in the Salon catalogue runs as follows: 'Cette vierge, ayant caché les livres saints, contre les ordres de l'empereur Dioclétien, fut mise en prison et percée d'une flèche' (Vies des Saints).

[40] Now in the Autun Museum; see pl. 19.

just expired at her feet. The composition does not lack majesty, and the painting has been executed with quite a daring simplicity; Cleopatra's head is beautiful, and the negress's green and pink attire contrasts happily with the colour of her skin. This huge picture has been successfully carried through with no regard for imitation, and it certainly contains something to please and attract the unattached *flâneur*.

<p style="text-align:center">v</p>

ON EROTIC SUBJECTS IN ART, AND ON M. TASSAERT

HAS IT EVER been your experience, as it has mine, that after spending long hours turning over a collection of bawdy prints, you fall into a great spell of melancholy? And have you ever asked yourself the reason for the charm sometimes to be found in rummaging among these annals of lewdness, which are buried in libraries or lost in dealers' portfolios— and sometimes also for the ill-humour which they cause you? It is a mixture of pleasure and pain, a vinegar for which the lips are always athirst! The pleasure lies in your seeing represented in all its forms that most important of natural feelings—and the anger in often finding it so badly copied or so stupidly slandered. Whether it has been by the fireside during the endless winter evenings, or in a corner of a glazier's shop, in the dog-days when the hours hang heavy, the sight of such drawings has often put my mind into enormous drifts of reverie, in much the same way as an obscene book sweeps us towards the mystical oceans of the deep. Many times, when faced with these countless samples of the universal feeling, I have found myself wishing that the poet, the connoisseur and the philosopher could grant themselves the enjoyment of a Museum of Love, where there would be a place for everything, from St. Teresa's undirected affections down to the serious debaucheries of the ages of ennui. No doubt an immense distance separates *Le Départ pour l'île de Cythère*[1] from the miser-

[1] By Watteau.

able daubs which hang above a cracked pot and a rickety side-table in a harlot's room; but with a subject of such importance, nothing should be neglected. Besides, all things are sanctified by genius, and if these subjects were treated with the necessary care and reflection, they would in no wise be soiled by that revolting obscenity, which is bravado rather than truth.

Let not the moralist be too alarmed! I shall know how to keep the proper bounds, and besides, my dream is limited to a wish for this immense poem of love as sketched by only the purest hands—by Ingres, Watteau, Rubens, Delacroix! The playful and elegant princesses of Watteau beside the grave and composed Venuses of M. Ingres, the resplendent pearls of Rubens and Jordaens and the sad beauties of Delacroix, just as one can imagine them—great pale women, drowned in satin!*

And so, to give complete reassurance to the reader's startled virtue, let me say that I should class among erotic subjects not only all pictures which are specially concerned with love, but also any picture which suggests love, be it only a portrait.**

In this immense museum I envisage the beauty and the love of all climes, expressed by the leading artists—from the mad, scatter-brained *merveilleuses* which Watteau *fils*[2] has bequeathed us in his fashion engravings, down to Rembrandt's Venuses who are having their nails done and their hair combed with great boxwood combs, just like simple mortals.

Subjects of this nature are so important a thing that there is no artist, small or great, who has not devoted himself to

* I have been told that many years ago Delacroix made a whole mass of marvellous studies of women in the most voluptuous attitudes, for his *Sardanapalus*. (C.B.)

** M. Ingres' *Grande* and *Petite Odalisque* are two pictures of our times which are essentially concerned with love, and are admirable, moreover. (C.B.) The *Grande Odalisque* is in the Louvre (see pl. 62): the *Petite Odalisque* is presumably the *Odalisque with Slave*, in the Fogg Art Museum, Cambridge, Mass.

[2] François Watteau (de Lille) (1758–1823), son of Louis Watteau and nephew of Antoine Watteau.

them, secretly or in public, from Giulio Romano to Devéria and Gavarni.

In general their great defect is a lack of sincerity and *naïveté*. I remember, however, a lithograph[3] which expresses one of the great truths of wanton love—though unhappily without too much refinement. A young man, disguised as a woman, and his mistress, dressed as a man, are seated side by side on a sofa—the sofa which you know so well, the sofa of the furnished lodgings and the private apartment. The young woman is trying to lift her lover's skirt.[*] In the ideal museum of which I was speaking, this lewd sheet would be counterbalanced by many others in which love would only appear in its most refined form.

These reflections have occurred to me in connection with two pictures by M. Tassaert—*Erigone* and *Le Marchand d'esclaves*.

M. Tassaert, of whom I made the grave mistake of not saying enough last year, is a painter of the greatest merit, and one whose talent would be most happily applied to erotic subjects.

Erigone is half recumbent upon a mound overshadowed with vines—in a provocative pose, with one leg almost bent back, the other stretched out, and the body thrust forward; the drawing is fine, and the lines sinuous and expertly organized. Nevertheless I would criticize M. Tassaert, who is a colourist, for having painted this torso in too uniform a tone.

The other picture represents a market of women awaiting buyers. These are true women, civilized women, whose feet have felt the rubbing of shoes; they are a little common, a little too pink perhaps, but a silly, sensual Turk is going to

[3] One of the series 'Les Amants et les Epoux' by Tassaert. The lady's words are 'Ne fais donc pas la cruelle!' See pl. 4.

[*] 'Sedebant in fornicibus pueri puellaeve sub titulis et lychnis, illi faeminio compti mundo sub stola, hae parum comptae sub puerorum veste, ore ad puerilem formam composito. Alter veniebat sexus sub altero sexu. *Corruperat omnis caro viam suam.*' Meursius. (C.B.) This passage is quoted from Nicolas Chorier's *Aloysiae Sygeae satira sotadica de arcanis Amoris et Veneris* (1658), which purported to be a Latin version (by Meursius) of a Spanish original.

buy them as superfine beauties. The one who is seen from
behind, and whose buttocks are enveloped in a transparent
gauze, still wears upon her head a milliner's hat, a hat
bought in the Rue Vivienne or at the Temple. The poor
girl has doubtless been carried off by pirates!

The colour of this picture is remarkable in the extreme
for its delicacy and transparency of tone. One would
imagine that M. Tassaert has been studying Delacroix's
manner; nevertheless he has managed to retain an original
colour.

He is an outstanding artist, whom only the *flâneurs* ap-
preciate and whom the public does not know well enough;
his talent has never ceased growing, and when you think
of whence he started, and where he has arrived, there is
reason to look forward to ravishing things from him in the
future.

VI

ON SOME COLOURISTS

THERE ARE two curiosities of a certain importance at the
Salon. These are the portraits of *Petit Loup* and of *Graisse
du dos de buffle*, by M. Catlin, the impresario of the red-
skins.[1] When M. Catlin came to Paris, with his Museum
and his Ioways, the word went round that he was a good

[1] George Catlin (1796–1872), the American artist, spent eight
years with Indian tribes residing in United States, British and
Mexican territories, between 1829 and 1837. During this period
he painted some five hundred portraits and other pictures of
Red Indians. During 1838 and 1839 he toured his collection in
the United States, and then brought it to London, where he
established himself at 6, Waterloo Place. In 1845 he visited
Paris, bringing with him not only his paintings but several live
Indians as well. One of these was *Shon-ta-yi-ga*, or *Little Wolf*,
whose portrait Baudelaire mentions here. See Alfred Delvau's
Lions du Jour (1867), and also Catlin's own *Descriptive Cata-
logue*, published by himself in London in 1848; it contains ap-
preciations from the American, English and French press.

Catlin's collection is now in the care of the Smithsonian In-
stitution, Washington; a small selection was brought to Europe
and exhibited in 1954. See pls. 52–3.

fellow who could neither paint nor draw, and that if he had produced some tolerable studies, it was thanks only to his courage and his patience. Was this an innocent trick of M. Catlin's, or a blunder on the part of the journalists? For today it is established that M. Catlin can paint and draw very well indeed. These two portraits would be enough to prove it to me, if I could not call to mind many other specimens equally fine. I had been particularly struck by the transparency and lightness of his skies.

M. Catlin has captured the proud, free character and the noble expression of these splendid fellows in a masterly way; the structure of their heads is wonderfully well understood. With their fine attitudes and their ease of movement, these savages make antique sculpture comprehensible. Turning to his colour, I find in it an element of mystery which delights me more than I can say. Red, the colour of blood, the colour of life, flowed so abundantly in his gloomy Museum that it was like an intoxication; and the landscapes—wooded mountains, vast savannahs, deserted rivers—were monotonously, eternally green. Once again I find Red (so inscrutable and dense a colour, and harder to penetrate than a serpent's eye)—and Green (the colour of Nature, calm, gay and smiling)—singing their melodic antiphon in the very faces of these two heroes.— There is no doubt that all their tattooings and pigmentations had been done in accordance with the harmonious modes of nature.

I believe that what has led the public and the journalists into error with regard to M. Catlin is the fact that his painting has nothing to do with that *brash* style, to which all our young men have so accustomed us that it has become the *classic* style of our time.

Last year I already entered my protest against the unanimous *De profundis*—against the conspiracy of ingratitude— concerning the brothers Devéria. This year has proved me right. Many a precocious name which has been substituted for theirs is not yet worth as much. M. Achille Devéria has attracted special attention at this year's Salon by a picture, *Le Repos de la Sainte Famille*,[2] which not only retains all

[2] Repro. *Illustr.*, vol. 7 (1846), p. 56.

of that grace peculiar to these charming brother-geniuses, but which also recalls the solid qualities of the older schools of painting—minor schools, perhaps, which do not precisely sweep the board either by their drawing or their colour, but which, nevertheless, by their sense of order and of sound tradition are placed well above the extravagances proper to transitional ages. In the great battle of Romanticism, the Devéria brothers were members of the sacred band of the colourists; and thus their place was marked out here. The composition of M. Achille Devéria's picture is excellent, and, over and above this, the eye is struck by its soft and harmonious appearance.

M. Boissard, whose beginnings were also brilliant and full of promise, is one of those excellent artists who have taken their nourishment from the old masters; his *Madeleine au désert* is good and sound in colour—except for the flesh-tones which are a trifle dingy. The pose is a happy one.

In this interminable Salon, where differences have been more than ever wiped out, and where everyone can draw and paint a little, but not enough to deserve even to be classed, it is a great joy to meet a frank and true painter like M. Debon. Perhaps his *Concert dans l'atelier*[3] is a little too *artistic* a picture—Valentin, Jordaens and several others have their part in it; but at least it is fine, healthy painting, which marks its author as a man who is perfectly sure of himself.

M. Duveau has sent *Le Lendemain d'une tempête*. I do not know if he has it in him to become a frank colourist, but some parts of his picture give hopes of it. At first sight you search your memory for some historical scene which it can represent; for in fact the English are almost alone in daring to paint genre-pictures of such vast proportions. Nevertheless it is well organized and in general seems well designed. The tonality, which is a little too uniform and offends the eye at first, is doubtless based on an effect of nature, all of whose features appear singularly crude in colour after being washed by the rains.

M. Laemlein's *Charité*[4] is a charming woman with a

[3] Repro. *Illustr.*, vol. 7 (1846), p. 121.

[4] Laemlein made a lithograph also of this subject.

whole bunch of little brats of all countries—white, yellow, black, and so on—held by the hand or carried at the breast. Certainly M. Laemlein has a feeling for good colour. If his picture contains one great fault, it is that the little China-man is so pretty, and his garment so delightful to the eye, that he practically monopolizes the spectator's attention. This little mandarin never stops trotting through the memory, and he will cause many people to forget all the rest.

M. Decamps is one of those who, for many years now, have tyrannically possessed the public's interest; and nothing could be more legitimate.

This artist, who is gifted with a marvellous capacity for analysis, used often to achieve powerfully effective results by means of a happy conflict of little tricks. If he shirked linear detail too much, often contenting himself with move-ment and general contour, and if his drawing used occa-sionally to verge upon the *chic*, nevertheless his meticulous taste for Nature, studied above all in her effects of light, always kept him safe and sustained him on a superior plane.

If M. Decamps was not precisely a draughtsman in the generally accepted sense of the word, nevertheless, in his own way and in a particular fashion, he was one. No one has seen large figures from his pencil; but certainly the drawing—that is to say, the *build*—of his little manikins was brought out and realized with remarkable boldness and felicity. Their bodily nature and habits were always clearly revealed; for M. Decamps can make a figure intelligible in a few lines. His sketches were diverting and profoundly comical. It was the draughtsmanship of a wit, almost of a caricaturist; for he possessed an extraordinary geniality, or mocking fancy, which was a perfect match for the ironies of nature; and so his figures were always posed, draped or dressed in accordance with the truth and with the eternal proprieties and habits of their persons. If there was a certain immobility in his drawing, this was by no means unpleasing, and actually put the seal upon his orientalism. Normally he took his models in repose; and when they were shown running, they often reminded you of frozen shadows or of silhouettes suddenly halted in their course; they ran as though they were part of a bas-relief.

But it was colour that was his strong suit, his great and
unique affair. Now M. Delacroix is without doubt a great
colourist; but he is not a fanatical one. He has many other
concerns, and the scale of his canvases demands it. But for
M. Decamps colour was the great thing; it was, so to speak,
his favourite mode of thought. His splendid and radiant
colour had, what is more, a style very much of its own. It
was, to use words borrowed from the moral order, both
sanguinary and mordant. The most appetizing dishes, the
most thoughtfully prepared kickshaws, the most piquantly
seasoned products of the kitchen, had less relish and tang,
and exhaled less fierce ecstasy upon the nose and the palate
of the epicure than M. Decamps' pictures possessed for the
lover of painting. Their strangeness of aspect halted you,
held you captive and inspired you with an irresistible
curiosity. Perhaps this had something to do with the unusual
and meticulous methods which the artist often employs—
for he *lucubrates* his painting, they say, with the tireless
will of an alchemist. So sudden and so novel was the im-
pression that it produced upon the mind of the spectator
at that time, that it was difficult to conceive its ancestry,
or to decide who had fathered this singular artist, and
from what studio this solitary and original talent had
emerged. Certainly a hundred years from now historians
will have trouble in identifying M. Decamps' master. Some-
times he seemed to stem from the boldest colourists of the
old Flemish school, but he had more style than they, and
he grouped his figures more harmoniously; sometimes the
splendour and the triviality of Rembrandt were his keen
preoccupation; at other times his skies would suggest a
loving memory of the skies of Claude. For M. Decamps was
a landscape-painter too, and, what is more, a landscape-
painter of the greatest merit. But his landscapes and his
figures formed a single whole and helped one another
mutually; one had no more importance than the other, for
with him nothing was an accessory—so curiously wrought
was every part of his canvas, and to such an extent was
each detail planned to contribute to the total effect! Nothing
was unnecessary—not even the rat swimming across a tank
in one or other of his Turkish pictures—a picture all

lethargy and fatalism; nor even the birds of prey which hover in the background of that masterpiece entitled *Le Supplice des Crochets*.

At that time the sun and light played a great part in M. Decamps' painting. No one studied atmospheric effects with so much care. The weirdest and most improbable tricks of shadow and light pleased him more than anything. In a picture by M. Decamps the sun seemed really to scorch the white walls and the chalky sands; every coloured object had a keen and lively transparency. The waters were of untold depth; the great shadows which used to cut across the flanks of his houses or to sleep stretched out upon the ground or the water had the languor and sweet drowsiness of shadows beyond description. And in the midst of this fascinating décor, you would find little figures bestirring themselves or dreaming—a complete little world in all its native and comic truth.

Yes, M. Decamps' pictures were full of poetry, and often of reverie; but what others, like Delacroix, would achieve by great draughtsmanship, by an original choice of model or by broad and flowing colour, M. Decamps achieved by intimacy of detail. The only criticism, in fact, which you could make, was that he was too concerned with the material execution of objects; his houses were made of true plaster and true wood, his walls were made of true lime-mortar; and in front of these masterpieces, the heart was often saddened by a painful idea of the time and the trouble which had been devoted to their making. How much finer they would have been if executed less artfully!

Last year, when M. Decamps took up a pencil and thought fit to challenge Raphael and Poussin, the enthusiastic *flâneurs* of both parties—men whose hearts embrace the whole world, but who are quite content with things as the Almighty has designed them, and who all of them adored M. Decamps as one of the rarest products of creation—these men said amongst themselves: 'If Raphael prevents Decamps from sleeping, then it's no more Decampses for us! who will do them now—? Alas! it will be MM. Guignet[5] and Chacaton.'

[5] See pp. 27–8.

All the same, M. Decamps has reappeared this year with some Turkish things, some landscapes, some genre-pictures, and an *Effet de Pluie*.[6] But you have to look for them; they no longer strike the eye at once.

M. Decamps, who is so good at doing the sun, has failed, however, with the rain; besides, he has given his ducks a slab of stone to swim on, etc., etc. His *Ecole turque*, nevertheless, is more like his best pictures; there they all are, those lovely children whom we know so well, and that luminous, dust-charged atmosphere of a room which the sun is trying to enter bodily.

It seems to me so easy to console ourselves with the magnificent Decampses which already adorn our galleries, that I do not want to analyse the faults of these. It would be a puerile task, and besides everyone will do it very well for himself without any help from me.

Amongst the paintings by M. Penguilly-l'Haridon,[7] which are all good pieces of workmanship—little pictures, broadly yet finely painted—there is one that especially stands out and attracts the eye; *Pierrot présente à l'assemblée ses compagnons Arlequin et Polichinelle*.[8]

Pierrot, with one eye open and the other closed, and that crafty air which is traditional, is presenting Harlequin to the public; Harlequin advances with sweeping and obsequious gestures, and with one leg gallantly pointed in front of him. Punchinello follows him, with swimming head, fatuous glance, and his poor little legs in great big sabots. A ridiculous face, with a huge nose, huge spectacles and a huge curled moustache, appears between two curtains. The colour of the whole thing is pleasing—both simple and fine—and the three characters stand out perfectly

[6] Of Decamps' four exhibits this year, one, the *Souvenir de la Turquie d'Asie* (catalogued as *Enfants turcs auprès d'une fontaine*, and incorrectly assigned to 1839) is in the Musée Condé, Chantilly; the remaining three are in the Fodor Museum, Amsterdam. See pls. 24–5.

[7] At one time Baudelaire considered him as a possible illustrator for the *Fleurs du Mal*.

[8] This painting was Lot 59 at the Moreau-Nélaton sale, Paris, 11 May 1900; its present whereabouts is unknown.

against a grey background. But the thrilling effect of this picture is less the result of its general appearance than of its composition, which is excessively simple. The figure of Punchinello, which is essentially comic, reminds us of the English *Punch*, who is usually shown touching the end of his nose with his index finger, to express his pride in it, or his vexation. I would, however, criticize M. Penguilly for not having taken his type from Deburau,[9] who is the true Pierrot of today—the Pierrot of modern history—and should therefore have his place in any painted harlequinade.

Now here is another fantasy, which is very much less adroit and less learned, and whose beauty is all the greater in that it is perhaps involuntary; I refer to M. Manzoni's *La Rixe des mendiants*. I have never seen anything so poetically brutal, even in the most Flemish of orgies. Here, under six heads, are the different reactions of the visitor who passes in front of this picture—1. Lively curiosity. 2. 'How shocking!' 3. 'It's badly painted, but the composition is unusual and does not lack charm.' 4. 'It's not so badly painted as we thought at first.' 5. 'Let's have another look at this picture.' And 6. A lasting memory.

It has a ferocity and a brutality of manner which suit the subject rather well and put us in mind of Goya's violent sketches. These, in fact, are the most ruffianly countenances that you could wish to see: it is a weird conglomeration of battered hats, wooden legs, broken glasses, befuddled topers; lust, ferocity and drunkenness are shaking their rags.

The ruddy beauty who is kindling the desires of these gentlemen is a fine stroke of the brush, and well formed to please the connoisseurs. I have rarely seen anything so comic as that poor wretch up against a wall, whom his neighbour has victoriously nailed with a pitch-fork.

The second picture, *L'Assassinat nocturne*, has a less strange look. Its colour is dim and commonplace, and the fantastic ingredient is confined to the manner in which the scene is represented. A beggar is brandishing a knife in the face of a miserable fellow whose pockets are being ransacked and who is half dead from fear. Those white domi-

[9] Jean Gaspard Deburau, the famous French pantomimist, died this year. See pp. 147–8.

noes, in the form of gigantic noses, are very droll and give the most singular stamp to this scene of terror.

M. Villa-Amil has painted the throne-room in Madrid. At first sight, you might say that it was very simply executed; but if you look at it with more care, you will recognize a lot of cleverness in the organization and in the general colouring of this decorative picture. It is less fine in tone, perhaps, but it is firmer in colour than the pictures of the same type for which M. Roberts[10] has a liking. If it has a fault, it is that the ceiling looks less like a ceiling than a veritable sky.

MM. Wattier and Pérèse generally treat almost similar subjects—fair ladies wearing old-fashioned costumes, in parks, beneath ancient shades. What distinguishes M. Pérèse is that he paints with much more simplicity, and his name does not compel him to ape Watteau. But in spite of the studied delicacy of M. Wattier's figures, M. Pérèse is his superior in invention. You might say that there is the same difference between their works as between the mincing gallantry of the time of Louis XV and the honest gallantry of the age of Louis XIII.

The school of Couture—since we must call it by its name —has given us much too much this year.

M. Diaz de la Peña,[11] who is, in little, the extreme representative of this *little* school, sets out from the principle that a palette is a picture. As for over-all harmony, M. Diaz thinks that you will invariably find it. Of draughtsmanship —the draughtsmanship of movement, the draughtsmanship of the colourists—there is no question; the limbs of all his little figures behave for all the world like bundles of rags, or like arms and legs scattered in a railway accident. I would far rather have a kaleidoscope; at least it does not presume to give us *Les Délaissées* or *Le Jardin des amours* —it provides designs for shawls and carpets, and its role is a modest one. It is true that M. Diaz is a colourist; but enlarge his frame by a foot, and his strength will fail him,

[10] Presumably David Roberts, R.A., who is chiefly remembered for his Spanish scenes.

[11] Diaz had eight paintings at the Salon this year, of which Baudelaire mentions the names of two. Another, entitled *Orientale*, is reproduced *Illustr.*, vol. 7 (1846), p. 136.

because he does not recognize the necessity for *general* colour. That is why his pictures leave no memory behind them.

But each man has his allotted part, you say. Great painting is not made for everyone, by any means. A fine dinner contains both hors-d'œuvres and main courses. Would you dare to sneer at the Arles sausages, the pimentoes, the anchovies, the *aioli*, and the rest?—Appetizing hors-d'œuvres?, I reply. Not a bit of it. These things are bon-bons and nauseating sweetmeats. Who would want to feed on dessert? You hardly do more than just touch it when you are pleased with your dinner.

M. Célestin Nanteuil knows how to place a brush-stroke, but he does not know how to fix the proportions and the harmony of a picture.

M. Verdier paints well enough, but fundamentally I believe him to be an enemy of thought.

M. Muller, the man of the *Sylphes*, the great connoisseur of poetic subjects—of subjects streaming with poetry—has painted a picture which he calls *Primavera*. People who do not know Italian will think that this word means *Decameron*.

M. Faustin Besson's colour loses much by being no longer dappled and befogged by the windows of Deforge's shop.[12]

M. Fontaine is obviously a serious-minded man; he has given us M. de Béranger surrounded by youngsters of both sexes, whom he is initiating into the mysteries of Couture's manner.

And what great mysteries they are! A pink or peach-coloured light, and a green shadow—that's all there is to it! The terrible thing about this painting is that it forces itself upon the eye; you notice it from a great distance.

Without a doubt the most unfortunate of all these gentlemen is M. Couture himself, who throughout plays the interesting role of victim. An imitator is a babbler who gives away surprises.

In the various specialities of Bas-Breton, Catalan, Swiss, Norman subjects and the rest, MM. Armand and Adolphe

[12] In the Boulevard Montmarte.

Leleux are outstripped by M. Guillemin, who is inferior to M. Hédouin, who himself yields the palm to M. Haffner.

Several times I have heard this peculiar criticism directed at the MM. Leleux—that whether they were supposed to be Swiss, Spanish or Breton, all their characters seemed to come from Brittany.

M. Hédouin is certainly a commendable painter, who possesses a firm touch and understands colour; no doubt he will succeed in establishing his own particular originality.

As for M. Haffner, I owe him a grudge for once having painted a portrait in a superably romantic style, and for not having painted any more like it.[18] I believed that he was a great artist, rich in poetry and, above all, in invention, a portraitist of the front rank, who came out with an occasional daub in his spare time; but it seems that he is no more than just a painter.

VII

ON THE IDEAL AND THE MODEL

SINCE COLOUR is the most natural and the most *visible* thing, the party of the colourists is the most numerous and the most important. But analysis, which facilitates the artist's means of execution, has divided nature into colour and line; and before I proceed to an examination of the men who form the second party, I think that it would be well if I explained some of the principles by which they are guided —sometimes even without their knowing it.

The title of this chapter is a contradiction, or rather an agreement of contraries; for the drawing of a great draughtsman ought to epitomize both things—the ideal and the model.

Colour is composed of coloured masses which are made up of an infinite number of tones, which, through harmony, become a unity; in the same way, Line, which also has its

[18] The portrait was at the Salon of the previous year: see p. 22. This year Haffner exhibited three landscapes only, of which one is reproduced *Illustr.*, vol. 7 (1846), p. 185.

masses and its generalizations, can be subdivided into a
profusion of particular lines, of which each one is a feature
of the model.

The circumference of a circle—the ideal of the curved
line—may be compared with an analogous figure, composed
of an infinite number of straight lines which have to fuse
with it, the inside angles becoming more and more obtuse.

But since there is no such thing as a perfect circum-
ference, the absolute ideal is a piece of nonsense. By his
exclusive taste for simplicity, the feeble-minded artist is led
to a perpetual imitation of the same type. But poets, artists,
and the whole human race would be miserable indeed if
the ideal—that absurdity, that impossibility—were ever dis-
covered. If that happened, what would everyone do with
his poor *ego*—with his crooked line?

I have already observed that memory is the great cri-
terion of art; art is a kind of mnemotechny of the beautiful.
Now exact imitation spoils a memory. There are some
wretched painters for whom the least wart is a stroke of
luck; not only is there no fear of their forgetting it, but they
find it necessary to paint it four times as large as life. And
thus they are the despair of lovers—and when a people
commissions a portrait of its king, it is nothing less than
a lover.

A memory is equally thwarted by too much particulariza-
tion as by too much generalization. I prefer the *Antinous*
to the *Apollo Belvedere* or to the *Gladiator*, because the
Antinous is the ideal of the charming Antinous himself.

Although the universal principle is one, Nature presents
us with nothing absolute, nothing even complete;* I see
only individuals. Every animal of a similar species differs in
some respect from its neighbour, and among the thousands
of fruits that the same tree can produce, it is impossible to
find two that are identical, for if so, they would be one
and the same; and duality, which is the contradiction of
unity, is also its consequence.** But it is in the human race

* Nothing absolute—thus the geometric ideal is the worst of
idiocies. Nothing complete—thus everything has to be com-
pleted, and every ideal recaptured. (c.b.)

** I say *contradiction*, and not *contrary*; for contradiction is an
invention of man's. (c.b.)

above all that we see the most appalling capacity for variety. Without counting the major types which nature has distributed over the globe, every day I see passing beneath my window a certain number of Kalmouks, Osages, Indians, Chinamen and Ancient Greeks, all more or less Parisianized. Each individual is a unique harmony; for you must often have had the surprising experience of turning back at the sound of a known voice and finding yourself face to face with an unknown stranger—the living reminder of someone else endowed with a similar voice and similar gestures. This is so true that Lavater has established a nomenclature of noses and mouths which agree together, and he has pointed out several errors of this kind in the old masters, who have been known to clothe religious or historical characters in forms which are contrary to their proper natures. It is possible that Lavater was mistaken in detail; but he had the basic idea. Such and such a hand demands such and such a foot; each epidermis produces its own hair. Thus each individual has his ideal.

I am not claiming that there are as many fundamental ideals as there are individuals, for a mould gives several impressions; but in the painter's soul there are just as many ideals as individuals, because a portrait is *a model complicated by an artist.*

Thus the ideal is not that vague thing—that boring and impalpable dream—which we see floating on the ceilings of academies; an ideal is an individual put right by an individual, reconstructed and restored by brush or chisel to the dazzling truth of its native harmony.

The first quality of a draughtsman is therefore a slow and sincere study of his model. Not only must the artist have a profound intuition of the character of his model; but further, he must generalize a little, he must deliberately exaggerate some of the details, in order to intensify a physiognomy and make its expression more clear.

It is curious to note that, when guided by this principle —namely, that the sublime ought to avoid details—art finds the way of self-perfection leading back towards its childhood. For the first artists also used not to express details. The great difference, however, is that, in doing the arms

and the legs of their figures like drain-pipes, it was not *they* who were avoiding the details, but the details which were avoiding *them;* for in order to choose, you have first to possess.

Drawing is a struggle between nature and the artist, in which the artist will triumph the more easily as he has a better understanding of the intentions of nature. For him it is not a matter of copying, but of interpreting in a simpler and more luminous language.

The introduction of the portrait—that is to say, of the idealized model—into historical, religious or imaginative subjects necessitates at the outset an exquisite choice of model, and is certainly capable of rejuvenating and re-vitalizing modern painting, which, like all our arts, is too inclined to be satisfied with the imitation of the old masters.

Everything else that I might say on the subject of ideals seems to me to be contained in a chapter of Stendhal, whose title is as clear as it is insolent:—

> 'How are we to go one better than Raphael?'

In the affecting scenes brought about by the passions, the great painter of modern times—if ever he appears—will give to each one of his characters *an ideal beauty, derived from a temperament* which is constituted to feel the effect of that passion with the utmost vividness.

Werther will not be indifferently sanguine or melan-cholic, nor Lovelace phlegmatic or bilious. Neither good Doctor Primrose nor gentle Cassio will have a bilious temperament; this is reserved for Shylock the Jew, for dark Iago, for Lady Macbeth, for Richard III. The pure and lovely Imogen will be a trifle phlegmatic.

The artist's first observations led him to fashion the *Apollo Belvedere.* But will he restrict himself to coldly producing copies of the Apollo every time that he wishes to represent a young and handsome god? No, he will set a link between the action and the type of beauty. Apollo delivering the Earth from the serpent Python will be more robust; Apollo paying court to Daphne will be more delicate of feature.*

* Stendhal, *Histoire de la Peinture en Italie*, ch. 101. This was printed in 1817. (c.b.)

VIII

SOME DRAUGHTSMEN

IN THE PRECEDING CHAPTER I said nothing at all about imaginative or creative draughtsmanship, because in general this is the prerogative of the colourists. Michelangelo, who, from a certain point of view, is the inventor of the ideal among the moderns, is the only man to have possessed the 'graphic' imagination in its supreme degree without being a colourist. Pure draughtsmen are naturalists endowed with excellent perception; but they draw by the light of reason, whereas colourists—that is, *great* colourists—draw by the light of temperament, almost without knowing it. Their method is analogous to nature; they draw because they colour, whereas pure draughtsmen, if they wanted to be logical and true to their profession of faith, would content themselves with a black pencil. Nevertheless they devote themselves to colour with an unimaginable enthusiasm, taking no notice at all of the contradictions involved. They start by delimiting their forms in a cruel and absolute manner, and then they proceed to fill up the spaces. This double method ceaselessly thwarts their efforts, and gives to all their productions a strange element of bitterness, toil and contention. Their works are an eternal piece of litigation, an exhausting dualism. A draughtsman is a would-be colourist.

This is so true that M. Ingres, the most illustrious representative of the naturalistic school of draughtsmanship, is forever in pursuit of colour. What admirable and unfortunate obstinacy! It is the eternal story of people wanting to trade a reputation which they have earned for one which they cannot win. M. Ingres adores colour, like a fashionable milliner. It is at once a pain and a pleasure to observe the efforts which he makes in choosing and coupling his tones. The result—which is not always discordant, but is nevertheless bitter and violent—is often pleasing to corrupt poets; but even so, when they have allowed their tired minds a

long spell of amusement in the midst of these dangerous struggles, they feel an absolute need to come to rest upon a Velasquez or a Lawrence.

If M. Ingres occupies the most important place after Eugène Delacroix, it is because of that entirely personal draughtsmanship whose mysteries I was analysing a moment ago, and with which he has achieved the best epitome to date of the ideal and the model. M. Ingres draws admirably well, and he draws rapidly. In his sketches he attains the ideal quite naturally. His drawing is often only lightly charged and does not contain many strokes; but each one realizes an important contour. But now take a look at the drawings of all those *artisans* of painting—many of them his pupils; they start by rendering the minute details, and it is for this reason that they enchant the vulgar, which will only open its eye for what is *little,* in whatever genre.

In a certain sense M. Ingres draws better than Raphael, the popular king of draughtsmen. Raphael decorated immense walls; but he would not have done the portrait of your mother, your friend or your mistress so well as Ingres. The daring of this man is all his own, and it is combined with cunning in such a way that he shirks no sort of ugliness or oddity. Did he stop at M. Molé's frock-coat[1] or Cherubini's *carrick?* And did he not put a blind man, a one-eyed and a one-armed man, and a hunchback into the *Plafond d'Homère*[2]—a work which, more than any other, aspires towards the ideal? Nature repays him handsomely for this pagan adoration. He could make a sublime thing even of Mayeux.[3]

The beautiful *Muse de Cherubini*[4] is still a portrait. If M. Ingres, who lacks the 'graphic' imagination, does not know how to make pictures—at least, on a large scale—it is nevertheless just to say that his portraits are *almost* pictures— that is, intimate poems.

His is a grudging, cruel, refractory and suffering talent—

[1] Now in a private collection (Wildenstein 225).

[2] See p. 61.

[3] A grotesque hunchback invented by the caricaturist Traviès and much used by him and others in the 1830s. See pp. 176-7.

[4] In the Louvre (Wildenstein 236); see pl. 59.

a singular mixture of contrary qualities, all placed to the credit of Nature, and one whose strangeness is not among its least charms. He is Flemish in his execution, an individualist and a naturalist in his drawing, antique by his sympathies and an idealist by reason.

To reconcile so many contraries is no meagre task; and so it is not without reason that, in order to display the sacred mysteries of his draughtsmanship, he has adopted an artificial system of lighting which serves to render his thought more clear—something similar to the sort of twilight in which a still sleepy Nature has a wan and raw appearance and in which the countryside reveals itself in a fantastic and striking guise.

A rather distinctive fact about M. Ingres' talent, and one which I believe has been overlooked, is that he is happier in dealing with female subjects. He depicts them as he sees them, for it would appear that he loves them too much to wish to change them; he fastens upon their slightest beauties with the keenness of a surgeon, he follows the gentlest sinuosities of their line with the humble devotion of a lover. His *Angélique*,[5] his two *Odalisques* and his portrait of Mme. d'Haussonville[6] are works of a deeply sensuous rapture. But we are never allowed to see any of these things except in a light which is almost frightening—it is neither the golden atmosphere in which the fields of the ideal lie bathed, nor yet the tranquil and measured light of the sublunar regions.

The works of M. Ingres are the result of an excessive attentiveness, and they demand an equal attentiveness in order to be understood. Born of suffering, they beget suffering. As I explained above, this is due to the fact that his method is not one and simple, but rather consists in the use of a succession of methods.

Around M. Ingres, whose teaching has a strange austerity which inspires fanaticism, there is a small group of artists,

[5] i.e. *Roger et Angélique* (1819), in the Louvre (Wildenstein 124).

[6] In the Frick Collection, New York (Wildenstein 248); see pl. 60.

of whom the best-known are MM. Flandrin, Lehmann and
Amaury-Duval.

But what an immense distance separates the master from
his pupils! M. Ingres remains alone in his school. His
method is the result of his nature, and however weird
and uncompromising it may be, it is frank and, so to speak,
involuntary. Passionately in love with the antique and with
his model, and a respectful servant of nature, he paints
portraits which can rival the best sculptures of the Romans.
These gentlemen, however, have coldly, deliberately and
pedantically chosen the unpleasing and unpopular part of
his genius to translate into a system; it is their pedantry
that pre-eminently distinguishes them. Curiosity and erudi-
tion are what they have seen and studied in their master.
Hence their pursuit of leanness and pallor, and all the rest
of those ridiculous conventions which they have adopted
without examination or good faith. They have plunged
deep, very deep, into the past, just in order to copy its
deplorable mistakes with a puerile servility; they have de-
liberately discarded all the means of successful execution
which the experience of the ages had made available to
them. People still remember *La Fille de Jephté pleurant sa
virginité;*[7] but those excessive elongations of hands and
feet, those exaggerated ovals of heads, all those ridiculous
affectations—conventions and habits of the brush which
have a tolerable resemblance to the *chic*—are singular faults
in an ardent worshipper of form. Since his portrait of the
Princess Belgiojoso, M. Lehmann has never ceased painting
abnormally big eyes, in which the pupil swims like an
oyster in a soup-tureen. This year he has sent some por-
traits and some other pictures. The pictures are *Les
Océanides, Hamlet* and *Ophelia. Les Océanides* is a sort
of Flaxman, and its general aspect is so ugly that it
kills any desire to examine the design. In the portraits
of *Hamlet* and *Ophelia*[8] there are visible pretensions
to *colour*—the great hobby-horse of this school! But this
unfortunate imitation of colour is as saddening and dis-

[7] Exhibited by Henri Lehmann at the Salon of 1836.

[8] Both repro. *Illustr.*, vol. 7 (1846), p. 184, and the *Illustrated
London News*, 23 May 1846.

tressing to me as a copy of a Veronese or a Rubens made by
an inhabitant of the moon. As for their physical and spirit-
ual deportment, these two figures reminded me of the
bombast of the actors at the old Bobino, when they used
to play melodramas there. Without a doubt Hamlet's hand
is fine; but a well-executed hand does not make a draughts-
man—that would really be asking too much of *detail*, even
for an Ingrist!

I think that Mme. Calamatta also belongs to the party of
the enemies of the sun; but sometimes her pictures are
quite happily composed, and they have a little of that air
of authority which women—even the most literary of them,
and the real *artists*—find it less easy to borrow from men
than their absurdities.

M. Janmot has done a *Station—Le Christ portant sa Croix*
—whose composition has some character and gravity, but
whose colour, being no longer mysterious, or rather *mys-
tical,* as in his last works, is unhappily reminiscent of the
colour of all possible *Stations.* As you look at this crude
and glossy picture, it is only too easy to guess that M. Jan-
mot comes from Lyons. In fact this is just the kind of paint-
ing which suits that city of cash-tills—that city of bigotry
and punctilio, where everything, down to religion, has to
have the calligraphic neatness of an account-book.[9]

The names of M. Curzon and M. Brillouin have already
often been linked in the public mind, although at the start
they gave promise of more originality. This year M. Bril-
louin—*A quoi rêvent les jeunes filles*[10]—has stepped out of
himself, and M. Curzon has been content to do Brillouins.
Their tendency reminds one of the school of Metz[11]—a
literary, mystical and *Germanic* school. M. Curzon, who
often paints fine, generously-coloured landscapes, could
interpret Hoffmann in a less erudite, a less conventional
way. But although he is obviously a man of wit—his choice

[9] The Lyons school of painting was particularly deplored by
Baudelaire. See p. 32 above.
[10] Under this main title, Brillouin exhibited four drawings, with
individual titles such as 'Les présents de l'étranger' and 'Le
retour du bien-aimé.'
[11] See p. 33 above.

of subjects is enough to prove it—you feel that the Hoffmannesque afflatus has passed nowhere near him.[12] The old-fashioned style of the German artists bears no resemblance to the style of this great poet, whose compositions have a very much more modern and more romantic character. The artist has vainly tried to obviate this capital defect by choosing the least fantastic of all the stories, *Master Martin and his Apprentices,* of which Hoffmann himself said: 'It is the most mediocre of my works; there is not a shred of the terrible or the grotesque in it, and these are the two most important arrows in my quiver!' But in spite of that, even in *Master Martin* Hoffmann's lines are more floating and his atmosphere more charged with wit than M. Curzon has made them.

Properly speaking M. Vidal's place is not here at all, for he is not a true draughtsman. Nevertheless the moment is not too badly chosen, for he has several of the ridiculous fads of the Ingrists—that is to say, a fanatical regard for the *little* and the *pretty,* and an enthusiasm for beautiful paper and fine canvases. All this has nothing to do with the sense of order with which a strong and vigorous mind is ruled and girt, nor yet with the adequate neatness of a man of good sense; it is neatness run mad.

The preconception about Vidal[13] began, I think, three or four years ago. Even so, at that time his drawings were less pedantic and less mannered than they are today.

This morning I was reading an article by M. Théophile Gautier,[14] in which he sang the praises of M. Vidal for being able to interpret modern beauty. I do not know why M. Gautier has donned the uniform of the 'good-natured man' this year; for he has praised everyone, and there is no wretched dauber whose pictures he has not catalogued. Can it be perchance that the hour of the Academy—that solemn and soporific hour—has struck for him, if he is

[12] Curzon exhibited five drawings illustrating Hoffmann's *Meister Martin;* five such drawings are now in the Poitiers Museum.

[13] See p. 34.

[14] In *La Presse,* 7th April 1846. Gautier's praise of Ary Scheffer in this article must have especially disgusted Baudelaire: see p. 105.

already so well-mannered? and has literary prosperity such disastrous results that the public is forced to call us to order by rubbing our noses in our original certificates of romanticism? Nature has endowed M. Gautier with an excellent, broad and poetic mind. Everyone knows what fierce admiration he has always evinced for sincere and generous works. What potion can the painters have poured into his wine this year? or what rose-tinted spectacles has he selected with which to go to work?

So M. Vidal understands modern beauty, does he? Come now! Thanks to nature, our women have not so much wit or sophistication; but they are infinitely more romantic. Look at nature, sir. A man does not arm himself with wit and with meticulously sharpened pencils in order to *paint!* for some critics rank you—I really do not know why—among the noble family of the painters. It is no use your calling your women *Fatinitza*,[15] *Stella, Vanessa, Saison des Roses*[16] —a bunch of names for cosmetics; you will not produce poetic women that way. You once set yourself the task of expressing the idea of *Self-love*[17]—a great and fine idea, a supremely feminine idea—but you quite failed to interpret the sharp element of greed and the magnificent egoism of the subject. You never rose above puerile obscurity.

Nevertheless all these affectations will pass away like rancid unguents. A ray of sunshine is enough to bring out all their stench. I would rather leave Time to do its work than waste my own in expounding all the poverties of this sorry genre.

IX

ON PORTRAITURE

THERE ARE two ways of understanding portraiture—either as history or as fiction.

The first is to set forth the contours and the modelling

[15] Salon of 1845.
[16] Salon of 1846.
[17] Salon of 1845: repro. *Illustr.*, vol. 5 (1845), p. 152.

of the model faithfully, severely and minutely; this does not however exclude idealization, which, for enlightened naturalists, will consist in choosing the sitter's most characteristic attitude—the attitude which best expresses his habits of mind. Further, one must know how to give a reasonable exaggeration to each important detail—to lay stress on everything which is naturally salient, marked and essential, and to disregard (or to merge with the whole) everything which is insignificant or which is the effect of some accidental blemish.

The masters of the 'historical' school are David and Ingres, and its best manifestations are the portraits by David which were to be seen at the Bonne Nouvelle exhibition,[1] and those of M. Ingres, such as M. Bertin and Cherubini.[2]

The second method, which is the special province of the colourists, is to transform the portrait into a picture—a poem with all its accessories, a poem full of space and reverie. This is a more difficult art, because it is a more ambitious one. The artist has to be able to immerse a head in the soft haze of a warm atmosphere, or to make it emerge from depths of gloom. Here the imagination has a greater part to play, and yet, just as it often happens that fiction is truer than history, so it can happen that a model is more clearly realized by the abundant and flowing brush of a colourist than by the draughtsman's pencil.

The masters of the 'fictional', or 'romantic' school are Rembrandt, Reynolds and Lawrence. Well-known examples are La Dame au chapeau de paille[3] and Master Lambton.[4]

A characteristic excellence of MM. Flandrin, Amaury-Duval and Lehmann is the truth and subtlety of their

[1] This exhibition took place in January 1846. Baudelaire wrote an article about it at the time.

[2] Ingres' portraits of M. Bertin (1832) and of Cherubini (1841) are in the Louvre (Wildenstein 208 and 236).

[3] It is not quite clear to which straw-hatted lady Baudelaire refers: Crépet suggests a portrait of the Countess Spencer by Reynolds, but several others of Reynolds' portraits (e.g. Nelly O'Brien, in the Wallace Collection) fit the description.

[4] Lawrence's Master Lambton was shown in Paris in 1827.

modelling. The detail is well grasped and executed easily and all in one breath, so to speak; nevertheless their portraits are often vitiated by a pretentious and clumsy affectation. Their immoderate taste for *distinction* never ceases to trip them up. We know with what an admirable simplicity of mind they seek after *distinguished* tones—that is to say, tones which, if intensified, would scream at one another like the devil and holy water, or like marble and vinegar; but since these are excessively etiolated and given in homoeopathic doses, their effect is one of surprise rather than of pain; and that is their great triumph!

The *distinction* in their draughtsmanship consists in their sharing the prejudices of certain modish ladies, who have a smattering of debased literature and a horror of little eyes, large feet, large hands, little brows and cheeks glowing with joy and health—all of which can be extremely beautiful.

This pedantry in colour and draughtsmanship does constant injury to the works of these gentlemen, however estimable they may be in other respects. Thus, while I was contemplating M. Amaury-Duval's *blue* portrait (and the same applies to many other portraits of Ingresque, or *Ingrized,* women), some strange association of ideas brought to mind the following wise words of the dog Berganza,[5] who used to run away from *blue-stockings* as ardently as these gentlemen seek them out:

'Have you never found Corinne[6] quite impossible? . . . At the idea of seeing her come near me, in flesh and blood, I used to feel an almost physical oppression, and found myself quite incapable of preserving my serenity and freedom of mind in her presence . . . Whatever the beauty of her arms or her hand, I could never have endured her caresses without feeling slightly sick—without a kind of internal shudder which tends to take away my appetite . . . Of course I am only speaking here in my canine capacity!'

[5] The reference is to Hoffmann's *Nachricht von den neuesten Schicksalen des Hundes Berganza.* Hoffmann had taken over the character of the speaking dog Berganza from a story by Cervantes.

[6] The heroine of Mme. de Staël's novel of that name.

I have had the same sensation as the witty Berganza in front of nearly all the portraits of women—whether old or new ones—by MM. Flandrin, Lehmann and Amaury-Duval; and this in spite of the beautiful hands (really well-painted, too) which they know how to give them, and in spite of the flattering elegance of certain details. If Dulcinea del Toboso herself were to pass through the studio of these gentlemen, she would emerge as pellucid and prim as an elegy, after a slimming diet of aesthetic tea and aesthetic butter.

M. Ingres, however—and this must be repeated over and over again—M. Ingres, the great master, understands things in quite another way.

In the sphere of portraiture understood according to the second method, MM. Dubufe the elder, Winterhalter, Lépaulle and Mme. Frédérique O'Connell, given a sincerer taste for nature and a solider colour, might have won a justifiable reputation.

M. Dubufe is destined to retain the privilege of elegance in portraiture for a long time yet; his natural and almost poetic taste successfully conceals his innumerable faults.

It is worth observing that the people who hurl the word 'bourgeois' so frequently at M. Dubufe are the very ones who have allowed themselves to be enchanted by M. Pérignon's wooden heads.[7] How much one would have forgiven M. Delaroche if it had been possible to foresee the Pérignon factory!

M. Winterhalter is really on the decline. M. Lépaulle is still the same, now and again an excellent painter, but always devoid of taste and good sense. Charming eyes and mouths, well-executed arms—and *toilettes* calculated to send decent people running!

Mme. O'Connell knows how to paint with freedom and rapidity; but her colour lacks firmness. That is the unhappy fault of English painting, which is transparent to excess and is always characterized by too great a fluidity.[8]

An excellent example of the kind of portrait whose essence I was attempting to define a moment ago is that por-

[7] See p. 22.

[8] In spite of her name, Mme. O'Connell seems to have been of German extraction.

trait of a woman by M. Haffner—drenched in grey and radiating mystery—which led the connoisseurs at the last Salon to entertain such high hopes; but M. Haffner had not yet become a genre-painter, seeking to fuse and to reconcile Diaz, Decamps and Troyon.

You would suppose that Mlle. E. Gautier was seeking to modify her manner a little. She is wrong to do so.

MM. Tissier and J. Guignet have preserved their touch and their colour, which are both firm and solid. Generally speaking there is this excellent quality about their portraits, that they are above all pleasant to look at—that is the first impression, and the most important.

M. Victor Robert, the creator of a vast allegory of Europe,[9] is certainly a good painter, gifted with a firm hand. But an artist who undertakes the portrait of a famous man ought not to be content to achieve a merely felicitous paint-surface; for he is also painting the portrait of a mind. M. Granier de Cassagnac[10] is much uglier, or, if you prefer it, much more handsome. To start with he has a broader nose, and his mouth, which is mobile and sensitive, has a slyness and a delicacy which the painter has forgotten. M. Granier de Cassagnac seems somehow smaller and more athletic—down to his very brow. The present pose is theatrical rather than expressive of the genuine force which characterizes the man. It gives no hint of that challenging and martial bearing with which he attacks life and all its problems. It is enough to have seen him suddenly thunder forth his passions, with leaps and starts of pen and chair—it is enough simply to have read them in the paper—to realize that the whole man is not here. The copy of *Le Globe,* which recedes into the shadow, is a complete absurdity—surely it ought to have been in full view, if it had to be there at all!

I have always had the notion that M. Boulanger would have made an excellent engraver; he is a simple workman, quite devoid of invention, who gains much by working on someone else's model. His romantic pictures are bad, but his portraits are good—clear, solid, easily and simply

[9] Exhibited at the Salon of 1845. See p. 17.
[10] Editor of *Le Globe.*

painted. And the curious thing is that they often have the look of those excellent engravings after the portraits of Van Dyck. They have the dense shadows and the bright highlights of vigorous etchings. Each time that M. L. Boulanger has tried to rise higher, he has fallen into bathos. I believe him to be a man of honest, calm and sound intelligence, whom only the exaggerated praises of the poets could have led astray.

What am I to say of M. L. Cogniet, that amiable eclectic, that painter of such sincerity and of so restless an intelligence that, in order to paint M. Granet's[11] portrait properly, he has had the idea of using the colour proper to M. Granet's own pictures—which is generally black, as we have all known for a long time?

Mme. de Mirbel is the only artist who knows how to thread her way through the difficult problem of taste and truth. It is because of this special sincerity, and also because of their enchanting appearance, that her miniatures have all the importance of serious painting.

x

THE 'CHIC' AND THE 'PONCIF'

THE WORD 'chic'—a dreadful, outlandish word of modern invention, which I do not even know how to spell correctly,* but which I am obliged to use, because it has been sanctioned by artists in order to describe a modern monstrosity —the word 'chic' means a total neglect of the model and of nature. The 'chic' is an abuse of the memory; moreover it is a manual, rather than an intellectual, memory that it abuses—for there are artists who are gifted with a profound memory for characters and forms—Delacroix or Daumier, for example—and who have nothing to do with it.

The 'chic' may be compared with the work of those writing-masters who, with an elegant hand and a pen shaped for italic or running script, can shut their eyes and

[11] Now in the Musée Granet, Aix-en-Provence.

* Somewhere or other Balzac spells it 'chique'. (C.B.)

boldly trace a head of Christ or Napoleon's hat, in the form of a flourish.

The meaning of the word 'poncif' has much in common with that of the word 'chic'. Nevertheless it applies more particularly to attitudes and to expressions of the head.

Rage can be 'poncif', and so can astonishment—for example, the kind of astonishment expressed by a horizontal arm with the thumb splayed out.

There are certain beings and things, in life and in nature, which are 'poncif'—that is to say, which are an epitome of the vulgar and banal ideas which are commonly held above those beings and those things; great artists, therefore, have a horror of them.

Everything that is conventional and traditional owes something to the 'chic' and the 'poncif'.

When a singer places his hand upon his heart, this commonly means 'I shall love her always!' If he clenches his fists and scowls at the boards or at the prompter, it means 'Death to him, the traitor!' That is the 'poncif' for you.

XI

M. HORACE VERNET

SUCH ARE the stern principles which guide this eminently *national* artist in his quest for beauty—this artist whose compositions decorate the poor peasant's cottage no less than the carefree student's garret, the salon of the meanest bordello as often as the palaces of our kings. I am quite aware that this man is a Frenchman, and that a Frenchman in France is a holy and sacred thing—even abroad I am told that this is so; but it is for that very reason that I hate him.

In its most widely accepted sense, the word 'Frenchman' means *vaudevilliste*,[1] and the word 'vaudevilliste' means a man whose head swims at the thought of Michelangelo, and whom Delacroix strikes into a brutish stupor, just as

[1] The literal, unsarcastic meaning of the word is a writer of *vaudevilles*, i.e. light theatrical entertainments interspersed with catchy, popular songs.

certain animals are struck by thunder. Everything that towers or plunges, above or below him, causes him prudently to take to his heels. The sublime always affects him like a riot, and he only opens his Molière in fear and trembling—because someone has persuaded him that Molière is an amusing author.

Therefore all respectable folk in France (excepting M. Horace Vernet) hate the Frenchman. It is not ideas that this restless people wants, but facts, historical reports, topical rhymes, and *Le Moniteur*.[2] That is all: abstractions, never! The Frenchman has done great things, but almost by mistake. He has been *caused* to do them.

M. Horace Vernet[3] is a soldier who practises painting. Now I hate an art which is improvised to the roll of the drum, I hate canvases splashed over at the gallop, I hate painting manufactured to the sound of pistol-shots, since I hate the army, the police-force—everything, in fact, that trails its noisy arms in a peaceful place. This immense popularity—which, however, will endure no longer than war itself, and will decline in proportion as the peoples of the world contrive other joys for themselves—this popularity, do I call it?—this *vox populi, vox Dei* is for me like a physical oppression.

I hate this man because his pictures have nothing whatever to do with painting (I would prefer to call them a kind of brisk and frequent masturbation in paint, a kind of itching on the French skin), just as I hate another such great man,[4] whose solemn hypocrisy has given him dreams of the consulate, and who has repaid the people's love with nothing more substantial than bad verses—verses which have nothing to do with poetry, but are ruptured and ill-composed, full of barbarities and solecisms, but also of civic virtue and patriotism.

[2] *Le Moniteur universel,* founded 1789, and until 1869 the official government organ.
[3] This year Horace Vernet exhibited a characteristically enormous picture (roughly 15 × 30 feet) of the Battle of Isly. It is now in the Versailles Museum.
[4] The reference is to Béranger. See note on p. 156.

I hate him because he was born under a lucky star,* and because for him art is a simple and easy matter. Nevertheless he is the chronicler of your National glory, and that is the great thing. But what, I ask you, can that matter to the enthusiastic traveller, to the cosmopolitan spirit who prefers beauty to glory?

To define M. Horace Vernet as clearly as possible, he is the absolute anthithesis of the artist: he substitutes *chic* for drawing, cacophony for colour and episodes for unity; he paints Meissoniers as big as houses.

Furthermore, in order to fulfil his official mission, M. Horace Vernet is gifted with two outstanding qualities—the one of deficiency, the other of excess; for he lacks all passion, and has a memory like an almanach!** Who knows better than he the correct number of buttons on each uniform, or the anatomy of a gaiter or a boot which is the worse for innumerable days' marching, or the exact spot on a soldier's gear where the copper of his small-arms deposits its verdigris? Therefore what a vast public he has, and what bliss he affords them! He has, in fact, as many different publics as it takes trades to manufacture uniforms, shakos, swords, muskets and cannons! Imagine all those honourable guilds mustered in front of a Horace Vernet by their common love of glory! What a sight!

One day I remember twitting some Germans with their

* (Literally 'with a caul on his head', Fr. *coiffé*). An expression of M. Marc Fournier's, which is applicable to almost all our fashionable novelists and historians, who are hardly more than literary journalists, like M. Horace Vernet. (c.b.) Marc Fournier (b. 1818) was a popular playwright.

** 'True memory, considered from a philosophical point of view, consists, I think, in nothing else but a very lively and easily-roused imagination, which is consequently given to reinforcing each of its sensations by evoking scenes from the past, and endowing them, as if by magic, with the life and character which are proper to each of them—at least I have heard this theory upheld by one of my past teachers who had a prodigious memory, although he could not carry a single date or proper name in his head. My teacher was right, and in this matter there is, no doubt, a difference between sayings or utterances which have embedded themselves deep in the soul and whose intimate and mysterious meaning has been grasped, and words which have merely been learnt by heart'. Hoffmann (c.b.)

taste for Scribe[5] and Horace Vernet. They answered, 'We have a deep admiration for Horace Vernet as being the most complete representative of his age.' Well said!

The tale is told that one day M. Horace Vernet went to see Peter Cornelius.[6] He overwhelmed him with compliments, but had to wait a long time to be repaid; for Peter Cornelius congratulated him only once during the whole interview—and that was on the quantity of champagne that he was able to consume without suffering ill effects! True or false, the story has all the ring of poetic truth.

And now tell me again that the Germans are a simple-minded people!

Many people who believe in the oblique approach when it comes to a critical drubbing, and who have no more love than I have for M. Horace Vernet, will blame me for being clumsy in my attack. But there can be no imprudence in being brutal and going straight to the point when in every sentence the 'I' stands for a 'we'—a vast, but silent and invisible 'we', a whole new generation which hates war and national follies; 'we', a generation full of health because it is young, a generation which is already elbowing its way to the front and working up into a good position—serious, derisive and menacing![*]

MM. Granet and Alfred Dedreux are two more vignette-makers and great adorers of the 'chic'. But they apply their capacities of improvisation to very different genres—M. Granet[7] to the sphere of religion, and M. Dedreux[8] to that

[5] Eugène Scribe (1791–1861), the popular dramatist of the mid-nineteenth century.

[6] Peter Cornelius (1783–1867), chiefly noted for his revival of fresco. From 1824 he was director of the Munich Academy.

[*] Thus there is not one of M. Horace Vernet's canvasses before which it would not be appropriate to sing:

> Vous n'avez qu'un temps à vivre,
> Amis, passez-le gaiement.

The gaiety is essentially French. (c.b.)
These lines are by the 18th-century French general, the Comte de Bonneval.

[7] All of Granet's eight pictures at this Salon had religious subjects.

[8] One of Dedreux's pictures, entitled Chasse au faucon, repro. Illustr., vol. 7 (1846), p. 57.

of smart life. The first does monks, and the second horses; the first is dark in colour, the second bright and dazzling. M. Alfred Dedreux has two excellent qualities; he knows how to paint, and his works have the fresh and vivid appearance of theatrical décors. One would suppose that he is more concerned with nature in those subjects which form his speciality; for his studies of running hounds are more convincing and more solid than the rest. There is a touch of the comic, however, in his hunting-scenes; each one of those all-important hounds could gobble up four horses. They remind one of those famous sheep in Jouvenet's *Vendeurs du Temple*,[9] which quite swamp the figure of Christ.

XII

ON ECLECTICISM AND DOUBT

As you see, we are now in the hospital of painting. We are probing its sores and its sicknesses; and this is by no means among the least strange or contagious of them.

In the present age, just as in ages past, today no less than yesterday, the strong and vigorous divide between them the various territories of art, each according to his taste and his temperament, and there they labour in full freedom, following the fatal law of propensities. Some gather an easy and abundant harvest in the golden, autumnal vineyards of colour; others toil patiently and laboriously to drive the deep furrow of drawing. Each of these men knows quite well that his monarchy involves a sacrifice, and that it is on this condition alone that he can reign securely up to his limiting frontiers. Each of them has a banner to his crown, and the words inscribed upon that banner are clear for all the world to read. Not one of their number has doubts of his monarchy, and it is in this unshakable conviction that their serene glory resides.

[9] One of the four pictures which Jean-Baptiste Jouvenet (1644–1717) painted for the church of Saint-Martin-des-Champs; it is now in the Lyons Museum, and a replica is in the Louvre.

M. Horace Vernet himself, that odious representative of the 'chic', has at least the merit of not being a *doubter*. He is a man of a happy and playful disposition, who inhabits an artificial country where the actors and the scenery are all made of the same pasteboard; yet he reigns as master in his kingdom of pantomime and parade.

Doubt, which today is the principal cause of all morbid affections in the moral world, and whose ravages are now greater than ever before, is itself dependent upon higher causes which I shall analyse in my penultimate chapter, entitled *On Schools and Journeymen*. And Doubt begat Eclecticism; for the doubters had a genuine will for salvation.

Eclecticism has at all periods and places held itself superior to past doctrines, because, coming last on to the scene, it finds the remotest horizons already open to it; but this *impartiality* only goes to prove the impotence of the eclectics. People who are so lavish with their time for reflection are not complete men: they lack the element of passion.

It has never occurred to the eclectics that man's attention is the more intense as it is restricted and limits its own field of observation. It is a question of grasp all, lose all.

It is in the arts, above all, that eclecticism has had the most manifest and palpable consequences, because if art is to be profound, it must aim at constant idealization, which is not to be achieved except in virtue of sacrifice—an involuntary sacrifice.

No matter how clever he may be, an eclectic is but a feeble man; for he is a man without love. Therefore he has no ideal, no *parti pris;* neither star nor compass.

He mixes four different systems, which only results in an effect of darkness—a negation.

An eclectic is a ship which tries to sail before all four winds at once.

However great its defects, a work conceived from an exclusive point of view will always have a great attraction for temperaments analogous to that of the artist.

An eclectic's work leaves no memory behind it.

The eclectic does not know that the first business of an

artist is to protest against Nature by putting Man in her place. This protest is not made coldly and calculatedly, like a decree or a rhetorical exercise; it is spontaneous and urgent, like vice, passion or appetite. Thus an eclectic is no man.

Doubt has led certain artists to beg the aid of all the other arts. Experiment with contradictory means, the encroachment of one art upon another, the importation of poetry, wit and sentiment into painting—all these modern miseries are vices peculiar to the eclectics.

XIII

ON M. ARY SCHEFFER AND THE APES OF SENTIMENT

M. ARY SCHEFFER is a disastrous example of this method—if an absence of method can be so called.

After imitating Delacroix, after aping the colourists and draughtsmen of the French school, and the neo-Christian school of Overbeck,[1] it dawned upon M. Ary Scheffer—a little late, no doubt—that he was not a painter born. From that moment he was obliged to turn to other shifts; and he decided to ask help and protection from poetry.

It was a ridiculous blunder, for two reasons. First of all, poetry is not the painter's immediate aim: when poetry happens to be mixed with painting, the resulting work cannot but be more valuable; but poetry is unable to disguise the shortcomings of a work. To make a deliberate point of looking for poetry during the conception of a picture is the surest means of not finding it. It must come without the artist's knowledge. It is the result of the art of painting itself; for it lies in the spectator's soul, and it is the mark of genius to awaken it there. Painting is only interesting in virtue of colour and form; it is no more like poetry than poetry is like painting—than the extent, I mean, to which poetry is able to awaken ideas of painting in the reader.

[1] Friedrich Overbeck (1789–1869), leader of the 'Nazarenes'. From 1810 he worked in Rome.

In the second place—and this is a consequence of these last observations—it should be noted that great artists, whose instinct always guides them aright, have only taken the most highly coloured and clearly visual subjects from the poets. Thus they prefer Shakespeare to Ariosto.

And now, to choose a striking example of M. Ary Scheffer's ineptitude, let us examine the subject of his painting entitled *St. Augustine and St. Monica*.[2] An honest painter of the Spanish School, with his double piety—artistic and religious—would simply and sincerely have done his best to paint the general idea which he had formed of the two saints. But put all that out of your mind; here the vital thing is to express the following passage—with brushes and colour:—'We did betwixt ourselves seek at that Present Truth (which Thou art) in what manner the eternal life of the saints was to be, which eye hath not seen, nor ear heard, nor hath it entered into the heart of man'.[3] It is the very height of absurdity. It is like watching a dancer execute a mathematical figure!

Formerly M. Ary Scheffer enjoyed the public's favour; in his *poetical* pictures, people rediscovered their dearest memories of the great poets—and that was enough for them. The transient vogue for M. Ary Scheffer was in fact a homage to the memory of Goethe.[4] But our artists—even those of them who are only gifted with a moderate originality—have for a long time been showing the public samples of real painting, executed with a sure hand and according to the simplest rules of art. And so, little by little the public has grown sick of *invisible* painting, and today, where M. Ary Scheffer is concerned, its favour has turned to harshness and ingratitude. How like all publics! But upon my word, they are quite right!

[2] The Salon of 1846 was the last at which Ary Scheffer exhibited. The painting of St. Augustine and his mother proved, however, to be one of his most popular works, and he painted at least four replicas; one is in the Tate Gallery, one in the Louvre and one in the Dordrecht Museum. See pl. 23.

[3] St. Augustine's *Confessions*, Bk. IX, ch. 10, Loeb transl.

[4] A reference to Gautier's Salon in *La Presse,* in which he wrote that Marguerite belonged to Scheffer almost as much as to Goethe himself.

Moreover this kind of painting is so wretched, so dismal, so blurred and so muddy that many people have taken M. Ary Scheffer's pictures for those of M. Henri Scheffer,[5] another artistic Girondist. In my opinion, they are more like pictures by M. Delaroche which have been left out in a heavy rainstorm.

A simple method of learning an artist's range is to examine his public. Eugène Delacroix has the painters and the poets on his side; M. Decamps has the painters; M. Horace Vernet has the garrisons, and M. Ary Scheffer those aesthetic ladies who revenge themselves on the curse of their sex by indulging in religious music.*

The apes of sentiment are, generally speaking, bad artists. If it were otherwise, they would do something other than sentimentalize. The best of them are those whose understanding does not go beyond the *pretty*.

As feeling or sentiment, like fashion, is an infinitely variable and multiple thing, there are apes of sentiment of different orders.

The ape of sentiment relies above all on the catalogue. It should be noted, however, that the picture's title never tells its subject—and this is particularly true with those artists who, by an engaging fusion of horrors, mix sentiment with wit. In this way, by extending the method, it will be possible to achieve the *sentimental rebus*.[6]

For example, you find in the catalogue something called *Pauvre Fileuse!*[7] Well, it is quite possible that the picture may represent a female silkworm, or a caterpillar, squashed by a child. It is an age without pity!

[5] Ary Scheffer's younger brother.

* To those who must sometimes have been shocked by my pious wrath, I would recommend the reading of Diderot's *Salons*. Among other examples of properly bestowed charity, they will find that that great philosopher, when speaking of a painter who had been recommended to him because he had many mouths to feed, observed that either pictures or family would have to be abolished. (C.B.)

[6] Baudelaire returns to the subject of titles in the *Salon of 1859*: see pp. 253 ff.

[7] By Mme. Céleste Pensotti.

Aujourd'hui and *Demain*.[8] What can that be? Perhaps a white flag—and a tricolour? or perhaps a deputy in his moment of triumph—and the same deputy after being sent packing? But no; it is a young maiden, promoted to the status of streetwalker, playing with roses and jewels; and then the same girl, crippled and emaciated, suffering the consequences of her indiscretions in the gutter.

L'Indiscret.[9] I beg you to look for this one. It represents a gentleman surprising a couple of blushing damsels with a naughty picture-book.

This picture comes into the Louis XV class of sentimental genre, which began, I believe, to slip into the Salon in the wake of *La Permission de dix heures*.[10] Quite a different order of sentiments is involved, as you can see; these are less *mystical*.

In general, sentimental genre-pictures are taken from the latest poems of some blue-stocking or other—that is the melancholy and misty kind; or else they are a pictorial translation of the outcries of the poor against the rich—the protesting kind; or else they are borrowed from the wisdom of the nations—the witty kind; and sometimes from the works of M. Bouilly[11] or of Bernardin de Saint-Pierre[12]—the moralizing kind.

Here are a few more examples of the same genre; *L'Amour à la campagne*—happiness, calm and repose: and *L'Amour à la ville*[13]—shouts, disorder, upturned chairs and books. It is a metaphysic within the reach of the simple.

La Vie d'une jeune fille en quatre compartiments.[14] A warning to those who have a bent for motherhood!

[8] By Charles Landelle.
[9] By H.-G. Schlésinger.
[10] By Eugène Giraud, exh. at the Salon of 1839.
[11] Jean-Nicolas Bouilly (1763–1842), playwright.
[12] The author of *Paul et Virginie*.
[13] Compte Calix exhibited *L'Amour au château* and *L'Amour à la chaumière* (both repro. *Illustr.* [1846], p. 89): Pierre Cottin exhibited *L'Amour à la ville*, an engraving after Guillemin.
[14] Charles Richard's picture was in fact in *five* divisions:—'le rendezvous: le bal: le luxe: la misère: Saint-Lazare'.

L'Aumône d'une vierge folle.[15] The crazed old creature is giving a copper, earned by the sweat of her brow, to the beggar who mounts eternal guard at the door of Félix, the pastry-cook.[16] Inside, the rich of the day are gorging themselves on sweetmeats. This one evidently derives from literature of the *Marion Delorme*[17] persuasion, which consists of preaching the virtues of whores and assassins.

How witty the French are, and what pains they take in order to delude themselves! Books, pictures, drawing-room ballads, nothing is without its use, no means is neglected by this charming people when it is a question of throwing dust in their own eyes.

XIV

ON SOME DOUBTERS

DOUBT assumes a whole host of forms; it is a Proteus which often does not recognize its own face. And so there is infinite variety among doubters, and I am obliged now to bundle together several individuals who have nothing in common beyond the absence of any substantial individuality.

Some of them are serious-minded and full of great goodwill. These deserve our pity.

There is M. Papety, for instance, who at the time of his return from Rome was regarded as a colourist by some people (chiefly his friends). This year he has sent a picture entitled *Solon dictant ses lois,*[1] which is shockingly unpleasant to look at.—Perhaps it is because it hangs too high for its details to be properly visible, that it reminds one of the ridiculous tail-end of the Imperial School.

[15] This was perhaps A. Béranger's *La Charité.*
[16] No. 42, rue Vivienne.
[17] Victor Hugo's play about the famous courtesan of the 17th century was produced in 1831.
[1] According to the Salon catalogue, this painting was commissioned by the Ministry of the Interior. Dominique Papety was for a while one of Chenavard's assistants.

For two years running now M. Papety has sent entirely different-looking pictures to the same Salon.

M. Glaize is compromising his early successes by giving us works both vulgar in style and muddled in composition. Every time that he has to do anything else but a study of a woman, he gets lost. M. Glaize believes that you become a colourist by the exclusive choice of certain hues. Window-dressers' assistants and theatrical costumiers, too, have a taste for rich hues; but that does not make a taste for harmony.

In *Le Sang de Vénus*,[2] the Venus is a pretty and delicate figure, with a good suggestion of movement; but the nymph who crouches in front of her is an appalling example of the *poncif*.

M. Matout is liable to the same criticism on the score of colour. Furthermore, an artist who formerly took his bow as a draughtsman, and who used to devote his mind above all to the compound harmony of lines, should avoid giving a figure improbable movements of the neck and arm. Even if nature demands it, the artist who is an idealist, and who wishes to be true to his principles, should not comply.

M. Chenavard is an eminently learned and hardworking artist, whose *Le Martyre de St. Polycarpe*, painted in collaboration with M. Comairas, attracted attention several years ago. This picture bespoke a real grasp of the science of composition and a thorough connoisseurship of all the Italian masters. This year M. Chenavard has given further proof of taste in his choice of subject, and of cleverness in his design.[3] But when you are contending with Michel-

[2] In the Montpellier Museum.

[3] This painting, entitled *L'Enfer de Dante*, is now in the Montpellier Museum. Chenavard was a high-minded and socially-conscious painter—Silvestre called him 'un orateur en peinture' —whose subdued colour often approached *grisaille*. His *Martyrdom of St. Polycarp*, mentioned here, was exhibited at the 1841 Salon, and then placed in the church of Argenton-sur-Creuze (Indre). Comairas was also one of his assistants in a later project, entitled *Palingénésie Universelle*, for a series of *grisailles* to decorate the interior of the Pantheon: after three years the work had to be abandoned when the Pantheon was returned to the Church, in 1851. For a painter who came from Lyons, Baudelaire treats Chenavard with surprising respect. He was a close friend of Delacroix's. See pl. 22.

angelo, would it not be fitting to outdo him in *colour*, at least?

M. Guignet always carries two men about in his head—Salvator Rosa and M. Decamps. M. Salvator Guignet paints in sepia; M. Guignet Decamps is an entity weakened by duality. *Les Condottières après un pillage*[4] is painted in the first manner; *Xerxès* verges upon the second. Nevertheless this picture is well enough composed, were it not for a taste for erudition and connoisseurship, which amuses and fascinates the spectator, and turns his attention from the principal idea; the same thing was wrong with his *Pharaons*.[5]

MM. Brune and Gigoux are already established names. But even at his best period, M. Gigoux hardly produced anything more than vast vignettes. After numerous setbacks, he has at last shown us a picture which, if not very original, is at least quite well *built*. *Le Mariage de la Sainte Vierge* looks like a work by one of those countless masters of the Florentine decadence, supposing him to have become suddenly preoccupied with colour.

M. Brune puts one in mind of the Carracci and the eclectic painters of the second epoch; a solid manner, but little or no soul—no great faults, but no great quality.

If there are some doubters who excite interest, there are also some grotesque ones, whom the public meets again each year with that wicked delight characteristic of bored *flâneurs* for whom excessive ugliness always secures a few moments' distraction.

The coldly frivolous M. Biard seems to be really and truly succumbing beneath the burden which he has imposed upon himself. He returns from time to time, however, to his natural manner—which is the same as everybody else's. I have been told that the author of *La Barque de Caron* was a pupil of M. Horace Vernet.

M. Biard[6] is a universal man. This would seem to indicate that he has not the least doubt in the world, and that

[4] Repro. *Illustr.*, vol. 7 (1846), p. 221.

[5] At the 1845 Salon: see p. 27.

[6] Of Biard's exhibits, three are reproduced *Illustr.*, vol. 7 (1846), pp. 152–3.

no one on earth is surer of his ground. Nevertheless I ask you to observe that amidst all this appalling lumber—history-pictures, travel-pictures, sentimental pictures, epigrammatic pictures—one genre is neglected. M. Biard has flinched before the religious picture. He is not yet sufficiently convinced of his merit.

<div style="text-align:center">XV</div>

<div style="text-align:center">ON LANDSCAPE</div>

IN LANDSCAPE, as in portraiture and history-painting, it is possible to establish classifications based on the different methods used; thus there are landscape-colourists, landscape-draughtsmen, and imaginative landscapists; there are naturalists who idealize without knowing it, and partisans of the 'poncif', who devote themselves to a weird and peculiar genre called *historical* landscape.

At the time of the romantic revolution, the landscape-painters, following the example of the most celebrated Flemish masters, devoted themselves exclusively to the study of nature; it was this that was their salvation and gave a particular lustre to the modern school of landscape. The essence of their talent lay in an eternal adoration of visible creation, under all its aspects and in all its details.

Others, more philosophic and more dialectical, concentrated chiefly on style—that is to say, on the harmony of the principal lines, and on the architecture of nature.

As for the landscape of fantasy, which is the expression of man's dreaming, or the egoism of man substituted for nature, it was little cultivated. This curious genre, of which the best examples are offered by Rembrandt, Rubens, Watteau and a handful of English illustrated annuals, and which is itself a small-scale counterpart of the magnificent stage décors at the Opera, represents our natural need for the marvellous. It is the 'graphic imagination' imported into landscape. Fabulous gardens, limitless horizons, streams more limpid than in nature, and flowing in defiance of the laws of topography, gigantic boulders constructed

according to ideal proportions, mists floating like a dream—the landscape of fantasy, in short, has had but few enthusiastic followers among us, either because it was a somewhat un-French fruit, or because our school of landscape needed before all else to reinvigorate itself at purely natural springs.

As for historical landscape, over which I want to say a few words in the manner of a requiem-mass, it is neither free fantasy, nor has it any connection with the admirable slavishness of the naturalists; it is ethics applied to nature.

What a contradiction, and what a monstrosity! Nature has no other ethics but the brute facts, because Nature is her own ethics; nevertheless we are asked to believe that she must be reconstructed and set in order according to sounder and purer rules—rules which are not to be found in simple enthusiasm for the ideal, but in esoteric codes which the adepts reveal to no one.

Thus, Tragedy—that genre forgotten of men, of which it is only at the Comédie Française (the most deserted theatre in the universe) that one can find a few samples[1]—the art of Tragedy, I say, consists in cutting out certain eternal patterns (for example, patterns of love, hate, filial piety, ambition, etc.), and after suspending them on wires, in making them walk, bow, sit down and speak, according to a sacred and mysterious ceremonial. Never, even by dint of using a mallet and a wedge, will you cause an idea of the infinite degrees of variety to penetrate the skull of a tragic poet, and even if you beat or kill him, you will not persuade him that there must be different sorts of morality too. Have you ever seen tragic persons eat or drink? It is obvious that these people have invented their own moral system to fit their natural needs, and that they have created their own temperament, whereas the majority of mankind have to *submit* to theirs. I once heard a poet-in-

[1] Baudelaire's remark is somewhat reminiscent of what Heine had to say some ten years before, in his *Letters on the French Stage*. Heine wrote 'I frequented the Théâtre-Français very little. That house has for me something of the mournfulness of the desert. There the spectres of the old tragedies reappear, with dagger and poisoned cup in their wan hands . . .'

ordinary to the Comédie Française say that Balzac's novels wrung his heart with pain and disgust; that, as far as he was concerned, he could not conceive of lovers existing on anything else but the scent of flowers and the tear-drops of the dawn. It seems to me that it is time the government took a hand; for if men of letters, who each have their own labours and their own dreams, and for whom there is no such thing as Sunday—if men of letters can escape the risk of tragedy quite naturally, there are nevertheless a certain number of people who have been persuaded that the Comédie Française is the sanctuary of art, and whose admirable goodwill is cheated one day in every seven. Is it reasonable to allow some of our citizens to besot themselves and to contract false ideas? But it seems that tragedy and historical landscape are stronger than the gods themselves.

So now you understand what is meant by a good tragic landscape. It is an arrangement of master-patterns of trees, fountains, tombs and funerary urns. The dogs are cut out on some sort of historical dog-pattern; a historical shepherd could never allow himself any others, on pain of disgrace. Every *immoral* tree that has allowed itself to grow up on its own, and in its own way, is, of necessity, cut down: every toad- or tadpole-pond is pitilessly buried beneath the earth. And if ever a historical landscape-painter feels remorse for some natural peccadillo or other, he imagines his Hell in the guise of a *real* landscape, a pure sky, a free and rich vegetation; a savannah, for example, or a virgin forest.

MM. Paul Flandrin, Desgoffe, Chevandier and Teytaud are the men who have undertaken the glorious task of struggling against the taste of a nation.

I do not know what is the origin of historical landscape. It certainly cannot have sprung from Poussin, for in comparison with these gentlemen, he is a depraved and perverted spirit.

MM. Aligny, Corot and Cabat are much concerned with style. But what, with M. Aligny, is a violent and philosophic dogma, is an instinctive habit and a natural turn of mind with M. Corot. Unfortunately he has only sent one landscape this year; it represents cows coming to drink at

a pool in the forest of Fontainebleau.[2] M. Corot is a harmonist rather than a colourist; and it is their very simplicity of colour, combined with their complete lack of pedantry, that gives such enchantment to his compositions. Almost all his works have the particular gift of unity, which is one of the requirements of the memory.

M. Aligny has etched some very beautiful views of Corinth and Athens, which perfectly express the preconceived idea of these places. M. Aligny's serious and idealistic talent has found a most suitable subject in these harmonious poems of stone, and his method of translating them on to copper suits him no less well.[3]

M. Cabat has completely deserted the path on which he had won himself such a great reputation. Without ever being a party to the *bravura* peculiar to certain naturalistic landscape-painters, he was formerly very much more brilliant and very much more *naïf*. He is truly mistaken in no longer putting his trust in nature, as he used to do. He is a man whose talent is too great for any of his compositions to lack a special distinction; but this latter-day Jansenism, this retrenchment of means, this deliberate self-privation cannot add to his glory.[4]

In general the influence of Ingrism cannot possibly produce satisfactory results in landscape. Line and style are no substitutes for light, shadow, reflections and the *colouring* atmosphere—all of which play too great a part in the poetry of Nature to allow her to submit to this method.

The members of the opposite party, the naturalists and the colourists, are much more popular and have made much more of a splash. Their main qualities are a rich and abundant colour, transparent and luminous skies, and a special kind of sincerity which makes them accept every-

[2] Entitled *Vue prise dans la forêt de Fontainebleau*: now in the Boston Museum; see pl. 21.

[3] The previous year Aligny had published a set of ten *Vues des sites les plus célèbres de la Grèce Antique, dessinées sur nature et gravées par Théodore Aligny*. To judge by a remark in Thoré's *Salon de 1846* (ed. of 1868, p. 371), it was eight of these etchings that Aligny exhibited this year. See pl. 51.

[4] Of Cabat's two exhibits, that entitled *Le Repos* is in the Louvain Museum.

thing that nature gives. It is a pity that some of them, like M. Troyon,[5] take too much delight in the tight-rope tricks of their brush; these devices, known in advance, acquired with much trouble, and monotonously triumphant, sometimes intrigue the spectator more than the landscape itself. In these circumstances it may even happen that a surprise pupil, like M. Charles Le Roux,[6] will push still further the limits of boldness and security; for there is only one inimitable thing, and that is natural simplicity.

M. Coignard has sent a large and fairly well-constructed landscape which has much attracted the public eye; it has a number of cows in the foreground, and in the background the skirts of a forest. The cows are beautiful and well painted, and the picture looks well as a whole; but I do not think that the trees are vigorous enough to support such a sky. This suggests that if you took away the cows, the landscape would become very unsightly.

M. Français is one of our most distinguished landscape-painters. He knows how to study nature, and how to blend with it a romantic perfume of the purest essence. His *Etude de Saint-Cloud* is a charming thing and full of taste, except for M. Meissonier's *fleas* which are a fault of taste.[7] They attract the attention too much, and they amuse the blockheads. Nevertheless they are done with that particular sort of perfection which this artist puts into all his little things.*

[5] Of Troyon's four exhibits, that entitled *Vallée de Chevreuse* is reproduced *Illustr.*, vol. 7 (1846), p. 187.

[6] Le Roux was a pupil of Corot's.

[7] Français's *Etude de Saint-Cloud*, with figures by Meissonier, was in the Pourtalès collection. His *Effet de soleil couchant*, also exhibited, is in the Musée Fabre, Montpellier.

* At last I have found a man who has contrived to express his admiration for this artist's works in the most judicious fashion and with an enthusiasm just like my own. It is M. Hippolyte Babou. I think, as he does, that they should all be hung along the *flies* of the Gymnase. '*Geneviève* or *La Jalousie paternelle* is a ravishing little Meissonier which M. Scribe has hung up on the flies of the Gymnase' *Courrier français*, in the *feuilleton* of the 6th April. This strikes me as so sublime that I take it that MM. Scribe, Meissonier and Babou cannot but gain all three by my quoting it here. (c.b.) It was Hippolyte Babou (1824–78) who later suggested the title 'Les Fleurs du Mal' to Baudelaire. On Scribe, see note on p. 101.

Unfortunately M. Flers has only sent pastels. His own loss is equal to that of the public.

M. Héroult is one of those who are particularly obsessed with light and atmosphere. He is very good at rendering clear, smiling skies, and floating mists shot through with a ray of sunlight. He is no stranger to the special poetry of the northern countries. But his colour, which is a little too soft and fluid, smacks of the methods of water-colour; and if he has been able to avoid the heroics of the other land-scape-painters, he does not always possess a sufficient firm-ness of touch.

As a rule MM. Joyant, Chacaton, Lottier and Borget go to distant lands in search of their subjects, and their pic-tures have the charm of an evening with a travel-book.

I have nothing against specialization; but I would not have anyone abuse it to the extent of M. Joyant, who has never set foot outside the Piazza San Marco and has never crossed the Lido.[8] If M. Joyant's specialty attracts the eye more than the next man's, it is doubtless because of the monotonous perfection which he brings to it and which results always from the same tricks. It seems to me that M. Joyant has never been able to move onwards.

M. Borget, however, has crossed the frontiers of China, and has brought us landscapes from Mexico, Peru and India. Without being a painter of the first rank, he has a brilliant and easy colour, and his tones are fresh and pure. With a little less art, and if he could concern himself less with other landscape-painters and could paint more as a simple traveller, M. Borget would perhaps obtain more interesting results.

M. Chacaton, who has devoted himself exclusively to the Orient, has for a long time been one of our cleverest paint-ers. His pictures are bright and smiling. Unfortunately they almost always suggest paintings by Decamps or Marilhat, bleached and reduced in size.

M. Lottier, instead of looking for the grey and misty

[8] Nevertheless the painting by Joyant reproduced in *l'Illustra-tion* this year (vol. 7, p. 89) represented *Le Pont Saint-Bénezet, Avignon*. His other two pictures were of Venetian sub-jects.

effects of the warm climates, loves to bring out their harsh-ness and their fiery dazzle. The truth of these sun-swamped panoramas is marvellously brutal. You would think that they had been done with a colour-daguerreotype.

There is one man who, more than all of these, and more even than the most celebrated absentees, seems to me to fulfil the conditions of beauty in landscape: he is a man but little known to the multitude, for past setbacks and under-hand plotting have combined together to keep him away from the Salon. You will already have guessed that I am referring to M. Rousseau[9]—and it seems to me to be high time that he took his bow once again before a public which, thanks to the efforts of other painters, has gradually be-come familiar with new aspects of landscape.

It is as difficult to interpret M. Rousseau's talent in words as it is to interpret that of Delacroix, with whom he has other affinities also. M. Rousseau is a northern landscape-painter. His painting breathes a great sigh of melancholy. He loves nature in her *bluish* moments—twilight effects—strange and moisture-laden sunsets—massive, breeze-haunted shades—great plays of light and shadow. His colour is magnificent, but not dazzling. The fleecy softness of his skies is incomparable. Think of certain landscapes by Rubens and Rembrandt; add a few memories of English painting, and assume a deep and serious love of nature dominating and ordering it all—and then perhaps you will be able to form some idea of the magic of his pictures. Like Delacroix, he adds much of his soul to the mixture; he is a naturalist ceaselessly swept toward the ideal.

M. Gudin[10] is increasingly compromising his reputation. The more the public sees good painting, the more it parts company from even the most popular artists if they cannot offer it the same amount of pleasure. For me, M. Gudin

[9] Although he had had a moderate success at the Salon in the early 1830s Théodore Rousseau's landscapes were consistently rejected from 1838 until 1849. He was nick-named 'Le Grand Refusé'.

[10] Gudin's thirteen exhibits this year ranged from landscape to sea-battles.

comes into the class of people who stop their wounds with artificial flesh; of bad singers of whom it is said that they are great actors; and of *poetic* painters.

M. Jules Noël has produced a really beautiful marine-painting, of a fine, clear colour, bright and luminous.[11] A huge *felucca*, with its strange shapes and colours, is lying at anchor in some great harbour, bathed in all the shifting light of the Orient. A little too much *colouring*, perhaps, and not enough unity? But M. Jules Noël certainly has too much talent not to have still more, and he is doubtless one of those who impose a daily amount of progress upon themselves.—Furthermore the success achieved by this canvas proves that the public of today is ready to extend a warm welcome to all newcomers, in all the genres.

M. Kiorboë is one of those sumptuous painters of old who knew so well how to decorate their noble dining-rooms, which one imagines full of heroic and ravenous huntsmen. M. Kiorboë's painting has joyfulness and power, and his colour is fluent and harmonious. The drama of his *Wolf Trap*,[12] however, is not quite easy enough to follow, perhaps because the trap itself is partly in the shadow. The hindquarters of the dog which is falling back with a yelp are not vigorously enough painted.

M. Saint-Jean,[13] who, I am told, is the delight and the glory of the city of Lyons, will never achieve more than a moderate success in a country of painters. That excessive minuteness of his is intolerably pedantic. Whenever anyone talks to you of the *naïveté* of a painter from Lyons, do not believe a word of it. For a long time now the over-all colour of M. Saint-Jean's pictures has been the yellow of urine. You might imagine that he had never seen real fruit, and that he does not care a scrap, because he can do them very nicely by mechanical means. Not only do natural

[11] Repro. *Illustr.*, vol. 7 (1846), p. 120.

[12] The correct title of Kioboë's painting was *Un renard au piège, trouvé par des chiens de bergers.*

[13] Saint-Jean specialized as a flower-and-fruit painter.

fruits look quite different, but they are less finished and less highly wrought than these.

It is quite a different matter with M. Arondel,[14] whose chief merit is a real artlessness. Therefore his painting contains several obvious blemishes; but the felicitous passages are entirely successful. Some other parts are too dark, and you might suppose that, while painting, this artist fails to take into account all the necessary accidents of the Salon —the adjacent paintings, the distance from the spectator, and the modification which distance causes in the mutual effect of tones. Besides, it is not enough to paint well. The famous Flemish painters all knew how to dispose their dead game and how to go on worrying at it for ages, just as one worries at a model; the point was to discover felicitous lines, and rich and clear tonal harmonies.

M. P. Rousseau, whose dazzling and colourful pictures have received such widespread notice, is making serious progress. He was already an excellent painter, it is true; but now he is looking at nature more attentively and he is striving to bring out her particularity of feature.[15] The other day at Durand-Ruel's[16] I saw some ducks by M. Rousseau; they were wonderfully beautiful, and really behaved and acted like ducks.

<center>XVI</center>

<center>WHY SCULPTURE IS TIRESOME</center>

THE ORIGIN of sculpture is lost in the mists of time; thus it is a *Carib* art.

We find, in fact, that all races bring real skill to the carving of fetishes long before they embark upon the art of painting, which is an art involving profound thought and one whose very enjoyment demands a particular initiation.

Sculpture comes much closer to nature, and that is why

[14] See p. 32.
[15] P. Rousseau's *Le chat et le vieux rat* was reproduced *Illustr.*, vol. 7 (1846), p. 88.
[16] The well-known dealer.

even today our peasants, who are enchanted by the sight of an ingeniously-turned fragment of wood or stone, will nevertheless remain unmoved in front of the most beautiful painting. Here we have a singular mystery which is quite beyond human solving.

Sculpture has several disadvantages which are a necessary consequence of its means and materials. Though as brutal and positive as nature herself, it has at the same time a certain vagueness and ambiguity, because it exhibits too many surfaces at once. It is in vain that the sculptor forces himself to take up a unique point of view, for the spectator who moves around the figure can choose a hundred different points of view, except for the right one, and it often happens that a chance trick of the light, an effect of the lamp, may discover a beauty which is not at all the one the artist had in mind—and this is a humiliating thing for him. A picture, however, is only what it wants to be; there is no other way of looking at it than on its own terms. Painting has but one point of view; it is exclusive and absolute, and therefore the painter's expression is much more forceful.

That is why it is as difficult to be a connoisseur of sculpture as it is to be a bad sculptor. I have heard the sculptor Préault[1] say, 'I am a connoisseur of Michelangelo, of Jean Goujon, of Germain Pilon; but of *sculpture* I am a complete ignoramus'. It is obvious that he meant the sculpture of the sculpturizers—in other words, of the Caribs.

Once out of the primitive era, sculpture, in its most magnificent development, is nothing else but a *complementary* art. It is no longer a question of skilfully carving portable figures, but of becoming a humble associate of painting and architecture, and of serving their intentions. Cathedrals soar up into the sky and load their thousand echoing chasms with sculptures, which form but one flesh and body with the edifice itself: please note that I am speaking of *painted* sculptures, whose pure and simple colours, arranged in ac-

[1] Like Théodore Rousseau, Auguste Préault was systematically refused by the Salon juries from the early 1830s until 1848. He was the Romantic sculptor *par excellence*, and was as well known for his wit as for his statuary.

cordance with a special scale, harmonize with the rest and complete the poetic effect of the whole. Versailles shelters her race of statues beneath leafy shades which serve them as background, or under arbours of living waters which shower upon them the thousand diamonds of the light. At all great periods, sculpture is a complement; at the beginning and at the end, it is an isolated art.

As soon as sculpture consents to be seen close at hand, there are no childish trivialities which the sculptor will not dare, and which triumphantly outrun the fetish and the calumet. When it has become a drawing-room or a bedroom art, it is the cue for the Caribs of lace (like M. Gayrard), or the Caribs of the wrinkle, the hair and the wart (like M. David[2]) to put in an appearance.

Next we have the Caribs of the andiron, the clock and the writing-desk, etc., like M. Cumberworth, whose *Marie* is a maid-of-all-work, employed at the Louvre and at Susse's, as a statue or a candelabra;[3] or like M. Feuchère, who possesses the gift of a universality which takes one's breath away; colossal figures, match-boxes, goldsmiths' motifs, busts and bas-reliefs—he is capable of anything. The bust which he has done this year of a very well-known actor[4] is no better a likeness than last year's; they are never more than rough approximations. Last year's bust resembled Jesus Christ, and this year's, which is dry and mean-looking, in no way conveys the original, angular, sardonic and shifting physiognomy of the model. Nevertheless you should not suppose that these people lack knowledge. They are as learned as academicians—or as *vaudevillistes*; they make free with all periods and all genres; they have plumbed the depths of all the schools. They would be happy to convert even the tombs of St. Denis into cigar- or shawl-boxes, and all Florentine bronzes into threepenny bits. If you want the fullest information

[2] i.e. David d'Angers.

[3] The catalogue makes it clear that Cumberworth's *Marie* was the negress slave in Bernardin de Saint-Pierre's *Paul et Virginie*. Cumberworth was regularly employed by Susse frères, the dealers in decorative sculpture who are still in business.

[4] J.-F.-S. Provost; the bust is now at the Comédie Française.

concerning the principles of this frivolous and trifling school, you should apply to M. Klagmann,[5] who is, I think, the master of the whole vast workshop.

An excellent proof of the pitiable state of sculpture to-day is the fact that M. Pradier[6] is its king. Admittedly this artist knows how to do flesh, and he has his particular refinements of the chisel; but he has neither the imagination necessary for great compositions, nor the 'graphic imagination'. His talent is cold and academic. He has spent his life fattening up a small stock of antique torsos and equipping them with the coiffures of kept women. His *Poésie Légère*[7] seems all the colder as it is the more mannered; its execution is not as opulent as in the sculptor's former works, and, seen from behind, it looks hideous. Besides this, he has done two bronzes—*Anacréon* and *La Sagesse*—which are impudent imitations of the antique, and show clearly that without this noble crutch M. Pradier would stumble at every step.

The bust is a genre which demands less imagination and capacities less lofty—though no less delicate—than sculpture on the grand scale. It is a more intimate and more restricted art, whose successes are less public. As in the portrait done according to the manner of the naturalists, it is necessary to have a perfect grasp of the model's essential nature, and to express its poetic quality; for there are few models who completely lack poetry. Almost all of M. Dantan's busts[8] are done according to the best doctrines. They all have a particular distinction, and their detail does not exclude breadth and ease of execution.

M. Lenglet's chief fault,[9] on the contrary, is a certain timidity, a childishness, an excess of sincerity in his execu-

[5] Klagmann's plaster statue was entitled *Une petite fille effeuillant une rose*.

[6] Pradier has been described as the Romantic sculptor of the 'juste-milieu'.

[7] In the Nîmes Museum.

[8] This is presumably Antoine-Laurent Dantan (1798–1878), though his younger brother Jean-Pierre Dantan (1800–69) also exhibited at this Salon.

[9] This was Lenglet's first Salon.

tion, which gives an appearance of dryness to his work; but, on the other hand, no one could give a truer and more authentic character to a human face. This little bust—stocky, grave and frowning—has the magnificent character of the best work of the Romans—an idealization discovered in nature herself. Another distinguishing quality of antique portraiture which I noticed in M. Lenglet's bust is a profound concentration of attention.

<p style="text-align:center">XVII</p>

ON SCHOOLS AND JOURNEYMEN

IF EVER YOUR idler's curiosity has landed you in a street brawl, perhaps you will have felt the same delight as I have often felt to see a protector of the public slumbers—a policeman or a municipal guard (the real army)—thumping a republican. And if so, like me, you will have said in your heart: 'Thump on, thump a little harder, thump again, beloved constable! for at this supreme thumping, I adore thee and judge thee the equal of Jupiter, the great dealer of justice! The man whom thou thumpest is an enemy of roses and of perfumes, and a maniac for *utensils*. He is the enemy of Watteau, the enemy of Raphael, the bitter enemy of luxury, of the fine arts and of literature, a sworn iconoclast and butcher of Venus and Apollo! He is no longer willing to help with the public roses and perfumes, as a humble and anonymous journeyman. He wants to be *free*, poor fool; but he is incapable of founding a factory for *new* flowers and *new* scents. Thump him religiously across the shoulder-blades, the anarchist!'*

In the same way philosophers and critics should pitilessly thump *artistic* apes—emancipated journeymen who hate the force and the sovereignty of genius.

* I often hear people complaining about the theatre of today; it lacks originality, they say, because there are no longer any types. But the republican? what about *him*? Is he not an essential for any comedy that aims at being gay? and in him have we not a successor to the role of Marquis? (C.B.)

Compare the present age with past ages. On leaving the Salon or some newly-decorated church, go and rest your eyes in a museum of old masters. And then analyse the differences.

In the one, all is turbulence, a hurly-burly of styles and colours, a cacophony of tones, enormous trivialities, platitudes of gesture and pose, nobility 'by numbers', clichés of all kinds—and all this clearly manifested not only by different pictures in juxtaposition, but even within one and the same picture. In short, there is a complete absence of unity, whose only result is a terrible weariness for the mind and the eyes.

In the other place you are immediately struck by that feeling of reverence which causes children to doff their hats and which catches at your soul in the way that the dust of vaults and tombs catches your throat. But this is by no means the mere effect of yellow varnish or the grime of ages: it is the effect of unity, of profound unity. For a great Venetian painting clashes less with a Giulio Romano beside it than a group of our pictures—and I do not mean the worst of them—clash amongst themselves.

A magnificence of costume, a nobility of movement—a nobility often mannered, yet grand and stately—and an absence of little tricks and contradictory tactics—these are qualities which are all implied in the phrase 'the great tradition'.

Then you had schools of painting; *now* you have emancipated journeymen.

There were still schools under Louis XV; there was one under the Empire—a school—that is, a faith—that is, the impossibility of doubt. There you found pupils united by common principles, obedient to the rule of a powerful leader, and helping him in all his undertakings.

Doubt, or the absence of faith and of *naïveté*, is a vice peculiar to this age, for today no one is obedient, and *naïveté*, which means the dominion of temperament within manner, is a divine privilege which almost all are without.

Few men have a right to rule, for few men have an overruling passion.

And as everyone today wants to rule, no one knows how to govern himself.

Now that everyone is abandoned to his own devices, a master has many unknown pupils for whom he is not responsible, and his blind and involuntary dominion extends well beyond his studio, as far as regions where his thought cannot be understood.

Those who are nearer to the word and the idiom of the master preserve the purity of his doctrine, and by obedience and tradition they do what the master does by the fatality of his nature.

But outside of this family-circle there is a vast population of mediocrities—apes of different and mixed breeds, a floating race of half-castes who each day move from one country to another, taking away from each the customs which suit them, and seeking to make a personality for themselves by a system of contradictory borrowings.

There are people who will steal a fragment from a picture by Rembrandt, and without modifying it, without digesting it, without even finding the glue to stick it on with, will incorporate it into a work composed from an entirely different point of view.

There are some who change from white to black in a day: yesterday, colourists in the 'chic' manner, colourists with neither love nor originality—to-morrow, sacrilegious imitators of M. Ingres, but without discovering any more taste or faith.

The sort of man who today comes into the class of the apes—even the cleverest apes—is not, and never will be, anything but a mediocre painter. There was a time when he would have made an excellent journeyman: but now he is lost, for himself and for all mankind.

That is why it would have been more in the interest of their own salvation, and even of their happiness, if the lukewarm had been subjected to the lash of a vigorous faith. For strong men are rare, and today you have to be a Delacroix or an Ingres if you are to come to the surface and be seen amid the chaos of an exhausting and sterile freedom.

The apes are the republicans of art, and the present state of painting is the result of an anarchic freedom which glori-

fies the individual, however feeble he may be, to the detriment of communities—that is to say, of schools.

In schools, which are nothing else but organizations of inventive force, those individuals who are truly worthy of the name absorb the weak. And that is justice, for an abundant production is only a mind equipped with the power of a thousand arms.

This glorification of the individual has necessitated the infinite division of the territory of art. The absolute and divergent liberty of each man, the division of effort and the disjunction of the human will have led to this weakness, this doubt and this poverty of invention. A few sublime and long-suffering eccentrics are a poor compensation for this swarming chaos of mediocrity. Individuality—that little *place of one's own*—has devoured collective originality. And just as a well-known chapter of a romantic novel[1] has shown that the printed book has killed the monument of stone, so it is fair to say that, for the time being, it is the painter that has killed the art of painting.

XVIII

ON THE HEROISM OF MODERN LIFE

MANY PEOPLE will attribute the present decadence in painting to the decadence in behaviour.* This dogma of the studios, which has gained currency among the public, is a poor excuse of the artists. For they had a vested interest in ceaselessly depicting the past; it is an easier task, and one that could be turned to good account by the lazy.

It is true that the great tradition has got lost, and that the new one is not yet established.

But what *was* this great tradition, if not a habitual, everyday idealization of ancient life—a robust and martial form

[1] Victor Hugo, *Notre-Dame de Paris*, Bk. V, ch. ii, 'Ceci tuera cela.'

* These two types of decadence must not be confused; one has regard to the public and its feelings, the other concerns the studios alone. (C.B.)

of life, a state of readiness on the part of each individual, which gave him a habit of gravity in his movements, and of majesty, or violence, in his attitudes? To this should be added a public splendour which found its reflection in private life. Ancient life was a great *parade*. It ministered above all to the pleasure of the eye, and this day-to-day paganism has marvellously served the arts.

Before trying to distinguish the epic side of modern life, and before bringing examples to prove that our age is no less fertile in sublime themes than past ages, we may assert that since all centuries and all peoples have had their own form of beauty, so inevitably we have ours. That is in the order of things.

All forms of beauty, like all possible phenomena, contain an element of the eternal and an element of the transitory —of the absolute and of the particular. Absolute and eternal beauty does not exist, or rather it is only an abstraction creamed from the general surface of different beauties. The particular element in each manifestation comes from the emotions: and just as we have our own particular emotions, so we have our own beauty.

Except for Hercules on Mount Oeta, Cato of Utica and Cleopatra (whose suicides are not *modern* suicides*), what suicides do you find represented in the old masters? You will search in vain among pagan existences—existences dedicated to appetite—for the suicide of Jean-Jacques,[1] or even the weird and marvellous suicide of Rafael de Valentin.[2]

As for the garb, the outer husk, of the modern hero, although the time is past when every little artist dressed up as a grand panjandrum and smoked pipes as long as duck-

* The first killed himself because he could no longer endure his burning shirt; the second, because there was nothing more that he could do for the cause of liberty; and the voluptuous queen, because she had lost both her throne and her lover. But none of them destroyed himself in order to change skins through metempsychosis. (c.b.)

[1] Rousseau. The belief that he committed suicide is now considered to be without foundation.

[2] The hero of Balzac's *La Peau de Chagrin*.

rifles, nevertheless the studios and the world at large are
still full of people who would like to poeticize *Antony* with
a Greek cloak and a parti-coloured vesture.³

But all the same, has not this much-abused garb its own
beauty and its native charm? Is it not the necessary garb
of our suffering age, which wears the symbol of a perpetual
mourning even upon its thin black shoulders? Note, too,
that the dress-coat and the frock-coat not only possess their
political beauty, which is an expression of universal
equality, but also their poetic beauty, which is an expression
of the public soul—an immense cortège of undertaker's
mutes (mutes in love, political mutes, bourgeois mutes
. . .). We are each of us celebrating some funeral.

A uniform livery of affliction bears witness to equality;
and as for the eccentrics, whose violent and contrasting
colours used easily to betray them to the eye, today they
are satisfied with slight nuances in design in cut, much
more than in colour. Look at those grinning creases which
play like serpents around mortified flesh—have they not
their own mysterious grace?

Although M. Eugène Lami⁴ and M. Gavarni⁵ are not
geniuses of the highest order, they have understood all this
very well—the former, the poet of official dandyism, the
latter the poet of a raffish and reach-me-down dandyism!
The reader who turns again to M. Jules Barbey d'Aurevilly's
book on Dandyism⁶ will see clearly that it is a modern
thing, resulting from causes entirely new.

Let not the tribe of the colourists be too indignant. For
if it is more difficult, their task is thereby only the more
glorious. Great colourists know how to create colour with
a black coat, a white cravat and a grey background.

³ Dumas the elder's prose-drama *Antony* was produced in 1831.
The central character became a powerful hero-figure of the
times, and young men who cast themselves for this role in real
life were popularly known as 'Antonys'.

⁴ Lami exhibited an oil-painting, *La reine Victoria dans le Salon
de famille au château d'Eu, le 3 Septembre 1843,* and a water-
colour, *Le grand bal masqué de l'Opéra.*

⁵ On Gavarni, see pp. 172–4.

⁶ Barbey d'Aurevilly's *Du Dandysme et de Georges Brummell*
had been published the previous year.

But to return to our principal and essential problem, which is to discover whether we possess a specific beauty, intrinsic to our new emotions, I observe that the majority of artists who have attacked modern life have contented themselves with public and official subjects—with our victories and our political heroism. Even so, they do it with an ill grace, and only because they are commissioned by the government which pays them. However there are private subjects which are very much more heroic than these.

The pageant of fashionable life and the thousands of floating existences—criminals and kept women—which drift about in the underworld of a great city; the *Gazette des Tribunaux* and the *Moniteur* all prove to us that we have only to open our eyes to recognize our heroism.

Suppose that a minister, baited by the opposition's impudent questioning, has given expression once and for all —with that proud and sovereign eloquence which is proper to him—to his scorn and disgust for all ignorant and mischief-making oppositions. The same evening you will hear the following words buzzing round you on the Boulevard des Italiens—'Were you in the Chamber today? and did you see the minister? Good Heavens, how handsome he was! I have never seen such scorn!'

So there *are* such things as modern beauty and modern heroism!

And a little later—'I hear that K.—or F.—has been commissioned to do a medal on the subject; but he won't know how to do it—he has no understanding for these things.'

So artists can be more, or less, fitted to understand modern beauty!

Or again—'The sublime rascal! Even Byron's pirates are less lofty and disdainful. Would you believe it—he jostled the Abbé Montès aside, and literally *fell* upon the guillotine, shouting: "Leave me my courage intact!"'

This last sentence alludes to the grave-side braggadocio of a criminal—a great *protestant*, robust of body and mind, whose fierce courage was unabashed in the face of the very engine of death![7]

[7] The reference is to Lacenaire (1800–36), deserter, murderer and rebel, whose career became a Romantic symbol for the re-

All these words that fall from your lips bear witness to your belief in a new and special beauty, which is neither that of Achilles nor yet of Agamemnon.

The life of our city is rich in poetic and marvellous subjects. We are enveloped and steeped as though in an atmosphere of the marvellous; but we do not notice it.

The *nude*—that darling of the artists, that necessary element of success—is just as frequent and necessary today as it was in the life of the ancients; in bed, for example, or in the bath, or in the anatomy theatre. The themes and resources of painting are equally abundant and varied; but there is a new element—modern beauty.

For the heroes of the Iliad are but pigmies compared to you, Vautrin, Rastignac and Birotteau![8]—and you, Fontanarès,[9] who dared not publicly declaim your sorrows in the funereal and tortured frock-coat which we all wear today!—and you, Honoré de Balzac, you the most heroic, the most extraordinary, the most romantic and the most poetic of all the characters that you have produced from your womb![10]

volt against society. The Abbé Montès was senior chaplain at the prison of La Grande Roquette.

[8] Well-known characters from Balzac's novels.

[9] The hero of Balzac's play *Les ressources de Quinola* (1842) which was set in the 16th century—the period of doublet and hose.

[10] A few months before, Baudelaire had published a satirical article at Balzac's expense, entitled *Comment on paie des dettes quand on a du génie*. There occurred here a passage strikingly similar in form, but with a marked difference of epithet: 'lui [Balzac] le personnage le plus cocasse, le plus intéressant, et le plus vaniteux des personnages de la *Comédie humaine*, lui, cet original aussi insupportable dans la vie que délicieux dans ses écrits, ce gros enfant bouffé de génie et de vanité . . .'

ON THE ESSENCE OF LAUGHTER,

AND, IN GENERAL,

ON THE COMIC IN THE PLASTIC ARTS[1]

I

I HAVE no intention of writing a treatise on caricature: I simply want to acquaint the reader with certain reflections which have often occurred to me on the subject of this singular genre. These reflections had become a kind of obsession for me, and I wanted to get them off my chest. Nevertheless I have made every effort to impose some order, and thus to make their digestion more easy. This, then, is purely an artist's and a philosopher's article. No doubt a general history of caricature in its references to all the facts by which humanity has been stirred—facts political and religious, weighty or frivolous; facts relative to the disposition of the nation or to fashion—would be a glorious and important work. The task still remains to be done, for the essays which have been published up to the present are hardly more than raw materials. But I thought that this task should be divided. It is clear that a work on caricature, understood in this way, would be a history of facts, an immense gallery of anecdote. In caricature, far more than in the other branches of art, there are two sorts of works which are to be prized and commended for different and almost contrary reasons. One kind have value only by reason of the *fact* which they represent. No doubt they have a right to the attention of the historian, the archaeologist, and even the philosopher; they deserve to take their place in the national archives, in the biographical

[1] Earliest traced publication in *Le Portefeuille,* 8th July 1855; reprinted, with minor variations, in *Le Présent,* 1st Sept. 1857, with the addition of the succeeding articles on French (1st Oct.) and Foreign (15th Oct.) Caricaturists. There is evidence, however, that all three articles were part of a larger whole, conceived and perhaps written some years before publication. A work to be entitled 'De la Caricature' was announced 'pour paraître prochainement' as early as 1845, and there are several references in Baudelaire's correspondence of 1851-2 to a work on caricature being finished, or nearly finished.

registers of human thought. Like the flysheets of journalism, they are swept out of sight by the same tireless breeze which supplies us with fresh ones. But the others—and it is with these that I want to concern myself especially—contain a mysterious, lasting, eternal element, which recommends them to the attention of artists. What a curious thing, and one truly worthy of attention, is the introduction of this indefinable element of beauty, even in works which are intended to represent his proper ugliness—both moral and physical—to man! And what is no less mysterious is that this lamentable spectacle excites in him an undying and incorrigible mirth. Here, then, is the true subject of my article.

A doubt assails me. Should I reply with a formal demonstration to the kind of preliminary question which no doubt will be raised by certain spiteful pundits of solemnity—charlatans of gravity, pedantic corpses which have emerged from the icy vaults of the *Institut* and have come again to the land of the living, like a band of miserly ghosts, to snatch a few coppers from the obliging administration? First of all, they would ask, is Caricature a genre? No, their cronies would reply, Caricature is not a genre. I have heard similar heresies ringing in my ears at academicians' dinners. It was these fine fellows who let the comedy of *Robert Macaire*[2] slip past them without noticing any of its great moral and literary symptoms. If they had been contemporaries of Rabelais, they would have treated him as a base and uncouth buffoon. In truth, then, have we got to show that nothing at all that issues from man is frivolous in the eyes of a philosopher? Surely, at the very least, there will be that obscure and mysterious element which no philosophy has so far analysed to its depths?

We are going to concern ourselves, then, with the essence of laughter and with the component elements of caricature. Later, perhaps, we shall examine some of the most remarkable works produced in this genre.

[2] The character of Robert Macaire (in the play *L'Auberge des Adrets*) had been created by the actor Frédérick Lemaître, in the 1820s. Later (see p. 168 below) Daumier developed the character in a famous series of caricatures.

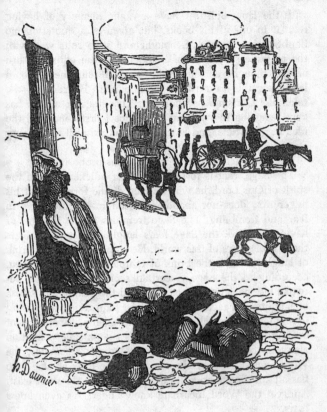

II

The Sage laughs not save in fear and trembling. From what authority-laden lips, from what completely orthodox pen, did this strange and striking maxim fall?[1] Does it come to us from the Philosopher-King of Judea? Or should we attribute it to Joseph de Maistre,[2] that soldier quickened

[1] Lavater's remark 'Le Sage sourit souvent et rit rarement' (*Souvenirs pour des voyageurs chéris*) has been suggested by G. T. Clapton; see Gilman p. 237, *n.* 32.

[2] On Baudelaire's debt to Joseph de Maistre, see Gilman pp. 63–6.

with the Holy Spirit? I have a vague memory of having read it in one of his books, but given as a quotation, no doubt. Such severity of thought and style suits well with the majestic saintliness of Bossuet; but the elliptical turn of the thought and its quintessential refinement would lead me rather to attribute the honour to Bourdaloue, the relentless Christian psychologist. This singular maxim has kept recurring to my mind ever since I first conceived the idea of my article, and I wanted to get rid of it at the very start.

But come, let us analyse this curious proposition—

The Sage, that is to say he who is quickened with the spirit of Our Lord, he who has the divine formulary at his finger tips, does not abandon himself to laughter save in fear and trembling. The Sage trembles at the thought of having laughed; the Sage fears laughter, just as he fears the lustful shows of this world. He stops short on the brink of laughter, as on the brink of temptation. There is, then, according to the Sage, a certain secret contradiction between his special nature as Sage and the primordial nature of laughter. In fact, to do no more than touch in passing upon memories which are more than solemn, I would point out—and this perfectly corroborates the officially Christian character of the maxim—that the Sage *par excellence*, the Word Incarnate, never laughed.[3] In the eyes of One who has all knowledge and all power, the comic does not exist. And yet the Word Incarnate knew anger; He even knew tears.

Let us make a note of this, then. In the first place, here is an author—a Christian, without doubt—who considers it as a certain fact that the Sage takes a very good look before allowing himself to laugh, as though some residue of uneasiness and anxiety must still be left him. And secondly, the comic vanishes altogether from the point of view of absolute knowledge and power. Now, if we inverted the two propositions, it would result that laughter is generally the apanage of madmen, and that it always implies more

[3] This suggests a line in a poem by Baudelaire's friend Gustave le Vavasseur, published in 1843. *Dieux joyeux, je vous hais. Jésus n'a jamais ri.* See also Gilman p. 237, n. 32.

or less of ignorance and weakness. I have no wish, however, to embark recklessly upon a theological ocean, for which I should without doubt be insufficiently equipped with compass or sails; I am content just to indicate these singular horizons to the reader—to point them out to him with my finger.

If you are prepared, then, to take the point of view of the orthodox mind, it is certain that human laughter is intimately linked with the accident of an ancient Fall, of a debasement both physical and moral. Laughter and grief are expressed by the organs in which the command and the knowledge of good and evil reside—I mean the eyes and the mouth. In the earthly paradise—whether one supposes it as past or to come, a memory or a prophecy, in the sense of the theologians or of the socialists—in the earthly paradise, that is to say in the surroundings in which it seemed to man that all created things were good, joy did not find its dwelling in laughter. As no trouble afflicted him, man's countenance was simple and smooth, and the laughter which now shakes the nations never distorted the features of his face. Laughter and tears cannot make their appearance in the paradise of delights. They are both equally the children of woe, and they came because the body of enfeebled man lacked the strength to restrain them.* From the point of view of my Christian philosopher, the laugh on his lips is a sign of just as great a misery as the tears in his eyes. The Being who sought to multiply his own image has in no wise put the teeth of the lion into the mouth of man— yet man rends with his laughter; nor all the seductive cunning of the serpent into his eyes—yet he beguiles with his tears. Observe also that it is with his tears that man washes the afflictions of man, and that it is with his laughter that sometimes he soothes and charms his heart; for the phenomena engendered by the Fall will become the means of redemption.

May I be permitted a poetic hypothesis in order to help

* Philippe de Chennevières (C.B.), an early friend of Baudelaire's. He wrote a number of books, and had a distinguished career in the official world of art. The exact source of this idea has not been traced among his works.

me prove the accuracy of these assertions, which otherwise
many people may find tainted with the *a priori* of mysti-
cism? Since the comic is a damnable element, and one
of diabolic origin, let us try to imagine before us a soul
absolutely pristine and fresh, so to speak, from the hands of
Nature. For our example let us take the great and typical
figure of Virginie,[4] who perfectly symbolizes absolute purity
and naïveté. Virginie arrives in Paris still bathed in sea-
mists and gilded by the tropic sun, her eyes full of great
primitive images of waves, mountains and forests. Here
she falls into the midst of a turbulent, overflowing and
mephitic civilization, all imbued as she is with the pure and
rich scents of the East. She is linked to humanity both by
her birth and her love, by her mother and her lover, her
Paul, who is as angelic as she and whose sex knows no dis-
tinction from hers, so to speak, in the unquenched ardours
of a love which is unaware of itself. God she has known
in the church of *Les Pamplemousses*—a modest and mean
little church, and in the vastness of the indescribable tropic
sky and the immortal music of the forests and the torrents.
Certainly Virginie is a noble intelligence; but a few images
and a few memories suffice her, just as a few books suffice
the Sage. Now one day by chance, in all innocence, at the
Palais-Royal, at a glazier's window, on a table, in a public
place, Virginie's eye falls upon—a caricature! a caricature
all very tempting for us, full-blown with gall and spite, just
such as a shrewd and bored civilization knows how to make
them. Let us suppose some broad buffoonery of the prize-
ring, some British enormity, full of clotted blood and spiced
with a monstrous 'Goddam!' or two: or, if this is more to
the taste of your curious imagination, let us suppose before
the eye of our virginal Virginie some charming and enticing
morsel of lubricity, a Gavarni of her times, and one of the
best—some insulting satire against the follies of the court,
some plastic diatribe against the Parc-aux-Cerfs,[5] the vile
activities of a great favourite, or the nocturnal escapades of
the proverbial *Autrichienne*.[6] Caricature is a double thing;

[4] From Bernardin de Saint-Pierre's *Paul et Virginie*.
[5] Louis XV's private brothel at Versailles.
[6] Marie Antoinette.

it is both drawing and idea—the drawing violent, the idea caustic and veiled. And a network of such elements gives trouble to a simple mind which is accustomed to understand by intuition things as simple as itself. Virginie has glimpsed; now she gazes. Why? She is gazing at the unknown. Nevertheless she hardly understands either what it means or what it is for. And yet, do you observe that sudden folding of the wings, that shudder of a soul that veils herself and wants to draw back? The angel has sensed that there is offence in it. And in truth, I tell you, whether she has understood it or not, she will be left with some strange element of uneasiness—something which resembles fear. No doubt, if Virginie remains in Paris and knowledge comes to her, laughter will come too: we shall see why. But for the moment, in our capacity as analysts and critics who would certainly not dare to assert that our intelligence is superior to that of Virginie, let us simply record the fear and the suffering of the immaculate angel brought face to face with caricature.

III

IF YOU wished to demonstrate that the comic is one of the clearest tokens of the Satanic in man, one of the numerous pips contained in the symbolic apple, it would be enough to draw attention to the unanimous agreement of physiologists of laughter on the primary ground of this monstrous phenomenon. Nevertheless their discovery is not very profound and hardly goes very far. Laughter, they say, comes from superiority. I should not be surprised if, on making this discovery, the physiologist had burst out laughing himself at the thought of his own superiority. Therefore he should have said: Laughter comes from the idea of one's *own* superiority. A Satanic idea, if there ever was one! And what pride and delusion! For it is a notorious fact that all the madmen in the asylums have an excessively overdeveloped idea of their own superiority: I hardly know of any who suffer from the madness of humility. Note, too, that laughter is one of the most frequent and numerous expressions of

madness. And now, see how everything falls into place. When Virginie, once fallen, has declined by one degree in purity, the idea of her own superiority will begin to dawn upon her; she will be more learned from the point of view of the world; and she will laugh.

I said that laughter contained a symptom of failing; and, in fact, what more striking token of debility could you demand than a nervous convulsion, an involuntary spasm comparable to a sneeze and prompted by the sight of some-one else's misfortune? This misfortune is almost always a *mental* failing. And can you imagine a phenomenon more deplorable than one failing taking delight in another? But there is worse to follow. The misfortune is sometimes of a very much lower kind—a failure in the physical order. To take one of the most commonplace examples in life, what is there so delightful in the sight of a man falling on the ice or in the street, or stumbling at the end of a pavement, that the countenance of his brother in Christ should contract in such an intemperate manner, and the muscles of his face should suddenly leap into life like a timepiece at mid-day or a clockwork toy? The poor devil has disfigured himself, at the very least; he may even have broken an essential member. Nevertheless the laugh has gone forth, sudden and irrepressible. It is certain that if you care to explore this situation, you will find a certain unconscious pride at the core of the laughter's thought. That is the point of departure. 'Look at me! *I* am not falling,' he seems to say. 'Look at me! *I* am walking upright. *I* would never be so silly as to fail to see a gap in the pavement or a cobblestone blocking the way.'

The Romantic school, or, to put it better, the Satanic school, which is one of its subdivisions, had a proper under-standing of this primordial law of laughter; or at least, if they did not all understand it, all, even in their grossest extravagances and exaggerations, sensed it and applied it exactly. All the miscreants of melodrama, accursed, damned and fatally marked with a grin which runs from ear to ear, are in the pure orthodoxy of laughter. Furthermore they are almost all the grand-children, legitimate or illegiti-

mate, of the renowned wanderer Melmoth,[1] that great satanic creation of the Reverend Maturin. What could be greater, what more mighty, relative to poor humanity, than the pale, bored figure of Melmoth? And yet he has a weak and contemptible side to him, which faces against God and against the light. See, therefore, how he laughs; see how he laughs, as he ceaselessly compares himself to the caterpillars of humanity, he so strong, he so intelligent, he for whom a part of the conditional laws of mankind, both physical and intellectual, no longer exist! And this laughter is the perpetual explosion of his rage and his suffering. It is —you must understand—the necessary resultant of his contradictory double nature, which is infinitely great in relation to man, and infinitely vile and base in relation to absolute Truth and Justice. Melmoth is a living contradiction. He has parted company with the fundamental conditions of life; his bodily organs can no longer sustain his thought. And that is why his laughter freezes and wrings his entrails. It is a laugh which never sleeps, like a malady which continues on its way and completes a destined course. And thus the laughter of Melmoth, which is the highest expression of pride, is for ever performing its function as it lacerates and scorches the lips of the laugher for whose sins there can be no remission.[2]

[1] *Melmoth the Wanderer* (1820) was the masterpiece of its author, the Rev. C. R. Maturin (1782–1824). It was one of the most influential of all the novels of horror, and Baudelaire's great admiration for it was revealed in his desire to make a new French translation, on the grounds that the existing translation was inadequate. See G. T. Capton, 'Balzac, Baudelaire and Maturin,' *French Quarterly*, June and Sept. 1930; see also Mario Praz, *The Romantic Agony* (O.U.P., 2nd ed., 1951) pp. 116–8.

[2] 'A mirth which is not riot gaiety is often the mask which hides the convulsed and distorted features of agony—and laughter, which never yet was the expression of rapture, has often been the only intelligible language of madness and misery. Ecstasy only smiles—despair laughs . . .' *Melmoth* (2nd ed., 1824), vol. III, p. 302.

IV

AND NOW let us recapitulate a little and establish more clearly our principal propositions, which amount to a sort of theory of laughter. Laughter is satanic: it is thus profoundly human. It is the consequence in man of the idea of his own superiority. And since laughter is essentially human, it is, in fact, essentially contradictory; that is to say that it is at once a token of an infinite grandeur and an infinite misery—the latter in relation to the absolute Being of whom man has an inkling, the former in relation to the beasts. It is from the perpetual collision of these two infinites that laughter is struck. The comic and the capacity for laughter are situated in the laugher and by no means in the object of his laughter. The man who trips would be the last to laugh at his own fall, unless he happened to be a philosopher, one who had acquired by habit a power of rapid self-division and thus of assisting as a disinterested spectator at the phenomena of his own ego. But such cases are rare. The most comic animals are the most serious—monkeys, for example, and parrots. For that matter, if man were to be banished from creation, there would be no such thing as the comic, for the animals do not hold themselves superior to the vegetables, nor the vegetables to the minerals. While it is a sign of superiority in relation to brute creation (and under this heading I include the numerous pariahs of the *mind*), laughter is a sign of inferiority in relation to the wise, who, through the contemplative innocence of their minds, approach a childlike state. Comparing mankind with man, as we have a right to do, we see that primitive nations, in the same way as Virginie, have no conception of caricature and have no comedy (Holy Books never laugh, to whatever nations they may belong), but that as they advance little by little in the direction of the cloudy peaks of the intellect, or as they pore over the gloomy braziers of metaphysics, the nations of the world begin to laugh diabolically with the laughter of Melmoth; and finally we see that if, in these selfsame ultra-civilized

nations, some mind is driven by superior ambition to pass beyond the limits of worldly pride and to make a bold leap towards pure poetry, then the resulting poetry, as limpid and profound as Nature herself, will be as void of laughter as is the soul of the Sage.

As the comic is a sign of superiority, or of a belief in one's own superiority, it is natural to hold that, before they can achieve the absolute purification promised by certain mystical prophets, the nations of the world will see a multiplication of comic themes in proportion as their superiority increases. But the comic changes its nature, too. In this way the angelic and the diabolic elements function in parallel. As humanity uplifts itself, it wins for evil, and for the understanding of evil, a power proportionate to that which it has won for good. And this is why I find nothing surprising in the fact that we, who are the children of a better law than the religious laws of antiquity—we, the favoured disciples of Jesus—should possess a greater number of comic elements than pagan antiquity. For this very thing is a condition of our general intellectual power. I am quite prepared for sworn dissenters to cite the classic tale of the philosopher who died of laughing when he saw a donkey eating figs, or even the comedies of Aristophanes and those of Plautus. I would reply that, quite apart from the fact that these periods were essentially civilized, and there had already been a considerable shrinkage of belief, their type of the comic is still not quite the same as ours. It even has a touch of barbarity about it, and we can really only adopt it by a backward effort of mind, the result of which is called *pastiche*. As for the grotesque figures which antiquity has bequeathed us—the masks, the bronze figurines, the Hercules (all muscles), the little Priapi, with tongue curled in air and pointed ears (all cranium and phallus); and as for those prodigious phalluses on which the white daughters of Romulus innocently ride astride, those monstrous engines of generation, equipped with wings and bells—I believe that these things are all full of deep seriousness.[1] Venus, Pan and Hercules were in no sense figures

[1] Curious readers will find examples reproduced in Fuchs, *Geschichte der erotischen Kunst*, 1908, vol. I, book 2, 'Das Altertum.'

of fun. It was not until after the coming of Christ, and with the aid of Plato and Seneca, that men began to laugh at them. I believe that the ancients were full of respect for drum-majors and for doers of mighty deeds of all kinds, and that none of those extravagant fetishes which I instanced a moment ago were anything other than tokens of adoration, or, at all events, symbols of power; in no sense were they intentionally comic emanations of the fancy. Indian and Chinese idols are unaware that they are ridiculous; it is in us, Christians, that their comicality resides.

<div align="center">v</div>

IT WOULD be a mistake to suppose that we have got rid of every difficulty. The mind that is least accustomed to these aesthetic subtleties would very quickly be able to counter me with the insidious objection that there are *different varieties of laughter*. It is not always a disaster, a failing or an inferiority in which we take our delight. Many sights which provoke our laughter are perfectly innocent; not only the amusements of childhood, but even many of the things that tickle the palate of artists, have nothing to do with the spirit of Satan.

There is certainly some semblance of truth in that. But first of all we ought to make a proper distinction between laughter and joy. Joy exists in itself, but it has various manifestations. Sometimes it is almost invisible; at others, it expresses itself in tears. Laughter is only an expression, a symptom, a diagnostic. Symptom of what? That is the question. Joy is a unity. Laughter is the expression of a double, or contradictory, feeling; and that is the reason why a convulsion occurs. And so, the laughter of children, which I hold for a vain objection, is altogether different, even as a physical expression, even as a form, from the laughter of a man who attends a play, or who looks at a caricature, or from the terrible laughter of Melmoth—of Melmoth, the outcast of society, wandering somewhere between the last boundaries of the territory of mankind and

the frontiers of the higher life; of Melmoth, who always believes himself to be on the point of freedom from his infernal pact, and longs without ceasing to barter that superhuman power, which is his disaster, for the pure conscience of a simpleton, which is his envy. For the laughter of children is like the blossoming of a flower. It is the joy of receiving, the joy of breathing, the joy of contemplating, of living, of growing. It is a vegetable joy. And so, in general, it is more like a smile—something analogous to the wagging of a dog's tail, or the purring of a cat. And if there still remains some distinction between the laughter of children and such expressions of animal contentment, I think that we should hold that this is because their laughter is not entirely exempt from ambition, as is only proper to little scraps of men—that is, to budding Satans.

But there is one case where the question is more complicated. It is the laughter of man—but a true and violent laughter—at the sight of an object which is neither a sign of weakness nor of disaster among his fellows. It is easy to guess that I am referring to the laughter caused by the grotesque. Fabulous creations, beings whose authority and *raison d'être* cannot be drawn from the code of common sense, often provoke in us an insane and excessive mirth, which expresses itself in interminable paroxysms and swoons. It is clear that a distinction must be made, and that here we have a higher degree of the phenomenon. From the artistic point of view, the comic is an imitation: the grotesque a creation. The comic is an imitation mixed with a certain creative faculty, that is to say with an artistic *ideality*. Now human pride, which always takes the upper hand and is the natural cause of laughter in the case of the comic, turns out to be the natural cause of laughter in the case of the grotesque too, for this is a creation mixed with a certain imitative faculty—imitative, that is, of elements pre-existing in nature. I mean that in this case laughter is still the expression of an idea of superiority—no longer now of man over man, but of man over nature. Do not retort that this idea is too subtle; that would be no sufficient reason for rejecting it. The difficulty is to find another plausible explanation. If this one seems far-fetched and

just a little hard to accept, that is because the laughter
caused by the grotesque has about it something profound,
primitive and axiomatic, which is much closer to the inno-
cent life and to absolute joy than is the laughter caused by
the comic in man's behaviour. Setting aside the question of
utility, there is the same difference between these two
sorts of laughter as there is between the *implicated* school
of writing and the school of art for art's sake. Thus the
grotesque dominates the comic from a proportionate height.

From now onwards I shall call the grotesque 'the
absolute comic', in antithesis to the ordinary comic, which
I shall call 'the significative comic'. The latter is a clearer
language, and one easier for the man in the street to under-
stand, and above all easier to analyse, its element being
visibly *double*—art and the moral idea. But the absolute
comic, which comes much closer to nature, emerges as a
unity which calls for the intuition to grasp it. There is but
one criterion of the grotesque, and that is laughter—im-
mediate laughter. Whereas with the significative comic it
is quite permissible to laugh a moment late—that is no
argument against its validity; it all depends upon one's
quickness of analysis.

I have called it 'the absolute comic'. Nevertheless we
should be on our guard. From the point of view of the
definitive absolute, all that remains is *joy*. The comic can
only be absolute in relation to fallen humanity, and it is in
this way that I am understanding it.

VI

IN ITS triple-distilled essence the absolute comic turns out
to be the prerogative of those superior artists whose minds
are sufficiently open to receive any absolute ideas at all.
Thus, the man who until now has been the most sensitive
to these ideas, and who set a good part of them in action
in his purely aesthetic, as well as his creative work, is
Theodore Hoffmann.[1] He always made a proper distinction

[1] On Hoffmann, and on the particular stories which Baudelaire
cites in this section, see H. W. Hewett-Thayer's *Hoffmann,
Author of the Tales* (Princeton and O.U.P., 1948).

between the ordinary comic and the type which he called 'the innocent comic'. The learned theories which he had put forth didactically, or thrown out in the form of inspired conversations or critical dialogues, he often sought to boil down into creative works; and it is from these very works that I shall shortly draw my most striking examples when I come to give a series of applications of the above-stated principles, and to pin a sample under each categorical heading.

Furthermore, within the absolute and significative types of the comic we find species, sub-species and families. The division can take place on different grounds. First of all it can be established according to a pure philosophic law, as I was making a start to do: and then according to the law of artistic creation. The first is brought about by the primary separation of the absolute from the significative comic; the second is based upon the kind of special capacities possessed by each artist. And finally it is also possible to establish a classification of varieties of the comic with regard to climates and various national aptitudes. It should be observed that each term of each classification can be completed and given a *nuance* by the adjunction of a term from one of the others, just as the law of grammar teaches us to modify a noun by an adjective. Thus, any German or English artist is more or less naturally equipped for the absolute comic, and at the same time he is more or less of an idealizer. I wish now to try and give selected examples of the absolute and significative comic, and briefly to characterize the comic spirit proper to one or two eminently artistic nations, before coming on to the section in which I want to discuss and analyse at greater length the talent of those men who have made it their study and their whole existence.

If you exaggerate and push the consequences of the significative comic to their furthest limits, you reach the *savage* variety, just as the synonymous expression of the innocent variety, pushed one degree further, is the *absolute* comic.

In France, the land of lucid thought and demonstration, where the natural and direct aim of art is utility, we gen-

erally find the significative type. In this genre Molière is our best expression. But since at the root of our character there is an aversion for all extremes, and since one of the symptoms of every emotion, every science and every art in France is an avoidance of the excessive, the absolute and the profound, there is consequently but little of the savage variety to be found in this country; in the same way our grotesque seldom rises to the absolute.

Rabelais, who is the great French master of the grotesque, preserves an element of utility and reason in the very midst of his most prodigious fantasies. He is directly symbolic. His comedy nearly always possesses the transparence of an allegory. In French caricature, in the *plastic* expression of the comic, we shall find this dominant spirit. It must be admitted that the enormous poetic good humour which is required for the true grotesque is found but rarely among us in level and continuous doses. At long intervals we see the vein reappear; but it is not an essentially national one. In this context I should mention certain interludes of Molière, which are unfortunately too little read or acted—those of the *Malade Imaginaire* and the *Bourgeois Gentilhomme*, for example; and the carnivalesque figures of Callot. As for the essentially French comedy in the *Contes* of Voltaire, its *raison d'être* is always based upon the idea of superiority; it is entirely significative.

Germany, sunk in her dreams, will afford us excellent specimens of the absolute comic. There all is weighty, profound and excessive. To find true comic savagery, however, you have to cross the Channel and visit the foggy realms of spleen. Happy, noisy, carefree Italy abounds in the innocent variety. It was at the very heart of Italy, at the hub of the southern carnival, in the midst of the turbulent Corso, that Theodore Hoffmann discerningly placed his eccentric drama, *The Princess Brambilla*. The Spaniards are very well endowed in this matter. They are quick to arrive at the cruel stage, and their most grotesque fantasies often contain a dark element.

It will be a long time before I forget the first English pantomime that I saw played. It was some years ago, at

the *Théâtre des Variétés*.[2] Doubtless only a few people
will remember it, for very few seem to have taken to this
kind of theatrical diversion, and those poor English mimes
had a sad reception from us. The French public does not
much like to be taken out of its element. Its taste is not
very cosmopolitan, and changes of horizon upset its vision.
Speaking for myself, however, I was excessively struck by
their way of understanding the comic. It was said—chiefly
by the indulgent, in order to explain their lack of success
—that these were vulgar, mediocre artists—understudies.
But that was not the point. They were English; that was the
important thing.

It seemed to me that the distinctive mark of this type of
the comic was *violence*. I propose to prove it with a few
samples from my memories.

First of all, Pierrot was not the figure to which the late-
lamented Deburau had accustomed us—that figure pale as
the moon, mysterious as silence, supple and mute as the
serpent, long and straight as a gibbet—that artificial man
activated by eccentric springs. The English Pierrot swept
upon us like a hurricane, fell down like a sack of coals, and

[2] It has not proved possible to identify this pantomime beyond
doubt, but, according to information kindly supplied by the
Bibliothèque de l'Arsénal, it seems more than likely that it was
a production entitled 'Arlequin, pantomime anglaise en 3 actes
et 11 tableaux,' performed at the Théâtre des Variétés from the
4th until the 13th August, 1842. The newspaper *Le Corsair* (4th
August) gives the following cast:—Arlequin: Howell.—Clown:
Matthews (presumably the well-known clown, Tom Matthews).
—Pantalon: Garders.—Colombine: Miss Maria Frood.—Une fée:
Anne Plowman—Reine des fées: Emilie Fitzj (?). A review of
this pantomime by Gautier, in *La Presse*, 14th Aug. 1842, has
several points of agreement with Baudelaire's description. First,
Gautier describes the apathy of the audience; secondly, he gives
special praise to the clown's costume; finally, he refers to the
incident of the clown's stealing his own head and stuffing it
into his pocket (though the guillotine is not mentioned).
Champfleury quotes the whole passage in his *Souvenirs des
Funambules*, 1859, pp. 256-7, and provides evidence for dat-
ing the pantomime to the early 1840s when he ironically assigns
the fragment to an article by Baudelaire 'sous presse depuis
quinze ans seulement'.

when he laughed his laughter made the auditorium quake; his laugh was like a joyful clap of thunder. He was a short, fat man, and to increase his imposingness he wore a be-ribboned costume which encompassed his jubilant person as birds are encompassed with their down and feathers, or angoras with their fur. Upon his floured face he had stuck, crudely and without transition or gradation, two enormous patches of pure red. A feigned prolongation of the lips, by means of two bands of carmine, brought it about that when he laughed his mouth seemed to run from ear to ear.

As for his moral nature, it was basically the same as that of the Pierrot whom we all know—heedlessness and in-difference, and consequently the gratification of every kind of greedy and rapacious whim, now at the expense of Harlequin, now of Cassandre or Léandre. The only dif-ference was that where Deburau would just have moistened the tip of his finger with his tongue, he stuck both fists and both feet into his mouth.

And everything else in this singular piece was expressed in the same way, with passionate gusto; it was the dizzy height of hyperbole.

Pierrot walks past a woman who is scrubbing her door-step; after rifling her pockets, he makes to stuff into his own her sponge, her mop, her bucket, water and all! As for the way in which he endeavoured to express his love to her, anyone who remembers observing the phanerogamous habits of the monkeys in their famous cage at the Jardin des Plantes can imagine it for himself. Perhaps I ought to add that the woman's role was taken by a very long, very thin man, whose outraged modesty emitted shrill screams. It was truly an intoxication of laughter—something both terrible and irresistible.

For some misdeed or other, Pierrot had in the end to be guillotined. Why the guillotine rather than the gallows, in the land of Albion? . . . I do not know; presumably to lead up to what we were to see next. Anyway, there it was, the engine of death, there, set up on the French boards which were markedly surprised at this romantic novelty. After struggling and bellowing like an ox that scents the

slaughter-house, at last Pierrot bowed to his fate. His head was severed from his neck—a great red and white head, which rolled noisily to rest in front of the prompter's box, showing the bleeding disk of the neck, the split vertebrae and all the details of a piece of butcher's meat just dressed for the counter. And then, all of a sudden, the decapitated trunk, moved by its irresistible obsession with theft, jumped to its feet, triumphantly 'lifted' its own head as though it was a ham or a bottle of wine, and, with far more circumspection than the great St. Denis, proceeded to stuff it into its pocket!

Set down in pen and ink, all this is pale and chilly. But how could the pen rival the pantomime? The pantomime is the refinement, the quintessence of comedy; it is the pure comic element, purged and concentrated. Therefore, with the English actors' special talent for hyperbole, all these monstrous buffooneries took on a strangely thrilling reality.

Certainly one of the most remarkable things, in the sense of absolute comedy—or if I may call it so, the metaphysics of absolute comedy—was the beginning of this beautiful piece, a prologue filled with a high aesthetic. The principal characters, Pierrot, Cassandre, Harlequin, Colombine and Léandre are facing the public, gentle and good as gold. They are all but rational beings and do not differ much from the fine fellows in the audience. The miraculous breath which is about to inspire them to such extraordinary antics has not yet touched their brains. A few quips from Pierrot can give no more than a pale idea of what he will be doing shortly. The rivalry between Harlequin and Léandre has just declared itself. A fairy takes Harlequin's side; she is the eternal protectress of mortals who are poor and in love. She promises him her protection, and, to give him immediate proof of it, she waves her wand in the air with a mysterious and authoritative gesture.

At once a dizzy intoxication is abroad; intoxication swims in the air; we breathe intoxication; it is intoxication that fills the lungs and renews the blood in the arteries.

What is this intoxication? It is the absolute comic, and it has taken charge of each one of them. The extraordinary gestures executed by Léandre, Pierrot and Cassandre make

it quite clear that they feel themselves forcibly projected into a new existence. They do not seem at all put out. They set about preparing for the great disasters and the tumultuous destiny which awaits them, like a man who spits on his hands and rubs them together before doing some heroic deed. They flourish their arms, like windmills lashed by the tempest. It must be to loosen their joints—and they will certainly need it. All this is carried out to great gusts of laughter, full of a huge contentment. Then they turn to a game of leap-frog, and once their aptitude and their agility have been duly registered, there follows a dazzling volley of kicks, punches and slaps which blaze and crash like a battery of artillery. But all of this is done in the best of spirits. Every gesture, every cry, every look seems to be saying: 'The fairy has willed it, and our fate hurls us on—it doesn't worry *me!* Come, let's get started! Let's get down to business!' And then they *do* get down to business, through the whole fantastic work, which, properly speaking, only starts at this point—that is to say, on the frontier of the marvellous.

Under cover of this hysteria, Harlequin and Colombine have danced away in flight, and with an airy foot they proceed to run the gauntlet of their adventures.

And now another example. This one is taken from a singular author—a man of ranging mind, whatever may be said, who unites to the significative mockery of France the mad, sparkling, lighthearted gaiety of the lands of the sun as well as the profound comic spirit of Germany. I am returning once again to Hoffmann.

In the story entitled *Daucus Carota, the King of the Carrots,* or by some translators *The King's Betrothed,* no sight could be more beautiful than the arrival of the great company of the Carrots in the farm-yard of the betrothed maiden's home. Look at all those little scarlet figures, like a regiment of English soldiers, with enormous green plumes on their heads, like carriage-footmen, going through a series of marvellous tricks and capers on their little horses! The whole thing is carried out with astonishing agility. The adroitness and ease with which they fall on their heads is assisted by their heads being bigger and heavier than the

rest of their bodies, like those toy soldiers made of elder-pith, which have lead weights in their caps.

The unfortunate young girl, obsessed with dreams of grandeur, is fascinated by this display of military might. But an army on parade is one thing; how different an army in barracks, furbishing its arms, polishing its equipment, or, worse still, ignobly snoring on its dirty, stinking camp-beds! That is the reverse of the medal; the rest was but a magic trick, an apparatus of seduction. But her father, who is a wise man and well versed in sorcery, wants to show her the other side of all this magnificence. Thus, at an hour when the vegetables are sleeping their brutish sleep, never suspecting that any spy could catch them unawares, he lifts the flap of one of the tents of this splendid army. Then it is that the poor dreaming girl sees all this mass of red and green soldiery in its appalling undress, wallowing and snoring in the filthy midden from which it first emerged. In its night-cap all that military magnificence is nothing more than a putrid swamp.

There are many other examples of the absolute comic that I might take from the admirable Hoffmann. Anyone who really wants to understand what I have in mind should read with care *Daucus Carota, Peregrinus Tyss, The Golden Pot,* and over and above all, *The Princess Brambilla,* which is like a catechism of high aesthetics. What pre-eminently distinguishes Hoffmann is his unintentional—and sometimes very intentional—blending of a certain measure of the significative comic with the most absolute variety. His most supernatural and fugitive comic conceptions, which are often like the visions of a drunken man, have a very conspicuous moral meaning; you might imagine that you had to do with the profoundest type of physiologist or alienist who was amusing himself by clothing his deep wisdom in poetic forms, like a learned man who might speak in parables and allegories.

Take for example, if you will, the character of Giglio Fava, the actor who suffered from a chronic dualism, in *The Princess Brambilla.* This *single* character changes personality from time to time. Under the name of Giglio Fava he swears enmity for the Assyrian prince, Cornelio Chiap-

peri; but when he is himself the Assyrian prince, he pours forth his deepest and the most regal scorn upon his rival for the hand of the Princess—upon a wretched mummer whose name, they say, is Giglio Fava.

I should perhaps add that one of the most distinctive marks of the absolute comic is that it remains unaware of itself. This is evident not only in certain animals, like monkeys, in whose comicality gravity plays an essential part, nor only in certain antique sculptural caricatures of which I have already spoken, but even in those Chinese monstrosities which delight us so much and whose intentions are far less comic than people generally think. A Chinese idol, although it be an object of veneration, looks very little different from a tumble-toy or a pot-bellied chimney-ornament.

And so, to be finished with all these subtleties and all these definitions, let me point out, once more and for the last time, that the dominant idea of superiority is found in the absolute, no less than in the significative comic, as I have already explained (at too great a length, perhaps): further, that in order to enable a comic emanation, explosion, or, as it were, a chemical separation of the comic to come about, there must be two beings face to face with one another: again, that the special abode of the comic is in the laugher, the spectator: and finally, that an exception must nevertheless be made in connection with the 'law of ignorance' for those men who have made a business of developing in themselves their feeling for the comic, and of dispensing it for the amusement of their fellows. This last phenomenon comes into the class of all artistic phenomena which indicate the existence of a permanent dualism in the human being—that is, the power of being oneself and someone else at one and the same time.

And so, to return to my primary definitions and to express myself more clearly, I would say that when Hoffmann gives birth to the absolute comic it is perfectly true that he knows what he is doing; but he also knows that the essence of this type of the comic is that it should appear to be unaware of itself and that it should produce in the spectator, or rather the reader, a joy in his own superiority and in the su-

periority of man over nature. Artists create the comic; after collecting and studying its elements, they know that such-and-such a being is comic, and that it is so only on condition of its being unaware of its nature, in the same way that, following an inverse law, an artist is only an artist on condition that he is a double man and that there is not one single phenomenon of his double nature of which he is ignorant.

SOME FRENCH CARICATURISTS

CARLE VERNET—PIGAL—CHARLET—DAUMIER
MONNIER—GRANDVILLE—GAVARNI
TRIMOLET—TRAVIES—JACQUE

HE WAS an astonishing man, was Carle Vernet.[1] His collected works are a world, a little *Comédie humaine* of their own; for trivial prints, sketches of the crowd and the street, and caricatures, often constitute the most faithful mirror of life. Often, too, caricatures, like fashion-plates, become more caricatural the more old-fashioned they become. Thus the stiff and ungainly bearing of the figures of those times seems to us oddly unexpected and jarring; and yet the whole of that world is much less intentionally odd than people generally suppose. Such was the fashion, such were its human beings; its men were like its paintings; the world had moulded itself on art. Everyone was stiff and upright; and with his skimpy frock-coat, his riding-boots, and his hair dripping over his brow, each citizen gave the impression of an academic nude which had called in at the old-clothes-shop. But it is not only because they have thoroughly preserved the sculptural imprint and the stylistic pretensions of their period—it is not only from the historical point of view, I mean—that Carle Vernet's caricatures have a great value for us; they also have a positive artistic worth. Each pose and gesture has the accent of truth; each head and physiognomy is endowed with an authentic style for which many of us can vouch when we think of the guests who used to enjoy our father's hospitality in the days of our childhood. His fashion-caricatures are superb. I need hardly remind you of that large plate of a gaming-house.[2]

[1] Son of Joseph, and father of Horace Vernet.

[2] It is not however recorded in any of the standard catalogues of Carle Vernet's work, and there is no copy of it at the Bibliothèque Nationale. Crépet suggests that Baudelaire may have had in mind an engraving by Darcis, after Guérain, entitled *Les Trente-un, ou la Maison de prêt sur nantissement*, which is stylistically similar to the work of Carle Vernet, and whose subject-matter agrees with Baudelaire's description.

Around a vast oval table are gathered players of different types and ages. There is no lack of those indispensable young women whose eyes are greedily fixed upon the odds —those ladies in perpetual waiting on the gambler whose luck is in. It is a scene of violent joys and despairs; of fiery young gamblers, burning up their luck; of cold, serious and tenacious gamblers; of old men whose scanty hair betokens the gales of long-departed equinoxes. Admittedly this composition, like everything else from the hand of Carle Vernet and his school, lacks freedom; but in return it has a deep seriousness, a pleasing asperity and a dryness of manner which suits the subject rather well, since gambling is a passion at once violent and restrained.

Pigal was among those who attracted most notice later on. The earliest works of Pigal go back quite a distance, and Carle Vernet lived a very long time. But it is often possible to say that two contemporaries represent two distinct epochs, even if they are quite close together in age. And does not this gentle and amusing caricaturist still grace our annual exhibitions with little pictures whose innocent comicality must seem very feeble to M. Biard? It is character and not age which is the decisive factor. And so Pigal is quite another thing from Carle Vernet. His manner serves as transitional between caricature as conceived by that artist and the more modern caricature of Charlet, for example, of whom I shall have something to say in a moment. Charlet, who belongs to the same generation as Pigal, may be the subject of a similar observation; for the word 'modern' refers to manner and not to date. Pigal's popular scenes are good. I do not mean that their originality is very lively, nor even their drawing very comic, for Pigal is a sober comedian; but the sentiment of his compositions is both just and good. His are commonplace truths, but they are truths for all that. The majority of his pictures are taken direct from nature. The procedure he follows is a simple and a modest one—he observes, he listens, and then he tells what he has seen and heard. In general there is a great simplicity and a certain innocence about all his compositions: they almost always have to do with men of the people, popular sayings, drunkards, family

scenes, and in particular they show a spontaneous predilection for elderly types. There is another thing about Pigal, which he shares with many other caricaturists—he is not very good at expressing the quality of youth; it often happens that his young people have a 'made-up' look. His drawing, which generally flows easily, is richer and less *contrived* than Carle Vernet's. Almost the whole of Pigal's merit can thus be summed up under three headings—a habit of sound observation, a good memory, and an adequate sureness of execution: little or no imagination, but a measure of good sense. The carnival gusto and gaiety of the Italians is as foreign to him as the maniac violence of the English. Pigal is an essentially *reasonable* caricaturist.

I am rather at a loss to express my opinion on Charlet in a seemly way. He is a great name, an essentially French name—one of the glories of France. He has delighted, entertained, he is said even to have *moved*, a whole generation of men still living. I have known people who were honestly indignant at not seeing Charlet at the Institut. For them it was as great a scandal as the exclusion of Molière from the Académie. Now I know that to come forward and tell people that they are wrong to have been amused or moved in a certain fashion is rather a shabby part to play: it is truly painful to find oneself at cross purposes with the universal vote. Nevertheless it is necessary to have the courage to say that Charlet has no place among the eternal spirits—among the cosmopolitan geniuses. This caricaturist is no citizen of the universe; and if you object that a caricaturist can never be quite that, I shall reply that to a certain extent he *can* be. Charlet is a topical artist and an exclusive patriot—two impediments in the way of genius. He has something in common with another famous man whom I do not wish to mention by name, for the time is not yet ripe;* like him he reaped his glory

* This fragment is taken from a book which I began some years ago, but left unfinished. M. de Béranger was still alive. (c.b.) Like Flaubert, Baudelaire focused much of his anti-bourgeois feeling upon the popular poet Béranger. For an opposite, and almost contemporary, English point of view, see Walter Bagehot's essay on Béranger (1857) in his *Literary Studies* (Everyman ed., vol. II, pp. 233 ff.). Béranger died in 1857.

exclusively from France, and above all from the aristocracy of the sword. I submit that this is bad, and denotes a small mind. Again, like that other great man he insulted the clerical party a great deal; this too, I say, is a very bad symptom—these people are unintelligible on the other side of the Channel, on the other side of the Rhine or the Pyrenees. In a minute or two we shall be speaking of the artist proper—that is, of his talent, his execution, his draughtsmanship, his style; we shall settle the matter once and for all. At present it is only his *wit* that I am discussing.

Charlet always paid court to the people. He was a slave, not a free man; do not expect to find a disinterested artist in him. A drawing by Charlet is seldom a truth; it is nearly always a piece of cajolery addressed to the preferred caste. There is no beauty, goodness, nobility, kindness or wit but in the soldier. The million million animalculae that graze upon this planet were created by God and endowed with organs and senses solely to enable them to contemplate the soldier, and the drawings of Charlet, in all their glory. Charlet asserts that the red-coat and the grenadier are the final cause of creation. These things have nothing whatever to do with caricature, I assure you; they are more like panegyrics, or dithyrambs, so strangely perverse is their author's approach to his profession. Admittedly the uncouth blunders which Charlet puts into the mouth of his recruits are turned with a certain charm which does them honour and makes them interesting. This smacks of the *vaudeville*, in which peasants are made to commit the most touching and witty malapropisms. They have hearts as pure as angels', with the wit of an academician (except for the social, or phonetic, *liaisons*). To show the peasant in his true self is an idle fancy of Balzac's: to depict the abominations of man's heart so relentlessly is all very well for a testy and hypochondriac spirit like Hogarth; but to exhibit to the life the vices of the soldier—there's real cruelty for you! it might discourage him! That is the way in which the famous Charlet understood caricature.

It is the same sentiment that guides our biased artist with respect to the clerics. He is not concerned with painting or delineating the moral deformities of the sacristy in an

original manner. No, his sole need is to please the soldier-bumpkin; and the soldier-bumpkin used to live on a diet of Jesuits. In the arts, *the only thing that matters is to please*, as the bourgeois say.

Goya, too, attacked the monastic tribe. I imagine that he had no love for monks, for he made them very ugly. But how beautiful they are in all their ugliness! how triumphant in their monkish squalor and crapulence! Here art dominates—art which purifies like fire: there it is servility, which corrupts art. Now compare the artist with the courtier: one gives us superb drawings; the other, a Voltairean sermon.

There has been much talk about Charlet's street-arabs—those angelic little darlings who will one day make such pretty soldiers, who are so fond of retired veterans and who play at war with wooden swords. They are always plump and fresh as rosy apples, all innocence and frankness, with eyes bright and smiling on the world. But what of the 'enfant terrible', what of the great poet's 'pale urchin, with his hoarse voice and his skin the colour of an old *sou*'?[3] I am afraid that Charlet has too pure a heart to see such things.

It must be owned, however, that occasionally he betrayed a good intention.—The scene is a forest. Some bandits and their women are sitting eating beside an oak-tree on which a hanged man, already elongated and thin, is loftily taking the air and sniffing the dew, with his nose bent towards the ground and his toes correctly aligned like a dancer's. One of the ruffians points to him with his finger and says, 'Maybe that's how we shall be next Sunday!'[4]

But alas, he has given us few sketches of this kind. And yet, even if the idea is a good one, the drawing is inadequate; there is no well-marked character about the heads. It could be far finer, and is certainly not to be compared

[3] Le race de Paris, c'est le pâle voyou,
 Au corps chétif, au teint jaune comme un vieux sou.
 Auguste Barbier, *Iambes*, X.
[4] Charlet, *Album lithographique* (1832), No. 4 (La Combe 786).

with Villon's lines as he supped with his comrades beneath the gallows on the gloomy plain.

Charlet's draughtsmanship hardly ever rises above the 'chic'—it is all loops and ovals. His sentiments he picked up ready-made at the vaudeville. He was a thoroughly artificial man who applied himself to imitating the current ideas of his time. He made a tracing, so to speak, of public opinion: he tailored his intelligence to fit the fashion. The public was truly his pattern no less than his patron.

Once however he produced something quite good. This was a series of costumes of the old and new guard,[5] which is not to be confused with a somewhat similar work published not so long ago—the latter may even be a posthumous work.[6] The figures have the stamp of reality; they must be very lifelike. Their gait, their gestures, the attitudes of their heads are all excellent. Charlet was young then; he did not think of himself as a great man, and his popularity had not yet absolved him from drawing his figures correctly and making them stand firm on their feet. But he always had a tendency towards self-neglect, and he ended by repeating over and over again the same vulgar scribble which the youngest of art-students would be unwilling to acknowledge if he had a scrap of self-respect. It is proper to point out that the work of which I am speaking is of a simple and serious kind, and that it demands none of the qualities which later on were gratuitously accorded to an artist whose sense of the comic was so deficient. But it is *caricaturists* with whom I am concerned here, and if I had followed my design straight through, I should not have introduced Charlet, any more than Pinelli, into my catalogue; but then I should have been accused of grave omissions.

In a word, what was this man but a manufacturer of nationalist nursery-rhymes, a licensed purveyor of political catchwords, an idol, in short, whose life is no more proof against mortality than that of any other idol? It will not be long before he knows the full force of oblivion and joins the *great* painter and the *great* poet[7]—his first cousins in

[5] La Combe 157–86 and 187–201 (1819–21).

[6] La Combe 209–64 (1845).

[7] Presumably Horace Vernet and Béranger respectively.

ignorance and ineptitude—to slumber in the waste-paper basket of indifference, like this sheet of paper which I have needlessly soiled and which is now only fit for pulping.[8]

But now I want to speak about one of the most important men, I will not say only in caricature, but in the whole of modern art. I want to speak about a man who each morning keeps the population of our city amused, a man who supplies the daily needs of public gaiety and provides its sustenance. The bourgeois, the business-man, the urchin and the housewife all laugh and pass on their way, as often as not—what base ingratitude!—without even glancing at his name. Until now his fellow-artists have been alone in understanding all the serious qualities in his work, and in recognizing that it is really the proper subject for a study. You will have guessed that I am referring to Daumier.

There was nothing very spectacular about Honoré Daumier's beginnings. He drew because he had to—it was his ineluctable vocation. First of all he placed a few sketches with a little paper edited by William Duckett;[9] then Achille Ricourt, who was a print-dealer at that time, bought some more from him.[10] The revolution of 1830, like all revolutions, occasioned a positive fever of caricature. For caricaturists, those were truly halcyon days. In that ruthless war against the government, and particularly against the king, men were all passion, all fire. It is a real curiosity today to look through that vast gallery of historical clowning which went by the name of *La Caricature*[11]—that great series of comic archives to which every artist of any consequence brought his quota. It is a hurly-burly, a far-

[8] Baudelaire's rough handling of Charlet earned him an indignant letter from Colonel de la Combe, whose book on the artist had been published in 1856. Delacroix also was displeased; see p. 332 below.

[9] Presumably *La Silhouette* (1829–31), the first journal of its kind to be published in Paris. In spite of his name, William Duckett was a Frenchman.

[10] Ricourt's shop was near the Louvre, in the rue du Coq. In 1832 he founded *L'Artiste*, to which Baudelaire contributed.

[11] Founded by Charles Philipon (1800–62) in 1830, it lasted until 1835. Daumier contributed to it a great deal, sometimes under the pseudonym Rogelin.

rago, a prodigious satanic comedy, now farcical, now gory, through whose pages all the political élite march past, rigged out in motley and grotesque costumes. Among all those great men of the dawning monarchy, how many are there not whose names are already forgotten! But it is the olympian and pyramidal *Pear*, of litigious memory, that dominates and crowns the whole fantastic epic. You will remember the time when Philipon (who was perpetually at cross purposes with His Majesty's justice) wanted to prove to the tribunal that nothing was more innocent than that prickly and provoking pear, and how, in the very presence of the court, he drew a series of sketches of which the first exactly reproduced the royal physiognomy, and each successive one, drawing further and further away from the primary image, approached ever closer to the fatal goal —the *pear!* 'There now,' he said. 'What connection can you see between this last sketch and the first?' Similar experiments were made with the head of Christ and that of Apollo, and I believe that it was even possible to refer back one of them to the likeness of a toad. But all this proved absolutely nothing. An obliging analogy had discovered the symbol: from that time onwards the symbol was enough. With this kind of plastic slang, it was possible to say, and to make the people understand, anything one wanted. And so that tyrannical and accursed pear became the focus for the whole pack of patriotic blood-hounds. There is no doubt about it that they went to work with a marvellous ferocity and *espirit de corps*, and however obstinately Justice retorted, it is a matter of enormous surprise to us today, when we turn the pages of these comic archives, that so furious a war should have been able to be kept up for years on end.

A moment ago, I think, I used the words 'a gory farce'; and indeed these drawings are often full of blood and passion. Massacres, imprisonments, arrests, trials, searches and beatings-up by the police—all those episodes of the first years of the government of 1830 keep on recurring. Just judge for yourselves—

Liberty, a young and beautiful girl, with her Phrygian cap upon her head, is sunk in a perilous sleep. She has

hardly a thought for the danger which is threatening her.
A *Man* is stealthily advancing upon her, with an evil pur-
pose in his heart. He has the burly shoulders of a market-
porter or a bloated landlord. His pear-shaped head is sur-
mounted by a prominent tuft of hair and flanked with
extensive side-whiskers. The monster is seen from behind,
and the fun of guessing his name must have added no little
value to the print. He advances upon the young person,
making ready to outrage her.

'*Have you pray'd to-night, Madam?*'—It is Othello-
Philippe about to stifle innocent Liberty, for all her cries
and resistance!

Or again, along the pavement outside a more than sus-
picious house quite a young girl is passing; she is wearing
her little Phrygian cap with all the innocent coquetry of a
grisette, a girl of the people. Monsieur X and Monsieur Y
(well-known faces—the most honourable of ministers, for
a certainty) are plying a singular trade this time. They are
closing in on the poor child, whispering blandishments or
indecencies in her ear, and gently pushing her towards a
narrow passageway. Behind a door the *Man* can just be
made out. His face is almost turned away, but it is he all
right! Just look at that tuft of hair and those side-whiskers.
He is impatient, he is waiting.

Or here is Liberty arraigned before the Provost's Court
or some other Gothic tribunal: this one is a great gallery of
contemporary portraits in mediaeval dress.

And here is Liberty dragged into the torture-chamber.
Her delicate ankles are about to be crushed, her stomach
to be distended with torrents of water, and every other
abomination to be performed upon her. These bare-armed,
brawny, torture-hungry athletes are easily recognizable.
They are Monsieur X, Monsieur Y, and Monsieur Z—the
bêtes noires of opinion.*

* I no longer have the documents in front of me, and it is pos-
sible that one of these last was by Traviès. (c.b.) None of these
caricatures has been exactly identified. Champfleury (who
quotes the passage in his *Histoire de la caricature moderne*,
1865, pp. 227-8) seems to imply that they were by Grandville

In every one of these drawings (of which the majority are executed with remarkable conscientiousness and seriousness of purpose) the king plays the part of an ogre, an assassin, an insatiate Gargantua,[12] and sometimes even worse. But since the February Revolution[13] I have only seen a single caricature whose savagery reminded me of the days of those high political passions; for none of the political appeals displayed in the shop-windows at the time of the great presidential elections offered anything but pale reflections in comparison with the products of the time of which I have just been speaking. The exception occurred shortly after the unfortunate massacre at Rouen.[14] In the foreground, on a stretcher, there lies a corpse, riddled with bullets: behind it are assembled all the city bigwigs in uniform, well crimped, well buckled, well turned out, their moustaches *en croc*, and bursting with arrogance; there must surely also be a few bourgeois dandies who are off to mount guard or to take a hand in quelling the riot, with a bunch of violets in the buttonhole of their tunics—in short, the very ideal of the *garde bourgeoise*, as the most celebrated of our demagogues termed it.[15] On his knees before the stretcher, wrapped in his judge's robe, with his mouth open to show his double row of saw-edged teeth like a shark, F.C.[16] is slowly passing his claws over the corpse's flesh and blissfully scratching it.—'Ah! that Norman!,' he says. 'He's only shamming dead so as to avoid answering to justice!'

It was with just such a fury that *La Caricature* waged war on the government. And Daumier played an important

and Traviès, but *La Caricature* of 27th June 1831 contained a print of Liberté about to receive the sentence of the Cour Prévôtale, by Decamps.

[12] Daumier's *Gargantua* (*La Caricature*, Dec. 1831) cost him six months in prison.

[13] The 1848 revolution.

[14] This took place at the time of the departmental elections, April 1848; a rising was brutally repressed by General Ordener.

[15] Probably Lafayette.

[16] Frank-Carré, a detested local politician.

role in that chronic skirmish. A means had been invented
to provide money for the fines which overwhelmed the
Charivari; this was to publish supplementary drawings, the
money from whose sale was appropriated to that purpose.[17]
Over the deplorable massacres in the rue Transnonain,
Daumier showed his true greatness; his print has become
rather rare, for it was confiscated and destroyed.[18] It is not
precisely caricature—it is history, reality, both trivial and
terrible. In a poor, mean room, the traditional room of the
proletarian, with shoddy, essential furniture, lies the corpse
of a workman, stripped but for his cotton shirt and cap:
he lies on his back, at full length, his legs and arms out-
spread. There has obviously been a great struggle and
tumult in the room, for the chairs are overturned, as are
the night-table and the chamber-pot. Beneath the weight
of his corpse—between his back and the bare boards—the
father is crushing the corpse of his little child. In this cold
attic all is silence and death.

It was about the same time that Daumier undertook a
satirical portrait gallery of political notabilities. There were
two series—one of full-length, the other of bust-portraits:
the latter series came later, I think, and only contained
members of the upper house.[19] In these works the artist
displayed a wonderful understanding of portraiture; whilst
exaggerating and burlesquing the original features, he re-
mained so soundly rooted in nature that these specimens
might serve as models for all portraitists. Every little mean-
ness of spirit, every absurdity, every quirk of intellect, every
vice of the heart can be clearly seen and read in these
animalized faces; and at the same time everything is

[17] This was the *Association Mensuelle Lithographique,* which
was started in August 1832. On the whole subject, see *Freedom
of the Press and 'L'Association Mensuelle': Philipon versus
Louis-Philippe,* by E. de T. Bechtel (New York, Grolier Club,
1952).
[18] Published in July 1834 by the *Association Mensuelle* (Del-
teil 135), it is now one of Daumier's best-known lithographs.
[19] In fact the two series were approximately contemporary with
one another; the full-length portraits were published in *La Cari-
cature* in 1833–4, and the majority of the bust-portraits in *Le
Charivari* in 1833.

broadly and emphatically drawn. Daumier combined the freedom of an artist with the accuracy of a Lavater. And yet such of his works as date back to that period are very different from what he is doing today. They lack the facility of improvisation, the looseness and lightness of pencil which he acquired later. Sometimes—though rarely—he was a little heavy, but always very finished, conscientious, and strict.

I remember one other very fine drawing which belongs to the same class—*La Liberté de la presse.*[20] Surrounded by his instruments of liberation—his printing-plant—and with his ritual paper-cap pulled down to his ears and his shirt-sleeves rolled up, a typographer's workman is standing four-square and solid on his sturdy legs; he is clenching both his fists and scowling. The man's whole frame is as rough-hewn and muscular as the figures of the great masters. In the background is the inevitable *Philippe* with his policemen. But they dare not come and interfere.

However, our great artist has done a wide diversity of things. What I propose to do is to describe some of his most striking plates, chosen from different genres. Then I shall analyse the philosophic and artistic importance of this extraordinary man, and finally, before taking leave of him, I shall give a list of the different series and categories of his work, or at least I shall do the best I can, for at the present moment his *œuvre* is a labyrinth, a forest of trackless abundance.

Le Dernier Bain[21] is a serious and pathetic caricature. Standing on the parapet of a quay and already leaning forward, so that his body forms an acute angle with the base from which it is parting company—like a statue losing its balance—a man is letting himself topple into the river. He must have really made up his mind, for his arms are calmly folded, and a huge paving-stone is attached to his neck with a rope. He has taken his oath not to escape. This is no suicide of a poet who means to be fished out and to get

[20] Published March 1834 by the *Association Mensuelle* (Delteil 133).

[21] No. 2 of 'Sentiments et Passions', published in *Le Charivari*, May 1840 (Delteil 800).

himself talked about. Just look at that shabby, creased frock-coat, with all the bones jutting through! And that seedy cravat, twisted like a snake, and that bony and pointed Adam's apple! Surely nobody would have the heart to grudge this man his underwater escape from the passing show of civilization. In the background, on the other side of the river, a well-fed, contemplative member of the bourgeoisie is devoting himself to the innocent joys of rod and line.

Imagine, now, a very remote corner of some obscure and little-frequented suburb, oppressed beneath a leaden sun. A man of somewhat funereal figure—an undertaker's mute, perhaps, or a doctor—is hobnobbing and drinking a glass, in a leafless arbour, beneath a trellis of dusty laths, with a hideous skeleton. The hour-glass and the scythe are lying on one side. I forget the title of this plate: but these two self-important creatures are evidently laying some murderous bet, or conducting a learned discussion on mortality.[22]

Daumier has scattered his talent in a thousand different fields. For example, he even produced some wonderful drawings when commissioned to illustrate a baddish medico-poetical publication called La Némésis médicale.[23] One of them, which deals with cholera, represents a public square flooded, overwhelmed with light and heat. True to its ironical custom in times of great calamity and political upheaval, the sky of Paris is superb; it is quite white and incandescent with heat. The shadows are black and clear-cut. A corpse is lying across a doorway. A woman is hurrying in, stopping up her nose and her mouth as she runs. The square is deserted and like an oven—more desolate, even, than a populous square after a riot. In the background can be seen the silhouettes of two or three little hearses drawn by grotesque old hacks, and in the midst of this forum of desola-

[22] Published 26th May 1840 in Le Charivari, with the title 'Association en commandite pour l'exploitation de l'humanité'— 'Limited Company for the Exploitation of Humanity' (Delteil 796).

[23] Published 1840. These wood-engravings are Nos. 111–139 in Arthur Rümann's Honoré Daumier, sein Holzschnittwerk (Munich, 1914). The example described by Baudelaire is reproduced above, on p. 133.

tion a wretched, bewildered dog, starved to the bone, with neither thought nor aim, is sniffing the dusty paving-stones, its tail stuffed between its legs.

The scene now shifts to a prison-yard. A very learned gentleman, with black coat and white cravat—a philanthropist, a redresser of wrongs—is ecstatically seated between two convicts of terrifying aspect—both as stupid as cretins, as ferocious as bull-dogs and as down-at-heel as old boots. One of them is saying that he has murdered his father, ravished his sister, or done some other heroic deed. 'Ah! my friend, what a splendid body of a man you must have been!' cries the savant, in raptures.[24]

These specimens are enough to show how serious Daumier's thought often is, and how spiritedly he attacks his subjects. Look through his works, and you will see parading before your eyes all that a great city contains of living monstrosities, in all their fantastic and thrilling reality. There can be no item of the fearful, the grotesque, the sinister or the farcical in its treasury, but Daumier knows it. The live and starving corpse, the plump and well-filled corpse, the ridiculous troubles of the home, every little stupidity, every little pride, every enthusiasm, every despair of the bourgeois—it is all there. By no one as by Daumier has the bourgeois been known and loved (after the fashion of artists)—the bourgeois, that last vestige of the middle ages, that Gothic ruin that dies so hard, that type at once so commonplace and so eccentric. Daumier has lived in intimacy with him, he has spied on him day and night, he has penetrated the mysteries of his bedroom, he has consorted with his wife and his children, he comprehends the form of his nose and the construction of his head, he knows the spirit that animates his house from top to bottom.

To make a complete analysis of Daumier's *œuvre* would be an impossibility; instead I am going to give the titles of his principal series of prints, without too much in the way of appreciation and commentary. Every one of them contains marvellous fragments.

Robert Macaire, Mœurs conjugales, Types parisiens, Pro-

[24] No. 12 of the series 'Les Philanthropes du jour', published in *Le Charivari*, 19th Oct. 1844 (Delteil 1304).

*fils et silhouettes, les Baigneurs, les Baigneuses, les Cano-
tiers parisiens, les Bas-bleus, Pastorales, Histoire ancienne,
les Bons Bourgeois, les Gens de Justice, la Journée de M.
Coquelet, les Philanthropes du jour, Actualités, Tout ce
qu'on voudra, les Représentants représentés.* Add the two
sets of portraits of which I have already spoken.*

I have two important observations to make about two of
these series—*Robert Macaire* and the *Histoire ancienne.
Robert Macaire*[25] was the decisive starting-point of the cari-
cature of manners. The great political war had died down
a little. The stubborn aggressiveness of the law, the atti-
tude of the government which had established its power,
and a certain weariness natural to the human spirit had
damped its fires a great deal. Something new had to be
found. The pamphlet gave way to the comedy. The *Satire
Ménippée*[26] surrendered the field to Molière, and the great
epic-cycle of Robert Macaire, told in Daumier's dazzling
version, succeeded to the rages of revolution and the draw-
ings of allusion. Thenceforth caricature changed its step;
it was no longer especially political. It had become the gen-
eral satire of the people. It entered the realm of the novel.

The *Histoire ancienne*[27] seems to me to be important be-
cause it is, so to say, the best paraphrase of the famous line
'*Qui nous délivrera des Grecs et des Romains?*'[28] Daumier

* A ceaseless and regular production has rendered this list more
than incomplete. Once, with Daumier himself, I tried to make
a complete catalogue of his works, but even together we could
not manage to do it. (c.b.) The catalogue by Delteil, to which
reference has been made in notes above, contains almost 4000
lithographic items.

[25] A hundred plates of this series appeared in *Le Charivari* be-
tween Aug. 1836 and Nov. 1838; and a further twenty between
Oct. 1840 and Sept. 1842. Daumier developed Robert Macaire
into a classic symbol of the rascally impostor; see Champfleury
(*op. cit.*) pp. 119 ff.

[26] A political pamphlet written in the form of a dramatic farce
in one act, with prologue and epilogue. It was directed against
the *Ligue,* and published in 1594.

[27] A series of 50 plates which appeared in *Le Charivari* between
Dec. 1841 and Jan. 1843 (Delteil 925–74); see pl. 76.

[28] The first line of a satire by Joseph Berchoux; Crépet, how-
ever, in his edition of the *Curiosités esthétiques,* attributes it to
M.-B. Clément.

came down brutally on antiquity—on false antiquity, that is, for no one has a better feeling than he for the grandeurs of antiquity. He snapped his fingers at it. The hot-headed Achilles, the cunning Ulysses, the wise Penelope, Telemachus, that great booby, and the fair Helen, who ruined Troy—they all of them, in fact, appear before our eyes in a farcical ugliness which is reminiscent of those decrepit old tragic actors whom one sometimes sees taking a pinch of snuff in the wings. It was a very amusing bit of blasphemy, and one which had its usefulness. I remember a lyric poet of my acquaintance[29]—one of the 'pagan school'—being deeply indignant at it. He called it sacrilege, and spoke of the fair Helen as others speak of the Blessed Virgin. But those who have no great respect for Olympus, or for tragedy, were naturally beside themselves with delight.

To conclude, Daumier has pushed his art very far; he has made a serious art of it; he is a *great* caricaturist. To appraise him worthily, it is necessary to analyse him both from the artistic and from the moral point of view. As an artist, what distinguishes Daumier is his sureness of touch. He draws as the great masters draw. His drawing is abundant and easy—it is a sustained improvisation; and yet it never descends to the 'chic'. He has a wonderful, an almost divine memory, which for him takes the place of the model. All his figures stand firm on their feet, and their movement is always true. His gift for observation is so sure that you will not find a single one of his heads which jars with its supporting body. The right nose, the right brow, the right eye, the right foot, the right hand. Here we have the logic of the *savant* transported into a light and fugitive art, which is pitted against the very mobility of life.

As a moralist, Daumier has several affinities with Molière. Like him, he goes straight to the point. The central idea immediately leaps out at you. You have only to look to have understood. The legends which are written at the foot of his drawings have no great value, and could generally be dispensed with.[30] His humour is, so to speak, involuntary. This artist does not search for an idea; it would

[29] Probably Théodore de Banville.
[30] They were mostly invented by Philipon.

be truer to say that he just lets it slip out. His caricature has a formidable breadth, but it is quite without bile or rancour. In all his work there is a foundation of decency and simplicity. Often he has gone so far as to refuse to handle certain very fine and violent satirical themes, because, he said, they passed the limits of the comic, and could wound the inner feelings of his fellow-men. And so, whenever he is harrowing or terrible, it is almost without having wished to be so. He has just depicted what he has seen, and this is the result. As he has a very passionate and a very natural love for nature, he would find difficulty in rising to the absolute comic. He even goes out of his way to avoid anything which a French public might not find an object of clear and immediate perception.

A word more. What completes Daumier's remarkable quality and renders him an exceptional artist who belongs to the illustrious family of the masters, is that his drawing is naturally coloured. His lithographs and his wood-engravings awake ideas of colour. His pencil contains more than just a black trace suitable for delineating contours. He evokes colour, as he does thought—and that is the sign of a higher art—a sign which all intelligent artists have clearly discerned in his works.

Henri Monnier made much of a stir a few years ago; he had a great success in the bourgeois world and in the world of the studios—which are both sorts of villages. And there are two reasons for this. The first is, like Julius Caesar, he fulfilled three functions at once—those of actor, writer and caricaturist. The second is that his talent is essentially a bourgeois one. As an actor he was cold and precise: as a writer, captious: and as an artist, he had discovered a method of doing his 'chic' from nature.

He is the exact counterpart of the man of whom we have just been speaking. Instead of instantly seizing upon the whole ensemble of a figure or a subject, Henri Monnier went to work by means of a slow and progressive examination of its details. He has never known great art. Take, for example, Monsieur Prudhomme,[31] that monstrously

[31] Monnier's best-known creation, a pompous and sententious bourgeois.

authentic type. Now Monsieur Prudhomme was never conceived on a large scale. Monnier studied him, the real, living Prudhomme; he studied him from day to day, over a very long period of time. I cannot tell how many cups of coffee Henri Monnier must have swallowed, or how many games of dominoes he must have played, before he arrived at that prodigious result. After studying him, he translated—no, he *traced* him on to his paper. At first sight the finished product strikes one as something extraordinary; but when all of Monsieur Prudhomme had been said, Henri Monnier had nothing left to say. Several of his *Scènes populaires*[32] are pleasant indeed—otherwise one would have to deny the cruel and amazing fascination of the daguerreotype; but Monnier is quite unable to create, to idealize, to arrange anything. To return to his drawings, which are the main object of our attention, they are generally cold and hard, and what is so odd is that, in spite of the sharpened precision of his pencil, there remains an element of vagueness in his thought. Monnier has a strange gift, but he has no more than one. It is the coldness, the limpidity of a mirror—of a mirror that cannot think, and contents itself with reflecting what passes in front of it.[33]

As for Grandville, he is quite another story. Grandville is a morbidly literary artist, always on the look-out for bastard means of projecting his thought into the domain of the plastic art; and so we have often seen him employing that old-fashioned device of the 'speaking balloon', attached to the mouths of his characters. A philosopher or a doctor would find material for a very pretty psychological or physiological study in Grandville. He spent his life seeking ideas, and sometimes he found them. But as he was an artist by profession and a man of letters by natural inclination, he never succeeded in expressing them properly. Naturally he touched upon several important questions, but he ended

[32] Published in 1830.

[33] Champfleury (*op. cit.* p. 243) relates how he was once in the company of a 'somewhat testy poet' (no doubt, Baudelaire), when the latter addressed a singular compliment to Monnier. 'Monsieur,' he said, 'I have for long wanted to congratulate you on your excellent *dictionaries*.'

by falling between two stools, being neither quite philosopher nor artist. During a large part of his life Grandville was much preoccupied with the general idea of Analogy. He even began that way—with the *Métamorphoses du jour*.[34] But he was never able to draw correct inferences from it; he tossed about hither and thither like a derailed locomotive. With superhuman courage this man devoted his life to refashioning creation. He took it in his hands, wrung it, rearranged it, explained it and annotated it; and Nature was transformed into a phantasmagoria. He turned the world upside down. Did he not, in fact, compose a picture-book called *Le Monde à l'envers?*[35] There are some superficial spirits who are amused by Grandville; for my part, I find him terrifying. For unfortunately it is the artist in whom I am interested, and not his drawings. When I open the door of Grandville's works I feel a certain uneasiness, as though I were entering an apartment where disorder was systematically organized—where preposterous cornices were propped up against the floor, where the pictures showed their faces through an optician's distorting-glass, where all the objects elbowed each other about obliquely, the furniture stood with its feet in the air, and the drawers slid inwards instead of out.

Doubtless Grandville produced some good and beautiful things, much assisted by his obstinate and meticulous habits; but he entirely lacked flexibility, and what is more, he was never able to draw a woman. But it is the lunatic side of his talent that makes Grandville important. Before his death he applied his always stubborn will to the noting of his successive dreams and nightmares in a plastic form,[36] with all the precision of a stenographer writing down an orator's speech. Grandville, the artist, wanted—he really wanted—his pencil to explain the law of the Association of Ideas! Grandville is indeed very comic; but he is often so without knowing it.

And now we come to an artist with an odd kind of charm,

[34] Published in 1829.

[35] Baudelaire is probably referring to Grandville's *Un autre monde* (1844).

[36] Also probably *Un autre monde*.

but who is very much more important. And yet he—Gavarni
—started by making engineering drawings; then he went on
to fashion-drawings; and he seems to me to have borne for
a long time the trace of these things. Nevertheless it is fair
to say that Gavarni has always shown progress. He is not
entirely a caricaturist, nor even uniquely a visual artist; he
is also a man of letters. He touches upon, he evokes. The
particular characteristic of his comic gift is a great nicety
of observation which sometimes goes as far as tenuity. Like
Marivaux, he knows the full force of understatement, which
is at once a lure and a flattery for the public intelligence.
He writes the legends to his own drawings, and they are
sometimes very intricate. Many people prefer Gavarni to
Daumier, and there is nothing surprising in that. Gavarni
is less of an artist, and therefore he is easier for them to
understand. Daumier is a frank and open genius. Take
away the text from one of his drawings, and it still remains
a thing of beauty and clarity. It is not the same way with
Gavarni; he is a double man—with him the legend is super-
added to the drawing. In the second place, Gavarni is not
essentially a satirist. Often he flatters instead of biting; he
encourages, he does not blame. Like all men of letters—
being a man of letters himself—he is very slightly tainted
with corruption. Thanks to the agreeable hypocrisy of his
thought and to the powerful tactics of innuendo, there is
nothing he does not dare. At other times, when his bawdry
openly declares itself, it dons a graceful garb, it caresses
the dogmas of fashion and takes the world into its confi-
dence. How could he fail to be popular? Here is one sample
among a thousand. Do you remember that fine, handsome
young woman who is giving a disdainful pout as she looks
at a young man clasping his hands to her in the attitude
of a suppliant? 'One little kiss, I beseech you, my good
kind lady, for the love of God!'—'Look in again this eve-
ning; your *father* has already had one this morning.' You
would really think that the lady must be a portrait. But
those rascals of Gavarni's are so engaging that young people
will inevitably want to imitate them. Note, besides, that the
best part is in the legend, the drawing itself being incapable
of saying so many things.

Gavarni created the *Lorette*. She existed, indeed, a little
before his time, but he *completed* her. I even believe it
was he who invented the word.[37] The Lorette, as has already
been observed, is not the same thing as the 'kept
woman', that feature of the Empire, condemned to live in
funereal intimacy with the clinking corpse—a general or a
banker—on which she depended. The Lorette is a free
agent. She comes and she goes. She keeps open house. She
is no one's mistress; she consorts with the artists and the
journalists. She does what she can to be witty. I said that
Gavarni had completed her; and in fact he is so swept along
by his literary imagination that he invents at least as much
as he sees, and for that reason he has had a considerable
effect upon manners. Paul de Kock[38] created the Grisette,
and Gavarni the Lorette; and not a few of those girls have
perfected themselves by using her as a mirror, just as the
youth of the Latin Quarter succumbed to the influence of
his *Students,* and as many people force themselves into the
likeness of fashion-plates.

Such as he is, Gavarni is a more than interesting artist, of
whom much will endure. It will be absolutely necessary to
peruse his works in order to understand the history of the
last years of the Monarchy. The Republic put him a little
in the shade, according to a cruel but natural law. He
emerged with the dawning of peace, and now he vanishes
with the storm. The veritable glory and the true mission
of Gavarni and Daumier were to complete Balzac, who,
moreover, was well aware of this, and reckoned them his
auxiliaries and commentators.

Gavarni's chief works are the following sets: *La Boîte
aux lettres, les Etudiants, les Lorettes, les Actrices, les
Coulisses, les Enfants terribles, Hommes et Femmes de
plume,* and a vast series of detached prints.

It remains for me to speak of Trimolet, Traviès and
Jacque.—Trimolet's was a melancholy destiny. To see the
graceful and childlike drollery which wafts through his
compositions, you would hardly suspect that his poor life

[37] The word was in fact 'invented' by Nestor Roqueplan, the
journalist and impresario.
[38] The popular novelist.

*Ici, la bouche est meilleure.
D'ailleurs, mêmes observations.*

1. BAUDELAIRE: SELF-PORTRAIT, *c.* 1860. Drawing.
M. Armand Godoy, Lausanne

BAUDELAIRE DUFAŸS

SALON DE 1846

> Aux bourgeois. — A quoi bon la critique ?
> Qu'est-ce que le romantisme ? — De la couleur.
> E. Delacroix.
> Des sujets amoureux et de Tassaert.
> De quelques coloristes.
> De l'idéal et du modèle. — De quelques dessinateurs.
> Du portrait. — Du chic et du poncif.
> Horace Vernet.
> De l'éclectisme et du doute.
> Ary Scheffer et les singes du sentiment.
> De quelques douteurs.
> Du paysage. — Pourquoi la sculpture est ennuyeuse.
> Des écoles et des ouvriers.
> De l'héroïsme de la vie moderne.

PARIS
MICHEL LÉVY FRÈRES, LIBRAIRES-ÉDITEURS
DES ŒUVRES D'ALEXANDRE DUMAS, FORMAT IN-18 ANGLAIS,
RUE VIVIENNE, 1.

1846

4. TASSAERT: 'DON'T PLAY THE HEARTLESS ONE!' Lithograph.
Bibliothèque Nationale, Paris

Opposite

2. BAUDELAIRE'S 'SALON DE 1846': Title-page.
British Museum, London

3. GAVARNI: THE ARTIST AND HIS CRITIC. Lithograph.
Victoria and Albert Museum, London

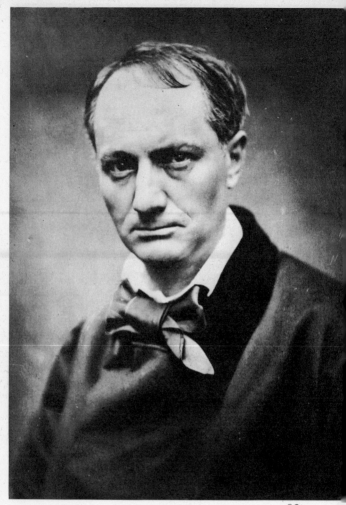

5. CARJAT: PHOTOGRAPH OF BAUDELAIRE, *c*. 1863

Opposite

6. MANET: PORTRAIT OF BAUDELAIRE, 1862. Etching.
Private Collection, London

7. LAMI: PORTRAIT OF DELACROIX. Water-colour, after a pastel
by Eugène Giraud. *Private Collection, France*

EUG. DELACROIX
Par Eug. LAMI

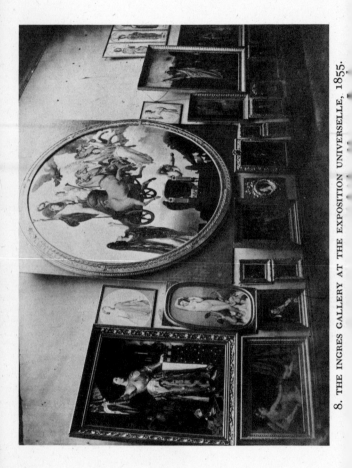

8. THE INGRES GALLERY AT THE EXPOSITION UNIVERSELLE, 1855.

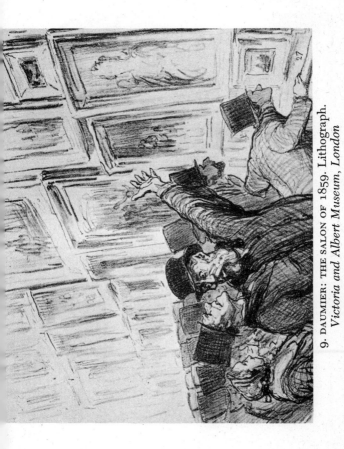

9. DAUMIER: THE SALON OF 1859. Lithograph.
Victoria and Albert Museum, London

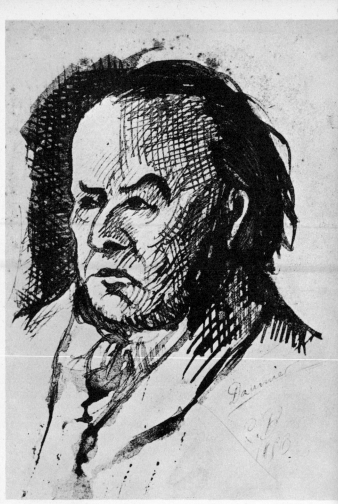

10. BAUDELAIRE: PORTRAIT OF DAUMIER, 1856. Drawing.
M. Armand Godoy, Lausanne

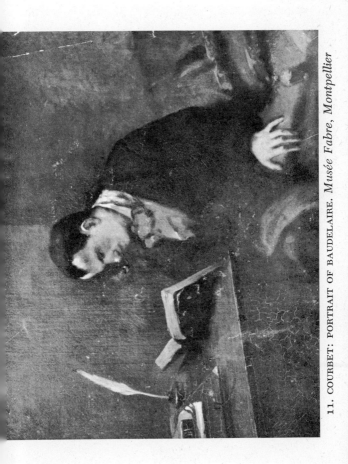

11. COURBET: PORTRAIT OF BAUDELAIRE. *Musée Fabre, Montpellier*

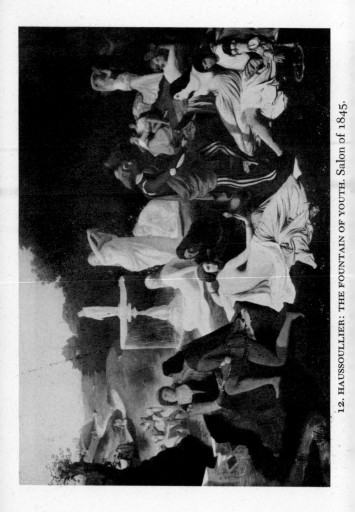

12. HAUSSOULLIER: THE FOUNTAIN OF YOUTH. Salon of 1845.

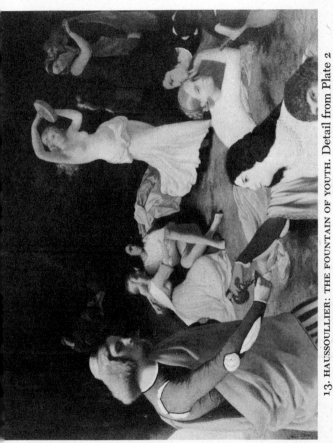

13. HAUSSOULLIER: THE FOUNTAIN OF YOUTH. Detail from Plate 2

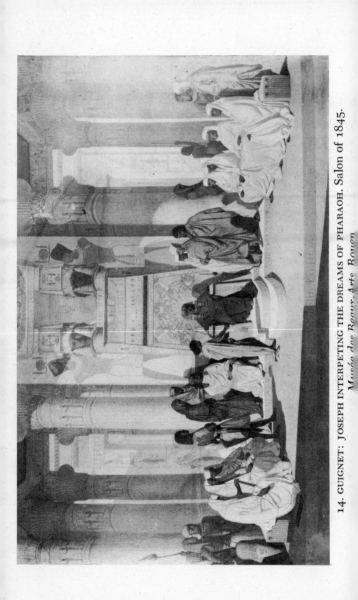

14. GUIGNET: JOSEPH INTERPETING THE DREAMS OF PHARAOH. Salon of 1845.

Musée des Beaux-Arts, Rouen

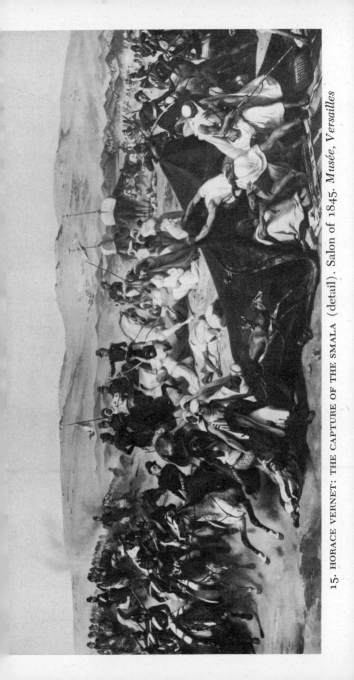

15. HORACE VERNET: THE CAPTURE OF THE SMALA (detail). Salon of 1845. *Musée, Versailles*

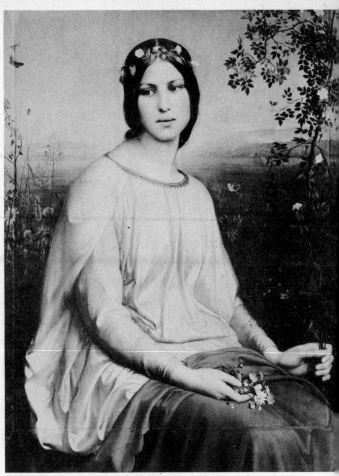

16. JANMOT: FLOWERS OF THE FIELD. Salon of 1845.
Musée des Beaux-Arts, Lyon

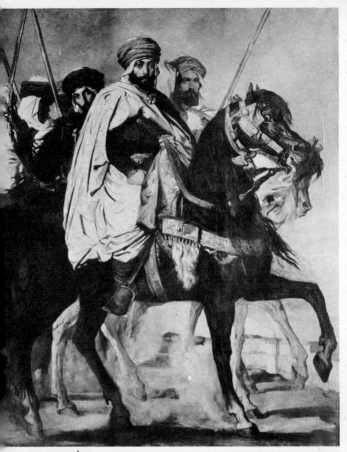

17. CHASSÉRIAU: THE CALIPH OF CONSTANTINE WITH HIS
BODYGUARD. Salon of 1845. *Musée, Versailles*

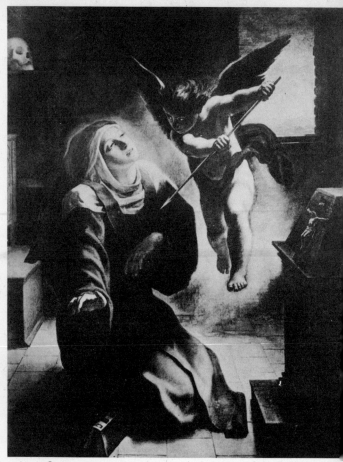

18. PLANET: THE VISION OF ST TERESA. Salon of 1845.
Private Collection, France

9. LASSALE BORDES: THE DEATH OF CLEOPATRA. Salon of 1846.
Musée Municipal, Autun

20. COROT: HOMER AND THE SHEPHERDS. Salon of 1845. *Musée, Saint-Lô*

21. COROT: LANDSCAPE—THE FOREST OF FONTAINEBLEAU. Salon of 1846.
Museum of Fine Arts, Boston

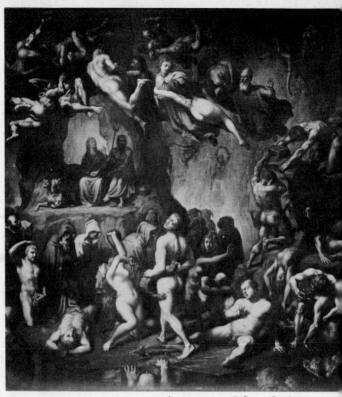

22. CHENAVARD: DANTE'S INFERNO. Salon of 1846.
Musée Fabre, Montpellier

Opposite

23. ARY SCHEFFER: ST AUGUSTINE AND ST MONICA. Salon of 1846
(version). *Tate Gallery, London*

24. DECAMPS: SOUVENIR OF TURKEY IN ASIA. Salon of 1846.
Musée Condé, Chantilly

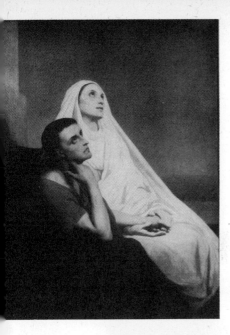

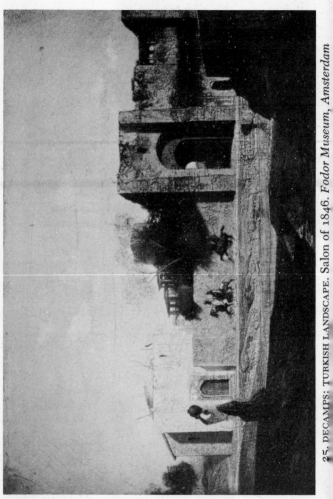

25. DECAMPS: TURKISH LANDSCAPE. Salon of 1846. *Fodor Museum, Amsterdam*

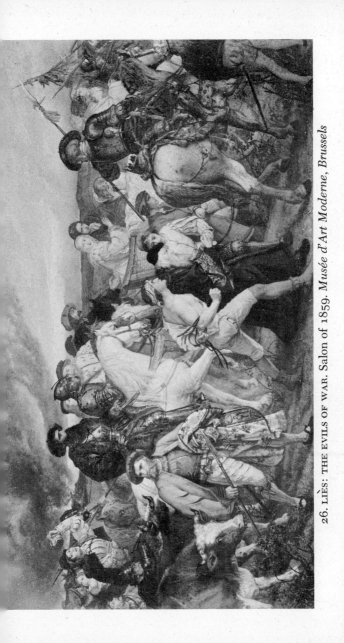

26. LIÈS: THE EVILS OF WAR. Salon of 1859. *Musée d'Art Moderne, Brussels*

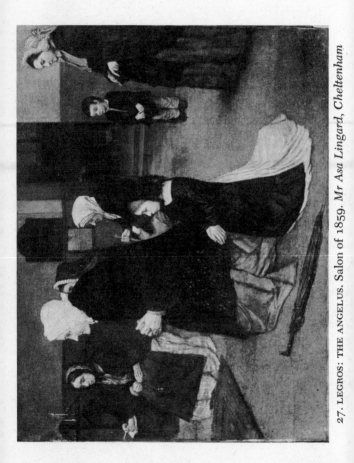

27. LEGROS: THE ANGELUS. Salon of 1859. *Mr Asa Lingard, Cheltenham*

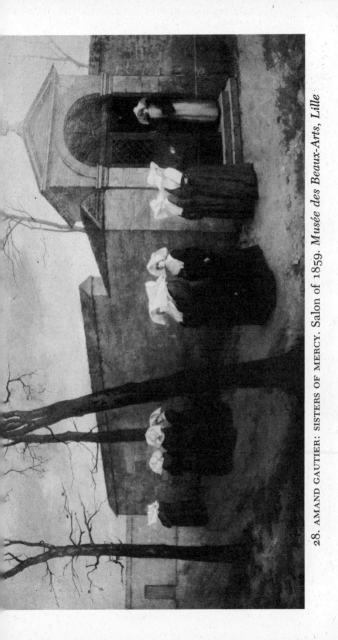

28. AMAND GAUTIER: SISTERS OF MERCY. Salon of 1859. *Musée des Beaux-Arts, Lille*

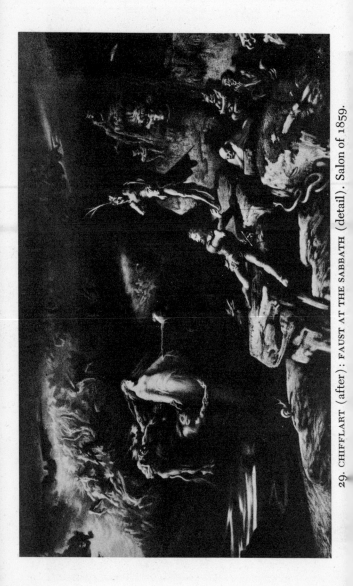

29. CHIFFLART (after) : FAUST AT THE SABBATH (detail). Salon of 1859.

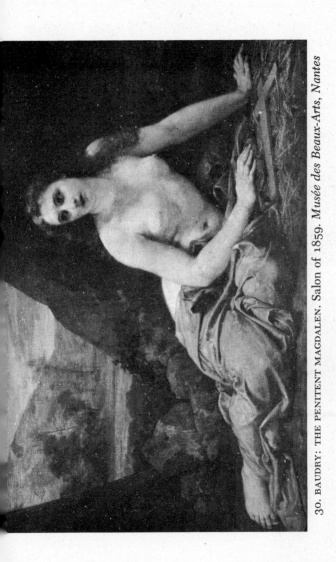

30. BAUDRY: THE PENITENT MAGDALEN. Salon of 1859. *Musée des Beaux-Arts, Nantes*

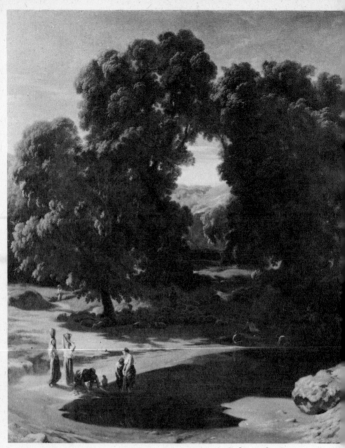

31. PAUL FLANDRIN: LANDSCAPE. Salon of 1859.
Musée Ingres, Montauban

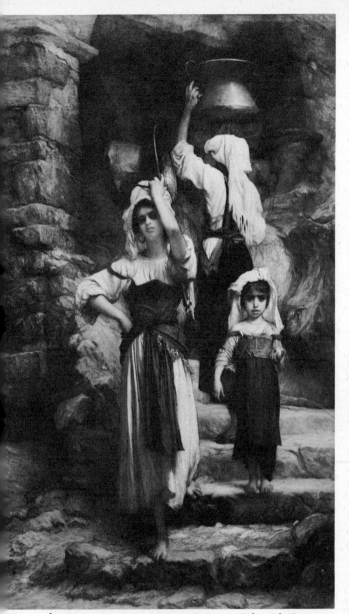

32. HÉBERT: PEASANT WOMEN OF CERVARO. Salon of 1859.
Musée du Louvre, Paris

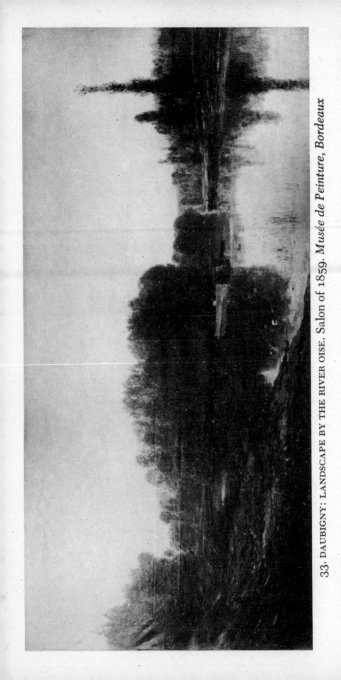

33. DAUBIGNY: LANDSCAPE BY THE RIVER OISE. Salon of 1859. *Musée de Peinture, Bordeaux*

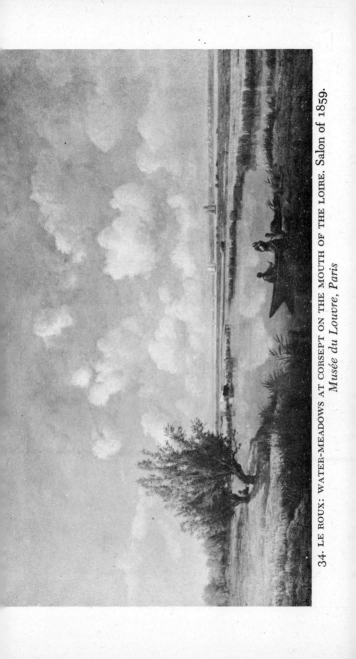

34. LE ROUX: WATER-MEADOWS AT CORSEPT ON THE MOUTH OF THE LOIRE. Salon of 1859.

Musée du Louvre, Paris

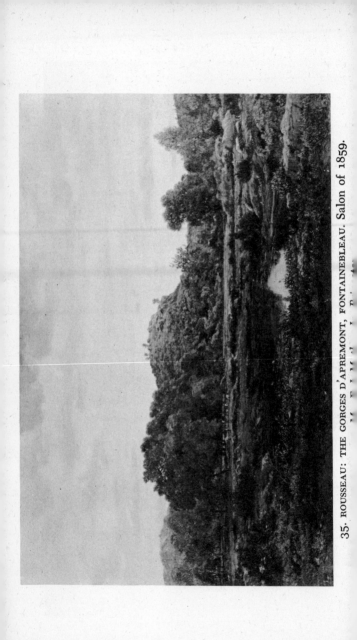

35. ROUSSEAU: THE GORGES D'APREMONT, FONTAINEBLEAU. Salon of 1859.

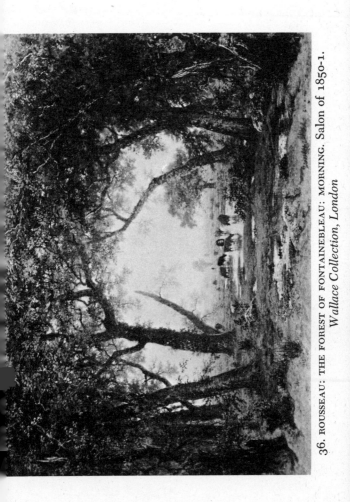

36. ROUSSEAU: THE FOREST OF FONTAINEBLEAU: MORNING. Salon of 1850-1.
Wallace Collection, London

37. MILLET: THE COWGIRL. Salon of 1859.
Musée de l'Ain, Bourg-en-Bresse

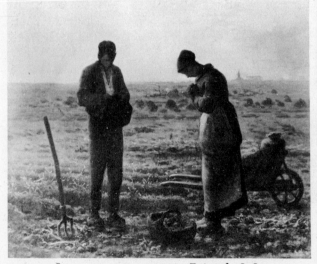

38. MILLET: THE ANGELUS. Painted 1858-9.
Musée du Louvre, Paris

39. BOUDIN: SKY-STUDY. Pastel, c. 1859. O'Hana Gallery, London

40 COROT: MACBETH AND THE WITCHES. Salon of 1859.

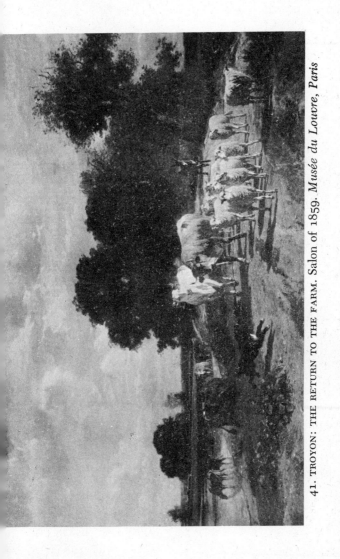

41. TROYON: THE RETURN TO THE FARM. Salon of 1859. *Musée du Louvre, Paris*

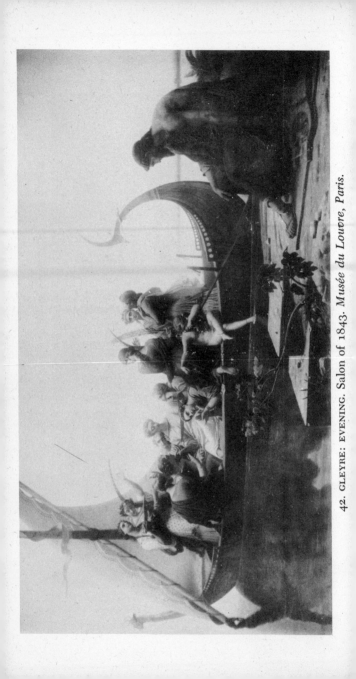

42. GLEYRE: EVENING. Salon of 1843. *Musée du Louvre, Paris.*

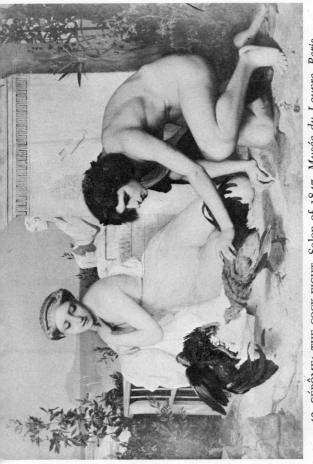

43. GÉRÔME: THE COCK-FIGHT. Salon of 1847. *Musée du Louvre, Paris*

44. GRANET: THE INTERROGATION OF SAVONAROLA.

45. HIPPOLYTE
FLANDRIN:
PORTRAIT OF
MME VINET.
Dated 1840.
*Musée du Louvre,
Paris*

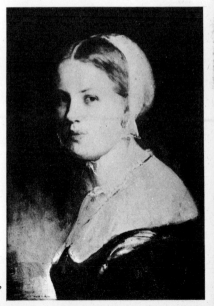

46. RICARD:
PORTRAIT OF A GIRL.
*Musée des Beaux-Arts,
Lyon*

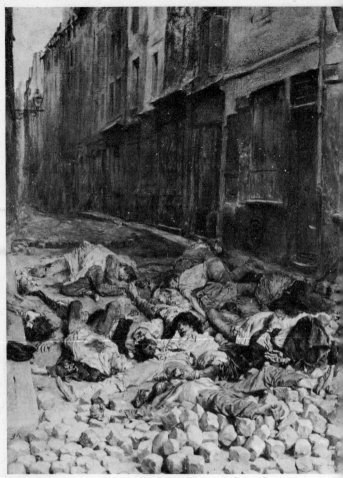

47. MEISSONIER: THE BARRICADE. Salon of 1850-1.
Musée du Louvre, Paris

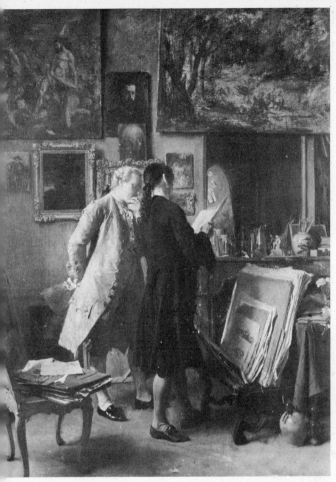

48. MEISSONIER: A PAINTER SHOWS HIS DRAWINGS.
Salon of 1850-1. *Wallace Collection, London*

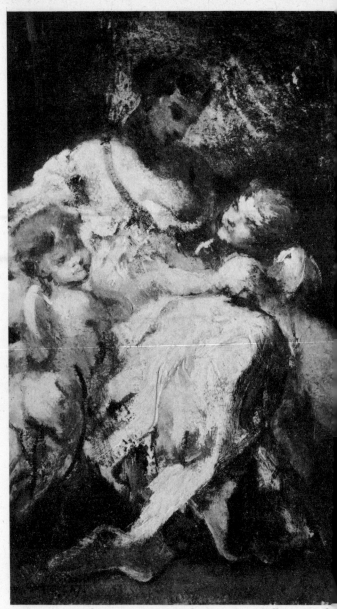

49. DIAZ: LOVE'S OFFSPRING. Dated 1847. *Tate Gallery, Londo*

50. DIAZ: STUDY OF TREES. *Metropolitan Museum of Art, New York*

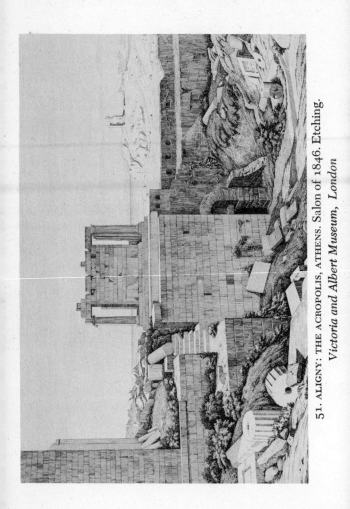

51. ALIGNY: THE ACROPOLIS, ATHENS. Salon of 1846. Etching.

Victoria and Albert Museum, London

52. CATLIN: BUFFALO-HUNT UNDER THE WOLF-SKIN MASK.
Smithsonian Institution, Washington

. CATLIN:
AH-TO-HE-HA,
E OLD BEAR.
mithsonian Institution,
ashington

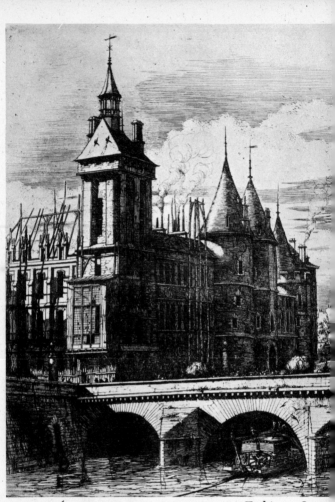

54. MÉRYON: THE CLOCK TOWER, PARIS. Etching, 1852.
Victoria and Albert Museum, London

Opposite

55. DAVID D'ANGERS: CHILD WITH A BUNCH OF GRAPES.
Salon of 1845. Marble. *Musée du Louvre, Paris*

56. PRADIER: THE FRIVOLOUS MUSE.
Salon of 1846. Marble. *Musée des Beaux-Arts, Nîmes*

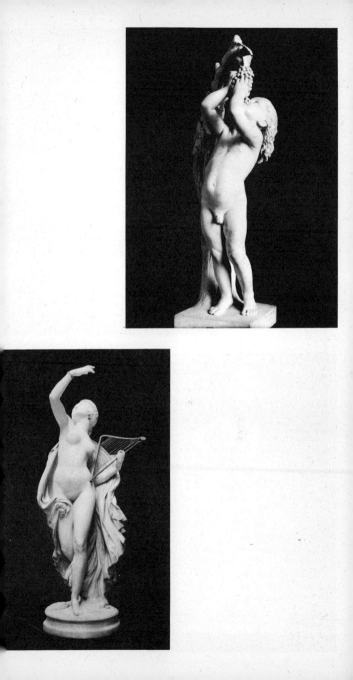

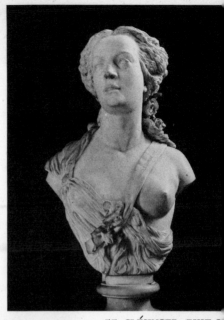

57. CLÉSINGER: BUST O
MADAME SABATIER.
Marble, 1847.
Musée du Louvre, Par

58. CHRISTOPHE:
'DANSE MACABRE'.
Terracotta (?), 1859.
*Formerly in the collection
of Comte Robert
de Montesquiou*

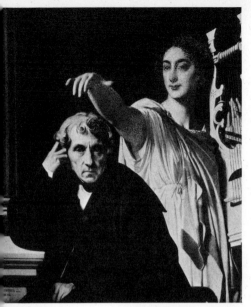

59. INGRES:
CHERUBINI AND
HIS MUSE.
Dated 1842.
Musée du Louvre, Paris

60. INGRES:
THE COMTESSE
D'HAUSSONVILLE.
Dated 1845.
*Frick Collection,
New York*

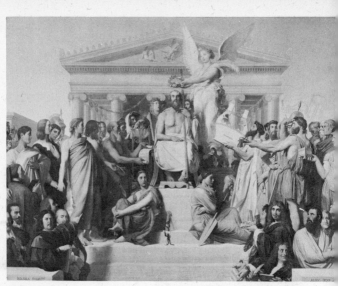

61. INGRES: APOTHEOSIS OF HOMER. Dated 1827.
Musée du Louvre, Paris

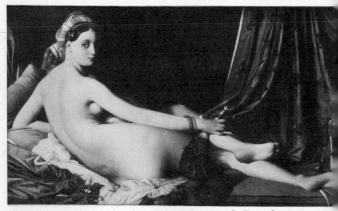

62. INGRES: THE 'GRANDE ODALISQUE'. Dated 1814.
Musée du Louvre, Paris

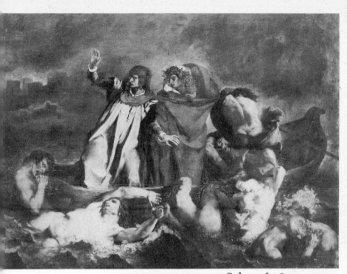

63. DELACROIX: DANTE AND VIRGIL. Salon of 1822.
Musée du Louvre, Paris

64. DELACROIX: WOMEN OF ALGIERS. Salon of 1834.
Musée du Louvre, Paris

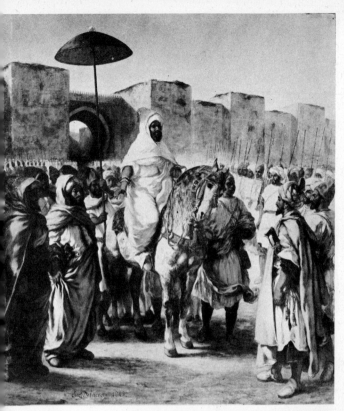

67. DELACROIX: THE SULTAN OF MOROCCO WITH HIS BODYGUARD.
Salon of 1845. *Musée des Augustins, Toulouse*

Opposite

65. DELACROIX: HAMLET AND THE GRAVEDIGGER. Salon of 1839.
Musée du Louvre, Paris

66. DELACROIX: ROMEO AND JULIET. Salon of 1846.
Formerly with Messrs Bernheim-Jeune, Paris

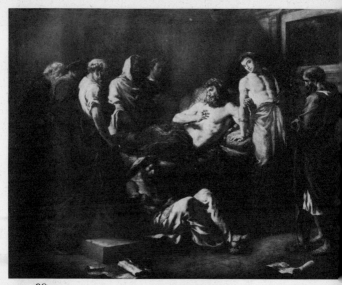

68. DELACROIX: THE LAST WORDS OF MARCUS AURELIUS.
Salon of 1845. *Musée des Beaux-Arts, Lyon*

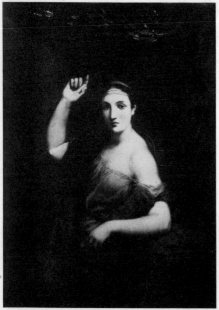

69. DELACROIX:
THE SIBYL WITH
THE GOLDEN BOUGH.
Salon of 1845.
*Formerly in
the collection of
M. Bessonneau*

70. DELACROIX: OVID IN EXILE AMONG THE SCYTHIANS. Salon of 1859. *Private Collection.*

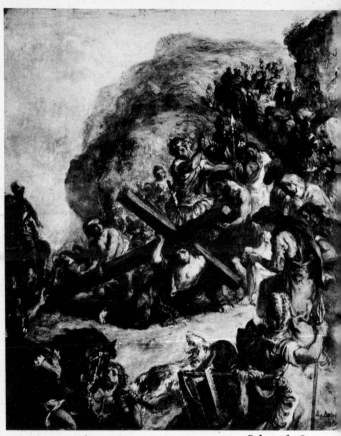

71. DELACROIX: THE ASCENT TO CALVARY. Salon of 1859.
Musée Central, Metz

Opposite

72. TRAVIÈS: LIARD—THE PHILOSOPHER TRAMP. Lithograph.
Victoria and Albert Museum, London

73. GAVARNI: AFTER THE BALL. Lithograph.
Bibliothèque Nationale, Paris

76. DAUMIER: DIDO AND AENEAS ('HISTOIRE ANCIENNE').
Lithograph. *Private Collection*

Opposite

74. PIGAL: 'THE OTHER FOOT, SIR, PLEASE!' Lithograph.
Victoria and Albert Museum, London

75. DAUMIER: ROBERT MACAIRE—BARRISTER. Lithograph.
Private Collection

Behold the Villain's dire disgrace!
Not Death itself can end:
He finds no peaceful Burial Place;
His breathless Corse, no friend.

Torn from the Root, that wicked Tongue,
Which daily swore and curst!
Those Eyeballs, from their Sockets wrung,
That glow'd with lawless Lust!

His Heart expos'd to prying Eyes,
To Pity has no Claim:
But dreadful! from his Bones shall rise,
His Monument of Shame.

77. HOGARTH: THE REWARD OF CRUELTY. Engraving.
Victoria and Albert Museum, London

78. GOYA: 'WHO WOULD HAVE BELIEVED IT?' Aquatint.
Victoria and Albert Museum, London

79. PINELLI: ROMAN CARNIVAL. Water-colour.

had been assailed by so many grievous afflictions and gnaw-
ng sorrows. He himself etched—for the collection of
Chansons populaires de la France[39] and for Aubert's *Comic
Almanacks*[40]—a number of very beautiful designs, or rather
sketches, in which the maddest and most innocent gaiety
reigns. Trimolet drew very complicated compositions freely
on the plate, without preliminary work—a procedure which
results, it must be admitted, in something of a muddle.
Obviously this artist had been very much struck by the
works of Cruikshank; but for all that, he kept his originality.
He is a humorist who deserves a place apart; he has a
flavour all his own, a subtle taste which fine palates must
find distinct from all others.

One day Trimolet painted a picture.[41] It was well con-
ceived, and the idea was a fine one: on a dark and soaking
night one of those old men who look like perambulating
ruins, or living bundles of rags, is lying stretched out at the
foot of a crumbling wall. He raises his eyes in gratitude
towards the starless sky, and cries out, 'I bless Thee, my
God, who hast given me this wall for my shelter and this
mat for my covering!' Like all the disinherited of the earth,
who feel the lash of affliction, this excellent fellow is not
hard to please, and for what remains he gladly puts his faith
in the All-Powerful. Whatever may be said by the tribe of
the optimists, who, according to Désaugiers,[42] have been
known to tumble down after drinking (at the risk of crush-
ing to pieces some 'poor man who has had no dinner'),
there are geniuses who have passed nights like that! Trimo-
let is dead; he died at the moment when the dawn was
already brightening his horizon and a kindlier fortune
seemed to want to smile upon him. His talent was growing;
his intellectual machinery was good and actively function-
ing; but his physical machinery had been gravely impaired
and undermined by the storms of the past.

Traviès, too, has had an ill-starred lot. In my opinion, he

Published in three volumes in 1843. Other illustrators col-
laborated on this work.

1842 and 1843.

Presumably *La Prière* (Salon 1841).

A prolific writer of *vaudevilles*.

is an outstanding artist, and one who was not nicely ap
preciated in his own time. He has produced much, but he
lacks sureness. He wants to be amusing, and you can be
certain that he will fail. Or else he will make a beautiful
discovery—and fail to recognize it. He amends and correct
himself without ceasing; he turns and returns, forever pur
suing an intangible ideal. He is the prince of bad luck.[43]
His muse is a nymph, but a nymph of the suburbs—a little
wan and melancholy. But through all his tergiversation
you can always follow a subterranean vein of quite note
worthy character and colour. Traviès has a deep feeling
for the joys and griefs of the people; he knows the rabble
through and through, and may be said to have loved i
with a tender sympathy. That is the reason why his *Scène
bachiques*[44] will remain a remarkable work; besides, those
tramps of his are generally very lifelike, and all their rag
and tatters have that almost undefinable fulness and nobilit
of a style ready-made, such as nature often provides in he
odd moments. We must not forget that Traviès is th
creator of *Mayeux*,[45] that true, eccentric character wh
amused Paris so much. Mayeux is his, just as *Rober
Macaire* is Daumier's and *M. Prudhomme* belongs to Mon
nier. At that already distant time there was in Paris a son
of *physiognomanic* clown called Léclaire, who did the rou
of the outlying taverns, the drinking clubs and the little
theatres. He was a puller of expressive faces, and, sittin
between two candles, he used to illumine his features with
all the passions in turn. It was the volume of the *Caractère
des passions de M. Lebrun, peintre du roi*,[46] all over again
This man was a very melancholy soul—a ridiculous acciden
more common than one supposes among the eccentri

[43] *Le prince du guignon.*

[44] Published 1839.

[45] The subject of some 160 lithographs published in *La Carica
ture* and elsewhere. One writer describes him as 'ce fantoch
priapique'. Other artists, such as Grandville, also used the cha
acter.

[46] Charles Lebrun's *Méthode pour apprendre à dessiner les Pa
sions* was extremely influential throughout the late 17th and th
entire 18th century, and was much translated.

classes—and he was possessed by a mania for friendship. Apart from his studies and his grotesque performances, he spent his time searching for a friend, and when he had had a drink, his eyes would overflow with the tears of solitude. This poor fellow possessed such *objective* power and so great an aptitude for make-up that he could imitate to the very life the hump and wrinkled brow of a hunch-back, no less than his great simian paws and noisy, slobbering utterance. Traviès saw him—it was in the midst of the great patriotic fervours of July—and a radiant idea exploded in his brain. Mayeux was created; and for a long time the turbulent Mayeux spoke, shouted, perorated and gesticulated in the memory of the Parisian people.[47] Since that time it has been recognized that Mayeux really existed, and it has been thought that Traviès knew and copied him. The same thing has occurred with several other popular creations.

Some time ago Traviès disappeared from the scene—I do not quite know why, for there is today, as always, a healthy growth of comic albums and journals. It is a real misfortune, for he is an acute observer, and in spite of his hesitations and failings, there is a seriousness and a sensitivity about his talent that make it singularly engaging.

I feel that I should warn collectors of the Mayeux caricatures that the women who, as is well known, played so great a part in the epic history of this gallant and patriotic Ragotin,[48] are not by Traviès; they are by Philipon, who had this exceptionally comic idea, as well as a fascinating way of drawing women. And so it came about that he reserved to himself the pleasant task of doing the women in the Mayeux caricatures of Traviès, and that in this way each drawing came to have a *lining* in a different style—which, however, can hardly be said to *underline* their comic intention.[49]

[47] The whole of the above passage dealing with Léclaire is quoted by Champfleury (*op. cit.*, pp. 198–9). Beyond admitting the plausibility of the explanation, as far as it goes, Champfleury does not offer any confirmation.

[48] A grotesque character in Scarron's *Roman comique*.

[49] M. Claude Ferment, who has recently been studying Traviès,

Jacque, that excellent artist with his multiple intelligence, has also on occasions shown himself an admirable caricaturist. Apart from his paintings and his etchings, in which he has always revealed a solemn poetry, he has also been responsible for some very good grotesque drawings in which the central idea usually tells at first sight. See, for example, his *Militairiana*[50] and his *Malades et Médecins*.[51] He draws richly and with wit, and his caricature, like everything else of his, has the pungency and the immediacy of the poet-observer.

informs me that he has been able to detect the possible hand of Philipon in only a relatively small number of the Mayeux caricatures.

[50] Published in the *Musée Philipon*.

[51] Published in *Le Charivari*, 1843.

SOME FOREIGN CARICATURISTS

HOGARTH—CRUIKSHANK—GOYA—PINELLI—
BRUEGHEL

I

An altogether popular name, not only with artists but also in the polite world: an artist among the most eminent in the sphere of the comic, who fills the memory like a proverb—that is Hogarth. I have often heard it said of Hogarth that he is the death and burial of the comic muse. Well, I have no objection to that. The remark can of course be taken as a witticism, but I am anxious for it to be understood as a tribute; for my part, I find in this ill-intentioned axiom the symptom and the diagnosis of a quite especial merit. Be assured, however, that Hogarth's talent does indeed include in its composition a cold, astringent and funereal ingredient. It wounds and harrows. Brutal and violent, yet always absorbed with the moral meaning of his compositions—a moralist, in fact, before all else—Hogarth, like our Grandville, loads them with allegorical and allusive details whose function, according to him, is to complete and elucidate his thought. For the spectator, however—I was just about to say, for the *reader*—the reverse sometimes happens, so that they may end by retarding and confusing the intelligence.

However, like all very adventurous artists, Hogarth has quite a variety of styles and samples to offer. He does not always adopt so harsh, so literary and so fidgety a manner. Compare, for example, the plates of *Marriage à-la-mode* with *The Rake's Progress, Gin Lane, The Enrag'd Musician* and the *Distress'd Poet,* and in these latter you will recognize a far greater freedom and spontaneity. Undoubtedly one of the most curious of all is the plate which shows us a corpse stretched out stiff and flat on the dissection-table.[1] On a pulley, or some other piece of tackle attached to the ceiling, the intestines of the dead debauchee are being unwound. How horrible is this most corpse-like of corpses!

The Reward of Cruelty. See pl. 77.

and what could provide a more singular contrast to it than
the surrounding figures of all those British doctors—tall
long, skinny or stout, grotesquely solemn and topped with
monstrous periwigs? In one corner there is a dog glutton
ously foraging in a bucket and filching some human remain
from it. Hogarth, the death and burial of the comic muse
I would sooner call him the comic muse of death and
burial. Hogarth's man-eating dog has always put me in
mind of that historical pig which outraged all decency by
getting drunk on the blood of the hapless Fualdès, while
a barrel-organ provided the dying man with a funeral
service, so to speak.[2]

I declared a moment ago that our studio witticism ought
to be taken in the sense of a tribute. And indeed with
Hogarth I do find myself renewing acquaintance with that
indefinable breath of the sinister, the violent and the ruth
less which characterizes almost every product of the land
of spleen. *Gin Lane*, for example, quite apart from the
innumerable mishaps and the grotesque disasters with
which the path of a drunkard's life is strewn, includes
some terrible incidents too, which scarce seem comic from
our French point of view; these are almost always cases of
violent death. But this is not the place to make a detailed
analysis of Hogarth's works; numerous appreciations of
this unique and punctilious moralist have already been
written, and I want to limit myself to establishing the
general character which informs the works of each im
portant artist.

While we are on the subject of England it would be un
just not to mention Seymour, whose admirable squibs on
shooting and fishing—that two-fold epic of fanaticism—are
familiar to all. He was the original inventor of the marvel
lous allegory of the spider weaving her web between the
arm and the line of a fisherman who sits so still that no
impatience could ever disturb his composure.[3]

As with the rest of the English, we find in Seymour

[2] Fualdès was assassinated at Rodez in 1817. The barrel-organ
was part of the plot, being played in order to drown his cries.
The matter became a *cause célèbre*.
[3] The idea was afterwards borrowed by Monnier.

violence, a love of the excessive, and a simple, ultra-brutal and direct manner of stating his subject; when it comes to caricature, the English are extremists. 'Oh! the deep, deep sea!' cries a stout Londoner in blissful contemplation, serenely seated in a rowing boat, a quarter of a league from harbour.[4] I fancy that you can still even make out a few rooftops in the distance. This imbecile is in such an extreme of ecstasy that he does not notice the two stout legs of his dear wife, projecting above the level of the water and standing straight up, toes in air. It seems that this massive party has allowed herself to tumble head first into that very liquid element whose sight so stirs the thick brain of her spouse. Her legs are all that we can see of the unhappy creature. Soon enough that stalwart nature-lover will be looking round phlegmatically for his wife—and he will not find her.

The special merit of George Cruikshank—setting aside all his other merits, his subtlety of expression, his understanding of the fantastic, etc.—is his inexhaustible abundance in the grotesque. A verve such as his is unimaginable, nor indeed would it be credited if the proofs were not before our very eyes in the form of an immense *œuvre*, a numberless collection of vignettes, a long series of comic albums—in short, of such a quantity of grotesque characters, situations, scenes and physiognomies that the observer's memory quite loses its bearings. The grotesque flows inevitably and incessantly from Cruikshank's etching-needle, like pluperfect rhymes from the pen of a natural poet. The grotesque is his natural habit.

If it was possible to make an unerring analysis of a thing so fugitive and impalpable as *feeling* in art—that indefinable something which always distinguishes one artist from another, however close their kinship may be in appearance—I should say that the essence of Cruikshank's

No. 153 in *Sketches by Seymour* (1867), a collection of Seymour's *Humorous Sketches* which had been published separately, at 3d each, between 1834 and 1836. The caption continues: 'Mr. Dobbs singing "Hearts as warm as those above lie under the waters cold." ' Seymour was the illustrator of the first two parts of *The Pickwick Papers*, and thus the creator of the original image of Mr. Pickwick. See p. 180.

grotesque is an extravagant violence of gesture and move-
ment, and a kind of explosion, so to speak, within the
expression. Each one of his little creatures mimes his part
in a frenzy and ferment, like a pantomime-actor. The only
fault that one might criticize is that he is often more of a
wit, more of a *cartoonist*, than an artist; in short, that he is
not always an entirely conscientious draughtsman. You
might suppose that in the pleasure that he feels in giving
way to his prodigious *verve*, the artist forgets to endow his
characters with a sufficient vitality. He draws a little too
much like those men of letters who amuse themselves
scribbling sketches. His fascinating little creatures are not
always born to live and breathe. The whole of this diminu-
tive company rushes pell-mell through its thousand capers
with indescribable high spirits, but without worrying too
much if all their limbs are in their proper places. Only too
often they are no more than human hypotheses, which
wriggle about as best they can. In a word, such as he is,
Cruikshank is an artist endowed with rich comic gifts, and
one who will retain his place in every collection. But what
is one to say of those modern French plagiarists whose im-
pertinence goes to the length of appropriating not only his
subjects and ideas, but even his manner and style? But
happily *naïveté* is not a thing to be stolen. Their assumed
childishness has not raised their temperature by one degree,
and the quality of their draughtsmanship leaves even more
to be desired than that of their victim.

II

NEW HORIZONS in the comic have been opened up in Spain
by a most extraordinary man.

On the subject of Goya, I must start by referring my
readers to Théophile Gautier's excellent article in the
Cabinet de l'Amateur,[1] which has since been reprinted in
a miscellaneous volume. Théophile Gautier is perfectly
equipped to understand a nature such as Goya's. Moreover,
with reference to his technical methods—aquatint and etch-

[1] Vol. I, 1842, pp. 337 ff.; reprinted in the *Voyage en Espagne*.

ing mixed, with heightenings of drypoint—the article in question contains all that is required. All I want to do is to add a few words upon that very precious element which Goya introduced into the comic—I want to speak about the *fantastic*. Goya does not fit exactly into any of the special or particular categories; his is neither the absolute nor the purely significative comic, in the French manner. Often of course he plunges down to the savage level, or soars up to the heights of the absolute, but the general aspect under which he sees things is above all fantastic; or rather, the eye which he casts upon things translates them naturally into the language of fantasy. The *Caprichos* are a marvellous work, not only on account of the originality of their conceptions, but also on account of their execution. I like to imagine a man suddenly faced with them—an enthusiast, an amateur, who has no notion of the historical facts alluded to in several of these prints, a simple artistic soul who does not know the first thing about Godoy, or King Charles, or the Queen; but for all that he will experience a sharp shock at the core of his brain, as a result of the artist's original manner, the fulness and sureness of his means, and also of that atmosphere of fantasy in which all his subjects are steeped. I would go further and say that in works which spring from profoundly individual minds there is something analogous to those periodical or chronic dreams with which our sleep is regularly besieged. That is the mark of the true artist, who always remains firm and indomitable even in those fugitive works—works which are, so to speak, hung upon events—which are called *caricatures*. That, I declare, is the quality which distinguishes *historical* from *artistic* caricaturists—the fugitive from the eternal comic.

Goya is always a great and often a terrifying artist. To the gaiety, the joviality, the typically Spanish satire of the good old days of Cervantes he unites a spirit far more modern, or at least one that has been far more sought after in modern times—I mean a love of the ungraspable, a feeling for violent contrasts, for the blank horrors of nature and for human countenances weirdly animalized by circumstances. It is curious to note that this man, who fol-

lowed after the great destructive and satirical movement of
the 18th century and to whom Voltaire would have
acknowledged his debt for all those monastic caricatures of
his—for all those monks yawning or stuffing their stomachs,
those bullet-headed cut-throats preparing for matins, those
brows as crafty, hypocritical, sharp and evil as profiles of
birds of prey (or rather for the idea only of these things,
for the great man is to be pitied for not being much of a
connoisseur in other artistic matters); it is curious, I say,
that this monk-hater should have dwelt so much on witches,
sabbaths, scenes of devilry, children roasting on the spit,
and Heaven knows what else—on every debauchery of
dream, every hyperbole of hallucination, and not least,
on all those slim, blond Spanish girls of his, with ancient
hags in attendance to wash and make them ready for the
Sabbath, perhaps, or it may be for the evening rite of pros-
titution, which is civilization's own Sabbath! Light and
darkness play across all these grotesque horrors; and what
a singular kind of playfulness! Two extraordinary plates
above all come to mind. The first[2] represents a fantastic
landscape, a conglomeration of clouds and boulders. Is it
a corner of some unknown and unfrequented Sierra? or a
sample of primeval chaos? There, at the heart of that
abominable theatre, a life-and-death struggle is taking place
between two witches, hanging in mid-air. One is astride the
other, belabouring and mastering her. Locked together
these two monsters are spinning through the gloomy void.
Every kind of hideousness, every vice and moral filthiness
that the human mind can conceive, is written upon these
two faces which, according to a frequent custom and an
inscrutable procedure of the artist's, stand half-way be-
tween man and beast.

The second plate[3] shows us a wretched being, a des-

[2] *Caprichos*, No. 62, 'Quien lo creyera!' See pl. 78.

[3] Klingender (*Goya in the Democratic Tradition*, London 1948,
p. 221) suggests that Baudelaire is here confusing his recollec-
tion of *Capricho* No. 59 ('Y aun no se van!') with Gautier's
description of the *Nada* print in the *Desastres de la guerra*.
Certainly Baudelaire's description is inaccurate if he has *Ca-
pricho* No. 59 in mind.

perate and solitary monad whose one desire is to get out
of its tomb. A crowd of mischievous demons, a myriad
lilliputian gnomes are bearing down with all their united
efforts upon the cover of the half-gaping sepulchre. These
watchful guardians of death have banded together against
a rebellious soul which is wearing itself out in its impos-
sible struggle. This throbbing nightmare is set amidst all
the horror of the vague and the indefinite.

At the end of his career Goya's eyesight weakened to the
point at which it is said that his pencils had to be sharpened
for him. Yet even at this stage he was able to produce some
large and very important lithographs, amongst them a set
of bullfighting scenes,[4] full of rout and rabble, wonderful
plates, vast pictures in miniature—new proofs in support
of that curious law which presides over the destinies of
great artists, and which wills it that, as life and understand-
ing follow opposing principles of development, so they
should win on the swings what they lose on the round-
abouts, and thus should tread a path of progressive youth
and go on renewing and reinvigorating themselves, growing
in boldness to the very brink of the grave.

In the foreground of one[5] of these prints, in which a
wonderful tumult and hurly-burly prevails, is an enraged
bull—one of the spiteful kind that savage the dead. It has
just unbreeched the hinder parts of one of the combatants.
No more than wounded, the poor wretch is heavily drag-
ging himself along on his knees. The formidable beast has
lifted his torn shirt with its horns, thus exposing his but-
tocks to view; and now, once again, down comes that
threatening muzzle—but the audience is scarcely moved by
this unseemly episode amid the carnage.

Goya's great merit consists in his having created a
credible form of the monstrous. His monsters are born
viable, harmonious. No one has ventured further than he
in the direction of the *possible* absurd. All those distortions,
those bestial faces, those diabolic grimaces of his are im-
pregnated with *humanity*. Even from the special view-
point of natural history it would be hard to condemn them,

[4] The four lithographs known as the 'Toros de Burdeos'.
[5] *Dibersión de España*.

so great is the analogy and harmony between all the parts
of their being. In a word, the line of suture, the point of
junction between the real and the fantastic is impossible
to grasp; it is a vague frontier which not even the subtlest
analyst could trace, such is the extent to which the tran-
scendent and the natural concur in his art.*

III

HOWEVER SOUTHERN it may be, the climate of Italy is not
that of Spain, and the fermentation of the comic in that
country does not produce the same results. The pedantry
of the Italians—I use that word for want of a better—has
found its expression in the caricatures of Leonardo da Vinci
and in Pinelli's scenes of contemporary manners. Every
artist knows Leonardo's caricatures—they are veritable por-
traits. Cold and hideous, those caricatures are not lacking
in cruelty—it is the comic that they lack; there is no ex-
pansiveness, no abandon about them, for the great artist
was not amusing himself when he drew them; he made
them, rather, in his capacity as savant, geometrician, pro-
fessor of natural history. He was careful not to omit the
least wart, the smallest hair. Perhaps, on the whole, he laid
no claim to be doing caricatures. He looked round him for
eccentric types of ugliness, and copied them.

Nevertheless the Italian character is not like this as a
rule. Its humour is low, but it is open and frank. We can
get a just idea of it from Bassano's pictures representing
the Venetian carnival.[1] Here we find a gaiety which is
bubbling over with sausages, hams and macaroni. Once a
year the Italian comic spirit makes its explosion in the
Corso, and then it reaches the bounds of frenzy. Everyone

* Some years ago we possessed several precious paintings by
Goya, though they were unhappily relegated to obscure corners
of the gallery; they disappeared, however, along with the
Musée Espagnol. (C.B.) See n. on p. 3.

[1] One such painting, by Leandro Bassano, is in the Kunsthis-
torisches Museum, Vienna, and it is possible that Baudelaire
may have seen a print of it. Even so, the name of Bassano seems
an odd one in the present context.

is witty, everyone becomes a comic artist; Marseilles or Bordeaux could perhaps provide us with samples of similar temperaments. Just see how well Hoffmann understood the Italian character in his *Princess Brambilla*, and how sensitively it is discussed by the German artists who drink at the Café Greco![2] But the Italian artists are clowns rather than comics. They lack depth, but they all submit to the sheer intoxication of their national gaiety. Materialistic, as the South generally is, their humour always smacks of the kitchen and the bordello. But all things considered, it is Callot, a French artist, who, by the concentration of wit and the firmness of will proper to our country, has given its finest expression to this species of the comic. It is a Frenchman who has remained the best Italian clown.

A short while ago I spoke of Pinelli, the classic Pinelli, whose glory is now a very diminished one. We would not call him a caricaturist, exactly—he is rather a *snapper-up* of picturesque scenes. I only mention him at all because the days of my youth were burdened by hearing him praised as the type of the *noble caricaturist*. In point of fact, the comic does not enter into his composition at all, save in infinitesimal doses. What we find in all the artist's studies is a constant preoccupation with line and with antique compositions, a systematic aspiration towards style.

But Pinelli—and this has doubtless contributed not a little to his reputation—Pinelli had an existence which was much more romantic than his talent. His originality displayed itself far more in his character than in his works. For he was one of the most perfect types of the *artist*, as the good bourgeois imagines him to be—that is, of classic disorder, of inspiration expressing itself in unseemly and violent behaviour. Pinelli possessed all the charlatanism of certain artists: his two enormous dogs which followed him everywhere, like comrades or confidants, his great gnarled stick, his locks in double pigtails framing his cheeks, the tavern, the low company, the deliberate practice of ostentatiously destroying works for which he was not offered a

[2] The Café Greco, in the Via Condotti, Rome, had been a favourite resort of artists and writers since the latter part of the 18th century.

satisfactory price—all these things formed part of his reputa-
tion. And Pinelli's household was hardly better ordered
than the conduct of its master. Sometimes he returned
home to find that his wife and daughter had come to blows,
their eyes flashing fire in all the fury and excitability of their
race. To Pinelli this was superb: 'Stop!' he shouted to them.
'Don't move! Stay still!' And the drama was transformed
into a drawing. It is clear that Pinelli was one of those
artists who wander through objective nature in the hope
that she will come to the aid of their mental laziness, and
who are always ready to *snatch up their brushes*. And thus,
in one respect, he may be likened to the unfortunate Léo-
pold Robert, who also claimed to find in, and only in, nature
those ready-made subjects which, for more imaginative
artists, are only good for notes. And yet Pinelli, no less than
Léopold Robert, always put these subjects—and even the
most nationally comic and picturesque of them—through
the sieve, through the merciless filter of *taste*.

Has Pinelli been slandered? I do not know; but such is
his legend. Now all this seems to me to be a sign of weak-
ness. I wish that someone would invent a neologism, I wish
that someone would manufacture a word destined to blast
once and for all this species of the 'poncif'—the 'poncif' in
conduct and behaviour, which creeps into the life of artists
as into their works. And besides I cannot help noticing that
history frequently presents us with the contrary, and that
those artists who are the most inventive, the most astonish-
ing and the most eccentric in their conceptions are often
men whose life is calm and minutely ordered. Several of
them have had the most highly-developed domestic virtues.
Have you not often noticed that there is nothing more like
the perfect bourgeois than the artist of concentrated genius?

IV

FROM the beginning the Flemish and the Dutch have done
very fine things, of a really special and indigenous char-
acter. Everyone is familiar with the extraordinary, early

productions of Brueghel 'the Droll',[1] who is not to be confused with 'Hell' Brueghel,[2] as several writers have done. That he betrays a certain systematization, a certain convention of eccentricity, a method in the bizarre, is in no doubt. But it is also quite certain that this weird talent of his has a loftier origin than in a species of artistic wager. In the fantastic pictures of Brueghel the Droll the full power of hallucination is revealed to us. But what artist could produce such monstrously paradoxical works if he had not been driven from the outset by some unknown force? In art—and this is a thing which is not sufficiently observed—in art, the portion that is left to the human will is much less great than is generally believed. The baroque ideal which Brueghel seems to have pursued shows many affinities with that of Grandville, particularly if you will examine carefully the tendencies which the French artist displayed during the last years of his life: visions of a sick brain, hallucinations of fever, dream's-eye transformations, bizarre associations of ideas, fortuitous and anomalous combinations of forms.

The works of Brueghel the Droll can be divided into two classes. The first contains political allegories which are almost undecipherable today; it is in this series that you find houses with eyes instead of windows, windmills with human arms for wings, and a thousand other terrifying compositions in which nature is ceaselessly transformed into a kind of anagram. And yet it is quite often impossible to decide whether this kind of composition belongs to the class of political and allegorical designs, or to the second class, which is patently the more curious. The works in this second class seem to me to contain a special kind of *mystery*, although the present age, which, thanks to its double character of incredulity and ignorance, finds nothing difficult to explain, would doubtless qualify them simply as fantasies and capriccios. The recent researches of a few doctors[3] who have at last glimpsed the need to explain a

[1] Peter Brueghel, the Elder.

[2] Peter Brueghel, the Younger.

[3] Baudelaire may be thinking of such doctors as Brierre de Boismont and J. J. Moreau (de Tours), whose *Des Hallucina-*

mass of historical and miraculous facts otherwise than by
the means of the Voltairean school (which could nowhere
see further than cleverness in charlatanry)—even these re-
searches are very far from disentangling all the secret
mysteries of the soul. Now I challenge anyone to explain
the diabolic and diverting farrago of Brueghel the Droll
otherwise than by a kind of special, Satanic grace. For the
words 'special grace' substitute, if you wish, the words
'madness' or 'hallucination'; but the mystery will remain
almost as dark. Brueghel's collected works[4] seem to spread
a contagion; his absurd capers make one's head swim. How
could a human intelligence contain so many marvels and
devilries? how could it beget and describe so many terrify-
ing extravagances? I cannot understand it, nor can I pos-
itively determine the reason. But often in history, and even
in more than one chapter of modern history, do we find
proof of the immense power of contagions, of poisoning
taking place through the moral atmosphere; and I cannot
restrain myself from observing (but without pretension,
without pedantry, without positive aim, as of seeking to
prove that Brueghel was permitted to see the devil himself
in person) that this prodigious efflorescence of monstrosities
coincided in the most surprising manner with the notorious
and historical *epidemic of witchcraft.*

tions and *Du Hachisch et de l'aliénation mentale* (respectively)
had been published in 1845.

[4] Baudelaire must have known Brueghel almost entirely through
engravings.

THE EXPOSITION UNIVERSELLE, 1855[1]

I

CRITICAL METHOD—ON THE MODERN IDEA OF PROGRESS AS APPLIED TO THE FINE ARTS—ON THE SHIFT OF VITALITY

THERE can be few occupations so interesting, so attractive, so full of surprises and revelations for a critic, a dreamer whose mind is given to generalization as well as to the study of details—or, to put it even better, to the idea of a universal order and hierarchy—as a comparison of the nations and their respective products. When I say 'hierarchy', I have no wish to assert the supremacy of any one nation over another. Although Nature contains certain plants which are more or less holy, certain forms more or less spiritual, certain animals more or less sacred; and although, following the promptings of the immense universal analogy, it is legitimate for us to conclude that certain nations (vast animals, whose organisms are adequate to their surroundings) have been prepared and educated by Providence for a determined goal—a goal more or less lofty, more or less near to Heaven—nevertheless all I wish to do here is to assert their *equal* utility in the eyes of Him who is indefinable, and the miraculous way in which they come to one another's aid in the harmony of the universe.

Any reader who has been at all accustomed by solitude (far better than by books) to these vast contemplations will already have guessed the point that I am wanting to make; and, to cut across the periphrastics and hesitations of Style

[1] The *Exposition Universelle* opened at the Palais des Beaux-Arts (the new *Palais de l'Industrie*), Avenue Montaigne, on 15th May 1855. Baudelaire had been commissioned to write a series of articles on the subject for *Le Pays*, but only the first and third of the following articles were published in that paper (26th May and 3rd June); the second article was published later in *Le Portefeuille* (12th August). It seems that Baudelaire's approach to his task was not acceptable to his employers, and from the 6th July a journalist called Louis Enault took over the succession.

with a question which is almost equivalent to a formula,
I will put it thus to any honest man, always provided that
he has thought and travelled a little. Let him imagine a
modern Winckelmann (we are full of them; the nation
overflows with them; they are the idols of the lazy). What
would *he* say, if faced with a product of China—something
weird, strange, distorted in form, intense in colour, and
sometimes delicate to the point of evanescence? And yet
such a thing is a specimen of universal beauty; but in order
for it to be understood, it is necessary for the critic, for the
spectator, to work a transformation in himself which par-
takes of the nature of a mystery—it is necessary for him,
by means of a phenomenon of the will acting upon the
imagination, to learn of himself to participate in the sur-
roundings which have given birth to this singular flowering.
Few men have the divine grace of cosmopolitanism in its
entirety; but all can acquire it in different degrees. The
best endowed in this respect are those solitary wanderers
who have lived for years in the heart of forests, in the
midst of illimitable prairies, with no other companion but
their gun—contemplating, dissecting, writing. No scholastic
veil, no university paradox, no academic utopia has in-
tervened between them and the complex truth. They know
the admirable, eternal and inevitable relationship between
form and function. Such people do not criticize; they con-
template, they study.

If, instead of a pedagogue, I were to take a man of the
world, an intelligent being, and transport him to a faraway
country, I feel sure that, while the shocks and surprises of
disembarkation might be great, and the business of habitua-
tion more or less long and laborious, nevertheless sooner
or later his sympathy would be so keen, so penetrating, that
it would create in him a whole new world of ideas, which
would form an integral part of himself and would accom-
pany him, in the form of memories, to the day of his death.[2]

[2] Baudelaire was doubtless thinking of his own experience, and
of that of Delacroix and Decamps (both of whom had made
early journeys, to Morocco and Turkey respectively, and had
been indelibly affected by them). The 'journey to the Orient'
was a classic Romantic experience.

Those curiously-shaped buildings, which at first provoke his academic eye (all people are academic when they judge others, and barbaric when they are themselves judged); those plants and trees which are disquieting for a mind filled with memories of its native land; those men and women whose muscles do not pulse to the classic rhythms of his country, whose gait is not measured according to the accustomed beat, and whose gaze is not directed with the same magnetic power; those perfumes, which are no longer the perfumes of his mother's boudoir; those mysterious flowers, whose deep colour forces an entrance into his eye, while his glance is teased by their shape; those fruits whose taste deludes and deranges the senses, and reveals to the palate ideas which belong to the sense of smell; all that world of new harmonies will enter slowly into him, will patiently penetrate him, like the vapours of a perfumed Turkish bath; all that undreamt-of vitality will be added to his own vitality; several thousands of ideas and sensations will enrich his earthly dictionary, and it is even possible that, going a step too far and transforming justice into revolt, he will do like the converted Sicambrian[3] and burn what he had formerly adored—and adore what he had formerly burnt.

Or take one of those modern 'aesthetic pundits', as Heinrich Heine[4] calls them—Heine, that delightful creature, who would be a genius if he turned more often towards the divine. What would *he* say? what, I repeat, would *he* write if faced with such unfamiliar phenomena? The crazy doctrinaire of Beauty would rave, no doubt; locked up within the blinding fortress of his system, he would blaspheme both life and nature; and under the influence of his fanaticism, be it Greek, Italian or Parisian, he would prohibit that insolent race from enjoying, from dreaming or from thinking in any other ways but his very own. Oh ink-smudged science, bastard taste, more barbarous than the barbarians themselves! you that have forgotten the colour of the sky, the movement and the smell of animality! you whose wizened fingers, paralysed by the pen, can no

[3] i.e. Clovis.

[4] In his *Salon of 1831*.

longer run with agility up and down the immense keyboard of the universal *correspondences!*[5]

Like all my friends I have tried more than once to lock myself up within a system in order to preach there at my ease. But a system is a kind of damnation which forces one to a perpetual recantation; it is always necessary to be inventing a new one, and the drudgery involved is a cruel punishment. Now my system was always beautiful, spacious, vast, convenient, neat, and above all, water-tight; at least so it seemed to me. But always some spontaneous, unexpected product of universal vitality would come to give the lie to my childish and superannuated wisdom—that lamentable child of Utopia! It was no good shifting or stretching my criterion—it always lagged behind universal

[5] Miss Gilman (p. 113) points out that this is the first time that Baudelaire uses this important word in its full sense.

man, and never stopped chasing after multiform and multi-coloured Beauty as it moved in the infinite spirals of life. Condemned unremittingly to the humiliation of a new conversion, I took a great decision. To escape from the horror of these philosophical apostasies, I haughtily resigned myself to modesty; I became content to *feel;* I returned to seek refuge in impeccable *naïveté.* I humbly beg pardon of the academics of all kinds who occupy the various workrooms of our artistic factory. But it is *there* that my philosophic conscience has found its rest; and at least I can declare—in so far as any man can answer for his virtues—that my mind now rejoices in a more abundant impartiality.

Anyone can easily understand that if those whose business it is to express beauty were to conform to the rules of the pundits, beauty itself would disappear from the earth, since all types, all ideas and all sensations would be fused into a vast, impersonal and monotonous unity, as immense as boredom or total negation. Variety, the *sine qua non* of life, would be effaced from life. So true is it that in the multiple productions of art there is an element of the ever-new which will eternally elude the rules and analyses of the school! That shock of surprise, which is one of the great joys produced by art and literature, is due to this very variety of types and sensations. The *aesthetic pundit*—a kind of mandarin-tyrant—always puts me in mind of a godless man who substitutes himself for God.

With all due respect to the over-proud sophists who have taken their wisdom from books, I shall go even further, and however delicate and difficult of expression my idea may be, I do not despair of succeeding. *The Beautiful is always strange.*[6] I do not mean that it is coldly, deliberately strange, for in that case it would be a monstrosity that had jumped the rails of life. I mean that it always contains a touch of strangeness, of simple, unpremeditated and unconscious strangeness, and that it is this touch of strangeness that

[6] Cf. Poe, who quotes Bacon: " 'There is no exquisite beauty,' says Bacon, Lord Verulam, speaking truly of all the forms and *genera* of beauty, 'without some *strangeness* in the proportion.' " (*Ligeia,* and elsewhere.)

gives it its particular quality as Beauty. It is its endorse-
ment, so to speak—its mathematical characteristic. Reverse
the proposition, and try to imagine a *commonplace Beauty!*
Now how could this necessary, irreducible and infinitely
varied strangeness, depending upon the environment, the
climate, the manners, the race, the religion and the tempera-
ment of the artist—how could it ever be controlled, amended
and corrected by Utopian rules conceived in some little
scientific temple or other on this planet, without mortal
danger to art itself? This dash of strangeness, which consti-
tutes and defines individuality (without which there can
be no Beauty), plays in art the role of taste and seasoning
in cooking (may the exactness of this comparison excuse its
triviality!), since, setting aside their utility or the quantity
of nutritive substance which they contain, the only way in
which dishes differ from one another is in the *idea* which
they reveal to the palate.

Therefore, in the glorious task of analysing this fine exhi-
bition, so varied in its elements, so disturbing in its variety,
and so baffling for the pedagogues, I shall endeavour to
steer clear of all kind of pedantry. Others enough will speak
the jargon of the studio and will exhibit *themselves* to the
detriment of the *pictures*. In many cases erudition seems
to me to be a childish thing and but little revealing of its
true nature. I would find it only too easy to discourse subtly
upon symmetrical or balanced composition, upon tonal
equipoise, upon warmth and coldness of tone, etc. Oh
Vanity! I choose instead to speak in the name of feeling,
of morality and of pleasure. And I hope that a few people
who are learned without pedantry will find my *ignorance*
to their liking.

The story is told of Balzac (and who would not listen
with respect to any anecdote, no matter how trivial, con-
cerning that great genius?) that one day he found himself
in front of a beautiful picture—a melancholy winter-scene,
heavy with hoar-frost and thinly sprinkled with cottages
and mean-looking peasants; and that after gazing at a little
house from which a thin wisp of smoke was rising, 'How
beautiful it is!' he cried. 'But what are they doing in that
cottage? What are their thoughts? what are their sorrows?

has it been a good harvest? *No doubt they have bills to pay?'*

Laugh if you will at M. de Balzac. I do not know the name of the painter whose honour it was to set the great novelist's soul a-quiver with anxiety and conjecture; but I think that in this way, with his delectable *naïveté,* he has given us an excellent lesson in criticism. You will often find me appraising a picture exclusively for the sum of ideas or of dreams that it suggests to my mind.

Painting is an evocation, a magical operation (if only we could consult the hearts of children on the subject!), and when the evoked character, when the reanimated idea has stood forth and looked us in the face, we have no right— at least it would be the acme of imbecility!—to discuss the magician's formulae of evocation. I know of no problem more mortifying for pedants and philosophizers than to attempt to discover in virtue of what law it is that artists who are the most opposed in their method can evoke the same ideas and stir up analogous feelings within us.

There is yet another, and very fashionable, error which I am anxious to avoid like the very devil. I refer to the idea of 'progress'. This gloomy beacon,[7] invention of present-day philosophizing, licensed without guarantee of Nature or of God—this modern lantern throws a stream of darkness upon all the objects of knowledge; liberty melts away, discipline vanishes. Anyone who wants to see his way clear through history must first and foremost extinguish this treacherous beacon. This grotesque idea, which has flowered upon the rotten soil of modern fatuity, has discharged each man from his duty, has delivered each soul from its responsibility and has released the will from all the bonds imposed upon it by the love of the Beautiful. And if this disastrous folly lasts for long, the dwindling races of the earth will fall into the drivelling slumber of decrepitude upon the pillow of their destiny. Such an infatuation is the symptom of an already too obvious decadence.

Take any good Frenchman who reads *his* newspaper

[7] The whole passage from the words 'This gloomy beacon' (*Ce fanal obscur . . .*) down to 'its own eternal despair' (*son éternel désespoir*) was absent from the text as printed in *Le Pays*.

each day in *his* taproom, and ask him what he understands by 'progress'. He will answer that it is steam, electricity and gas—miracles unknown to the Romans—whose discovery bears full witness to our superiority over the ancients. Such is the darkness that has gathered in that unhappy brain, and so weird is the confusion of the material and the spiritual orders that prevails therein! The poor man has become so Americanized by zoöcratic and industrial philosophers that he has lost all notion of the differences which characterize the phenomena of the physical and the moral world—of the natural and the supernatural.[8]

If a nation understands the issues of morality with a greater refinement than they were understood in the previous century, then you have progress; that is clear enough. If this year an artist produces a work which gives evidence of greater knowledge or imaginative force than he showed last year, it is certain that he has made progress. If provisions are cheaper and of better quality today than they were yesterday, that is an indisputable example of progress in the material order. But where, I ask you, is the guarantee that this progress will continue overnight? For that is how the disciples of the philosophers of steam and sulphur-matches understand it; progress only appears to them in the form of an unending series. But where *is* that guarantee? It does not exist, I tell you, except in your credulity and your fatuity.

I leave on one side the question of deciding whether, by continually refining humanity in proportion to the new enjoyments which it offers, indefinite progress would not be its most cruel and ingenious torture; whether, proceeding

[8] See *Fusées* XXII: 'La mécanique nous aura tellement américanisés, le progrès aura si bien atrophié en nous toute la partie spirituelle, que rien parmi les rêveries sanguinaires sacrilèges ou antinaturelles des utopistes ne pourra être comparé à ses résultats positifs . . .' See also Andrew Lang's *Letters to Dead Authors* (1886), p. 148: '. . . By this time, of course, you [Poe] have made the acquaintance of your translator, M. Charles Baudelaire, who so strenuously shared your views about Mr. Emerson and the Transcendentalists, and who so energetically resisted all those ideas of "progress" which "came from Hell or Boston".'

as it does by a stubborn negation of itself, it would not turn out to be a perpetually renewed form of suicide, and whether, shut up in the fiery circle of divine logic, it would not be like the scorpion which stings itself with its own terrible tail—progress, that eternal desideratum which is its own eternal despair!

Transported into the sphere of the imagination—and there have been hotheads, fanatics of logic who have attempted to do so—the idea of progress takes the stage with a gigantic absurdity, a grotesqueness which reaches nightmare heights. The theory can no longer be upheld. The facts are too palpable, too well known. They mock at sophistry and confront it without flinching. In the poetic and artistic order, the true prophets are seldom preceded by forerunners. Every efflorescence is spontaneous, individual. Was Signorelli really the begetter of Michelangelo? Did Perugino contain Raphael? The artist stems only from himself. His own works are the only promises that he makes to the coming centuries. He stands security only for himself. He dies childless. He has been his own king, his own priest, his own God. It is in prodigies like this that the famous and violent formula of Pierre Leroux finds its true application.[9]

It is just the same with the nations that joyfully and successfully cultivate the arts of the imagination. Present prosperity is no more than a temporary and alas! a very short-termed guarantee. There was a time when the dawn broke in the east; then the light moved towards the south, and now it streams forth from the west. It is true that France, by reason of her central position in the civilized world, seems to be summoned to gather to herself all the ideas, all the poetic products of her neighbours and to return them to other peoples, marvellously worked upon and embroidered. But it must never be forgotten that nations, those vast collective beings, are subject to the same laws as individuals. They have their childhood, in which

[9] This sentence did not occur in the text as printed in *Le Pays*. Crépet relates it to a passage in Pierre Leroux's *La Grève de Samarez*, which was not published until 1863.

they utter their first stammering cries and gradually grow in strength and size. They have their youth and maturity, the period of sound and courageous works. Finally they have their old age, when they fall asleep upon their piled-up riches. It often happens that it is the root principle itself that has constituted their strength, and the process of development that has brought with it their decadence—above all when that root principle, which was formerly quickened by an all-conquering enthusiasm, has become for the majority a kind of routine. Then, as I half suggested a moment ago, the vital spirit shifts and goes to visit other races and other lands. But it must not be thought that the newcomers inherit lock, stock and barrel from their predecessors, or that they receive from them a ready-made body of doctrine. It often happens (as happened in the middle ages) that all being lost, all has to be re-fashioned.

Anyone who visited the *Exposition Universelle* with the preconceived idea of finding the children of Leonardo, Raphael and Michelangelo among the Italians, the spirit of Dürer among the Germans, or the soul of Zurbaran and Velasquez among the Spaniards, would be preparing himself for a needless shock. I have neither the time, nor perhaps sufficient knowledge, to investigate what are the laws which shift artistic vitality, or to discover why it is that God dispossesses the nations sometimes for a while only, and sometimes for ever; I content myself with noting a very frequent occurrence in history. We are living in an age in which it is necessary to go on repeating certain platitudes—in an arrogant age which believes itself to be above the misadventures of Greece and Rome.

The English section of the exhibition is very fine, most uncommonly fine, and worthy of a long and patient study. I had wanted to begin with a glorification of our neighbours, of that nation so admirably rich in poets and novelists, of the nation of Shakespeare, Crabbe, Byron, Maturin and Godwin; of the fellow-citizens of Reynolds, Hogarth and Gainsborough. But I want to study them further. I have an excellent excuse. It is only out of extreme politeness

that I am putting off such a pleasurable task. I am biding my time in order to do better.[10]

I begin therefore with an easier undertaking. I propose to make a rapid study of the principal masters of the French School, and to analyse the elements of progress or the seeds of dissolution that it contains within it.

II

INGRES

THE FRENCH SECTION of this exhibition is at once so vast and is in general made up of such familiar items—quite enough of whose bloom has already been rubbed off by the artistic curiosity of the metropolis—that the duty of criticism should be to seek to penetrate deep into the temperament and activating motives of each artist, rather than to attempt to analyze and describe each work minutely.

When David, that icy star, rose above the horizon of art, with Guérin and Girodet (his historical satellites, who might be called the *dialecticians* of the party), a great revolution took place. Without analysing here the goal which they pursued; without endorsing its legitimacy or considering whether they did not overshoot it, let us state quite simply that they had a goal, a great goal which consisted in reaction against an excess of gay and charming frivolities, and which I want neither to appraise nor to define; further, that they fixed this goal steadfastly before their eyes, and that they marched by the light of their artificial sun with a frankness, a resolution and an *esprit de corps* worthy of true party-men. When the harsh idea softened and became tender beneath the brush of Gros, the cause was already lost.

I remember most distinctly the prodigious reverence which in the days of our childhood surrounded all those

[10] There is no evidence that Baudelaire's article on the English painters was ever written. But the passage devoted to English painters in the *Salon de 1859* (see pp. 221–2 below) was clearly based on notes and studies made at this time.

unintentionally fantastic figures, all those academic spectres
—those elongated human freaks, those grave and lanky
Adonises, those prudishly chaste and classically voluptuous
women (the former shielding their modesty beneath an-
tique swords, the latter behind pedantically transparent
draperies)—believe me, I could not look at them without
a kind of religious awe. And the whole of that truly extra-
natural world was forever moving about, or rather *posing*,
beneath a greenish light, a fantastic parody of the real sun.
But these masters, who were once over-praised and today
are over-scorned, had the great merit—if you will not con-
cern yourself too much with their eccentric methods and
systems—of bringing back the taste for heroism into the
French character. That endless contemplation of Greek and
Roman history could not, after all, but have a salutary
Stoic influence; but they were not always quite so Greek
and Roman as they wished to appear. David, it is true,
never ceased to be heroic—David the inflexible, the despotic
evangelist. But as for Guérin and Girodet, it would not be
hard to find in them a few slight specks of corruption, one
or two amusing and sinister symptoms of future Romanti-
cism—so dedicated were they, like their prophet, to the
spirit of melodrama. Does it not seem to you that Guérin's
Dido[1]—so affectedly and theatrically adorned, so languor-
ously stretched out in the setting sun, like an indolent
Creole woman—reveals more kinship with the first visions
of Chateaubriand than with the conceptions of Virgil, and
that her moist eye, bathed in the misty vapours of a Keep-
sake, almost looks forward to certain of Balzac's Parisian
heroines? As for Girodet's *Atala*,[2] whatever certain ageing
wags may think of it, as drama it is far superior to a whole
crowd of unmentionable modern insipidities.

But today we are faced with a man of an immense and
incontestable renown, whose work is very much more diffi-
cult to understand and to explain. A moment ago, in
connection with those illustrious unfortunates, I was ir-
reverently bold enough to utter the word 'freakish'. No
one, then, could object if, in order to explain the sensations

[1] Exhibited at the 1817 Salon; now in the Louvre.
[2] Exhibited at the 1808 Salon; now in the Louvre.

of certain sorts of artistic temperament when placed in con-
tact with the works of M. Ingres, I say that they feel
themselves face to face with a *freakishness* far more com-
plex and mysterious than that of the masters of the Repub-
lican and Imperial school—whence, nevertheless, it took its
point of departure.

Before broaching the subject more seriously, I am anxious
to record a first impression which has been felt by many
people and which they will inevitably remember the mo-
ment that they enter the sanctuary consecrated to the
works of M. Ingres. This impression, which is hard to
define—and which partakes, in unknown quantities, of
uneasiness, boredom and fear—reminds one vaguely and
involuntarily of the feelings of faintness induced by the
rarefied air, the physical atmosphere of a chemistry labora-
tory, or by the awareness that one is in the presence of
an unearthly order of being; let me say, rather, of an order
of being which *imitates* the unearthly—of an *automatic*
population whose too palpable and visible extraneity would
make our senses swim. It is no longer that childlike rev-
erence of which I spoke a moment ago—that reverence
which possessed us in front of the *Sabines*,[3] and of *The
Death of Marat*[4]—in front of the *Déluge*[5] or the melodra-
matic *Brutus*.[3] It is a powerful sensation, it is true—why
deny M. Ingres's power?—but of an inferior, an almost
morbid variety. We might almost call it a negative sensa-
tion, if the phrase were admissible. In fact, as must be
owned right away, this famous, and in his own way revo-
lutionary, painter has merits—charms, even—which are so
indisputable (and whose origin I shall shortly analyse) that
it would be absurd not to record at this point a gap, a
deficiency, a shrinkage in his stock of spiritual faculties.
The Imagination, which sustained his great predecessors,
lost though they were amid their academic gymnastics—the
Imagination, that Queen of the Faculties, has vanished.

No more imagination: therefore no more movement. I
do not propose to push irreverence and ill-will to the lengths

[3] By David; now in the Louvre.
[4] By David; now in the Brussels Museum.
[5] By Girodet; now in the Louvre.

of saying that this is an act of resignation on the part of M. Ingres; I have sufficient insight into his character to hold that with him it is an heroic immolation, a sacrifice upon the altar of those faculties which he sincerely considers as nobler and more important.

However enormous a paradox it may seem, it is in this particular that he comes near to a young painter whose remarkable début[6] took place recently with all the violence of an armed revolt. I refer of course to M. Courbet, who also is a mighty workman, a man of fierce and indomitable will; and the results that he has achieved—results that for certain minds have already more charm than those of the great master of the Raphaelesque tradition, owing doubtless to their positive solidity and their unabashed indelicacy[7]—have just the same peculiarity, in that they also reveal a dissenting spirit, a massacrer of faculties. Politics and literature, no less, produce robust temperaments like these—protestants, anti-supernaturalists, whose sole justification is a spirit of reaction which is sometimes salutary. The providence which presides over the affairs of painting gives them as confederates all those whom the ideas of the prevailing opposition have worn down or oppressed. But the difference is that the heroic sacrifice offered by M. Ingres in honour of the idea and the tradition of Raphaelesque Beauty is performed by M. Courbet on behalf of external, positive and immediate Nature. In their war against the imagination they are obedient to different motives; but their two opposing varieties of fanaticism lead them to the same immolation.

And now, to resume the regular course of our analysis, let us ask what is M. Ingres's goal. It is certainly not the translation of sentiments, emotions, or variations of those emotions and sentiments; no more is it the representation of great historical scenes (in spite of its Italianate, its over-Italianate, beauties, his picture of St. Symphorian,[8] which

[6] Courbet held an exhibition of his own simultaneously with the *Exposition Universelle*.

[7] Such paintings as the *Baigneuses* (1853) had already caused some scandal.

[8] In Autun Cathedral (Wildenstein 212).

is Italianized down to the very congestion of its figures, does nothing to reveal the sublime glory of a Christian victim, nor the bestiality, at once savage and indifferent, of the orthodox heathen). What then is M. Ingres seeking? What are his dreams? What has he come into this world to say? What new appendix is he bringing to the gospel of Painting?

I would be inclined to believe that his ideal is a sort of ideal composed half of good health and half of a calm which amounts almost to indifference—something analogous to the antique ideal, to which he has added the frills and furbelows of modern art. It is just this coupling which often gives his works their singular charm. Thus smitten with an ideal which is an enticingly adulterous union between Raphael's calm solidity and the gewgaws of a *petite-maîtresse*, M. Ingres might be expected to succeed above all in portraiture; and in fact it is precisely in this genre that he has achieved his greatest and his most legitimate successes. But he is far from being one of those painters-by-the-hour, one of those routine portrait-factories to which a common lout can go, purse in hand, to demand the reproduction of his unseemly person. M. Ingres *chooses* his models, and it must be admitted that he brings a wonderful discernment to his choice of those that are best suited to exploit his especial kind of talent. Beautiful women, rich and generous natures, embodiments of calm and flourishing health—here lie his triumph and his joy!

But at this point a question arises which has been a thousand times debated, and which is still worth returning to. What is the quality of M. Ingres's drawing? Is it of a superior order? is it absolutely *intelligent*? Anyone who has made a comparison of the graphic styles of the leading masters will understand me when I say that M. Ingres's drawing is the drawing of a man with a system. He holds that nature ought to be corrected, improved; he believes that a happily-contrived and agreeable artifice, which ministers to the eye's pleasure, is not only a right but a duty. Formerly it was said that nature must be interpreted and translated as a whole and in her total logic; but in the works of the present master, sleight-of-hand, trickery and

violence are common occurrences, and sometimes down-
right deception and sharp-practice. Here we find an army
of too-uniformly tapered fingers whose narrow extremities
cramp the nails, such as a Lavater, on inspection of that
ample bosom, that muscular forearm, that somewhat virile
frame, would have expected to be square-tipped—indica-
tive of a mind given to masculine pursuits, to the symmetry
and disciplines of art. Here again we find a sensitive face
and shoulders of a simple elegance associated with arms
too robust, too full of a Raphaelesque opulence. But
Raphael loved stout arms, and the first thing required was
to obey and to please the master. Elsewhere we shall find
a navel which has strayed in the direction of the ribs, or
a breast which points too much towards the armpit; and
in one place—a thing less pardonable, for generally these
various conjuring-tricks have a more or less plausible ex-
cuse, and one that can always be easily traced to his im-
moderate appetite for *style*—in one place, I say, we are
utterly baffled by an egregious leg, thin as a lath, with
neither muscles nor contours, and without even a fold at
the knee-joint (*Jupiter and Antiope*[9]).

Let us note further that, carried away as he is by this
almost morbid preoccupation with *style,* our painter often
does away with his modelling, or reduces it to the point of
invisibility, hoping thus to give more importance to the
contour, so that his figures look like the most correct of
paper-patterns, inflated in a soft, lifeless manner, and one
quite alien to the human organism. Sometimes it happens
that tho eye falls upon charming details, irreproachably
alive; but at once the wicked notion flashes across the mind,
that it is not M. Ingres who has been seeking nature, but
Nature that has *ravished* M. Ingres—that that high and
mighty dame has overpowered him by her irresistible
ascendancy.

From all that goes before, the reader will easily under-
stand that M. Ingres may be considered as a man endowed
with lofty qualities, an eloquent amateur of beauty, but
quite devoid of that energy of temperament which consti-
tutes the fatality of genius. His dominant preoccupations

[9] Now in the Louvre (Wildenstein 265).

are his taste for the antique and his respect for the School. His admiration, on the whole, is fairly easily bestowed, and his character is somewhat eclectic, like all men who are lacking in fatality. And so we see him wandering from archaism to archaism; Titian (*The Sistine Chapel*[10]), the Renaissance enamellers (*Venus Anadyomene*[11]), Poussin and the Carracci (*Venus* and *Antiope*), Raphael (*St. Symphorian*), the German primitives (all those little things in an anecdotal, picture-book style), antique bric-à-brac and the chequered colouring of Persian and Chinese art (the small *Odalisque*[12]), are forever disputing for his preference. The love and influence of antiquity make themselves felt throughout his work; but it often seems to me that M. Ingres is to antiquity what the transitory caprices of good taste are to the natural good manners which spring from the dignity and charity of the individual.

It is above all in the *Apotheosis of the Emperor Napoleon*[13]—the picture that has been lent from the Hôtel de Ville—that M. Ingres has let his taste for the Etruscans be revealed. And yet, great simplifiers as they were, even the Etruscans never pushed simplification to the lengths of not harnessing their horses to their chariots! But these supernatural horses of M. Ingres (what, by the way, are they made of, these horses that seem to be of some polished, solid substance, like the wooden horse that captured the city of Troy?)—can it be that they are endowed with some magnetic force, that they are able to drag the car behind them with neither traces nor harness? As for the figure of the emperor himself, I feel bound to say that it gave me no hint of that epic and fatal beauty with which his contemporaries and historians generally endow him; and

[10] Now in the Louvre (Wildenstein 131).

[11] Now in the Musée Condé, Chantilly (Wildenstein 257).

[12] Presumably the *Odalisque with Slave,* which was exhibited at the *Exposition Universelle,* and is now in the Fogg Art Museum, Cambridge, Mass. (Wildenstein 228).

[13] Painted for the ceiling of the Salon de l'Empereur in the Hôtel de Ville. It was completed at the end of 1853, and destroyed by fire in 1871 (Wildenstein 270). There is a sketch for it at the Musée Carnavalet, Paris (Wildenstein 271). See pl. 8.

further, that it distresses me not to see the outward and legendary characteristics of great men preserved, and that the populace, agreeing with me in this, can hardly imagine its favourite hero except in his official, ceremonial robes, or in that historic iron-grey cloak, which, with all due deference to the fanatical amateurs of Style, would do nothing to mar a modern apotheosis.

But there is a more serious criticism to be made of this work. The cardinal feature of an apotheosis ought to be its supernatural feeling, a power of ascent towards loftier regions, an impulse, an irresistible surge towards Heaven, the goal of every human aspiration and classic abode of all great men. Well, *this* apotheosis, or rather this *equipage*, is falling—falling with a speed proportionate to its weight. The horses are dragging the chariot earthwards. The whole thing, like a fully-ballasted balloon without gas, is inevitably going to smash itself to bits on the surface of the globe.

As for his *Joan of Arc*,[14] a picture whose most obvious distinction is an inordinate technical pedantry—I do not trust myself to speak of it. However lacking in sympathy towards M. Ingres I may have appeared in the eyes of his fanatical admirers, I prefer to believe that the loftiest talent always reserves certain rights to make mistakes. Here, as in the *Apotheosis*, there is a total absence of sentiment and supernaturalism. We look in vain for that noble virgin who, according to the promises of the good M. Delécluze, was to avenge herself, and us, upon the scurrilous attacks of Voltaire. To sum up, and setting aside his erudition and his intolerant and almost wanton taste for beauty, I believe that the faculty which has made M. Ingres what he is—the mighty, the indisputable, the absolute despot—is the power of his will, or rather an immense abuse of that power. On the whole, what he is now he has been from the very start. And thanks to that vital energy which he possesses, he will remain the same to the end. As he has not progressed, he will not grow old. His over-passionate admirers will always be what they were—in love to the point of blindness; and nothing will change in France—not even the eccentric habit

[14] Now in the Louvre (Wildenstein 273).

of taking over from a great artist those odd qualities which can only belong to him; and of imitating the inimitable.

A thousand lucky circumstances have combined in the establishment of this formidable renown. He has commanded the respect of polite society by his ostentatious love of antiquity and the great tradition. The eccentric, the *blasé* and the thousand fastidious spirits who are always looking for something new, even if it has a bitter taste—all these he has pleased by his *oddness*. But his good, or at all events his *engaging* qualities have produced a lamentable effect in the crowd of his imitators; and this is a fact that I shall have more than one opportunity of demonstrating.

III

EUGÈNE DELACROIX[1]

MM. EUGÈNE DELACROIX AND INGRES share between them the support and the antipathy of the public. It is a long time since popular opinion first drew a cordon round them, like a pair of wrestlers. But without giving our acceptance to this childish and vulgar love of antithesis, we must nevertheless begin by an examination of these two French masters, since around and below them are grouped and ranged almost all the individuals who go to make up our artistic company.

Faced with thirty-five pictures by M. Delacroix, the first idea to take possession of the spectator is the idea of a well-filled life, of a stubborn and unremitting love of art. Which of these pictures is the finest?—it is impossible to say. Which the most interesting?—one hesitates. Here and there one seems to detect instances of progress; but if some of the more recent pictures show that certain important qualities

[1] As has been pointed out in a footnote on p. 192, this article appeared in *Le Pays* a week after the introductory article. To judge by the opening paragraph, it seems clearly to have been intended as the second, and not the third, article of the series. We are however retaining the order in which the three articles were first printed together in *Curiosités esthétiques*.

have been pushed to their extreme limits, it is humbling for the impartial critic to have to recognize that from his earliest productions, from his very youth (*Dante and Virgil* dates from 1822) M. Delacroix has possessed greatness. At times perhaps he has been more subtle, at times more curious, at times more painterly—but he has never ceased to be great.

In[2] the presence of a destiny so nobly and so happily fulfilled, a destiny blessed by nature and consummated by the most admirable power of will, I am conscious of some lines by one of our great poets, ceaselessly echoing in my mind:

Il naît sous le soleil de nobles créatures
Unissant ici-bas tout ce qu'on peut rêver;
Corps de fer, cœurs de flamme, admirables natures.

Dieu semble les produire afin de se prouver;
Il prend, pour les pétrir, une argile plus douce,
Et souvent passe un siècle à les parachever.

Il met, comme un sculpteur, l'empriente de son pouce
Sur leurs fronts rayonnant de la gloire des cieux,
Et l'ardente auréole en gerbes d'or y pousse.

Ces hommes-là s'en vont, calmes et radieux,
Sans quitter un instant leur pose solennelle,
Avec l'œil immobile et le maintien des dieux.

.

Ne leur donnez qu'un jour ou donnez-leur cent ans,
L'orage ou le repos, la palette ou le glaive:
Il mèneront à bout leurs destins éclatants.

Leur existence étrange est le réel du rêve;
Ils exécuteront votre plan idéal,
Comme un maître savant le croquis d'un élève.

[2] The following paragraph, with Gautier's poem and the sentence which rounds it off, were not in the text as printed in 1855.

Vos désirs inconnus, sous l'arceau triomphal,
Dont votre esprit en songe arrondissait la voûte,
Passent assis en croupe au dos de leur cheval.

.

De ceux-là chaque peuple en compte cinq ou six,
Cinq ou six, tout au plus, dans les siècles prospères,
Types toujours vivants dont on fait des récits.

Théophile Gautier calls this a *'Compensation'*.[3] And could not M. Delacroix fill up the vacant spaces of a whole century entirely on his own?

Never was an artist more attacked, more held up to ridicule, or more thwarted. But what care we for the hesitations of governments (I speak of some years ago), the scoldings of a few bourgeois salons, the spiteful tracts of a smoking-room academy or two, or the pedantry of domino-players? *Probatum est,* the matter has been settled once and for all, the result is before our eyes in its manifest, immense and blazing truth.

M. Delacroix has practised every genre; his imagination and his learning have ranged over every inch of the territory of painting. He has painted charming little pictures, filled with depth and intimate feeling—and with what a loving sensitivity has he painted them! He has glorified the walls of our palaces: he has filled our museums with enormous compositions.

This year he has most rightfully availed himself of the opportunity of showing a fairly considerable portion of his life's work, and thus of making us reconsider, so to speak, the documents of the case. The collection has been most discerningly assembled, so as to provide us with a set of varied and decisive samples of his mind and his talent.

We start with *Dante and Virgil,*[4] that young man's picture which was a revolution in itself, and in which one figure (the upturned male torso) was for long falsely attributed to Géricault. Among the big pictures, we may perhaps be allowed to hesitate between the *Justice of*

[3] From *La Comédie de la Mort* (1838). See Appendix.
[4] Now in the Louvre.

Trajan[5] and the *Taking of Constantinople by the Crusaders*.[4] The former is such a marvellously luminous picture, so airy, so full of tumult and splendour! How handsome the Emperor! how turbulent the crowd as it twists round the columns or moves along with the procession! how dramatic the weeping widow! This is the picture that was immortalized some years ago by the egregious M. Karr[6] and his little jokes about *pink horses*— as if some horses were not slightly pink, and as if in any case a painter had not a perfect right to do them that way if he wished!

But quite apart from its subject-matter, what makes the second picture so deeply moving is its tempestuous and gloomy harmony. What a sky, and what a sea! All is tumult and tranquillity, as in the aftermath of a great event. The city, ranged behind the Crusaders who have just passed through it, stretches back into the distance with a miraculous truth. And everywhere the fluttering and waving of flags, unfurling and snapping their bright folds in the transparent atmosphere! Everywhere the restless, stirring crowd, the tumult of arms, the ceremonial splendour of the clothes, and a rhetorical truth of gesture amid the great occasions of life! These two pictures are of an essentially Shakespearean beauty. For after Shakespeare, no one has excelled like Delacroix in fusing a mysterious unity of drama and reverie.

The public will renew acquaintance with all those pictures of stormy memory which were in themselves revolts, struggles and triumphs: the *Doge Marino Faliero*[7] (Salon of 1827; it is curious to note that *Justinian drafting his laws*[8] and the *Christ in the Garden of Olives*[9] are of the same year); the *Bishop of Liège*,[10] that admirable transla-

[5] Now in the Rouen Museum; repro. *Journal*, pl. 27.

[6] Alphonse Karr (1808–90), novelist, journalist and occasional art-critic.

[7] Now in the Wallace Collection; repro. *Journal*, pl. 7.

[8] Burnt in 1871.

[9] Church of Saint-Paul-Saint-Louis.

[10] With the Marlborough Gallery, London; sketch repro. *Journal*, pl. 12.

tion of Walter Scott, all crowd, bustle and light; the *Massacre at Chios;*[11] the *Prisoner of Chillon;*[11] the *Tasso in Prison;*[12] the *Jewish Wedding;*[11] the *Convulsionaries of Tangier,*[13] etc., etc. But how is one to define that charming class of picture, such as the *Hamlet in the graveyard scene,*[11] and the *Farewell of Romeo and Juliet,*[14] which are so deeply moving and attractive that once it has bathed in their little worlds of melancholy, the eye can no longer escape them, and the mind is for ever in their thrall?

Et le tableau quitté *nous* tourmente et *nous* suit.[15]

But this is not the Hamlet which Rouvière[16] showed us recently, and with such brilliant success—the sour, unhappy, violent Hamlet, driving his restlessness to the pitch of frenzy. There you have the romantic *strangeness* of the great tragedian; but Delacroix, more faithful perhaps to his text, has shown us a delicate and pallid Hamlet, a Hamlet with white, feminine hands, a refined, soft and somewhat irresolute nature, and an almost colourless eye.

Here too is the famous upturned head of the Magdalen,[17] with her strange, mysterious smile, and so supernaturally beautiful that you cannot tell whether she has been transfigured by death or beautified by the spasms of divine love.

On the subject of the *Romeo and Juliet* I have an observation to make which I believe to be of no little importance. I have heard so much fun made of the *ugliness* of Delacroix's women—though without being able to understand

[11] Now in the Louvre.

[12] Private collection, England.

[13] Now in the St. Paul Museum, Minnesota, U.S.A.

[14] See pl. 67.

[15] From the *Terza Rima* in Gautier's *Comédie de la mort.* See Appendix.

[16] The actor Philibert Rouvière had played the part of Hamlet at the Théâtre Historique, December 1847, in Dumas and Meurice's version of the play. Baudelaire published an enthusiastic article on Rouvière in 1855 (reprinted in *L'Art Romantique*). Manet's *L'Acteur Tragique* represents Rouvière as Hamlet.

[17] 1845 Salon: see p. 4 above.

that kind of fun—that I welcome the opportunity of pro-
testing against this misguided notion, which was shared, I
understand, by M. Victor Hugo. You will remember how,
in the high summer of Romanticism, he deplored the fact
that the man who enjoyed a parallel glory to his own in
the eyes of the public should commit such monstrous errors
in respect of beauty. He went so far as to liken Delacroix's
women to *frogs*. But M. Victor Hugo is a great *sculptural*
poet whose eye is closed to spirituality.

I am sorry that the *Sardanapalus*[18] has not reappeared
this year, for there you would have seen some very beauti-
ful women, bright and shining and pink—to the best of my
recollection. And Sardanapalus himself was as beautiful as
a woman. Generally speaking, Delacroix's women may be
divided into two classes. Those of the first class, who pre-
sent no difficulties to the understanding and are often
mythological, are of necessity beautiful (for example the
recumbent nymph, seen from behind, in the ceiling of the
Galerie d'Apollon[19]). They are rich, robust, opulent, abun-
dant women, and are endowed with a wonderful trans-
parency of flesh and superb heads of hair.

But the others, who are sometimes historical women
(like the *Cleopatra*[20] looking at the asp), but are more
often women of fancy, of *genre*—Marguerites, Ophelias,
even Blessed Virgins or Magdalens—these I would be in-
clined to call 'women in intimacy'. Their eyes seem heavy
with some painful secret which cannot be buried in the
grave of secrecy. Their pallor is like a revelation of their
internal struggles. Whether they owe their distinction to
the fascination of crime or to the odour of sanctity, and
whether their gestures are languid or violent, these women,
sick at heart or in mind, have in their eyes the leaden hues
of fever, or the strange, abnormal sparkle of their malady—
and in their glance the intensity of a supernatural vision.

But always, and in spite of everything, these are dis-
tinguished, essentially *distinguished* women; and if I am to
put the whole thing in a nutshell, I would say that M. Dela-

[18] Now in the Louvre; repro. *Journal*, pl. 8.
[19] In the Louvre; sketch repro. *Journal*, pl. 33.
[20] In a private collection, Switzerland.

croix seems to me to be of all artists the best equipped to
express modern woman, and, above all, modern woman in
her heroic manifestation, in the divine or the infernal in-
terpretation of the word. These women even have the
physical beauty of today, that air of reverie (for all the
fulness of their breasts), with their slightly narrow ribs,
their broad hips and their charming limbs.

Some of these paintings are new and unknown to the
public; such are the *Two Foscari*,[21] the *Arab Family*,[22] the
Lion Hunt[23] and a *Head of an Old Woman*[24] (a portrait
by M. Delacroix is a rarity). These different paintings serve
to demonstrate the prodigious sureness which the master
has achieved. The *Lion Hunt* is a veritable *explosion* of
colour (the word is intended in its good sense). Never can
colours more beautiful or more intense have penetrated to
the soul through the channel of the eyes!

The minute and careful examination of these pictures can
only reinforce certain irrefutable truths suggested by a first
rapid and generalized glance. First of all it is to be noted—
and this is very important—that even at a distance too great
for the spectator to be able to analyse or even to compre-
hend its subject-matter, a picture by Delacroix will already
have produced a rich, joyful or melancholy impression upon
the soul. It almost seems as though this kind of painting,
like a magician or a hypnotist, can project its thought at
a distance. This curious phenomenon results from the
colourist's special power, from the perfect concord of his
tones and from the harmony, which is pre-established in the
painter's brain, between colour and subject-matter. If the
reader will pardon me a stratagem of language in order to
express an idea of some subtlety, it seems to me that M.
Delacroix's colour *thinks for itself*, independently of the
objects which it clothes. Further, these wonderful *chords* of
colour often give one ideas of melody and harmony, and
the impression that one takes away from his pictures is

[21] Now at the Musée Condé, Chantilly.
[22] In a private collection, Paris.
[23] Now in the Bordeaux Museum; repro. *Journal*, pl. 55.
[24] In a private collection, France.

often, as it were, a musical one. A[25] poet has attempted to express these subtle sensations in some lines whose sincerity must excuse their singularity:

> Delacroix, lac de sang, hanté des mauvais anges,
> Ombragé par un bois de sapins toujours vert,
> Où, sous un ciel chagrin, des fanfares étranges
> Passent comme un soupir étouffé de Weber.[26]

Lac de sang [lake of blood]—the colour red; *hanté des mauvais anges* [haunted by bad angels]—supernaturalism; *un bois toujours vert* [an ever-green wood]—the colour green, the complementary of red; *un ciel chagrin* [a sullen sky]—the turbulent, stormy backgrounds of his pictures; *les fanfares et Weber* [fanfares, and Weber]—ideas of romantic music awakened by the harmonies of his colour.

Of Delacroix's drawing, which has been so absurdly and so banally criticized, what am I to say, except that it is one of those elementary truths which are completely misunderstood? What am I to say, except that a good drawing is not a hard, cruel, despotic and rigid line, imprisoning a form like a strait-jacket? that drawing should be like nature, alive and in motion? that simplification in drawing is a monstrosity, like tragedy in the world of the theatre, and that nature presents us with an infinite series of curved, receding and crooked lines, following an impeccable law of generation, in which parallelism is always vague and sinuous, and concavities and convexities correspond with and pursue one another? and, last of all, that M. Delacroix admirably satisfies all these conditions, and that even though his drawing may admit of occasional weaknesses or excesses, it has at least the enormous merit of being a constant and effective protest against the barbarous invasion of the straight line—that tragic, systematic line whose present ravages in painting and in sculpture are already enormous?

Another very great and far-reaching quality of M. Dela-

[25] The passage from this sentence down to the end of the paragraph was not in the text as printed in 1855.

[26] From *Les Phares* (*Les Fleurs du Mal*, VI), which was not published until 1857.

croix's talent, and one which makes him the painter beloved
of the poets, is that he is essentially literary. Not only has
his art ranged—and successfully ranged—over the field of
the great literatures of the world; not only has it translated,
and been the companion of, Ariosto, Byron, Dante, Scott
and Shakespeare, but it has the power of revealing ideas
of a loftier, a subtler and a deeper order than the art of the
majority of modern painters. And rest assured that it is
never by means of a mere feint, by a trifle or a trick of the
brush that M. Delacroix achieves this prodigious result;
rather is it by means of the total effect, the profound and
perfect harmony between his colour, his subject and his
drawing, and the dramatic gesticulation of his figures.

Edgar Poe has it somewhere[27] that the effect of opium
upon the senses is to invest the whole of nature with a
supernatural intensity of interest, which gives to every ob-
ject a deeper, a more wilful, a more despotic meaning.
Without having recourse to opium, who has not known those
miraculous moments—veritable feast-days of the brain—
when the senses are keener and sensations more ringing,
when the firmament of a more transparent blue plunges
headlong into an abyss more infinite, when sounds chime
like music, when colours speak, and scents tell of whole
worlds of ideas? Very well then, M. Delacroix's painting
seems to me to *translate* those fine days of the soul. It is
invested with intensity, and splendour is its special privi-
lege. Like nature apprehended through extra-sensitive
nerves, it reveals what lies beyond nature.

How will M. Delacroix stand with Posterity? what will
that redresser of wrongs have to say of him? He has now
reached a point in his career at which it is already easy to
give the answer without finding too many to contradict one.
Like us, Posterity will say that he was a unique meeting-
place of the most astonishing faculties; that like Rembrandt
he had a sense of intimacy and a profoundly magical
quality, like Rubens and Lebrun a feeling for decoration
and combination, like Veronese an enchanted sense of
colour, etc.; but that he also had a quality all his own, a
quality indefinable but itself defining the melancholy and

[27] In *A Tale of the Ragged Mountains.*

the passion of his age—something quite new, which has made him a unique artist, without ancestry, without precedent, and probably without a successor—a link so precious that it could in no wise be replaced; and that by destroying it—if such a thing were possible—a whole world of ideas and sensations would be destroyed, and too great a gap would be blasted in the chain of history.

THE SALON OF 1859

LETTERS
TO THE EDITOR OF THE REVUE FRANÇAISE[1]

I

THE MODERN ARTIST

MY DEAR M—, when you did me the honour of asking for
an analysis of the Salon, you said, 'Be brief; do not write
a catalogue, but a general impression, something like the
account of a rapid philosophical walk through the galleries.'
Very well, you shall have your wish; not because your
programme accords (as it does) with my own conception
of that tiresome kind of article called a 'Salon'; nor because
your method is easier than the other—it is not, for brevity
always demands more effort than diffuseness; but simply
because, above all in the present instance, there is no other
possible way. Certainly I should have been more seriously
embarrassed if I had found myself lost in a forest of
originality, if the modern French temperament, suddenly
modified, purified, and rejuvenated, had put forth flowers
so vigorous and of a scent so varied as to command irre-
pressible wonder, to provoke floods of praise—a garrulous
admiration—or to necessitate a whole series of new cate-
gories in the language of criticism. But there is nothing of
all that, fortunately (for me). No explosions; not a single
unknown genius. The thoughts suggested by the sight of
this Salon are of so simple, so traditional, so classic an order,
that a few pages will doubtless be sufficient to develop
them. Do not be surprised, then, if banality in the painter

[1] Published in four instalments, between 10th June and 20th
July 1859. The name of the editor of the *Revue Française* was
Jean Morel. The Salon opened on 15th April at the Palais des
Champs-Elysées. In a letter to Nadar of 14th May, Baudelaire
claimed that he was writing this *Salon* without having seen it; a
few days later he admitted (also to Nadar) that he had been
once.

should have given rise to the *commonplace* in your writer. Besides, you will be no whit the loser; for is there anything (I am delighted to record that you share my opinion in this)—is there anything in the world more charming, more fruitful, of a nature more positively *exciting*, than the commonplace?

Before I begin, allow me to express a regret, which I believe will be but seldom expressed. We had been told that we should have some guests to receive—guests, however, who are not exactly unknown to us, for the exhibition in the Avenue Montaigne[2] has already introduced to the Parisian public several of those charming artists of whom it had been for too long ignorant. I was thus looking forward with the greatest pleasure to re-establishing my acquaintance with Leslie,[3] that rich, naïf and noble *humourist,* one of the most emphatic expressions of the British mind; with the two Hunts,[4] the one a stubborn naturalist, and the other the passionate and self-willed creator of Pre-Raphaelitism; with the bold compositions of Maclise,[5] no less impetuous than sure of himself; with Millais,[6] that poet of meticulous detail; with J. Chalon,[7] that mixture of Claude and Watteau, chronicler of charming *fêtes champêtres* in great Italian parks; with Grant, that natural heir of Reynolds; with Hook,[8] who knows how to flood his *Venetian*

[2] The *Exposition Universelle* of 1855. At the end of his first article on that exhibition, Baudelaire had announced his intention of writing an article on the contemporary English school (see pp. 201–2).

[3] Leslie's pictures at the *Exposition Universelle* had included *Uncle Toby and the Widow Wadman* (now in the Victoria and Albert Museum) and *Sancho Panza and the Duchess* (National Gallery). The word 'humourist' is Baudelaire's own.

[4] W. H. Hunt had 11 water-colours, and Holman Hunt had *The Light of the World, Strayed Sheep* (Tate Gallery), and *Claudio and Isabella.*

[5] Maclise's two exhibits were *Merry Christmas in the Baron's Hall,* and *Ordeal by Touch.*

[6] Millais had *The Order of Release, The Return of the Dove to the Ark,* and *Ophelia.*

[7] J. J. Chalon had *A Summer's Day:* Morning, Afternoon and Evening.

[8] J. C. Hook had one Venetian painting.

dreams with a magic light; with that strange Paton,[9] who brings back Fuseli to mind and embroiders his graceful pantheistic chaos with the patience of another age; with Cattermole, the history-painter in water-colour, and with that other astonishing artist whose name escapes me, a visionary architect, who builds on paper cities whose bridges have elephants for supports, allowing gigantic three-masters in full sail to pass between their countless, colossal limbs.[10] A special place had even been set aside for these devotees of the imagination and of exotic colour, for these favourites of the fantastic muse; but alas, for reasons which I do not know and whose explanation cannot, I think, find a place in your journal, my hopes were disappointed. And so farewell, you tragic passions—gesticulations *à la* Kean or Macready; you charming, intimate glimpses of the *home*; you splendours of the Orient, reflected in the poetic mirror of the English mind; you Scottish verdures, magical visions of freshness, receding depths in water-colours as vast as stage-decorations, although so small—we shall not gaze upon you, this time at least. Were you so badly received then the first time, you eager representatives of the imagination and of the most precious powers of the soul? and do you consider us unworthy of understanding you?

And so, my dear M—, we shall content ourselves with France, of necessity. And believe me, it would give me immense pleasure to adopt a lyrical tone in speaking of the artists of my own country; but unhappily, however little practised a critic's mind may be, patriotism does not play an absolutely tyrannical role therein, and we have some humiliating admissions to make. The first time that I set foot in the Salon, I met on the staircase one of the most subtle and best-regarded of our critics, and to my first

[9] Noel Paton had *Oberon and Titania* (National Gallery of Scotland).

[10] In Baudelaire's article on Gautier, where the greater part of this paragraph also occurs, the names of Cockerell or Kendall are suggested here. From Adolphe Lance's *Compte-rendu* of the architectural exhibits at the exhibition (pp. 56 ff.), it is quite clear that H. E. Kendall, jun. is the 'visionary architect' in question. See F. W. Leakey's 'Baudelaire et Kendall', shortly to be published in the *Revue de littérature comparée*.

question—to the natural question that I put to him—he replied, 'Flat, mediocre; I have seldom seen so dismal a Salon.' He was both right and wrong. An exhibition which contains numerous works by Delacroix, Penguilly, Fromentin, cannot be dismal; but from the point of view of a general inspection, I saw that he was in the right. It cannot be doubted that at all times mediocrity has dominated; but that it should be more than ever on the throne, that its encumbrance should have turned into an absolute triumph—it is this fact that is as true as it is distressing. After having passed my eyes for some time over so many successfully-completed platitudes, so much carefully-laboured drivel, so much cleverly-constructed stupidity and falseness, I was led by the natural course of my reflections to consider the artist in times past and to place him face to face with the artist of the present: and then, at the end of these discouraging reflections, that terrible and eternal question-mark inevitably reared its head, as it always does. It would seem that littleness, puerility, incuriosity and the leaden calm of fatuity have taken the place of ardour, nobility and turbulent ambition, no less in the fine arts than in literature; and that for the moment nothing gives us reason to hope for any spiritual flowering as abundant as that of the Restoration. (And believe me, I am not alone in being oppressed by these bitter reflections; I will prove it to you in good time.) I therefore asked myself the following questions: What *was* he, then—the artist of former times (Lebrun or David, for example)? Lebrun was all erudition, imagination, knowledge of the past, and love of grandeur; and David, that colossus slandered by pigmies—did not he also embody love of the past and love of grandeur combined with erudition? But what of the artist today—that ancient brother to the poet? To answer that question properly, my dear M—, one must not shrink from being too stern. A scandalous favoritism sometimes demands an equivalent response. Despite his lack of merit, the artist is today, and has been for many years, nothing but a *spoiled child*. How many honours, how much money has been showered upon men without soul and without education! I am certainly far from advocating the introduction

into an art of means which are alien to it; and yet to quote an example, I cannot prevent myself from feeling sympathetic towards an artist such as Chenavard, who is always agreeable in the way that books are agreeable, and graceful even when he is dull and pompous. What do I care that he is the butt of every dauber's jokes? At least with him I am sure that I can have a conversation about Virgil or about Plato. Préault has a charming talent, an instinctive taste which hurls him upon the beautiful like a hunting animal upon its natural prey. Daumier is gifted with a radiant good sense which colours all his conversation. Ricard, in spite of the dazzle and elusiveness of his talk, never fails to let one see that he knows, and has compared a great deal. It is unnecessary, I think, to speak of the conversation of Eugène Delacroix, which is an admirable mixture of philosophical solidity, of witty lightness and of blazing enthusiasm. But apart from these, I cannot think of any other artist who is worthy to converse with a philosopher or a poet. Apart from them, you will hardly find anything but *spoiled children*. I beg and implore you to tell me in what salon, in what tavern, in what social or intimate gathering you have heard a single witty remark uttered by a *spoiled child*—a profound, brilliant, or acute remark, to make one ponder or dream—in short, a *suggestive* remark? If such a remark has been thrown out, it may not indeed have been by a politician or a philosopher, but by someone of an outlandish profession, like a hunter, a sailor or a taxidermist; but by an artist, a *spoiled child*, never.

The *spoiled child* has inherited privileges, once legitimate, from his predecessors. The enthusiasm which greeted David, Guérin, Girodet, Gros, Delacroix and Bonington, still sheds its charitable light upon his sorry person; and while good poets and vigorous historians make their living with extreme difficulty, the besotted business-man pays magnificently for the indecent little fooleries of the *spoiled child*. Please do not misunderstand me; if this goodwill were bestowed upon men of merit, I should not complain. When a singer or a dancer has reached the summit of her art, I am not one of those who envy her the fortune which

she has gained by the labours and the risks of every day. I should be afraid of falling into the vice of the late Girardin,[11] of sophistical memory, who one day rebuked Théophile Gautier for rating his imagination at a much higher value than the services of a *sous-préfet*. It was, if you remember, on one of those ill-omened days when the terrified public heard him speaking Latin: *pecudesque locutae!* No, I am not as unjust as all that; but it is a good thing to raise the voice and to cry shame on contemporary folly when, at the same time that a ravishing picture by Delacroix had difficulty in finding a buyer at 1000 francs, the practically-invisible figures of Meissonier fetched ten or twenty times as much. But those happy times have passed; we have fallen even lower, and M. Meissonier, who, in spite of all his merits, had the misfortune of introducing and popularizing the taste for littleness, is a veritable giant compared with today's toy-makers.

Discredit of the imagination, disdain of the great, love—no, this is too fine a word—exclusive *practice*, rather, of technique—such, I believe, are the principal reasons for the artist's degradation. The more imagination one has, the better will be the technique needed to accompany it in its adventures and to overcome the difficulties which it avidly courts. And the better one's technique, the less should one make a virtue of it and display it, so that the imagination may be allowed to burn with its full brilliance. This is the counsel of wisdom; and wisdom says also: He who possesses no more than the technical skill is but a beast, and the imagination which attempts to do without it is insane. But for all their simplicity, these things are both above and below the modern artist. A concierge's daughter says to herself: 'I shall go to the Conservatoire, I shall make my début at the Comédie Française, I shall declaim the verses of Corneille until I am classed above those who have been declaiming them for years.' And she does as she has said. She is very classically monotonous, and very classically boring and ignorant; but she has suc-

[11] The journalist and politician Girardin was a particular *bête noire* of Baudelaire's.

ceeded in what was very easy, that is to say, in winning by her patience the privileges of a *sociétaire*. And the *spoiled child*, the modern painter, says to himself: 'What is imagination? A danger and a toil. What is reading and contemplation of the past? Waste of time. I shall be classical, not like Bertin[12] (for the classical changes its place and its name), but like . . . Troyon, for example.' And he does as he has said. He paints on and on; he stops up his soul and continues to paint, until at last he becomes like the artist of the moment and by his stupidity and his skill he earns the acclaim and the money of the public. The imitator of the imitator finds his own imitators, and in this way each pursues his dream of greatness, better and better stopping up his soul and above all *reading nothing*, not even *The Perfect Cook*, which at any rate would have been able to open up for him a career of greater glory, if less profit. When he is thoroughly master of the art of sauces, of patinas, of glazes, of scumbles, of gravies, of stews (I speak of painting), the *spoiled child* strikes proud attitudes and repeats with more conviction than ever that nothing else is necessary.

There was once a German peasant who went to a painter and said to him: '*Sir*, I want you to paint my portrait. You will show me sitting at the front door of my farm-house, in the great arm-chair which I inherited from my father. Beside me you will paint my wife with her distaff, and behind us my daughters passing to and fro, preparing the family supper. By the avenue to the left come those of my sons who are returning from the fields after having herded the cattle to their byres; others, with my grandsons, are bringing back waggons laden with hay. While I am watching this scene, I beg you not to forget the puffs of smoke from my pipe, which are shot through by the rays of the setting sun. I should like the spectator to *hear* the sound of the Angelus which is ringing from the nearby church-tower. That is where we were all married, both the fathers and the sons. It is important that you should paint the *air of satisfaction* which I enjoy at this moment of the day,

[12] Victor Bertin, a pupil of P.-H. Valenciennes, the neo-classic landscape-painter.

when at one and the same time I contemplate *my family and my riches increased by the labours of a day!*[13]

Three cheers for that peasant! Without for a moment suspecting it, he understood painting. Love of his profession had heightened his *imagination*. But which of our fashionable painters would be worthy of executing this portrait? Which of them can claim that his imagination has reached such a level?

II

THE MODERN PUBLIC AND PHOTOGRAPHY

MY DEAR M—, if I had time to divert you, it would be the easiest thing in the world, merely by flicking through the catalogue and making an extract of all the ridiculous titles and preposterous subjects which are intended to attract our eyes. There's the famous Gallic wit for you! To seek to astonish by means which are alien to the art in question is the great standby of men who are not *natural* painters. Sometimes even—but always in France—this vice infects men who are not altogether devoid of talent and who debase it in this way with an adulterous mixture. I could parade before your eyes the comic title (in the manner of the *vaudevillistes*), the sentimental title (which lacks only an exclamation-mark), the punning title, the profound and philosophical title, the false or trick title, of the type of *'Brutus, lâche César!'* 'O faithless generation!', said Our Lord. 'How long shall I be with you? how long shall I suffer you?' This generation, in fact, both artists and public, has so little faith in painting that it spends its time in seeking to disguise it, to wrap it up in sugar pills like an unpleasant medicine; and what sugar, Great Heavens! I will instance two titles of pictures, which however I have not seen. The first is *Amour et Gibelotte!*[1] Doesn't that

[13] The above paragraph seems to be an imitation and development of a passage in Diderot's *Essai sur la peinture;* the passage is quoted in Crépet's edition of *Curiosités esthétiques* (p. 489).

[1] By Ernest Seigneurgens.

immediately whet the appetite of your curiosity? 'Love and
Rabbit-stew!' Let me try and make an intimate combination
of these two ideas, the idea of love and the idea of a rabbit
skinned and made into a a stew. I can hardly suppose that
the painter's imagination can have gone so far as to fit a
quiver, a pair of wings and an eye-bandage upon the corpse
of a domestic animal; the allegory would be really too
obscure. I imagine rather that the title has been invented
upon the recipe of *Misanthropie et Repentir*.[2] The true title
would thus be *Lovers Eating a Rabbit-Stew*. Now you will
ask, are they young or old, a labourer and a working-girl,
or perhaps a retired veteran and a waif in some dusty
bower? I really ought to have seen the picture!—Next we
have *Monarchique, catholique et soldat!*[3] Here is one in
the noble, the *crusader* style, like *Itinéraire de Paris à
Jérusalem* (forgive me, Chateaubriand! but the most noble
peal of bells can become means of caricature, and the
political utterances of the leader of an empire can be turned
into a dauber's squibs). This picture can only represent one
character doing three things *at once*—fighting in battle,
making his communion and assisting at the *petit lever* of
Louis XIV. Or could it be a warrior tattooed with *fleurs
de lys* and devotional images? But what is the good of
perplexing ourselves further? Let us simply say that this is
a false and sterile method of striking wonder. What is even
more deplorable is that the picture may perhaps be a good
one, however odd this may seem. And the same with *Amour
et Gibelotte*. Did I not catch sight of an excellent little
group of sculpture whose number I had unfortunately not
noted, and when I wanted to know the subject I re-read
the catalogue four times—but to no avail! At last you kindly
informed me that it was called *Toujours et Jamais*.[4] I felt
truly sorry to see a man of real talent uselessly cultivating
the art of the rebus.

I beg your forgiveness for having amused myself a little

[2] The French translation of Kotzebue's play *Menschenhass und
Reue* (1789), in which a wife's infidelity occasions a husband's
misanthropy, which leads to repentance and a happy ending.
[3] By Joseph Gouézou.
[4] By Emile Hébert. See pp. 299–300 below.

while in the manner of the lighter journals. But however frivolous the matter may seem to you, if you look carefully you will find that it contains a deplorable symptom. To sum up in a style of paradox, I will ask you and those of my friends who are more learned than I in the history of art, if the taste for the asinine and the taste for the witty (which is really the same thing) have always existed; if *Appartement à Louer*[5] and other far-fetched conceptions have appeared in all ages, in order to provoke the same popular enthusiasm; if the Venice of Veronese and Bassano was afflicted by these pictorial anagrams, and if the eyes of Giulio Romano, of Michelangelo, and of Bandinelli were alarmed by similar monstrosities; I ask, in a word, if M. Biard is eternal and omnipresent, like God. I do not believe so; I regard these horrors as a special grace bestowed upon the French nation. It is true that her artists infect her with the taste for them; that, once infected, she demands to have her needs satisfied is no less true; for if the artist makes the public stupid, the public pays him back in kind. They are two correlative terms which act upon one another with an equal power. And so let us marvel at the momentum with which we plunge into the track of progress (by progress I mean the progressive domination of matter), and at the miraculous everyday diffusion of the common run of skill—of something which can be acquired by patience alone.

For us the natural painter, like the natural poet, is almost a monster. The exclusive taste for the True (so noble a thing when it is limited to its proper applications) oppresses and stifles the taste for the Beautiful. Where one should see nothing but Beauty (I mean in a beautiful painting, and you can easily guess what is in my mind), our public looks only for Truth. The people are not artists, not naturally artists; philosophers perhaps, moralists, engineers, connoisseurs of instructive anecdotes, whatever you like, but never spontaneously artists. They feel, or rather they judge, in stages, analytically. Other more fortunate peoples feel immediately, all at once, synthetically.

I was speaking just now of artists who seek to astonish

[5] By F.-A. Biard; one of the great successes of the 1844 Salon.

the public. The desire to astonish and to be astonished is
very proper. 'It is a happiness to wonder'; but also 'it is
a happiness to dream'.[6] The whole question, then, if you
insist that I confer upon you the title of artist or of con-
noisseur of the fine arts, is to know by what processes you
wish to create or to feel wonder. Because the Beautiful is
always wonderful, it would be absurd to suppose that what
is wonderful is *always* beautiful. Now our public, which is
singularly incapable of feeling the happiness of dreaming
or of marvelling (a sign of its meanness of soul), wishes to
be made to wonder by means which are alien to art, and
its obedient artists bow to its taste; they try to strike, to
surprise, to stupefy it by means of unworthy tricks, because
they know that it is incapable of ecstasy in front of the
natural devices of true art.

During this lamentable period, a new industry arose
which contributed not a little to confirm stupidity in its
faith and to ruin whatever might remain of the divine in
the French mind. The idolatrous mob demanded an ideal
worthy of itself and appropriate to its nature—that is per-
fectly understood. In matters of painting and sculpture, the
present-day *Credo* of the sophisticated, above all in France
(and I do not think that anyone at all would dare to state
the contrary), is this: 'I believe in Nature, and I believe
only in Nature (there are good reasons for that). I believe
that Art is, and cannot be other than, the exact reproduc-
tion of Nature (a timid and dissident sect would wish to
exclude the more repellent objects of nature, such as skele-
tons or chamber-pots). Thus an industry that could give
us a result identical to Nature would be the absolute of art.'
A revengeful God has given ear to the prayers of this mul-
titude. Daguerre was his Messiah. And now the faithful
says to himself: 'Since photography gives us every guaran-
tee of exactitude that we could desire (they really believe
that, the mad fools!), then photography and Art are the
same thing.' From that moment our squalid society rushed,
Narcissus to a man, to gaze at its trivial image on a scrap
of metal. A madness, an extraordinary fanaticism took pos-
session of all these new sun-worshippers. Strange abomina-

[6] Quoted from Poe, *Morella*.

tions took form. By bringing together a group of male and female clowns, got up like butchers and laundry-maids in a carnival, and by begging these *heroes* to be so kind as to hold their chance grimaces for the time necessary for the performance, the operator flattered himself that he was reproducing tragic or elegant scenes from ancient history. Some democratic writer ought to have seen here a cheap method of disseminating a loathing for history and for painting among the people, thus committing a double sacrilege and insulting at one and the same time the divine art of painting and the noble art of the actor. A little later a thousand hungry eyes were bending over the peep-holes of the stereoscope, as though they were the attic-windows of the infinite. The love of pornography, which is no less deep-rooted in the natural heart of man than the love of himself, was not to let slip so fine an opportunity of self-satisfaction. And do not imagine that it was only children on their way back from school who took pleasure in these follies; the world was infatuated with them. I was once present when some friends were discreetly concealing some such pictures from a beautiful woman, a woman of high society, not of mine—they were taking upon themselves some feeling of delicacy in her presence; but 'No', she replied. 'Give them to me! Nothing is too strong for me.' I swear that I heard that; but who will believe me? 'You can see that they are great ladies,' said Alexandre Dumas. 'There are some still greater!,' said Cazotte.[7]

As the photographic industry was the refuge of every would-be painter, every painter too ill-endowed or too lazy to complete his studies, this universal infatuation bore not only the mark of a blindness, an imbecility, but had also the air of a vengeance. I do not believe, or at least I do not wish to believe, in the absolute success of such a brutish conspiracy, in which, as in all others, one finds both fools and knaves; but I am convinced that the ill-applied devel-

[7] The first remark is taken from Dumas' play *La Tour de Nesle* (Act I, sc. 9); the second from Gérard de Nerval's preface to Cazotte's *Le Diable amoureux*. The somewhat complicated point of the joke is explained by Crépet in his note on this passage (*Curiosités*, ed. Crépet, p. 490).

opments of photography, like all other purely material developments of progress, have contributed much to the impoverishment of the French artistic genius, which is already so scarce. In vain may our modern Fatuity roar, belch forth all the rumbling wind of its rotund stomach, spew out all the undigested sophisms with which recent philosophy has stuffed it from top to bottom; it is nonetheless obvious that this industry, by invading the territories of art, has become art's most mortal enemy, and that the confusion of their several functions prevents any of them from being properly fulfilled. Poetry and progress are like two ambitious men who hate one another with an instinctive hatred, and when they meet upon the same road, one of them has to give place. If photography is allowed to supplement art in some of its functions, it will soon have supplanted or corrupted it altogether, thanks to the stupidity of the multitude which is its natural ally. It is time, then, for it to return to its true duty, which is to be the servant of the sciences and arts—but the very humble servant, like printing or shorthand, which has neither created nor supplemented literature. Let it hasten to enrich the tourist's album and restore to his eye the precision which his memory may lack; let it adorn the naturalist's library, and enlarge microscopic animals; let it even provide information to corroborate the astronomer's hypotheses; in short, let it be the secretary and clerk of whoever needs an absolute factual exactitude in his profession—up to that point nothing could be better. Let it rescue from oblivion those tumbling ruins, those books, prints and manuscripts which time is devouring, precious things whose form is dissolving and which demand a place in the archives of our memory—it will be thanked and applauded. But if it be allowed to encroach upon the domain of the impalpable and the imaginary, upon anything whose value depends solely upon the addition of something of a man's soul, then it will be so much the worse for us!

I know very well that some people will retort, 'The disease which you have just been diagnosing is a disease of imbeciles. What man worthy of the name of artist, and what true connoisseur, has ever confused art with industry?'

I know it; and yet I will ask them in my turn if they believe in the contagion of good and evil, in the action of the mass on individuals, and in the involuntary, forced obedience of the individual to the mass. It is an incontestable, an irresistible law that the artist should act upon the public, and that the public should react upon the artist; and besides, those terrible witnesses, the facts, are easy to study; the disaster is verifiable. Each day art further diminishes its self-respect by bowing down before external reality; each day the painter becomes more and more given to painting not what he dreams but what he sees. Nevertheless *it is a happiness to dream*, and it used to be a glory to express what one dreamt. But I ask you! does the painter still know this happiness?

Could you find an honest observer to declare that the invasion of photography and the great industrial madness of our times have no part at all in this deplorable result? Are we to suppose that a people whose eyes are growing used to considering the results of a material science as though they were the products of the beautiful, will not in the course of time have singularly diminished its faculties of judging and of feeling what are among the most ethereal and immaterial aspects of creation?

III

THE QUEEN OF THE FACULTIES

IN RECENT YEARS we have heard it said in a thousand different ways, 'Copy nature; only copy nature. There is no greater delight, no finer triumph than an excellent copy of nature.' And this doctrine (the enemy of art) was alleged to apply not only to painting but to all the arts, even to the novel and to poetry. To these doctrinaires, who were so completely satisfied by Nature, a man of imagination would certainly have had the right to reply: 'I consider it useless and tedious to represent what *exists*, because nothing that *exists* satisfies me. Nature is ugly, and I prefer the monsters of my fancy to what is positively trivial.' And yet it would

have been more philosophical to ask the doctrinaires in question first of all whether they were quite certain of the existence of external nature, or (if this question might seem too well calculated to pander to their sarcasm) whether they were quite certain of knowing *all nature*, that is, all that is contained in nature. A 'yes' would have been the most boastful and extravagant of answers. So far as I have been able to understand its singular and humiliating incoherences, the doctrine meant—at least I do it the honour of believing that it meant: The artist, the true artist, the true poet, should only paint in accordance with what he sees and with what he feels. He must be *really* faithful to his own nature. He must avoid like the plague borrowing the eyes and the feelings of another man, however great that man may be; for then his productions would be lies in relation to himself, and not *realities*. But if these pedants of whom I am speaking (for there is a pedantry even among the mean-spirited) and who have representatives everywhere (for their theory flatters impotence no less than laziness)—if these pedants, I say, did not wish the matter to be understood in this way, let us simply believe that they meant to say, 'We have no imagination, and we decree that no one else is to have any.'

How mysterious is Imagination, that Queen of the Faculties! It touches all the others; it rouses them and sends them into combat. At times it resembles them to the point of confusion, and yet it is always itself, and those men who are not quickened thereby are easily recognizable by some strange curse which withers their productions like the fig-tree in the Gospel.

It is both analysis and synthesis; and yet men who are clever at analysis and sufficiently quick at summing up, can be devoid of imagination. It is that, and it is not entirely that. It is sensitivity, and yet there are people who are very sensitive, too sensitive perhaps, who have none of it. It is Imagination that first taught man the moral meaning of colour, of contour, of sound and of scent. In the beginning of the world it created analogy and metaphor. It decomposes all creation, and with the raw materials accumulated and disposed in accordance with rules

whose origins one cannot find save in the furthest depths of the soul, it creates a new world, it produces the sensation of newness. As it has created the world (so much can be said, I think, even in a religious sense), it is proper that it should govern it. What would be said of a warrior without imagination? that he might make an excellent soldier, but that if he is put in command of an army, he will make no conquests. The case could be compared to that of a poet or a novelist who took away the command of his faculties from the imagination to give it, for example, to his knowledge of language or to his observation of facts. What would be said of a diplomat without imagination? that he may have an excellent knowledge of the history of treaties and alliances in the past, but that he will never guess the treaties and alliances held in store by the future. Of a scholar without imagination? that he has learnt everything that, having been taught, could be learnt, but that he will never discover any laws that have not yet been guessed at. Imagination is the queen of truth, and the *possible* is one of the provinces of truth. It has a positive relationship with the infinite.

Without imagination, all the faculties, however sound or sharpened they may be, are as though they did not exist, whereas a weakness in some of the secondary faculties, so long as they are excited by a vigorous imagination, is a secondary misfortune. None of them can do without it, but the lack of some of them can be made up by it. Often when our other faculties only find what they are seeking after successive trials of several different methods which are ill-adapted to the nature of things, imagination steps in, and proudly and simply guesses the answer. Finally, it plays a powerful role even in ethical matters; for—allow me to go so far and to ask, What is virtue without imagination? You might as well speak of virtue without pity, virtue without Heaven—it is a hard, cruel, sterilizing thing, which in some countries has become bigotry and in others protestantism.

In spite of all the magnificent privileges that I attribute to the imagination, I will not pay your readers the insult of explaining to them that the more it is helped in its work,

the more powerful it is, and that there is nothing more
formidable in our battles with the ideal than a fine imagi-
nation disposing of an immense armoury of observed fact.
Nevertheless, to return to what I was saying a moment ago
concerning the prerogative of making up deficiencies, which
the imagination owes to its divine origin, I should like to
quote you an example, a tiny example, which I hope you
will not scorn. Do you think that the author of *Antony*,
of *Count Hermann*, and of *Monte Cristo*, is a scholar? I
imagine not. Do you suppose that he has steeped himself
in the practice of the arts and has made a patient study of
them? Of course not. I should even imagine that to do so
would be antipathetic to his nature. Very well then, *he* is
an example to prove that the imagination, although unas-
sisted by practice or by acquaintance with technical terms,
is nevertheless incapable of producing heretical nonsense
in a matter which is, for the most important part, within
its province. Not long ago I was in a train and I was pon-
dering over the article which I am now writing: I was
considering above all that singular reversal of values which
has permitted (in a century, I grant you, in which, for
man's chastening, everything has been permitted him) a
disdain of the most honourable and the most useful of the
moral faculties. And then I saw lying on a nearby cushion
a forgotten copy of the *Indépendance Belge*. Alexandre
Dumas had taken over this year's account of the works in
the Salon.[1] This circumstance aroused my curiosity. You
can guess my delight when I discovered my reflections
amply verified by an example thrown in my way by
chance. What a fine subject for surprise!, you will say—
that this man, who seems to represent universal vitality,
should pronounce a magnificent eulogy on a period when
life overflowed; that the creator of the romantic drama
should raise his voice, which I assure you did not lack
grandeur, and should sing the praises of that happy time
when at the side of the new school of literature there flour-
ished a new school of painting—Delacroix, the Devéria
brothers, Boulanger, Poterlet, Bonington, etc.—that is ex-

[1] Dumas' articles on this Salon were collected and published as
L'art et les artistes contemporains au Salon de 1859.

actly what you would expect! *Laudator temporis acti!* But that he should pay a witty tribute to Delacroix, that he should succinctly explain the nature of his opponents' madness, and that he should go even further and point out the sins of the best of the most recently celebrated painters; that he, Alexandre Dumas, so reckless and fluent a writer, should demonstrate so well, for example, that Troyon has no genius, and should even analyse what he lacks in order to simulate genius—tell me, my friend, do you find *that* so simple? All this, of course, was written in that loose dramatic style which he has gradually adopted in talking to his innumerable audience; and yet, what grace, what swiftness in the expression of truth! You will already have finished my argument for me: If Alexandre Dumas, who is no scholar, had not been lucky enough to possess a rich imagination, he would only have spoken nonsense; as it is, he has spoken sound sense, and he has spoken it well, because imagination, one must conclude, thanks to its *supplementing* nature, embraces also the critical spirit.

There remains yet one device for my adversary; it is to declare that Alexandre Dumas is not the author of his *Salon*. But this insult is such an old one, and this device so stale, that it should be thrown to the old-clothes-fanciers, to journalistic hacks and penny-a-liners. If they have not already picked it up, they will do so.

We shall shortly be embarking upon a more intimate examination of the functions of this *cardinal* faculty (does not its richness put you in mind of ecclesiastical crimson?). I shall simply tell you what I learnt from the lips of a master;[2] and just as at that time I used to verify his simple precepts by reference to every picture that came under my eyes—with all the delight of a man who is educating himself—so we, in our turn, shall be able to apply them in succession, like touch-stones, to several of our painters.

[2] i.e. Delacroix.

IV

THE GOVERNANCE OF THE IMAGINATION

YESTERDAY evening I sent you the last pages of my letter, in which I wrote, not without a certain diffidence, 'Since Imagination created the world, it is Imagination that governs it.' Afterwards, as I was turning the pages of The Night Side of Nature,[1] I came across this passage, which I quote simply because it is a paraphrase and justification of the line which was worrying me: 'By imagination, I do not simply mean to convey the common notion implied by that much abused word, which is only fancy, but the constructive imagination, which is a much higher function, and which, in as much as man is made in the likeness of God, bears a distant relation to that sublime power by which the Creator projects, creates, and upholds his universe.' I feel no shame—on the contrary, I am very happy—to have coincided with the excellent Mrs. Crowe on this point; I have always admired and envied her capacity for belief, which is as fully developed as is that of doubt in others.

I said that a long time ago I had heard a man who was a true scholar and deeply learned in his art, expressing the most spacious and yet the simplest of ideas on this subject. When I met him for the first time, I possessed no other experience but that which results from a consuming love, nor any other power of reasoning but instinct. It is true that this love and this instinct were passably lively; for even in my extreme youth my eyes had never been able to drink their fill of painted or sculpted images, and I think that worlds could have come to an end, impavidum ferient, before I had become an iconoclast. Obviously he wished to show the greatest indulgence and kindness to me; for we talked from the very beginning of commonplaces—that is to say, of the vastest and most profound questions. About

[1] On Mrs. Crowe's The Night Side of Nature (London 1848) see Gilman, pp. 128 ff. and notes.

nature, for example: 'Nature is but a dictionary,' he kept
on repeating. Properly to understand the extent of mean-
ing implied in this sentence, you should consider the nu-
merous ordinary usages of a dictionary. In it you look for
the meaning of words, their genealogy and their etymology
—in brief, you extract from it all the elements that compose
a sentence or a narrative: but no one has ever thought of
his dictionary as a *composition*, in the poetic sense of the
word. Painters who are obedient to the imagination seek
in their dictionary for the elements which suit with their
conception; in adjusting those elements, however, with
more or less of art, they confer upon them a totally new
physiognomy. But those who have no imagination just copy
the dictionary. The result is a great vice, the vice of banal-
ity, to which those painters are particularly prone whose
specialty brings them closer to external nature—landscape-
painters, for example, who generally consider it a triumph
if they contrive not to show their personalities. By dint of
contemplating, they forget to feel and to think.

For this great painter, however, no element of art, of
which one man takes this and another that as the most
important, was—I should rather say, is—anything but the
humblest servant of a unique and superior faculty.

If a very neat execution is called for, that is so that the
language of the dream may be translated as neatly as pos-
sible; if it should be very rapid, that is lest anything may
be lost of the extraordinary vividness which accompanied
its conception; if the artist's attention should even be di-
rected to something so humble as the material cleanliness
of his tools, that is easily intelligible, seeing that every
precaution must be taken to make his execution both deft
and unerring.

With such a method, which is essentially logical, all the
figures, their relative disposition, the landscape or interior
which provides them with horizon or background, their
garments—everything, in fact, must serve to illuminate the
idea which gave them birth, must carry its original warmth,
its livery, so to speak. Just as a dream inhabits its own
proper atmosphere, so a conception which has become a
composition needs to move with a coloured setting which

is peculiar to itself. Obviously a particular tone is allotted to whichever part of a picture is to become the key and to govern the others. Everyone knows that yellow, orange and red inspire and express the ideas of joy, richness, glory and love: but there are thousands of different yellow or red atmospheres, and all the other colours will be affected logically and to a proportionate degree by the atmosphere which dominates. In certain of its aspects the art of the colourist has an evident affinity with mathematics and music. And yet its most delicate operations are performed by means of a sentiment or perception to which long practice has given an unqualifiable sureness. We can see that this great law of over-all harmony condemns many instances of dazzling or raw colour, even in the work of the most illustrious painters. There are paintings by Rubens which not only make one think of a coloured firework, but of several fireworks set off on the same platform. It is obvious that the larger a picture, the broader must be its *touch;* but it is better that individual touches should not be materially fused, for they will fuse naturally at a distance determined by the law of sympathy which has brought them together. Colour will thus achieve a greater energy and freshness.

A good picture, which is a faithful equivalent of the dream which has begotten it, should be brought into being like a world. Just as the creation, as we see it, is the result of several creations in which the preceding ones are always completed by the following, so a harmoniously-conducted picture consists of a series of pictures superimposed on one another, each new layer conferring greater reality upon the dream, and raising it by one degree towards perfection. On the other hand I remember having seen in the studios of Paul Delaroche and Horace Vernet huge pictures, not sketched but actually begun—that is to say, with certain passages completely finished, while others were only indicated with a black or a white outline. You might compare this kind of work to a piece of purely manual labour—so much space to be covered in a given time—or to a long road divided into a great number of stages. As soon as each stage is reached, it is finished with, and when the whole

road has been run, the artist is delivered of his picture.

It is clear that all these rules are more or less modifiable, in accordance with the varying temperaments of artists. Nevertheless I am convinced that what I have just described is the surest method for men of a rich imagination. Consequently, if an artist's divergences from the method in question are too great, there is evidence that an abnormal and undue importance is being set upon some secondary element of art.

I have no fear that anyone may consider it absurd to suppose a single education to be applicable to a crowd of different individuals. For it is obvious that systems of rhetoric or prosody are no arbitrarily invented tyrannies, but rather they are collections of rules demanded by the very constitution of the spiritual being. And systems of prosody and rhetoric have never yet prevented originality from clearly emerging. The contrary—namely that they have assisted the birth of originality—would be infinitely more true.

To be brief, I must pass over a whole crowd of corollaries resulting from my principal formula, in which is contained, so to speak, the entire formulary of the true aesthetic, and which may be expressed thus: The whole visible universe is but a storehouse of images and signs to which the imagination will give a relative place and value; it is a sort of pasture which the imagination must digest and transform. All the faculties of the human soul must be subordinated to the imagination, which puts them in requisition all at once. Just as a good knowledge of the dictionary does not necessarily imply a knowledge of the art of composition, and just as the art of composition does not itself imply a *universal* imagination, in the same way a *good* painter need not be a *great* painter. But a great painter is perforce a good painter, because a universal imagination embraces the understanding of all means of expression and the desire to acquire them.

As a result of the ideas which I have just been making as clear as I have been able (but there are still so many things that I should have mentioned, particularly concerning the concordant aspects of all the arts, and their similarities in

method), it is clear that the vast family of artists—that is to say, of men who have devoted themselves to artistic expression—can be divided into two quite distinct camps. There are those who call themselves 'realists'—a word with a double meaning, whose sense has not been properly defined, and so in order the better to characterize their error, I propose to call them 'positivists'; and *they* say, 'I want to represent things as they are, or rather as they would be, supposing that I did not exist.' In other words, the universe without man. The others however—the 'imaginatives'—say, 'I want to illuminate things with my mind, and to project their reflection upon other minds.' Although these two absolutely contrary methods could magnify or diminish any subject, from a religious scene to the most modest landscape, nevertheless the man of imagination has generally tended to express himself in religious painting and in fantasy, while landscape and the type of painting called 'genre' would appear to offer enormous opportunities to those whose minds are lazy and excitable only with difficulty.

But besides the imaginatives and the self-styled realists, there is a third class of painters who are timid and servile, and who place all their pride at the disposal of a code of false dignity. While one group believes that it is copying nature, and another is seeking to paint its own soul, these men conform to a purely conventional set of rules—rules entirely arbitrary, not derived from the human soul, but simply imposed by the routine of a celebrated studio. In this very numerous but very boring class we include the false amateurs of the antique, the false amateurs of style—in short, all those men who by their impotence have elevated the 'poncif' to the honours of the grand style.

V

RELIGION, HISTORY, FANTASY

At every fresh exhibition, the critics observe that religious painting is more and more deficient. I do not know if they

are correct so far as numbers are concerned; but certainly they make no mistake as to quality. Religious writers, like socialist writers, naturally tend to make beauty dependent upon belief, and more than one religious writer has attributed to a simple lack of faith this difficulty in giving expression to the things of faith. This error could be philosophically demonstrated if the facts did not show us sufficient proof to the contrary, and if the history of painting did not offer us the example of impious and atheistical artists producing excellent religious works. Let us simply say then that since religion is the highest *fiction* of the human mind (I am purposely speaking as an atheistic professor of the fine arts would speak, and nothing of what I say should be inferred as arguing against my own faith) it will require the most vigorous imagination and the most concentrated efforts from those who devote themselves to the expression of its acts and its sentiments. In the same way the character of Polyeuctes demands from the poet and the actor a spiritual ascent and an enthusiasm far more lively than those demanded by some vulgar character in love with a vulgar earthly creature, or even than a purely political hero. The only concession that one can reasonably make to those who hold to the theory of faith as the unique source of religious inspiration, is that at the moment of executing his work, the poet, the actor and the artist must believe in the reality of what he is representing, fired as he is by necessity. Thus it is that art is the only spiritual sphere in which man can say, 'I shall believe if I wish, and if I do not wish, I shall not believe.' The cruel and humiliating maxim, *Spiritus flat ubi vult,* loses its credit in matters of art.

I do not know if MM. Legros and Amand Gautier have faith as the Church understands it, but certainly, in composing each of them an excellent devotional work, they have had sufficient faith for the object in view. They have proved that even in the 19th century an artist can produce a good religious picture, provided that his imagination is fit to rise so far. Although the more important paintings of Eugène Delacroix are calling us and demanding our attention, I have nevertheless thought it right, my dear M—, to start off with two names but little, if at all, known. To

the natural scent of the forgotten or unfamiliar flower is added the paradoxical scent of its own obscurity, and its positive value is enhanced for us by the joy of having discovered it. Perhaps I am wrong to be totally ignorant of M. Legros, but I will admit that I had never before seen a work signed with his name. The first time that I noticed his picture, I was with our common friend Monsieur C—, whose attention I drew to this humble and penetrating work. He could not deny its singular merits; but his eyes, being in love with elegant and worldly beauties, like those of a good connoisseur, were a little disconcerted by its *rustic* aspect—by this little community clothed in corduroy, cotton and home-spun, which the evening *Angelus*[1] assembles within the nave of the church of one of our great cities—these simple people with their sabots and their umbrellas, all bowed with work, wrinkled with age and their skin parched by the flame of sorrow. He was evidently subject to that national mood, that fear above all of being made a dupe, which was most cruelly mocked by the French writer who was himself most singularly obsessed by it.[2] Nevertheless the mind of the true critic, like that of the true poet, should be open to every beauty; it is as easy for him to take delight in the dazzling grandeur of Caesar in triumph as in the grandeur of a poor suburbanite on his knees in the presence of his God. See how the artist has realized and recaptured for us all those feelings of refreshment which dwell beneath the roof of the Catholic church—the humility which rejoices in itself, the confidence of the poor in the justice of God, and the hope of succour, even if it does not mean the forgetting of present misfortunes! That the vulgar trappings of his subject do no injury to its moral grandeur, but that, on the contrary, this triviality is like a seasoning for its charity and tenderness, only goes to prove that M. Legros is a man of vigorous mind. By a mysterious association of ideas which subtle wits will understand, the grotesquely attired child who is

[1] Now in the collection of Mr. Asa Lingard. See pl. 16.
[2] Probably Stendhal (see p. 323 below), though Crépet, in his note on this passage, suggests the possibility that Mérimée may be intended.

awkwardly twisting his cap in the temple of God made me think of Sterne's donkey and the macaroons. The donkey's comic appearance while eating a cake does nothing to diminish the feeling of compassion that we feel when we see the miserable slave of the farm receiving a few dainties at the hand of a philosopher. In the same way this poor man's child is all embarrassment, and trembles as he tastes the celestial sweets. I forgot to mention that the execution of this pious work is of a remarkable solidity; the somewhat dull colour and the minuteness of the details are in harmony with the eternally *precious* character of devotion. Monsieur C— pointed out to me that the background does not recede sufficiently[3] and that the figures seem to be stuck somewhat flatly on to the decoration which surrounds them. But I own that this fault, by recalling the burning *naïveté* of the primitives, was for me but an added charm. In a work less intimate and less penetrating, it would not have been acceptable.

M. Amand Gautier is the author of a work which had already struck the eye of the critics several years ago—a remarkable work, which was rejected, I believe, by the jury, but which can be studied today in the window of one of the principal picture-dealers of the city. It represents the courtyard of an asylum for female lunatics—a subject which he treated not according to the philosophic, Germanic method (that of Kaulbach for example, which makes one think of the categories of Aristotle), but with the dramatic feeling of the French, combined with a faithful and intelligent amount of observation. The painter's friends claim that everything in the work—heads, gestures and physiognomies—was minutely exact, and copied from nature. I do not agree, first because I detected symptoms to the contrary in the organization of the picture, and then because what is positively and universally exact is never

[3] According to Pennell, *Life of Whistler,* 1908, vol. I, p. 77, Seymour Haden, the original owner of the picture, also noticed a fault of perspective here. He found this so irritating that finally he corrected it himself, to the great annoyance of Legros, who stole the picture back in order to restore it to its original state.

admirable. This year M. Amand Gautier has exhibited a
single work which bears the simple title, *Les Sœurs de
Charité*.[4] It requires a true mastery to distil the tender
poetry contained in those long uniform garments, in those
rigid head-dresses and those attitudes as modest and serious
as the religious life itself. Everything in M. Gautier's pic-
ture contributes to the development of the central thought;
those long white walls, those trees correctly set in line, that
façade which is simple to a degree of poverty, those up-
right attitudes, lacking all feminine coquetry, that whole
sex subdued to discipline like a soldier, its face gleaming
sadly with the rosy pallor of consecrated virginity—all these
things give us a sensation of the eternal, of the invariable,
of duty pleasurable in all its monotony. While studying this
canvas, which is painted with a touch as broad and simple
as its subject, I felt that curious impression which is pro-
duced by certain paintings of Lesueur and by the best of
Philippe de Champaigne—those, I mean, which represent
the monastic life. If any of my readers wants to seek these
pictures out, I should warn him that they are to be found
at the far end of the gallery, in the left part of the building,
in the depths of a great square hall where an innumerable
multitude of canvases have been confined—so-called re-
ligious paintings, for the most part. The general effect of
this gallery is so chilly that few people find their way to it,
as if it were a corner of a garden unvisited by the sun. It is
to this glory-hole of false *ex-votos*, to this immense milky
way of chalky ineptitudes that these two modest canvases
have been banished.

But the imagination of Delacroix! Never has it flinched
before the arduous peaks of religion! The heavens belong
to it, no less than hell, war, Olympus and love! In him you
have the model of the painter-poet. He is indeed one of
the rare elect, and the scope of his mind embraces religion
in its domain. His imagination blazes with every flame and
every shade of crimson, like the banks of glowing candles
before a shrine. All that there is of anguish in the Passion
impassions him; all that there is of splendour in the Church
casts its glory upon him. On his inspired canvases he pours

[4] Now in the Lille Museum; see pl. 17.

blood, light and darkness in turn. I believe that he would willingly bestow his own natural magnificence upon the majesties of the Gospel itself, out of superabundance. I remember seeing a little *Annunciation*[5] by Delacroix in which the angel visiting Mary was not alone, but was escorted in ceremony by two other angels, and the effect of this celestial retinue was powerful and touching. One of his youthful pictures, the *Christ in the Garden of Olives*[6] ('O my Father, if it be possible, let this cup pass from me!,' in the church of St. Paul, rue St. Antoine), positively melts with feminine sensibility and poetic unction. Anguish and Splendour, which ring forth so sublimely in religion, are never without an echo in his mind.

Very well, my friend, this extraordinary man who has wrestled with Scott, Byron, Goethe, Shakespeare, Ariosto, Tasso, Dante and the Gospels; this man who has illumined history with shafts of light from his palette, and has poured out his fantasy in waves upon our dazzled eyes; this man who, though advanced in the number of his years, is yet stamped with the stubbornness of youth, and who since his earliest manhood has consecrated all his time to the exercise of his hand, his memory and his eye for the forging of ever surer weapons for his imagination—this genius, in short, has recently found a master to teach him his art, in a young *journalist*[7] whose ministry had so far confined itself to giving an account of the dress of Madame So-and-so at the latest ball at the Hôtel de Ville. Oh! those *pink* horses, those *lilac-coloured* peasants, and that *red* smoke (red smoke! what a daring touch!)! In what a *bilious-green* manner have they been treated! Delacroix's complete works have been ground to powder and scattered to the four winds of heaven. This kind of article, which you can hear *spoken* in any bourgeois drawing-room, begins invariably with these words: 'I must own that I make no pretensions of being a connoisseur, for the mysteries of painting are a closed book for me, *but nevertheless* . . .' (in that case,

[5] Painted in 1841 (Robaut No. 1707).

[6] Exhibited in 1827.

[7] See the *Exposition Universelle* article (p. 213), where the journalist's name is given; it was Alphonse Karr.

why speak of it?), and it generally ends with some acri-
monious remark which is equivalent to a glance of envy
directed towards those fortunate people who comprehend
the incomprehensible.

But what does stupidity matter, you may say, so long as
genius triumphs? Nevertheless, my friend, it is by no means
time wasted to measure the strength of resistance against
which genius is pitted; the whole importance of this young
journalist amounts to the fact that he represents the general
level of the bourgeois mind—and that is quite enough for
our purpose. Please remember that this comedy has been
played against Delacroix since 1822, and that ever since
that time our painter, always punctual for his engagements,
has at every exhibition given us several pictures amongst
which there has always been at least one masterpiece, show-
ing untiringly (to use M. Thiers' polite and indulgent
expression) 'that spurt of superiority which revives hopes
which have already been a trifle dashed by the *too moderate
merit of all the others.*' And a little later he added, 'Some
strange recollection of the great masters seized hold of me
at the sight of this picture (*Dante and Virgil*). Once more
I found that power—wild, ardent yet natural—which yields
without effort to its own impulse . . . I do not think that
I am mistaken when I say that M. Delacroix *has been given
genius;* let him advance with assurance, let him devote
himself to *immense* tasks, an *indispensable* condition of
talent . . .'[8] I do not know how many times during his
life M. Thiers has been a prophet, but he was so on that
day. Delacroix has hurled himself into *immense tasks*—and
he has not disarmed opinion. To see this majestic, inex-
haustible outpouring of painting, it would be easy to guess
the name of the man whom I heard one evening saying:
'Like all men of my age, I have known many passions; but
it is only in *work* that I have felt myself perfectly happy.'
Pascal said that togas, purple and plumes were very happy
inventions to impress the vulgar, to mark with a label what
is truly to be respected; and yet the official distinctions of

[8] Baudelaire had already quoted a long passage from Thiers'
Salon de 1822 (including the sentences quoted here) in his
own *Salon de 1846* (see pp. 51–2 above).

which Delacroix has been the object have done nothing to
silence ignorance. But to look carefully at the matter, I
think that for those, who, like myself, hold that artistic
affairs should only be discussed between aristocrats, and
believe that it is the scarcity of the elect that makes a
paradise, everything is perhaps for the best. He is indeed
a privileged man for whom Providence keeps enemies in
reserve; fortunate among the fortunate is he whose talent
not only triumphs over obstacles, but even creates new
obstacles in order to triumph over them. He is as great as
the old masters, in a country and a century in which the
old masters would not have been able to survive. For when
I hear men like Raphael and Veronese being lauded to the
skies, with the manifest intention of diminishing the merit
of those who came after them, then, although I am quite
prepared to bestow my enthusiasm upon these great shades
who have no need of it, I ask myself if a merit which is
at least the equal of theirs (I will even admit for a moment,
and out of pure compliance, that it may be inferior) is not
infinitely more *meritorious*, since it has triumphantly
evolved in an atmosphere and a territory which are hostile
to it. The noble artists of the Renaissance would have been
positively to blame if they had not been great, prolific and
sublime, encouraged and incited as they were by an illus-
trious company of princes and prelates—but why do I stop
here? by the masses themselves, I should say, who were
artists to a man in that golden age! But what are we to
say of the modern artist who has risen to the heights *in spite
of* his century, unless it be things which this age will not
accept, and which we must leave to future ages to utter?

But to return to religious painting, tell me if you have
ever seen the essential solemnity of the *Entombment*[9] better
expressed? Do you honestly believe that Titian would have
invented this? He would have conceived it, or rather he
did conceive it, differently; but I prefer it this way. The
setting is the vault itself, an emblem of the subterranean life
which the new religion was to lead for many years. Outside,
a spiral of light and air gliding upwards. The Holy Mother
is about to faint, she can scarcely support herself. We

[9] Repro. *Escholier*, vol. III, facing p. 240.

should note in passing that, instead of turning the most
Holy Mother into a little woman from an Easter Album,
Eugène Delacroix always bestows upon her a tragic breadth
of gesture which is perfectly appropriate to this Queen
of Mothers. It is impossible for an amateur who is anything
of a poet not to feel his imagination struck, not by an
historical impression, but by an impression of poetry, re-
ligion and universality, as he gazes at that little group of
men who are tenderly carrying the body of their God into
the depths of a crypt, into that sepulchre which the world
will adore, 'the only sepulchre', as René superbly said,
'which will have nothing to give up at the end of time.'

The *Saint Sebastian*[10] is not only a marvel of painting,
but is also an exquisite thrill of sadness. The *Ascent to
Calvary*[11] is a complicated, passionate and learned com-
position. '*It was to have been carried out on a large scale*
at St. Sulpice', we are told by the artist who knows his
world, 'in the baptismal chapel, whose purpose has now
been altered.' Although he has taken every precaution, and
has clearly said to the public, 'I want to show you the
small-scale project of a large work with which I had been
commissioned', the critics have not failed, as usual, to
rebuke him for only being able to paint sketches!

Look next upon the famous poet who taught the *Art of
Love*; there he is, lying on the wild grass, with a soft sad-
ness which is almost that of a woman.[12] Will his noble
friends in Rome be able to overcome the emperor's spite?
Will he one day know again the luxurious pleasures of that
prodigious city? No: from this inglorious land the long
and melancholy river of the *Tristia* will flow in vain; here
he is to live and to die. 'One day, after crossing the Ister
near its mouth and becoming separated from my band of
huntsmen, I found myself within sight of the waves of the
Euxine Sea. I came upon a tomb of stone, o'er which a
laurel was growing. I tore away the grasses which covered

[10] Robaut 1353: repro. *Gazette des Beaux-Arts*, 1859, vol. II,
facing p. 138.

[11] Now in the Metz Museum; see pl. 60.

[12] The picture in question is *Ovid in Exile among the Scythians*
(Robaut 1376); see pl. 59.

several words of Latin, and soon I succeeded in reading
this first line of the elegies of an ill-fated poet;

> 'You will go to Rome, my book, and you will go to
> Rome without me.'

'I could not depict to you my feelings on finding the
tomb of Ovid in the heart of this desert. You can imagine
the sadness of my reflections upon the pains of exile, which
were also my own, and upon the uselessness of talents in
securing happiness! Rome today delights in the pictures
painted by the most ingenious of her poets; but for twenty
years Rome could watch the flowing tears of Ovid with
dry eyes. But less ungrateful than the peoples of Ausonia,
the wild inhabitants of the banks of the Ister still remember
the Orpheus who appeared in their forests! They come and
dance around his ashes; they have even retained something
of his language, so sweet to them is the memory of that
Roman who accused himself of being a barbarian because
his voice was not heard from the Sarmatic shore!'[13]

It is not without reason that, on the subject of Ovid, I
have quoted these reflections of Eudorus. The melancholy
tone of the poet of *Les Martyrs* suits this picture, and the
languishing sadness of the Christian prisoner is faithfully
reflected in it. You will find therein the broadness of touch
and feeling which characterized the pen which wrote *Les
Natchez;* and in Eugène Delacroix's rough idyll I recog-
nized a 'tale of perfect beauty', because he has put into it
'the desert's flower, the grace of the primitive dwelling and
a simplicity in telling a tale of sorrow which I do not flatter
myself have preserved'.[14] I shall certainly not try to translate
with my pen all the luxurious melancholy which this
verdant exile distils. Perhaps it is better just to quote the
catalogue, which speaks in the concise, tidy language of
Delacroix's literary works; 'Some of them are examining
him with curiosity', we are told quite simply; 'others are
greeting him in their manner, and are offering him wild
fruits and mare's milk.' For all his sadness, the poet of
fashionable elegance is not insensible to these barbarian

[13] The above passage is quoted from Chateaubriand's *Les Mar-
tyrs.*
[14] Quoted from the epilogue to Chateaubriand's *Atala.*

graces, to the charm of this rustic hospitality. All the deli-
cacy and fertility of talent that Ovid possessed have passed
into Delacroix's picture. And just as exile gave the brilliant
poet that quality of sadness which he had hitherto lacked,
so melancholy has clothed the painter's superabundant
landscape with its own magical glaze. I find it impossible
to say that any one of Delacroix's pictures is his best, for
the wine comes always from the same cask, heady, ex-
quisite, *sui generis;* but it can be said of *Ovid among the
Scythians* that it is one of those wonderful works such as
Delacroix alone can conceive and paint. The artist who has
painted this can count himself a happy man, and he who
is able to feast his eyes upon it every day may also call
himself happy. The mind sinks into it with a slow and
appreciative rapture, as it would sink into the heavens, or
into the sea's horizon—into eyes brimming with thought,
or a rich and fertile drift of reverie. I am convinced that
this picture has a charm all its own for subtle spirits; I
would almost be prepared to swear that, more than others
perhaps, it must have pleased highly-strung and poetic
temperaments—M. Fromentin, for example, of whom I shall
have the pleasure of talking to you presently.

I am cudgelling my brain in order to extract some
formula which may properly express Eugène Delacroix's
speciality.[15] He is an excellent draughtsman, a prodigious
colourist, an eager and resourceful composer—all this is
obvious, all this has already been said. But how comes
it that he produces a sensation of novelty? What does he
give us which is more than the past has given us? He is as
great as the great, as clever as the clever, but why does
he please us more? One might perhaps say that, gifted
with a richer imagination, he expresses for us above all the
inmost secret of the brain, the *wonderful* aspect of things,
so faithfully does his work retain the stamp and temper of
its conception. It is the infinite within the finite! It has
the quality of a dream! and by this word I do not mean
those riotous Bedlams of the night, but rather the vision
which comes from intense meditation, or, with minds less
naturally fertile, from artificial stimulants. In a word,

[15] See *n.* on p. 307.

Eugène Delacroix is above all the painter of the *soul* in its golden hours. Believe me, this man sometimes makes me crave to live as long as a patriarch, or, in spite of all the courage that it would need for a dead man to consent to come alive again ('Send me back to Hell!', as the poor soul cried when the Thessalian witch restored him to life), nevertheless to be revived in time to take part in the raptures and the praises which he will provoke in a future age! But what is the good? For even if I should be granted this childish prayer and should see my prophecy fulfilled, what profit would I gain, beyond the shame of having to admit that I was a feeble spirit, possessed by the need of seeing its convictions ratified?

VI

RELIGION, HISTORY, FANTASY
(continued)

COMBINE the epigrammatic wit of France with an element of pedantry, so as to lend a little weight to its natural buoyancy, and you will have the *fons et origo* of a school which Théophile Gautier, in his benevolence, politely calls the 'Neo-Greek', but which I, if you will allow me, propose to dub the 'school of the *pointus*'.[1] In this school the object of erudition is to disguise a lack of imagination. For most of the time it has simply been a matter of transporting common, everyday life into a Greek or Roman setting. Dezobry and Barthélemy[2] will be of great assistance in this, and pastiches of the frescoes of Herculaneum, with their pale tints obtained by means of impalpable washes of colour, will allow the painter to dodge all the difficulties of rich and solid painting. Thus on one side you will find a pile of bric-à-brac (the serious element), and on the other a transposition of the trivialities of life into antique cir-

[1] According to Crépet, Baudelaire borrowed this phrase from his friend Nadar, who used it to describe pedantic authors.
[2] Both celebrated antiquarian writers, the former of the 19th and the latter of the 18th century.

cumstances (the element of surprise and success), and
these between them will henceforth take the place of all
the conditions required for good painting. So we shall see
antique urchins playing at antique ball and with antique
hoops, amusing themselves with antique dolls and antique
toys; idyllic tots playing at grown-ups (*Ma Sœur n'y est
pas*);[3] cupids astride aquatic monsters (*Decoration for a
bathroom*);[4] and 'Love-Brokers' in plenty, who offer their
merchandise hung up by the wings, like rabbits pinned by
the ears—these should be sent back to the Place de la
Morgue, where an abundant traffic in more natural birds is
carried on. Love, inevitable Love, the immortal Cupid of
the confectioners, plays a dominant and universal role in
this school. He is the president of this courtly and simpering
republic. He is a fish which accommodates itself to every
sauce. And yet are we not very weary of seeing paint and
marble squandered on behalf of this elderly scamp, winged
like an insect or like a duck, whom Thomas Hood has shown
us squatting like a cripple and squashing flat his cloud-
pillow with his flabby obesity? In his left hand he holds his
bow propped against his thigh, like a sabre; with his
arrow in his right hand he executes the order 'Shoulder
arms!'; his hair is thickly curled like a coachman's wig; his
fat wobbling cheeks press against his nostrils and his eyes;
it is doubtless the elegiac sighs of the universe which dis-
tend his flesh, or perhaps I should rather call it his *meat*, for
it is stuffed, tubular and blown out like a bag of lard
hanging on a butcher's hook; on his mountainous back is
attached a pair of butterfly's wings.

'In sober verity,—does such an incubus oppress the fe-
male bosom? . . . Is this personage the disproportionate
partner for whom Pastorella sigheth,—in the smallest of
cots?—Does the platonic Amanda (who is all soul), refer,
in her discourses on Love, to this palpable being, who
is all body? Or does Belinda, indeed, believe that such

[3] By J. L. Hamon (Salon, 1853); it was bought by the Emperor,
and perished at the burning of the Tuileries in 1871.
[4] Probably the four *Seasons* by Etex, described in the catalogue
as 'panneaux décoratifs d'un salon de bains'.

a substantial Sagittarius lies ambush'd in her perilous blue eye?

'It is the legend, that a girl of Provence was smitten once, and died, by the marble Apollo; but did impassioned damsel ever dote, and wither, beside the pedestal of this preposterous effigy? or, rather, is not the unseemly emblem accountable for the coyness and proverbial reluctance of maidens to the approaches of Love?

'I can believe in his dwelling alone in the heart—seeing that he must occupy it to repletion;—in his constancy, because he looks sedentary and not apt to roam. That he is given to melt—from his great pinguitude. That he burneth with a flame, for so all fat burneth—and hath languishings—like other bodies of his tonnage. That he sighs—from his size.

'I dispute not his kneeling at ladies' feet—since it is the posture of elephants,—nor his promise that the homage shall remain eternal. I doubt not of his dying,—being of a corpulent habit, and a short neck.—Of his blindness—with that inflated pig's cheek. But for his lodging in Belinda's eye, my whole faith is heretic—*for she hath never a sty in it.*'[5]

This makes sweet reading, does it not?—and it gives us a little revenge on that great chubby, dimpled dolly which represents the popular idea of Love. For my part, if I were asked to represent Love, I think I should paint him in the form of a maddened horse devouring its master, or perhaps a demon with eyes ringed by debauch and insomnia, dragging noisy chains at its ankles, like a ghost or a galley-slave, shaking a phial of poison in one hand, and in the other a dagger dripping with the blood of its crime.

Translated by Baudelaire from Thomas Hood's sketch, 'On the Popular Cupid', in *Whims and Oddities* (1826). The passage is here given in the original. Against the final pun, Baudelaire added the following footnote: 'Une étable contient *plusieurs* cochons, et, de plus, il y a calembour; on peut deviner quel est le sens du mot *sty* au figuré'. On the whole passage, see Margaret Gilman's 'Baudelaire and Thomas Hood', in *The Romanic Review*, vol. XXVI, No. 3, July–Sept. 1935, pp. 241–4. Hood's essay was accompanied by his own sketch which is described by Baudelaire above, and reproduced here on p. 305.

The school in question, whose principal characteristic (to my eyes) is to be perpetually *irritating*, has simultaneous contact with the proverb, the rebus and the neo-archaism. In the rebus, it has not yet reached the standard of *L'Amour fait passer le Temps* and *Le Temps fait passer l'Amour*,[6] which taken together have the merit of an exact, brazen and irreproachable rebus. Next, by their mania for dressing up trivial modern life in antique garments, the adherents of this school are forever perpetrating what I should be inclined to call *counter-caricatures*. If they want to become even more irritating, I fancy that I am doing them a great service by suggesting M. Edouard Fournier's little book[7] as an inexhaustible source of subjects. To clothe all modern history and all the modern professions and industries in the costumes of the past would be, I think, an infallible and infinite means of causing wonder. Even the honorable sage will take some pleasure in it.

It is impossible to fail to recognize some noble qualities in M. Gérôme, chief among which are his quest for the new and his taste for great subjects; and yet his originality (if at least he has such a thing) is often of a laborious nature and scarcely to be detected. Coldly he warms up his subjects by the addition of little ingredients and by childish devices. The idea of a cock-fight[8] naturally evokes a memory of Manila or of England. M. Gérôme, however, will seek to beguile our curiosity by transforming this game into a kind of antique pastoral. In spite of great and noble efforts—the *Siècle d'Auguste*[9] for example, which is yet one more proof of his national tendency to look for success elsewhere than in pure painting—M. Gérôme was never yet, nor *will* he be, any more than the first of the *pointus*—at least this is much to be feared. I have no doubt at all that he has exactly portrayed those Roman games,[10] nor that

[6] Cf. *L'Amour et le Temps*, a song by the comte de Ségur.
[7] *Le Vieux neuf*, published in 1859.
[8] Gérôme's *Combat de Coqs* was exhibited at the 1847 Salon, and is now in the Louvre. See pl. 32.
[9] Formerly in the Amiens Museum; destroyed by enemy action.
[10] In his *Ave, César!*, which was Lot 165 at Christies, 30 Nov. 1928.

the local colour has been scrupulously observed—I shall not whisper the slightest suspicion on this subject (and yet, seeing that he gives us the *retiarius*, why not also the *mirmillo?*); but if you base your success upon elements of this kind, are you not playing a game which, if not positively dishonest, is at least a dangerous one? and are you not liable to stir up a suspicious resistance among many who will go away shaking their heads and wondering if it is really certain that things happened exactly like this? Even supposing that such a criticism may be unjust (for one can generally recognize in M. Gérôme a mind which is both curious of the past and eager for instruction), it is nevertheless the deserved punishment of an artist who substitutes the amusement of a page of erudition for the joys of pure painting. The *facture* of M. Gérôme's painting, it must be admitted, has never been either strong or original. Indecisive, on the contrary, and but feebly distinguished, it has always oscillated between Ingres and Delaroche. But apart from this I have a sharper criticism to make of the picture in question. Even in order to demonstrate a callousness in crime and debauchery, even to make us suspect the secret abysms of gluttony, it is not necessary to join hands with caricature; and I think that the habit of exercising command—above all when it is a question of commanding the world—confers, in default of virtues, at any rate a certain nobility of attitude which is far too remote from this self-styled Caesar, this butcher, this obese wine-merchant; the most that *he* could aspire to would be the editorship of the *Good Trencherman's Journal*, as his own seductive and trenchermanly pose suggests.

His *King Candaules* is once again a snare and a distraction. Many people go into ecstasies in front of the furnishings and the decoration of its royal bed. Just look, an Asiatic bedroom! what a triumph! But is it really true that his terrible queen, who was so jealous of her own person that she considered herself no less polluted by a glance than by the touch of a hand, looked like this flat marionette? There is, besides, a great danger in a subject such as this, which is situated at an equal distance between the tragic and the comic. If an Asiatic anecdote is not treated in a way

which is itself sinister, bloody and *Asiatic*, it will always
raise a laugh; it will invariably call to mind the licentious
frivolities of the Baudouins and Biards of the 18th century,
in which a half-open door allows two wide-open eyes to
observe the play of a syringe between the exaggerated
adornments of a Marquise.

Julius Caesar![11] What a sunset splendour this name sheds
upon the imagination! If ever a man on earth has seemed
like God, it was Caesar. Powerful and charming, coura-
geous, learned and generous, he had every power, every
glory and every elegance! He whose greatness always went
beyond victory, and who grew in stature even in death! he
whose breast, transfixed by the blade, could find utterance
only for a cry of a father's love! he to whom the dagger
seemed less cruel than the wound of ingratitude! Certainly
M. Gérôme's imagination has been carried away this
time; it was indeed a happy moment when he conceived
his Caesar *alone*, stretched out in front of his overturned
throne—when he imagined the corpse of this Roman who
was pontiff, warrior, orator, historian and master of the
world, filling an immense and deserted hall. This way of
showing the subject has been criticized, but to my mind it
could not be too highly praised. Its effect is truly great.
This terrible summary is enough. We all of us know suffi-
cient Roman history to imagine all that is implied, both the
disorder which preceded and the tumult which followed.
We can guess at Rome behind this wall, and we can hear
the cries of the Roman people, stunned at their deliverance,
and thankless at one and the same time towards both victim
and assassin: 'Let Brutus be Caesar!' About the picture
itself, there remains to explain one thing which is inex-
plicable. Caesar cannot be made into a Moor; his skin was
very fair; besides, it is by no means silly to recall that the
dictator took as much care of his person as the most refined
dandy. Why then this earthy colour with which his face
and arms are veiled? I have heard it suggested that it is
the corpse-like hue with which death strikes the face. In
that case how long a time are we to suppose it is since the

[11] See Moreau-Vauthier, *Gérôme*, Paris 1906, pp. 152–3. A ver-
sion of this subject was in the Corcoran Gallery, Washington.

living man became a corpse? Those who put forward such an excuse must regret the absence of putrefaction. Others are content to point out that the arm and the head are enveloped in shadow. But this excuse would imply that M. Gérôme is incapable of representing white flesh in a half light, and that is not to be believed. And so I am forced to abandon the solution of the mystery. Such as it is, and with all its faults, this canvas is the best, and incontestably the most striking, that the artist has shown us for a long time.

French victories in the field are ceaselessly responsible for great quantities of military pictures. I do not know, my dear M—, what you think of military painting considered as a professional speciality. For my part I do not believe that patriotism compels a taste for the false or the insignificant. But if you think about it carefully, this kind of painting positively *exacts* either falseness or nullity. A *real* battle is not a picture; for, in order to be intelligible, and consequently interesting as a *battle,* it can only be represented in the form of black, white or blue lines, which stand for the battalions drawn up. In a composition of this kind, no less than in reality, the *terrain* becomes more important than the men. But in such conditions there is no picture left, or at least there is only a picture of tactics and topography. M. Horace Vernet believed once, or even several times, that he was solving the difficulty by accumulating and juxtaposing a series of episodes. From that moment his picture lost all unity, and began to be like one of those bad plays in which an excess of parasitic incidents prevents one perceiving its central idea, the conception which gave it birth. Thus, apart from pictures made for tacticians and topographers, which we must exclude from pure art, a military picture will only be intelligible and interesting on the condition that it is a *simple episode from military life.* This has been very well understood by M. Pils for example, whose solid and imaginative compositions we have often admired; and in earlier times, by Charlet and Raffet. But even within a simple episode, even within the simple representation of a hand-to-hand fight in a small, enclosed space, how much falseness, exaggeration, and

monotony the spectator's eye has often had to endure!
I own that what distresses me most of all in this kind of
spectacle is not the abundance of wounds, the hideous pro-
fusion of slashed limbs, but rather the immobility within
the violence, the dreadful cold grimace of a motionless
frenzy. How many more criticisms could one not justly
make! First of all, those long, drab lines of troops, dressed
as our modern Governments dress them, can hardly sustain
a picturesque treatment, and it is rather to the past that
our artists turn in their bellicose hours; there they can find
a plausible pretext for displaying a fine variety of arms and
costumes, as M. Penguilly has done in his *Combat des
Trente*. Next, there exists in the heart of man a peculiar
love of victory which is not confined by truth, and this often
gives to such canvases the false air of an advocate's speech.
This is not a little apt to chill an enthusiasm in a rational
mind, which is otherwise quite ready to burst into flame.
When Alexandre Dumas recently recalled the fable, 'Ah!
si les lions savaient peindre!'[12] in this context he drew
upon himself a sharp rebuke from one of his colleagues. It
is only fair to mention that the moment was not very well
chosen,[13] and that he ought to have added that all peoples
naïvely display the same fault in their theatres and mu-
seums. Just consider, my friend, to what a pitch of madness
a patriotic writer can be led by a passion which is exclusive
and foreign to the arts. One day I was turning the pages
of a famous compilation which depicts the military vic-
tories of the French, with the accompaniment of a text.
One of these prints represented the conclusion of a Peace
Treaty. The French actors in this drama were booted,
spurred and haughty in bearing, and their very glances
seemed to insult the humble and embarrassed diplomats of
the opposing side; and the text praised the artist for having
contrived to express the moral vigour of the former by
means of their muscular energy, and the cowardice and
feebleness of the others by a roundness of form which was
quite feminine! But let us set aside these idiocies, whose
too lengthy analysis is but an *hors-d'œuvre*, and let us con-

[12] La Fontaine, Book III, No. 10, *Le Lion abattu par l'homme*.
[13] Because of the Austrian war.

tent ourselves with drawing this moral: namely, that it is
possible to lack modesty even in the expression of the most
noble and the most magnificent of sentiments.

There is one military picture, however, which we must
praise, and with all our fervour; it is not a battle-piece; on
the contrary, it is almost a pastoral. You will already have
guessed that I am referring to M. Tabar's picture. The
catalogue says simply: *Guerre de Crimée, Fourrageurs.*
What an expanse of grassland, and what beautiful grass-
land, gently rolling in lines which follow the movement of
the hills! Here the soul breathes a complex scent; it is not
only the freshness of growing things, the tranquil beauty
of a scene which sets us dreaming rather than arguing, but
it is at the same time the contemplation of that eager,
adventurous life, in which every day commands a different
task. It is an idyll shot through by war. The sheaves are
stacked, the needful harvest is done and the day's work is
doubtless finished, for the bugle's recall is echoing through
the air. The soldiers are returning in groups, following the
undulations of the landscape up and down with an ease of
movement which is at once nonchalant and regular. It
would be difficult to turn so simple a subject to better ac-
count; all is poetic here—both nature and man; all is true
and picturesque, down to the piece of twine or the single
strap which here and there supports a pair of red trousers.
And the soldiers' uniforms set the gay flame of the poppy
to this vast ocean of greenery. Moreover the subject-matter
is of an allusive nature; and before I opened the catalogue,
as I stood in front of this army of reapers, my thoughts
turned first to our African troops, whom the imagination
depicts as always so prepared for anything, so active, so
truly *Roman*—although, in fact, this scene is set in the
Crimea.

Do not be surprised to find an apparent confusion inter-
rupting the methodical gait of my report for several pages.
In the triple title of this chapter it was not without some
reason that I chose the word *Fantasy*. *Genre-painting* im-
plies a certain prosaic quality, and *Fancy-painting*,[14] which
answered my idea rather better, excludes the idea of the

[14] *Peinture romanesque.*

fantastic. In this type of painting one's judgement must be more than usually strict; for fantasy is all the more dangerous as it is the more easy and unconstrained; as dangerous as the prose-poem or the novel, it has much in common with the love inspired by a prostitute, which quickly falls into idiocy or degradation; it is as dangerous as all absolute liberty. But fantasy is as vast as the universe, multiplied by the number of all the thinking beings who inhabit it. It is the first thing that comes, interpreted by the first comer; and if he has no soul to throw a magic and supernatural light upon the natural obscurity of things, fantasy is a purposeless horror, it is the first thing that comes *defiled* by the first comer. Here then you must expect no more analogies, except by chance; on the contrary, you must be prepared for disorder and contrast—a field chequered by an absence of regular cultivation.

First let us throw a passing glance of admiration, and almost of regret, upon the charming productions of some few men who, during that period of noble renaissance of which I spoke at the beginning of this work, were the artists of the pretty, the precious and the delightful—Eugène Lami, for example, who, between his paradoxical little figures, gives us a glimpse of a world and a taste which have disappeared; and Wattier, that scholar who loved Watteau so much. It was a period of such beauty and fruitfulness, that not one spiritual need was forgotten by its artists. While Eugène Delacroix and Devéria were creating a great and picturesque art, others, witty and noble within a little sphere—painters of the boudoir and of a lighter kind of beauty—were adding incessantly to the present-day album of ideal elegance. This renaissance was great in everything, from the heroic down to the vignette. On the robuster scale of today, M. Chaplin, who is moreover an excellent painter, sometimes continues this cult of the pretty, though he does it with a touch of heaviness; his work smacks less of the world, and a little more of the studio. M. Nanteuil[15] is one of the most nobly productive workers to honour the second phase of this epoch. Admittedly he has poured a

[15] Nanteuil was a prolific illustrator of such authors as Balzac, Dumas, Eugène Sue and Victor Hugo.

finger of water into his wine; but he always paints with energy and imagination. There is a *fatal* quality in the children of that triumphant school: Romanticism is a grace, either from Heaven or Hell, to which we owe eternal stigmata. I can never contemplate that series of dusky and white vignettes with which Nanteuil illustrated the works of his friends, the authors, without feeling a little shiver of the memory, as though caused by a gust of cool air. And in M. Baron have we not also a man of rare gifts? without exaggerating his merit beyond all measure, is it not delightful to see so many faculties employed in such modest and fanciful works?[16] He composes admirably, he groups his figures with ingenuity and colours with ardour, and into all his little dramas he casts an amusing flame; I call them *dramas* because his composition is dramatic, and he possesses something like the genius of opera. I should be really ungrateful if I forgot him; for I owe him a delightful sensation. When a man comes out of a dirty and ill-lit hovel, and finds himself suddenly transported into an apartment which is clean, adorned with well-contrived furniture and clothed with caressing colours, he feels his mind light up and his sensibility prepare itself for the things of happiness. Such is the physical pleasure which the *Hôtellerie de saint Luc* caused me. I had just been sadly contemplating a whole chaos of horror and vulgarity, constructed as it were of plaster and earth, and when I approached this rich and luminous painting, I felt my heart cry out: At last, we are back again in fine society! How cool they are, these waters which bear those parties of distinguished guests beneath a portico streaming with ivy and roses! How splendid they are, these women, and their escorts, these master-painters who are past-masters in beauty, all plunging into this haunt of joy, to do honour to their patron saint! This composition, which is so rich, so gay, and at the same time so noble and elegant in attitude, is one of the most perfect dreams of happiness which painting has ever attempted to translate.

Because of her noble proportions, M. Clésinger's *Eve*

[16] Henri Baron's *Entrée d'un cabaret vénitien où les maîtres peintres allaient fêter leur patron saint Luc* was repro. *Illustr.*, vol. 33 (1859), p. 388.

forms a natural antithesis to all these charming, tiny creatures of whom we have just been speaking. Before the Salon opened, I had heard much gossip about this prodigious Eve, and when at last I saw her, I had been so forewarned against her that my first reaction was a feeling that people had mocked far too much. It was quite a natural reaction, and one, furthermore, which was favoured by my incorrigible passion for the *large*. For I must make an admission, my friend, which will perhaps cause you to smile; both in nature and art, supposing an equality of merit, I prefer *large* things above all others—large animals, large landscapes, large ships, large men, large women, large churches; and transforming my tastes into principles, like so many others, I have come to believe that size is no unimportant consideration in the eyes of the Muse. However, to return to M. Clésinger's *Eve*, she possesses other merits too; a happy movement, a tortured elegance in the Florentine taste, and impeccable modelling, particularly in the lower parts of the body, in the knees, the thighs and the stomach—such, in short, as one might expect from a sculptor; it is a very good work, which deserved better than it received.

Do you remember the first appearance of M. Hébert, that happy, almost riotous occasion?[17] His second picture claimed particular attention; if I am not mistaken it was the portrait of a woman, sinuous and opalescent—more than that, she was blessed almost with transparence—and writhing (mannered, but exquisite) in an atmosphere of enchantment.[18] Certainly the success was a deserved one, and M. Hébert, like a man of full distinction, announced himself with a flourish, as though he would always be a welcome guest. Unfortunately the very thing that caused his just celebrity will one day perhaps cause his decline. For his kind of *distinction* limits itself too readily to the charms of morbidity and to the monotonous languors of the album or the keepsake. It is undeniable that he paints very well indeed, but even so he does it without sufficient authority

[17] His first picture, *Le Tasse en prison* (1839), was bought by the state, and is now in the Grenoble Museum.

[18] Probably his *Almée* (Salon 1849).

and energy to hide a weakness of conception. I have tried hard to dig beneath all the engaging qualities which I see in him, and what I have found is a singular degree of worldly ambition, an explicit intention to please by means accepted in advance by the public, and finally a certain fault which it is horribly difficult to define and which, for want of a better term, I shall call the fault of all the *littératisants*. I am eager that an artist should be literate, but it distresses me to see him attempting to woo imagination by means of devices which are situated at the extreme limits of his art, if they be not positively beyond them.[19]

M. Baudry is more of a natural artist, although his painting is not always sufficiently solid. His works betray a serious and loving study of the Italian masters, and his figure of a little girl, who I believe is called *Guillemette*, has had the honour of causing more than one critic to think of the dashing and lively portraits of Velasquez. All in all, however, I cannot help fearing that M. Baudry remains no more than a 'distinguished' artist. His *Madeleine pénitente*[20] is just a little frivolous and facilely painted, and on the whole I prefer his ambitious, complicated and courageous picture of the *Vestal*[21] to his canvases of this year.

M. Diaz is a curious example of an easy fortune achieved by a unique faculty. The time is not yet long past when there was a positive craze for him. The gaiety of his colour, which was scintillating rather than rich, called to mind the happy motley of oriental fabrics. The eye was so honestly entertained that it readily forgot to look for contour and modelling. Like a true prodigal, M. Diaz used up this unique faculty with which nature had prodigally endowed him; and then he felt a more difficult ambition stirring within him. These first impulses expressed themselves in the form of pictures of a greater size than those in which he had generally taken so much pleasure. But it was an ambition which turned out to be his ruin. Everyone noticed

Of Ernest Hébert's exhibits this year, *Les Cervarolles* is now in the Louvre (see pl. 21), and *Rosa Nera à la fontaine* was repro. *Illustr.*, vol. 33 (1859), p. 276.

Now in the Nantes Museum; see pl. 30.

Exhibited 1857, and now in the Lille Museum.

the time when his mind was tormented by jealousy in re-
spect of Correggio and Prud'hon. But it would seem that
his eye, which had grown used to noting down the scin-
tillation of a little world, could now no longer see vivid
colours on a large scale. His sparkling palette turned to
plaster and chalk; or perhaps, seeing that his ambition from
now on was to model with care, he therefore deliberately
forgot the qualities which had hitherto constituted his
glory. It is difficult to define the causes which have so
rapidly diminished M. Diaz's lively personality; but perhaps
we may be allowed to suppose that these laudable desires
have come to him too late. Some reforms are impossible
after a certain age, and nothing is more dangerous in the
practice of the arts than to be always putting off indispen-
sable studies until the next day. For long years you rely on
an instinct which is generally happy, and when at last you
want to correct a haphazard education and to acquire prin-
ciples until then neglected, it is already too late. The brain
has adopted incorrigible habits, and the rebellious and un-
settled hand can no more express what it once expressed
so well than it can give form to the new ideas with which it
has now been entrusted. It is truly disagreeable to have to
say things like this about a man of such renowned worth
as M. Diaz. But I am only an echo; what I am writing
today, everyone has already said for himself, either aloud
or in a whisper, with malice or with sorrow.

It is quite different with M. Bida; he, on the contrary,
seems to have stoically repudiated colour and all its pomp
in order to give more value and light to the human char-
acters which his pencil undertakes to express. And he
expresses them with a remarkable intensity and depth.
Sometimes he agreeably heightens his drawing by the
application of a delicate and transparent tint in a luminous
passage—but this, however, without breaking its severe
unity. One thing that distinguishes M. Bida's works above
all is the intimate expression of his faces. It is impossible to
attribute them indifferently to one or another race, or to
suppose that these individuals profess a religion which is
not theirs. Even without the catalogue's explanation
(*Prédication maronite dans le Liban, Corps de garde*

d'Arnautes au Caire), any experienced eye would easily guess the differences.[22]

M. Chifflart won the *grand prix de Rome*, and, what a miracle!, he has his originality. His sojourn in the eternal city has not quenched his mental powers—which, after all, only goes to prove one thing: namely, that they alone die there who are too weak to live there, and that the 'school' only humiliates those who are dedicated to humility. Everyone justly rebukes M. Chifflart's two drawings (*Faust au combat* and *Faust au sabbat*[23]) for their excess of darkness and gloom, above all in drawings of such complexity. But their *style* is truly fine and imposing. What a dream of chaos! Mephisto and his friend Faust, invincible and invulnerable, are plunging at the gallop through the storm of war, with their swords held high. Marguerite, a long, sinister, unforgettable figure, floats in mid-air and stands out in relief, like a pang of remorse, upon the immense, pale disk of the moon. I count it to M. Chifflart's greatest credit that he has treated these poetic subjects heroically and dramatically, and that he has thrust far from him all the accepted trappings of melancholy. The painter who never tired of doing just one more Christ in the form of his Faust, and one more Faust in the form of his Christ, either of which was indistinguishable from a pianist about to pour forth his private sorrows upon the ivory keys—the good Ary Scheffer,[24] I mean, should really have seen these two vigorous drawings in order to understand that he alone may be allowed to translate the poets who feels in himself an energy equal to theirs. I do not believe that the assured pencil which has drawn this sabbath and this slaughter could ever abandon itself to the silly melancholy of young maidens.

Among the younger reputations, one of the most solidly established is that of M. Fromentin. He is neither precisely a landscape nor a genre painter; these two territories are too restricted to contain his free and supple fancy. If I

[22] Bida's *La Prière* was repro. *Illustr.*, vol. 34 (1859), p. 21, where it is described as a drawing.
[23] Both lithographed by Alfred Bahuet. See pl. 29.
[24] He had died the previous year.

said of him that he is a teller of travellers' tales, I should not be saying enough, for there are many travellers with neither poetry nor soul, and his soul is one of the rarest and most poetic that I know. His painting, which is properly so called, judicious, powerful, and well-controlled, evidently derives from Eugène Delacroix. With him too we find that expert and innate understanding of colour, which is so rare among us. But light and heat, which cast a kind of tropical madness into certain brains, shaking them with an unappeasable frenzy and driving them to unknown dances, only pour the sweetness and repose of contemplation into his soul. It is ecstasy rather than fanaticism. It is to be presumed that I myself am suffering to some extent from a nostalgia which drags me towards the sun; for I find an intoxicating mist arising from these luminous canvases, which soon condenses into desires and regrets. I catch myself envying the lot of those men who are lying outstretched amid their azure shades, and whose eyes, neither waking nor sleeping, express, if anything at all, only love of repose and the feeling of a blissful happiness inspired by an immensity of light. M. Fromentin's mind has something of the feminine about it—just enough to add a grace to his strength. But a faculty which is certainly not feminine, and which he possesses to an eminent degree, is that of snatching up the particles of beauty which lie scattered over the face of the earth, and of tracking out beauty wherever it may have slipped in between the trivialities of a degenerate nature. Therefore it is not difficult to understand the passion with which he loves the grandeurs of the patriarchal life, nor the interest with which he observes those men among whom some trace of an antique heroism still remains. It is not only with gorgeous fabrics or with curiously-wrought arms that his eyes are in love, but above all with that patrician gravity and dandyism which mark the chiefs of powerful tribes. We had the same sensation some fourteen years ago when the painter Catlin[25] brought us his North American Indians, who, even in their state of decadence, made us dream of the art of Pheidias and of Homeric grandeurs. But what is the object

[25] In April, 1845. See pp. 72–3 above.

of dwelling on this subject? why explain what M. Fromentin has himself so well explained in his two charming books, *Un été dans le Sahara* and *Le Sahel*?[26] Everyone knows that M. Fromentin tells his travellers' tales twice over; that he writes them as well as painting them, in a style which is his alone. The old masters also love to have a foot in both camps and to use twin tools to express their thought. M. Fromentin has succeeded both as writer and as artist, and both his written and his painted works have such charm that if one were given permission to prune and to cut back some of the shoots of the one in order to give more solidity, more vigour to the other, it would be really very difficult to choose. For in order to achieve a possible gain, we should have to resign ourselves to a great loss.

We remember seeing, at the 1855 Exhibition, some excellent little pictures of a rich and intense colour but of a meticulous finish, whose costumes and figures reflected a curious love of the past; these charming canvases were signed with the name 'Liès'. Not far from them were hanging some other exquisite pictures, no less preciously wrought, and marked with the same qualities and the same retrospective passion; these bore the name 'Leys'. Practically the same painter; practically the same name. This change of a letter is like one of those intelligent sports of Chance, which sometimes shows a subtlety of wit which is almost human. One is the pupil of the other; it is said that a warm friendship unites them. But have they for that reason been raised to the dignity of the Dioscures? In order to enjoy one of them, must we be deprived of the other? M. Liès has taken his bow this year without his Pollux; will M. Leys pay us a visit next without his Castor? The comparison is all the more legitimate in that M. Leys was, I believe, the teacher of his friend, and it was Pollux too who wanted to cede one half of his immortality to his brother. *Les Maux de la Guerre!*[27] what a title! Think of the conquered prisoner with his brutal conqueror lunging

[26] The first of these was published in 1857, the second in 1859. Of Fromentin's exhibits this year, *Une rue à El-Aghouat* was repro. in the *Gazette des Beaux-Arts*, 1859, vol. II, p. 293.

[27] Now in the Brussels Museum. See pl. 26.

after him; think of the disordered bundles of loot, the rav
ished maidens, that whole world of blood, misery and dejec
tion; the sturdy cavalryman with his shaggy red hair; the
camp-follower, who, I believe, is not present, but migh
easily be—that *painted jade* of the middle ages, who ha
the authority of the Prince and of the Church to accom
pany the army, just like the Canadian courtesan wh
accompanied those other warriors in their beaver-skins
and finally the waggons, harshly and indiscriminately buf
feting the young, the weak and the infirm: all this wa
bound of necessity to produce a thrilling, a truly poeti
picture. At first the mind harks back towards Callot; bu
I do not think that I have seen anything in all the lon
series of his works which is more dramatically composed
I have nevertheless two criticisms to make to M. Liès. Firs
his light is too generally spread out—or rather squandered
his colour, monotonously bright, seems to quiver. In th
second place, the immediate impression that the eye
fated to receive as it falls upon this picture is the disagree
able, uneasy impression of a piece of trellis-work; M. Liè
has put a black line not only around the general contou
of his figures, but also around every detail of their accoutre
ment, and he has done it in such a way that each of thes
characters has the appearance of a leaded fragment of
stained glass window. Observe too that this annoying effe
is only reinforced by the general brightness of the colour

M. Penguilly is also in love with the past. His is a
ingenious, enquiring, assiduous mind. Add, if you will, a
the most honourable and courteous epithets which can l
applied to poetry of the second rank—to poetry which ju
fails of being nakedly great and simple. He has the minut
ness, the burning patience and the neatness of the an
quarian. His works are wrought like the weapons and th
furniture of ancient times. His painting has the polish
metal and the cutting-edge of a razor. As for his imagin
tion, I shall not say that it is positively great, but it
singularly active, impressionable and enquiring. I was e
chanted by his *Petite Danse Macabre*, which reminded m
of a band of belated drunkards, half dragging themselv
along, half dancing, in step with their scrawny captain.

beg you to look carefully at each of the little *grisailles* which serve the principal composition both as frame and commentary. There is not one of them which is not an excellent little picture in itself. Modern artists are far too neglectful of those magnificent allegories of the middle ages, in which the grotesque and the horrible entwined themselves in a kind of mad, eternal game, as they do still. Perhaps our nerves have now become too delicate to endure a symbol which is too plainly forbidding. Or perhaps it is charity which exhorts us to avoid anything which may distress our fellows—but this is extremely unlikely! Towards the end of last year a publisher in the rue Royale put on sale a prayer-book of a very choice type; and the advertisements published in the newspapers informed us that all the vignettes which framed the text had been copied from ancient works of the same period, in such a way as to give a rare unity of style to the whole. They went on to say that a unique exception had been made with respect to the macabre figures; according to the note, doubtless drafted by the publisher himself, the greatest care had been taken to avoid reproducing these, *as being no longer to the taste of this age;* 'to such an *enlightened* taste', he should have added, if he had wished to conform entirely to the taste of the said age.

Le mauvais goût du siècle en cela me fait peur.[28]

There is a worthy publication[29] in which every contributor knows all and has a word to say about all, a journal in which every member of the staff is as universal and encyclopedic in his knowledge as the citizens of ancient Rome, and can instruct us turn and turn about in politics, religion, economics, the fine arts, philosophy and literature. In this vast monument of fatuity, which leans towards the future like the tower of Pisa, and in which nothing less than the happiness of the human kind is being worked out, there is one very honest man who does not want us to admire M. Penguilly. And his reason, my dear M—, his reason? It

[28] Molière, *Misanthrope*, Act I. See Appendix.
[29] This was *Le Siècle*; the critic referred to below was called Louis Jordan.

is because there is a *tedious monotony* in his work. Surely
these words do not refer to M. Penguilly's imagination,
which is excessively picturesque and varied? This thinker
must have meant that he did not like a painter who treated
all his subjects in the same style. But Good Heavens! it is
his *own* style! Do you want him to change it, then?

I do not want to leave this agreeable artist, all of whose
pictures are equally interesting this year, without drawing
your attention more particularly to his *Petites Mouettes;*
the intense blue of the sky and the water, the two rocky
boulders which form a door open upon the infinite (you
must know that the infinite seems all the more immense
the more it is restricted), a cloud, a multitude, an ava-
lanche, a *plague* of white birds—and solitude! Reflect on
that, my dear M—, and then tell me if you think that M.
Penguilly's mind is devoid of poetry.

Before concluding this chapter I would also direct your
eye to M. Leighton's picture—he was the only English
artist, I presume, to be punctual for his appointment: it is
called *Count Paris comes to the house of the Capulets to
claim his bride Juliet, and finds her apparently lifeless.*[30]
This is a rich, meticulous painting, violent in colour and
choice in finish; a very dogged work, but dramatic, rhe-
torical even; for our friends from across the Channel do
not paint theatrical subjects as though they were *real*
scenes, but as scenes *acted* with the necessary exaggera-
tion; and this fault, if it be one, confers upon their works
an element of strange and paradoxical beauty.

In conclusion, if you have time to return to the Salon,
do not forget to look at the enamel-paintings of M. Marc
Baud. This artist, in a thankless and ill-appreciated genre,
displays surprising qualities—those of a true painter. To
sum up in a word, he paints *richly* precisely where so many
others spread out their poor colours *meanly;* he knows how
to make a great gesture in a small space.

[30] Exhibited the previous year at the Royal Academy. Leighton
had one other painting at the Salon in 1859.

VII

PORTRAITURE

I DO NOT imagine that the birds of the air would ever make it their business to provide for the expenses of my table, nor that a lion would do me the honour of serving me as grave-digger or undertaker. Nevertheless, in the Thebaid my brain has made for itself, I too, like one of those who knelt alone and wrangled with that incorrigible death's-head, still stuffed with all the false reasoning of the mortal and perishable flesh—I, too, sometimes dispute with grotesque monsters, with phantasms of the daylight, with spectres of the street, the salon and the omnibus. I see in front of me the Soul of the Bourgeoisie; and believe me, if I were not afraid of indelibly staining the hangings of my cell, I would gladly fling my ink-stand in her face, and with a vigour that she does not suspect me of possessing! Just listen to what she said to me today, that wretched Soul who is no hallucination: 'In truth, our poets are singularly mad to claim that imagination is necessary in all the functions of art. What need is there of imagination in painting a portrait, for example? in painting my soul—my soul which is so visible, so clear, so well-known? I pose, and in reality it is I, the model, who consent to do the bulk of the work. I am the artist's true *supplier*. I myself, all by myself, am the whole thing!' To which I reply: '*Caput mortuum*, be silent! Hyperborean brute of ancient days, eternal Esquimau, be-spectacled, or rather be-scaled, whose eyes not all the visions of Damascus, not all the thunders and lightnings of the heavens, would be able to lighten! The more positive and solid the *thing* appears to be, the more subtle and laborious is the work of the imagination. A portrait! what could be simpler and more complicated, more obvious and more profound? If La Bruyère had had no imagination, would he have been able to compose his *Caractères*, whose raw-material was nevertheless so obvious, and presented itself so obligingly to him? And however restricted one may

suppose some historical subject or other, what historian can flatter himself that he can paint and *illuminate* it—without imagination?'

The portrait, that type of painting which appears so modest, calls for an immense intelligence. No doubt the artist's submissiveness must be great, but his power of divination must be equally so. Whenever I see a good portrait, I can guess at all the artist's efforts, just as he must not only have seen at once all that lay on the surface, but must also have guessed at what lay hidden. I compared him just now to the historian, and I might also compare him to the actor, whose duty it is to adopt any character and any costume. If you will examine the matter closely, nothing in a portrait is a matter of indifference. Gesture, grimace, clothing, décor even—all must combine to realize a *character*. Great painters, excellent painters—David, for example (both when he was just an 18th-century artist, and after he had become a *chef d'école*), or Holbein, in all his portraits—have often aimed at expressing the character which they undertook to paint, with sobriety but with intensity. Others have sought to do more, or to do it differently. Reynolds and Gérard added an element of romance, but always in accord with the natural disposition of the sitter; thus a stormy and troubled sky, light and airy backgrounds, poetic furnishings, a languorous attitude, an intrepid bearing, etc. . . . There you have a dangerous, but not a culpable procedure, which unfortunately demands genius. Finally, whatever may be the means most visibly employed by the artist, whether he be Holbein, David, Velasquez or Lawrence, a good portrait always seems to me to be like a dramatized biography, or rather, like the natural drama inherent in every man. Others have wanted to restrict the means. Was it because of their incapacity to use them all? or was it in the hope of obtaining a greater intensity of expression? I do not know; or rather I should be inclined to believe that in this, as in many other human affairs, both reasons are equally acceptable.

At this point, my friend, I am very much afraid that I am forced to lay hands on one of your idols. I want to speak of the school of Ingres in general, and of his method as

applied to the portrait in particular. Not all his pupils have strictly and humbly followed their master's precepts. Whereas M. Amaury-Duval courageously pushes the asceticism of the school to extremes, M. Lehmann makes some attempts to excuse the origin of his pictures by the admixture of alien ingredients. On the whole one might say that his teaching has been despotic, and that it has left a painful scar on French painting. A very stubborn man, gifted with several precious faculties, but determined to deny the utility of those which he does not possess, he has laid claim to an extraordinary and exceptional glory—that of extinguishing the sun. As for the few smoky embers that are still left to wander in space, the master's disciples have undertaken to stamp them out. It is not to be denied that Nature, as expressed by these simplifiers, has turned out to seem more intelligible; but it is obvious how much less beautiful and exciting she has become in the process. I am bound to admit that I have seen a few portraits by MM. Flandrin and Amaury-Duval which, though falsely disguised as *paintings*, nevertheless offered some admirable specimens of modelling. I will even admit that the visible character of these portraits, save everything relating to colour and light, was vigorously and carefully expressed, and in a penetrating manner. But I ask you if it is playing fair to decrease the difficulties of an art by suppressing some of its parts. I think that M. Chenavard is more courageous and more frank. He has simply repudiated colour as a perilous display, as a reprehensible, emotional element, and has put his trust in the simple pencil to express all the import of his idea. M. Chenavard is incapable of denying all the advantages conferred upon laziness by a procedure which consists in expressing the form of an object without the variously-coloured light which clings to each of its molecules; only he claims that this sacrifice is a glorious and a useful one, and that form and idea are both equally the gainers. But M. Ingres's pupils have very pointlessly retained a semblance of colour. They believe, or they pretend to believe, that they are *painters*.

Here is another charge—a commendation, perhaps, in the eyes of some—which touches them more sharply; it is that

their portraits are not true likenesses. Just because I never cease to call for the employment of the imagination and the introduction of poetry into all the functions of art, surely no one will suppose that I desire a conscientious alteration of the model, in the portrait above all? Holbein *knew* Erasmus; he knew him and studied him so well that he created him afresh and evoked him visibly, immortally and superlatively. M. Ingres finds a model that is fine, picturesque and attractive. 'Here we have a curious type, to be sure,' he says to himself. 'Beauty or grandeur, I shall express it with care; I shall leave nothing out, but I shall *add to it something which is indispensable: that is, style.*' And we know what he means by 'style'. It is not the naturally poetic quality of the subject, which must be extracted so that it may become more visible. It is an alien poetry, usually borrowed from the past. I think that I am justified in concluding that if M. Ingres adds something to his model, it is because he is incapable of making it at once both great and true. But by what right does he add? It is the art of painting that should alone be borrowed from tradition, and not the devices of sophistication. Take that Parisian lady, a ravishing specimen of the butterfly graces of a French *salon;* in spite of herself, he will endow her with a certain heaviness, with a *Roman* complacency. Raphael demands it. Those arms are of the purest curve and the most seductive contour—there is no doubt about it; but they are a trifle slender, and if they are to achieve the preconceived *style*, they require a certain measure of embonpoint—of the sap of matronhood. M. Ingres is the victim of an obsession which relentlessly drives him to displace, to transpose and to alter the beautiful. His pupils do likewise; as each one of them sets to work, he always makes ready, according to his dominant taste, to *distort* his model. Do you find this fault a slight one, or my criticism unmerited?

Among those artists who are content with the natural picturesqueness of the original, the most outstanding are M. Bonvin, who gives a vigorous and surprising vitality to his portraits, and M. Heim, at whom some superficial critics have mocked in the past, and who, this year again, as in 1855, has revealed to us a marvellous understanding of the

human *grimace* in a whole cavalcade of sketches. I presume that you will not take this word in a disagreeable sense. I am alluding to the natural and professional grimace which belongs to each one of us.

M. Chaplin and M. Besson both know how to paint portraits. The first has not shown us anything of the kind this year; but enthusiasts who follow the exhibitions attentively, and who know to which of his earlier works I am referring, will have noted their absence with regret, as I did. The second, who is a very good painter, has in addition all the literary qualities and the imagination needed to portray actresses worthily. More than once, while contemplating M. Besson's living and luminous portraits, have I found myself dreaming of all the grace and devotion which the artists of the 18th century put into the pictures which they have bequeathed us of their favourite *goddesses*.

At different times, various portrait-painters have caught the fashion, some by reason of their *qualities,* others by their *defects*. The public, which is passionately in love with its own image, knows no half-measures in its love for the artist to whom it most willingly entrusts the task of depicting it. Amongst all those who have managed to snatch this favour, the man who seems to me to have deserved it the most, because he has always remained a frank and genuine artist, is M. Ricard. A lack of solidity in his painting has sometimes been noticed; his taste for Van Dyck, Rembrandt and Titian, and his grace, which is sometimes English, sometimes Italian, have been exaggeratedly rebuked. But such criticisms are just a little unfair. For imitation is the intoxication of supple and brilliant minds, and often even a proof of their superiority. To his painter's instincts, which are altogether remarkable, M. Ricard unites a very wide learning in the history of his art and a critical mind of great finesse; there is not a single work of his in which we do not find evidence of all these qualities. Formerly perhaps he made his models too pretty; and yet I ought to add that in the portraits of which I am speaking, this particular fault may have been *demanded* by his model. Nevertheless the virile and noble part of his mind was

quick to prevail. He truly has an understanding which is always ready to grasp and depict the *soul* which poses in front of him. Take that portrait of an old lady, in which there is no cowardly disguising of her age; it immediately reveals a reposeful character, a sweetness and a charity which command confidence. The simplicity of her gaze and of her attitude accords happily with that warm, softly-golden colour which seems to me to have been specially made to convey the sweet thoughts of the evening. But if you want to recognize energy in youth, grace in health, and candour in a countenance which is trembling with life, then consider his portrait of Mlle. L. J. This certainly is a portrait both true and great. If a beautiful model does not *confer* talent, it is certain that at least it adds a charm to existing talent. But how few painters are masters of an execution which could better realize the solidity of this pure and generous nature, and the deep heavens of this eye with its great velvet star! The contour of the face, the curves of this broad, youthful brow with its helmet of heavy tresses, the richness of these lips and the dazzling grain of the skin—all is carefully expressed; and then—the most charming thing of all, and the most difficult to paint—that touch of slyness which is always mingled with innocence, and that strange, nobly ecstatic air which in human beings, no less than in animals, gives such a mysterious appeal to the countenances of the young. The number of portraits painted by M. Ricard is already very considerable; but this one is as good as any, and the activity of this remarkable mind, which is always on the alert and in pursuit, promises us many others.

I think that in a summary but sufficient manner I have explained why the portrait, the true portrait, this genre which is apparently so modest, is in fact so difficult to practise. It is therefore only natural that I have but few specimens to adduce. Many other artists—Mme. O'Connell for example—know how to paint a human head; but if I was to deal with them all, I should be obliged to go over the same ground again and again, with reference to this quality or that defect—and we agreed at the beginning that I should content myself as far as possible with explain-

ing what may be regarded as the *ideal*, in respect of each
class of painting.

VIII

LANDSCAPE

IF AN assemblage of trees, mountains, water and houses,
such as we call a landscape, is beautiful, it is not so of
itself, but through me, through my own grace and favour,
through the idea or the feeling which *I* attach to it. It
amounts to saying, I think, that any landscape-painter who
does not know how to convey a *feeling* by means of an
assemblage of vegetable or mineral matter, is no artist.
I know very well that by a singular effort the human
imagination can momentarily conceive of Nature without
Man—can conceive of all the suggestive mass of the universe
dispersed throughout space without a contemplator to ex-
tract from it comparison, metaphor and allegory. It is true
enough that all that universal order and harmony would
lose none of the inspirational quality with which providence
has entrusted it; but in that case, in default of an intelli-
gence to inspire, this quality would be as though it did
not exist at all. Those artists who want to express nature
minus the feelings which she inspires are submitting to an
odd sort of operation which consists in killing the reflective
and sentient man within them; and believe me, the disaster
is that for the majority of them this operation has nothing
odd nor painful about it at all! Such is the school which
prevails today, and for a long time has prevailed. Like
everyone else, I will admit that our modern school of land-
scape-painters is singularly strong and skilful; but in this
triumph and predominance of an inferior genre, in this
silly cult of a nature neither purged nor explained by
imagination, I see an obvious symptom of general degra-
dation. We shall doubtless seize upon several differences in
practical skill between this and that landscape-painter; but
these differences are very small. Pupils of various masters,
they all of them paint remarkably well, and almost all of

them forget that a natural view has no value beyond the
immediate feeling that an artist can put into it. Most of
them fall into the error to which I drew attention at the
beginning of this study. They take the dictionary of art for
art itself; they copy a word from the dictionary, believing
that they are copying a poem. But a poem can never be
copied; it has to be *composed*. Thus, they open a window,
and the whole space contained in the rectangle of that
window—trees, sky and house—assumes for them the value
of a ready-made poem. Some of them go even further. In
their eyes a study is a picture. M. Français[1] shows us a
tree—an enormous, ancient tree, it is true—and he says to
us, 'Behold, a landscape.' The technical superiority shown
by MM. Anastasi,[2] Leroux,[3] Breton,[4] Belly, Chintreuil, etc.,
only serves to make the universal lacuna more visible and
more distressing. I know that M. Daubigny[5] wishes, and
is able, to do more. His landscapes have a grace and a fresh-
ness which fascinate the eye at once. They immediately
convey to the spectator's soul the original feeling in which
they are steeped. But it seems that M. Daubigny has only
been able to obtain this quality at the expense of finish and
of perfection in detail. Many a picture of his, otherwise
ingenious and charming, lacks solidity. It has the grace,
but also the flabbiness and impermanence, of an improvisa-
tion. Before all else, however, we must record to M.
Daubigny's credit the fact that his works are generally
poetic, and with all their faults I prefer them to many
others which are more perfect, but lack the quality which
distinguishes him.

It is style, especially, that M. Millet[6] seeks; he makes no
secret, rather he makes a show and glory of it. But part of

[1] His *Soleil couchant* repro. *Illustr.*, vol. 34 (1859), p. 20.
[2] His *Un lac en Tyrol* repro. *Illustr.*, vol. 33 (1859), p. 388.
[3] See pl. 23.
[4] His *Rappel des glaneuses* is now in the Louvre.
[5] Of Daubigny's five exhibits, *Les Graves au bord de la mer, à
Villerville* is in the Marseilles Museum and *Les Bords de l'Oise*
in the Bordeaux Museum. See pl. 33.
[6] Millet's sole exhibit, his *Femme faisant paître sa vache* is now
in the Bourg Museum. See pl. 37.

the ridicule which I directed against M. Ingres's pupils
sticks to him. For 'style' has been his disaster. His peasants
are pedants who have too high an opinion of themselves.
They display a kind of dark and fatal boorishness which
makes me want to hate them. Whether they are reaping
or sowing, whether they are grazing or shearing their
animals, they always seem to be saying, 'We are the poor
and disinherited of this earth—but it is we who make it
fertile! We are accomplishing a mission, we are exercising
a priestly function!' Instead of simply distilling the natural
poetry of his subject, M. Millet wants to add something
to it at any price. In their monotonous ugliness, all these
little pariahs have a pretentiousness which is philosophic,
melancholy and Raphaelesque. This disastrous element in
M. Millet's painting spoils all the fine qualities by which
one's glance is first of all attracted towards him.

M. Troyon is the finest example of skill without soul.
And so, look at his popularity! With a soul-less public, he
deserved it. While still a young man, M. Troyon painted
with the same assurance, the same skill and the same in-
sensitivity. Long years ago he had already amazed us by
the soundness of his craftsmanship, by the 'directness of his
playing', as one says of an actor, and by his unfailing,
moderate and continual merit. He *has* a soul—I grant that—
but it is a soul too much within the reach of all other souls.
The encroachment of these second-class talents cannot take
place without injustices being created. When any other
beast but the lion takes the lion's share for itself, there
cannot fail to be some modest creatures who find their
modest portions much too much reduced. I mean that
among those second-class talents who are successfully
cultivating an inferior branch of art, there are several who
are worth every bit of M. Troyon, and who may find it odd
that they do not obtain all that is their due, while this
man takes much more than is his. I must be careful not
to mention names; the victims would perhaps feel them-
selves no less outraged than the encroacher.

The two men who have always been marked out by
public opinion as the most important in the special field
of landscape are MM. Rousseau and Corot. With artists of

such eminence one must be full of reserve and respect. M. Rousseau's manner of working is complicated, full of tricks and second thoughts. Few men have had a sincere love for light, or have rendered it better. But the general silhouette of his forms is often difficult to grasp. His luminous haze, which sparkles as it is tossed about, is upsetting to the physical *anatomy* of objects. M. Rousseau has always dazzled, but he has sometimes exhausted me too. And then he falls into that famous modern fault which is born of a blind love of nature and nothing but nature; he takes a simple study for a composition. A glistening marsh, teeming with damp grasses and dappled with luminous patches, a rugged tree-trunk, a cottage with a flowery thatch, in short a little scrap of nature, becomes a sufficient and a perfect picture in his loving eyes. But even all the charm which he can put into this fragment torn from our planet is not always enough to make us forget the absence of construction in his pictures.[7]

If M. Rousseau—who, for all his occasional incompleteness, is perpetually restless and throbbing with life—if M. Rousseau seems like a man who is tormented by several devils and does not know which to heed, M. Corot,[8] who is his absolute antithesis, has the devil too seldom within him. However inadequate and even unjust this expression may be, I chose it as approximately giving the reason which prevents this serious artist from dazzling and astonishing us. He does astonish—I freely admit—but slowly; he does enchant—little by little; but you have to know how to penetrate into the science of his art, for with him there is no glaring brilliance, but everywhere an infallible strictness of harmony. More than that, he is one of the rare ones, the only one left, perhaps, who has retained a deep feeling for construction, who observes the proportional value of each detail within the whole, and (if I may be allowed to compare the composition of a landscape to that of the human frame) the only one who always knows where to place the

[7] Rousseau exhibited five landscapes this year. See pl. 35.
[8] Among Corot's seven exhibits were the *Dante and Virgil* (Boston Museum), the *Macbeth* (Wallace Collection) and the *Idylle* (Lille Museum). See pl. 40.

bones and what dimensions to give them. You feel, you guess that M. Corot draws in a summary and broad manner, which is the only way of making a rapid accumulation of a great quantity of precious raw-materials. If it had been granted to a single man to restrain the modern French school in its impertinent and tedious love of detail, certainly he would have been that man. We have heard this eminent artist criticized because his colour is somewhat too soft and his light is almost crepuscular. It might be said that for him all the light which floods the earth is everywhere dimmed by one or more degrees. His eye, which is keen and judicious, is more concerned with what establishes harmony than with what emphasizes contrast. But even supposing that this criticism is not too unjust, it is well to remark that our exhibitions of painting are not favourable to the effect of good pictures—above all of those which are conceived and executed soundly and with moderation. The sound of a clear voice, but one which is both modest and harmonious, gets lost amid an uproar of deafening or raucous shouts, and even the most luminous Veroneses would often appear pale and grey if they were surrounded by certain modern paintings which are more garish than peasants' scarves.

Among M. Corot's merits one must not forget the excellence of his teaching, which is sound, luminous and methodical. Of the numerous pupils whom he has shaped, sustained or restrained far from the seductions of the times, M. Lavieille is the one who has given me the greatest pleasure. There is quite a simple landscape of his; a cottage on the skirts of a wood, with a road disappearing into it. The snow's whiteness makes a pleasant contrast with the conflagration of the evening, which is slowly burning down behind the innumerable mastheads of the leafless forest. For several years now our landscape-painters have been turning more frequently to the picturesque beauties of the sad season. But no one, I think, feels them better than M. Lavieille. Not a few of the effects which he has often realized seem to me, however, to be chosen extracts from the *joys* of winter. In the sadness of this landscape, which wears the sombrely pink and white livery of the fine days

of winter as they draw towards their close, there is an irresistible and elegiac thrill of pleasure which is known to all lovers of solitary walks.

Allow me, my friend, to return once more to my obsession —I mean to my feeling of regret when I see the imagination's part in landscape being more and more diminished. Here and there, at long intervals, there appears the trace of a protest, a great and free talent which is no longer in the taste of the age. There is M. Paul Huet, for example; in him we have a *veteran of the old guard!* (I can apply this familiar and grandiloquent expression to the débris of a fighting glory like *Romanticism*, which is already so far behind us.) M. Paul Huet remains faithful to the tastes of his youth. His eight paintings of marine or rustic subjects, which are to serve for the decoration of a salon, are veritable poems of lightness, splendour and freshness. It seems superfluous to detail the talents of so exalted an artist, who has produced so much; but what seems to me to be all the more remarkable and praiseworthy in him is that all the time that the taste for minuteness has been everywhere gaining ground step by step, *he* has remained constant in his nature and his method, and has continued to give to all his compositions a character which is lovingly poetic.

Nevertheless this year a little consolation has come my way, from two artists of whom I should not have expected it. M. Jadin, who up to the present has too modestly confined his glory to the hovel and the stable (this is now obvious), has sent a splendid view of Rome, taken from the Arco di Parma. It contains first of all this artist's usual qualities, which are those of energy and solidity, but in addition it reveals the perfect capturing and realization of a poetic impression. It is the glorious and melancholy impression of evening as it falls upon the holy city; a solemn evening, shot with bands of scarlet and blazing with splendour like the Roman religion itself. The second is M. Clésinger, for whom sculpture alone is not enough; he is like those children whose turbulent blood and bounding ardour impel them to scale all heights in order to inscribe their names thereon. His two landscapes, *Isola Farnese* and *Castel Fusana*, are penetrating of aspect, and of a

native and austere melancholy. Their waters are heavier and more solemn than elsewhere, their solitude more silent, their very trees more monumental. M. Clésinger's *rhetoric* has often raised a laugh; but he will never lay himself open to mockery on the score of littleness. Vice for vice, I agree with him that excess in everything is better than meanness.

Yes, imagination certainly avoids landscape! I can understand how a mind which is absorbed in taking notes has no time to abandon itself to the prodigious reveries contained in the natural sights which confront it; but why does imagination avoid the landscape-painter's *studio?* Perhaps the artists who cultivate this genre are far too mistrustful of their memory, and adopt a method of immediate copying because it perfectly suits their laziness of mind. If they had been with me recently in the studio of M. Boudin (who, by the way, has exhibited a good and careful picture: *Le Pardon de sainte Anne Palud*[9]), they would have seen several hundred pastel-studies, improvised in front of the sea and sky, and would then have understood what they do not yet seem to understand—the gulf which separates a study from a picture.[10] But M. Boudin, who might plume himself on this devotion to his art, evinces the greatest modesty in showing his curious collection. He knows quite well that all this will have to be turned into a picture, by means of the poetic impression recalled at will; and he lays no claim to be offering his notes as pictures. Later, no doubt, these prodigious enchantments of air and water will be displayed for us in finished paintings. On the margin of each of these studies, so rapidly and so faithfully sketched from the waves and the clouds (which are of all things the most inconstant and difficult to grasp, both in form and in colour), he has inscribed the date, the time and the wind: thus for example, *8th October, midday,*

[9] Now in the Museum at Le Havre.

[10] Baudelaire had recently met Boudin at Honfleur. See John Rewald, *History of Impressionism* (New York, Museum of Modern Art, 1946, p. 38). Rewald reproduces one of Boudin's sky-studies. It is hardly necessary to point out the parallel with Constable's activities in the early 1820s. See pl. 39.

North-West wind. If you have ever had the time to become acquainted with these meteorological beauties, you will be able to verify by memory the accuracy of M. Boudin's observations. Cover the inscription with your hand, and you could guess the season, the time and the wind. I am not exaggerating. I have seen it. In the end, all these clouds, with their fantastic and luminous forms; these ferments of gloom; these immensities of green and pink, suspended and added one upon another; these gaping furnaces; these firmaments of black or purple satin, crumpled, rolled or torn; these horizons in mourning, or streaming with molten metal—in short, all these depths and all these splendours rose to my brain like a heady drink or like the eloquence of opium. It is rather an odd thing, but never once, while examining these liquid or aerial enchantments, did I think to complain of the absence of man. But I must take care not to allow the abundance of my pleasure to dictate a piece of advice to the world at large, any more than to M. Boudin himself. It would really be too dangerous. Let him remember that man is never loth to see his fellow (as was observed by Robespierre, who was well versed in the *humanities*); and if he wants to win a little popularity, let him take care not to imagine that the public has arrived at an equal enthusiasm for solitude.

There is a lack not only of seascapes—such a poetic genre, moreover; though I do not count as seascapes those military dramas which are played at sea—but also of a genre which I can only call the landscape of great cities, by which I mean that collection of grandeurs and beauties which results from a powerful agglomeration of men and monuments—the profound and complex charm of a capital city which has grown old and aged in the glories and tribulations of life.

Some years ago a strange and stalwart man—a Naval Officer, I am told—began a series of etched studies of the most picturesque views in Paris. By the sharpness, the refinement and the assurance of his drawing, M. Méryon[11]

[11] There was at one time a project that Baudelaire should write short texts to accompany a collection of Méryon's etchings of Paris, but unfortunately it came to nothing.

reminded us of the excellent etchers of the past. I have rarely seen the natural solemnity of an immense city more poetically reproduced. Those majestic accumulations of stone; those spires 'whose fingers point to heaven';[12] those obelisks of industry, spewing forth their conglomerations of smoke against the firmament; those prodigies of scaffolding round buildings under repair, applying their openwork architecture, so paradoxically beautiful, upon architecture's solid body; that tumultuous sky, charged with anger and spite; those limitless perspectives, only increased by the thought of all the drama they contain—he forgot not one of the complex elements which go to make up the painful and glorious décor of civilization. If Victor Hugo has seen these excellent prints, he must have been pleased; again he will have found worthily depicted his—

> Morne Isis, couverte d'un voile!
> Araignée à l'immense toile,
> Où se prennent les nations!
> Fontaine d'urnes obsédée!
> Mamelle sans cesse inondée,
> Où, pour se nourrir de l'idée,
> Viennent les générations! . . .
>
> Ville qu'un orage enveloppe![13]

But a cruel demon has touched M. Méryon's brain; a mysterious madness has deranged those faculties which seemed as robust as they were brilliant. His dawning glory and his labours were both suddenly cut short. And from that moment we have never ceased waiting anxiously for some

[12] The phrase 'clochers *montrant du doigt le ciel*' (italicized by Baudelaire) deserves a note. Baudelaire probably had it from Gautier, who quoted it (*Fantaisies*, III), with the addition of the adjective 'silencieux', as the only line of Wordsworth that he knew. The line occurs in Wordsworth's *The Excursion* (Book VI, l. 19); in the first edition of that poem, Wordsworth has a note to the effect that he had derived the phrase 'point as with silent finger' from Coleridge.

[13] *Les Voix intérieures*, IV, 'A l'Arc de Triomphe'. Crépet, in his edition of the *Curiosités esthétiques* (p. 497–8) quotes an appreciative letter which Baudelaire received from the exiled Hugo. See Appendix.

consoling news of this singular naval officer who in one short day turned into a mighty artist, and who bade farewell to the ocean's solemn adventures in order to paint the gloomy majesty of this most disquieting of capitals.

In still regretting the landscape of Romanticism, and even the landscape of Romance (which already existed in the 18th century), I am perhaps being unconsciously obedient to the customs of my youth. But surely our landscape-painters are far too herbivorous in their diet? They never willingly take their nourishment from ruins, and apart from a small number of men such as Fromentin, the sky and the desert terrify them. I feel a longing for those great lakes, representing immobility in despair; for immense mountains, staircases from our planet to the skies, from which everything which formerly seemed great now seems small; for castle keeps (yes, I do not even stop at that!); for crenellated abbeys, reflected in gloomy pools; for gigantic bridges, towering Ninevite constructions, haunts of dizziness—for everything, in short, which would have to be invented if it did not already exist!

I must confess in passing that, although he is not endowed with a very decided originality of manner, M. Hildebrandt has given me a keen pleasure with his enormous display of water-colours. As I run through these amusing travel-albums, it always seems to me that I am *seeing again*, that I am *recognizing* what in fact I have never seen. Stimulated by him, my imagination has ranged across thirty-eight[14] romantic countrysides, from the echoing ramparts of Scandinavia to the luminous countries of the ibis and the stork, from the Fiord of Seraphitus to the point of Teneriffe. The moon and the sun have taken it in turns to illumine these scenes, the one pouring forth his explosive light, the other her patient enchantments.

You see, my friend, that I can never regard choice of subject as a matter of indifference, and that, in spite of the necessary love which needs must fertilize the humblest fragment, I hold that *subject-matter* plays a part in the artist's genius, just as it plays a part in my own pleasure—barbarian as I am! On the whole my examination of the

[14] Two of these were oil-paintings; the remainder, water-colours.

landscape-painters has only yielded a few well-behaved or *little* talents, accompanied by a great idleness of imagination. Not one of them has been able to show me the natural charm, so simply expressed, of Catlin's savannahs and prairies (I'll wager they do not even know the name Catlin!)—let alone the supernatural beauty of Delacroix's landscapes, or the magnificent imagination which streams through the drawings of Victor Hugo, just as mystery streams through the heavens. (I speak of his drawings[15] in Chinese ink, for it is too obvious to mention that in poetry our poet is the king of landscape-painters.)

I would rather return to the diorama, whose brutal and enormous magic has the power to impose a genuine illusion upon me! I would rather go to the theatre and feast my eyes on the scenery, in which I find my dearest dreams artistically expressed and tragically concentrated! These things, because they are false, are infinitely closer to the truth; whereas the majority of our landscape-painters are liars, precisely because they have neglected to lie.

IX

SCULPTURE

AT THE HEART of an ancient library, in the propitious gloom which fosters and inspires lengthy thoughts, Harpocrates, standing upright and solemn, a finger placed upon his lips, commands silence and, like a Pythagorean pedagogue, bids you 'Hush!' with an authoritative gesture. Apollo and the Muses, those imperious phantoms whose divine forms shine forth in the half-light, watch over your thoughts, assist at your labours and urge you to the sublime.

In the fold of a wood, sheltered beneath heavy shades, eternal Melancholy gazes at her august face in the waters of a pool as motionless as she is. And the passing dreamer, both saddened and charmed as he contemplates this great

[15] An excellent collection of these is to be seen at the Musée Victor Hugo, in the Place des Vosges, Paris.

figure whose limbs, though robust, are languid from a secret grief, cries out, 'Behold, my sister!'

As you are hurrying towards the confessional, in the midst of that little chapel which is shaken by the clatter of the omnibus, you are halted by a gaunt and magnificent phantom who is cautiously raising the cover of his enormous tomb in order to implore you, a creature of passage, to think of eternity! And at the corner of that flowery pathway which leads to the burial-place of those who are still dear to you, the prodigious figure of Mourning, prostrate, dishevelled, drowned in the flood of her tears and crushing the powdered remains of some famous man beneath her heavy desolation, teaches you that riches, glory, your country even, are pure frivolities compared to that great Unknown which no one has named nor defined; which man can only represent by mysterious adverbs such as 'Perhaps', 'Never', 'Always!';—and which contains, as some hope, the infinite beatitude which they so much desire, or else an anguish without respite, whose image is rejected by modern reason with the convulsive gesture of a death-agony.

Your spirit charmed by the music of gushing waters, sweeter still than the tongues of nurses, you tumble into a boudoir of greenery, where Venus and Hebe, those playful goddesses who sometimes presided over your life, are displaying beneath alcoves of leafage the charms of their well-rounded limbs, upon which the furnace has bestowed the rosy sheen of life. But you are hardly likely to find these delightful surprises elsewhere but in the gardens of the past; for of the three excellent substances—bronze, terracotta and marble—which are available to the imagination for the fulfilment of its sculptural dream, the last alone enjoys an almost exclusive popularity in our age—and very unjustly so, in our opinion.

You are passing through a great city which has grown old in civilization—one of those cities which harbour the most important archives of the universal life—and your eyes are drawn upwards, *sursum, ad sidera;* for in the public squares, at the corners of the crossways, stand motionless figures, larger than those who pass at their feet, repeating

to you the solemn legends of Glory, War, Science and Martyrdom, in a dumb language. Some are pointing to the sky, whither they ceaselessly aspired; others indicate the earth from which they sprang. They brandish, or they contemplate, what was the passion of their life and what has become its emblem; a tool, a sword, a book, a torch, *vitai lampada!* Be you the most heedless of men, the most unhappy or the vilest, a beggar or a banker, the stone phantom takes possession of you for a few minutes and commands you, in the name of the past, to think of things which are not of the earth.

Such is the divine role of sculpture.

Who could doubt that a powerful imagination is needed to fulfil such a magnificent programme? It is indeed a strange art, whose roots disappear into the darkness of time and which already, in primitive ages, was producing works which cause the civilized mind to marvel! It is an art in which the very thing which would rightly be counted as *quality* in painting can turn into a defect or a vice, an art in which true perfection is by so much the more necessary as the means at its disposal—which are apparently more complete, but are also more barbarous and childish —will always give a *semblance* of finish and perfection, even to the most mediocre works. Faced with an object taken from nature and represented by sculpture—that is to say, a round, three-dimensional object about which one can move freely, and, like the natural object itself, enveloped in atmosphere—the peasant, the savage or the primitive man feels no indecision; whereas a painting, because of its immense pretensions and its paradoxical and abstractive nature, will disquiet and upset him. We may observe at this point that the *bas-relief* is already a lie, that is to say a step taken in the direction of a more civilized art, departing by that much from the pure idea of sculpture. You will remember that, because he did not understand this, the painter Catlin was all but embroiled in a very dangerous quarrel between two of his native chiefs; after he had painted a profile-portrait of one of them, some of the others started to tease and reprove the sitter for allowing himself to be robbed of half his face! In the same

way monkeys have been known to be deceived by some
magical painting of nature and to go round behind the
picture in order to find the other side. It is a result of the
barbarous conditions which restrict sculpture that, as well
as a very perfect execution, it demands a very elevated
spirituality. Otherwise it will only produce the kind of
marvellous object which dumbfounds the ape and the
savage. Another result is that even the eye of the true
amateur is sometimes so wearied by the monotonous white-
ness of all these great dolls, exact in all their proportions
of height and thickness, that it abdicates its authority. The
mediocre does not always appear contemptible to it, and
short of a statue's being aggressively wretched, it is
capable of taking it for a good one; but a sublime for a bad
one, never! In sculpture, more than in any other medium,
beauty imprints itself indelibly on the memory. With what
a prodigious power have Egypt, Greece, Michelangelo,
Coustou[1] and a few others invested these motionless phan-
toms! with what a glance these pupil-less eyes! Just as
lyric poetry makes everything noble—even passion; so sculp-
ture, true sculpture, makes everything solemn—even move-
ment. Upon everything which is human it bestows
something of eternity, which partakes of the hardness of
the substance used. Anger becomes calm, tenderness
severe, and the flickering and faceted dream of painting is
transformed into a solid and stubborn meditation. But if
you will stop to think how many different types of perfec-
tion must be brought together in order to achieve this
austere magic, you will not be surprised at the exhaustion
and discouragement which often take possession of our
minds as we hasten through these galleries of modern
sculpture, where the divine aim is nearly always misunder-
stood and a trifling prettiness is indulgently substituted for
grandeur.

But our taste is a tolerant one, and our dilettantism can
accommodate itself in turn to every sort of grandeur or
frivolity. We are capable of loving the mysterious and
sacerdotal art of Egypt and Nineveh; the art of Greece—

[1] The reference is probably to Guillaume Coustou I (1677–
1746), the sculptor of the 'Chevaux de Marly'.

at once so charming and so rational; the art of Michelangelo —as precise as a science, as prodigious as a dream; and the cleverness of the eighteenth century, which is bravura within Truth: but in all these different manifestations of sculpture we find a power of expression and a richness of feeling which are the inevitable results of a deep imagination only too often lacking amongst us today. And so you will not be surprised to find me brief in my examination of this year's works. Nothing is sweeter than to admire, and nothing more disagreeable than to criticize. But the great and cardinal faculty, like the pictures of the Roman patriots, is only conspicuous by its absence. Now, then, is the moment to thank M. Franceschi for his *Andromède*.[2] While exciting general attention, this figure has given rise to several criticisms which in our opinion were too facile. It has the immense merit of being poetic, exciting and noble. It has been called a plagiarism, and M. Franceschi has been accused of simply taking a recumbent figure by Michelangelo and standing it upright. This is not true. The languor of these forms, which are small in size though great in feeling, and the paradoxical elegance of these limbs are clearly the doing of a modern artist. But even if he should have borrowed his inspiration from the past, I would see in this a ground for praise rather than for criticism; it is not given to everyone to imitate what is great, and when such imitation is the doing of a young man, who has naturally a great span of life open before him, it gives the critic far more reason for hope than for suspicion.

What an extraordinary man is this M. Clésinger! Perhaps the finest thing that you can say of him is that, to see such an easy production of works so varied, you imagine an intelligence, or rather a temperament, which is always on the alert, a man who has the love of sculpture in his very bowels. You admire a marvellously well-executed fragment; but then some other fragment completely spoils the statue. How thrilling is the slender thrust of this figure! but look at those draperies, which, with the intention of seeming light, are nevertheless tubular and twisted like macaroni!

[2] Repro. *Gazette des Beaux-Arts*, 1859, vol. II, p. 369.

If M. Clésinger sometimes catches movement, he never achieves complete elegance. The beauty of style and of character, which has been so much praised in his busts of Roman ladies,[3] is neither assured nor perfect. It would seem that in his impetuous passion for his work, he often forgets muscles and is neglectful of a thing so precious and important as the shifting planes of modelling. I would rather not speak of his unhappy *Sapphos,* for I know that he has frequently done much better; but even in his best-executed statues, the practised eye is distressed by his method of *abbreviation,* whereby the human face and human limbs all have the banal finish and polish of wax cast in a mould. If Canova was sometimes charming, it was certainly not thanks to this defect. His *Taureau Romain* has received well-deserved praise from everybody; it is really a very fine work: but if I were M. Clésinger, I should not like to be praised so magnificently for having created the image of an *animal,* however noble and superb that animal may have been. A sculptor of his calibre ought to have other ambitions and to set his hand to the creation of other images than those of bulls.[4]

The *Saint Sebastian* by a pupil of Rude, M. Just Becquet, is a painstaking and vigorous piece of sculpture. It makes one think at once of the painting of Ribera and of the harsh statuary of Spain. M. Rude's teaching has had a great effect upon the school of our time; but if it has profited some—those, doubtless, who were able to *edit* that teaching with the aid of their own natural intelligence—it has nevertheless plunged others, too docile, into the most amazing aberrations. Look at that Gaulish woman[5] for example! The first shape that a woman of Gaul assumes in your mind is that of a figure of noble bearing, free, powerful, robust and supple of form, a strapping daughter of the forests, a wild and warlike woman, whose voice was heard

[3] Mme. Sabatier (pl. 57) was represented by Clésinger as a Roman lady.

[4] Three of Clésinger's exhibits, including one of his Sapphos, and the Roman bull, are repro. Estignard, *Clésinger* (Paris 1900), facing pp. 56, 72, and 172.

[5] By J. B. Baujault.

in the councils of the fatherland. But in the unfortunate
object of which I am speaking, there is a complete absence
of all that constitutes beauty and strength. The breast, hips,
thighs, legs—everything, in fact, that ought to stand
in relief, is hollow. I have seen corpses like this on dissec-
tion-tables, ravaged by disease and a continuous poverty
of forty years. Can it be that the artist has sought to repre-
sent the decay and the exhaustion of a woman who has
known no other nourishment but acorns? and has he con-
fused his warrior-woman of ancient Gaul with a decrepit
female Papuan? Let us look for a less ambitious explanation
and simply assume that, having heard it frequently re-
peated that one must faithfully copy the model, and not
being endowed with the necessary perspicacity to choose a
fine one, he has copied the ugliest that he could find, with
a perfect devotion. This statue has found praise, doubtless
because of its far-darting eye, like a 'Keepsake' Velléda. I
am not at all surprised.

If you want to study the opposite of sculpture once
again, but this time in another form, look at those two
little theatrical microcosms invented by M. Butté: they
represent, I believe, *The Tower of Babel* and *The Flood*.
But subject-matter has little importance, anyway, when
by its nature, or by the manner in which it is treated, the
very essence of the art is found to have perished. This
lilliputian world, these miniature processions, these little
crowds which wind in and out among the rocky boulders,
put one simultaneously in mind of the relief maps in the
Marine Museum, of musical picture-clocks, and of those
landscapes with fortress, draw-bridge and the changing
of the guard which may be seen in pastry-cooks' and toy-
sellers' shops. I find it extremely unpleasant to have to write
such things, especially when we are concerned with works
in which both imagination and ingenuity are otherwise to
be found; and if I speak of them, it is only because they
are important in this one respect—that they serve to put
on record one of the mind's greatest vices, which is a
stubborn disobedience to the constituent rules of art. How
could one conceive of qualities fine enough to counter-
balance such an enormity of error? What healthy brain

could imagine without horror a painting in relief, a piece of sculpture mechanically activated, a rhymeless ode, a novel in verse, and so on? When the natural aim of an art is misunderstood, it is natural to call to its aid all the devices which are alien to that art. And in the case of M. Butté, who has wanted to represent, on a small scale, vast scenes demanding an innumerable quantity of figures, we may observe that the ancients always confined such ventures to the bas-relief, and that among the moderns, even very great and clever sculptors have never attempted them without damage and danger to their art. The two essential conditions—unity of impression and totality of effect—are grievously violated thereby, and no matter how great the 'stage director's' talent, the spectator's mind will be troubled and will start wondering if it has not had a somewhat similar impression from Curtius's[6] waxworks. The vast and magnificent groups which adorn the gardens of Versailles are not a complete refutation of my opinion; for, apart from the fact that they are not all equally successful, and that some of them, by their chaotic structure, would only serve, on the contrary, to confirm the said opinion (I refer particularly to those in which almost all the figures are vertical), I would like to point out that there you have an entirely special kind of sculpture, whose faults, which are sometimes quite deliberate, vanish altogether beneath a liquid firework display, beneath a luminous rain; in a word, it is an art which is completed by hydraulics, an inferior art on the whole. Yet even the most perfect among these groups are only so because they approach the closer to true sculpture, and because, by means of their leaning attitudes and their interlacings, the figures create that general compositional arabesque which is motionless and fixed in painting, but as mobile and variable in sculpture as it is in a mountainous landscape.

We have already spoken, my dear M—, about the school of the *pointus*, and we recognized that amongst these subtle

[6] The popularizer of waxwork shows in Paris, during the last half of the 18th century. He had two museums, one of 'grands hommes et gens de marque' at the Palais-Royal, and another for 'les criminels' on the Boulevard du Temple.

spirits, who are all more or less tainted with disobedience
to the idea of pure art, there were nevertheless one or two
of some interest. In sculpture too we find the same mis-
fortunes. Undoubtedly M. Fremiet is a good sculptor; he
is clever, daring, and subtle; he searches for the striking
effect, and sometimes he finds it; but that is precisely where
his misfortune lies, for he often searches for it some little
way from the natural road. His *Orang-outang dragging a
woman into a wood*[7] (a rejected work, which naturally I
have not seen) is very much the idea of a *pointu*. Why not
a crocodile, a tiger, or any other animal which is liable
to eat a woman? But that is not the point! Be assured that
this is no question of eating, but of rape! Now it is the
ape alone, the gigantic ape, at once more and less than a
man, that has been known to betray a human appetite for
woman. So there, he has found his means of astonishing
us! 'He is carrying her off; will *she* be able to resist?' Such
is the question which will engage the entire female public.
A strange and complex feeling, composed partly of terror
and partly of priapic curiosity, will sweep it to success.
Nevertheless, seeing that M. Fremiet is an excellent work-
man, both the animal and the woman will be equally well
imitated and modelled. But to tell the truth, such subjects
are unworthy of so ripe a talent, and the jury has acted
well in refusing this wretched melodrama.

If M. Fremiet tells me that I have no right to scrutinize
the aims, or even to speak, of what I have not seen, I will
humbly fall back upon his *Cheval de saltimbanque*.[8] Taken
in himself, the little horse is charming; his thick mane, his
square muzzle, his intelligent air, his low-hung quarters,
his little legs, both solid and spindly at the same time—
everything marks him out as one of those humble beasts
that have breeding. But I find the owl perched upon his
back just a little disturbing (for I suppose I have not read
the catalogue), and I start to wonder why Minerva's bird

[7] Repro. facing p. 82 in Philippe Faure-Fremiet, *Fremiet* (Paris
1934); see also pp. 67–70. Fremiet later made several variations
on this subject; examples are in the Nantes Museum and at
Melbourne.

[8] Repro. Faure-Fremiet, *op. cit.*, facing p. 48.

should be placed upon Neptune's creation. Then I notice
the puppets which are hooked to his saddle; the idea of
wisdom represented by the owl leads me to deduce that
the puppets embody the frivolities of the world. It remains
to explain the function of the horse, who, in the language
of apocalypse, may well symbolize Intelligence, Will or
Life. In the end I positively and patiently worked it out
that M. Fremiet's work represents human intelligence car-
rying everywhere with it the idea of wisdom and the taste
for folly. So here we have the immortal philosophic an-
tithesis, the essentially human contradiction upon which,
from the beginning of time, all philosophy and all litera-
ture have turned, from the tumultuous reigns of Ormuzd
and Ahriman to the Reverend Maturin, from Manes to
Shakespeare! . . . But a bystander whom I pestered with
my questions was pleased to inform me that I was 'looking
for apples on a pear-tree' and that the statue simply repre-
sents a tumbler's horse . . . What, then, of that solemn
owl, those mysterious marionettes? do they add nothing
new to the idea of the horse? In so far as it is simply a
horse, in what particular do they increase its merit? Obvi-
ously this work should have been entitled *A tumbler's horse
in the absence of the tumbler, who has gone off to have a
game of cards and a drink in a neighbouring tavern!* That
is the real title!

MM. Carrier, Oliva and Prouha are more modest than
M. Fremiet or myself; they are content to astonish us by
the flexibility and skill of their art. All three of them have
an evident sympathy with the living sculpture of the 17th
and 18th centuries, and to this they devote their more or
less concentrated faculties. They have loved and studied
Caffieri, Puget, Coustou, Houdon, Pigalle and Francin.
True enthusiasts have for long admired M. Oliva's vigor-
ously-modelled busts, in which life breathes and even the
eyes sparkle. That which represents *General Bizot* is one
of the most *military* busts that I have seen, and *M. de
Mercey* is a masterpiece of finesse. Everyone will have
recently noticed M. Prouha's statue in the courtyard of
the Louvre—it recalled the noble and courtly graces of the
Renaissance. M. Carrier may congratulate and compliment

himself. Like his favourite masters, he possesses energy and spirit, though a slight excess of disorder and disarray in the costume may perhaps be held to contrast unhappily with the vigorous and patient finish of his faces. I am not claiming that it is a fault to crumple a shirt or a cravat, or to give a pleasant twist to the lapel of a coat; I am only referring to a lack of harmony with relation to the total idea. And yet I will readily own that I hesitate to attach too much importance to this observation, for M. Carrier's busts have caused me a pleasure quite keen enough to make me forget this entirely fleeting little impression.

You will remember, my friend, that we have already spoken of *Jamais et Toujours;* I have not yet been able to discover the explanation of this riddling title. Can it be a last resort, or a motiveless whim, like *Rouge et Noir?* Or perhaps M. Hébert[9] has bowed to the taste of MM. Commerson and Paul de Kock which prompts them to see a thought in the fortuitous clash of any antithesis? However that may be, he has made a charming piece of sculpture (*chamber-sculpture,* shall we call it? although it is doubtful if the ladies and gentlemen of the bourgeoisie would want it to decorate their boudoirs)—a kind of vignette in sculpture, but one which nevertheless might make an excellent funereal decoration in a cemetery or a chapel, if executed on a larger scale. A young girl, generous and supple of form, is being lifted and swung up with a harmonious lightness; and her body, convulsed in ecstasy or in agony, is resignedly submitting to the kiss of an immense skeleton. It is generally held, perhaps because antiquity did not know it, or knew it but little, that the skeleton should be excluded from the realm of sculpture. This is a great error. We see it appear in the middle ages, comporting and displaying itself with all the impudent clumsiness, with all the arrogance of the Idea without Art. But from then until the 18th century (the historical climate of love and roses) we see the skeleton blossom and flourish in every subject in which it is allowed to make an entrance. The sculptor was very quick to understand all the mysterious and abstract beauty inherent in this scraggy carcass which the

[9] i.e. Emile Hébert: see p. 228 above.

flesh serves as clothing, and which is itself a kind of map
of the human poem. And so this sentimental, sardonic,
almost scientific kind of Grace, cleansed and purified of the
soil's defilement, took its stand in its turn among the in-
numerable other Graces which Art had already wrested
from ignorant Nature. M. Hébert's skeleton is not, properly
speaking, a skeleton at all. Nevertheless I am not suggest-
ing that the artist has tried to *sidestep* the difficulty, as
they say. If this redoubtable personage has here assumed
the vague character of a phantom, a spectre or a lamia;
if in some parts it is still clothed with a parchment-like skin
which adheres to its joints like the membranes of a palmi-
ped; and if it is half enfolded and draped in an immense
shroud which is raised here and there by its projecting
articulations, all this is doubtless because the artist wanted
above all to give expression to the vast and floating idea
of total negation. He has succeeded, and his phantom is
full of nothingness.

The pleasant occurrence of this macabre subject has
made me regret that M. Christophe has not exhibited two
pieces of his composition, the one of an altogether analo-
gous nature, the other more gracefully allegorical. This
second[10] represents a naked woman, quite Florentine in the
grandeur and vigour of her frame (for M. Christophe is
not one of those feeble artists whose imagination has been
destroyed by Rude's positive and finicky teaching); seen
from the front, she presents the spectator with a smiling
and dainty face, an actress's face. A light drapery, cleverly
knotted, serves to join this pretty, conventional head to the
robust bosom on which it seems to be resting. But if you
take a further step to the right or the left, you will discover
the secret of the allegory, the moral of the fable—her *real*
head, I mean, twisted out of position and in a swoon of
agony and tears. What at first had enchanted your eyes
was but a mask—the universal mask, your mask, my mask,
the pretty fan which a clever hand uses to conceal its pain
or remorse from the eyes of the world. This work is all

[10] A later version of this statue is now in the Tuileries. It is the
subject of Baudelaire's poem, *Le Masque* (*Les Fleurs du Mal,*
XX).

charm and solidity. The robust character of the body is in
picturesque contrast to the mystical expression of an en-
tirely worldly idea, and surprise does not play a more
important part than is permissible. If ever the artist should
agree to let the dealers have this child of his brain, in the
form of a small-scale bronze, I can confidently predict it an
immense success.

As for the other idea, believe me, for all its charm I
would not answer for it; so much the less because, in order
to be fully realized, it needs two substances, the one pale
and dull (to represent the skeleton), the other dark and
shining (to render the clothing), and this would naturally
increase the horror of the idea, and its unpopularity.[11]
Alas!

> Les charmes de l'horreur n'enivrent que les forts![12]

Imagine a great female skeleton all ready to set out for a
revel. With her flattened, negress's face, her lipless and
gumless smile, and her gaze, which is no more than a pit
of shadows, this horrible thing, which once was a beautiful
woman, seems to be vaguely searching in space for the deli-
cious moment of her rendezvous, or for the solemn moment
of the sabbath which is recorded on the invisible clock of
the centuries. Her bust, which Time has eaten away, leaps
coquettishly from her corsage, like a withered bouquet from
its cone, and this whole funereal conception takes its stand
upon the pedestal of a sumptuous crinoline. To cut matters
short, may I be allowed to quote a fragment of verse in
which I have tried, not to *illustrate*, but to explain the
subtle pleasure distilled by this figurine—rather in the man-
ner that a careful reader scribbles with his pencil in the
margin of his book?

> Fière, autant qu'un vivant, de sa noble stature,
> Avec son gros bouquet, son mouchoir et ses gants,
> Elle a la nonchalance et la désinvolture
> D'une coquette maigre aux airs extravagants.

[11] See pl. 58.
[12] From *Danse Macabre* (*Les Fleurs du Mal*, XCVII). See Ap-
pendix.

Voit-on jamais au bal une taille plus mince?
Sa robe, exagérée en sa royale ampleur,
S'écroule abondamment sur un pied sec que pince
Un soulier pomponné joli comme une fleur.

La ruche qui se joue au bord des clavicules,
Comme un ruisseau lascif qui se frotte au rocher,
Défend pudiquement des lazzi ridicules
Les funèbres appas qu'elle tient à cacher.

Ses yeux profonds sont faits de vide et de ténèbres,
Et son crâne, de fleurs artistement coiffé,
Oscille mollement sur ses frêles vertèbres.
O charme du néant follement attifé!

Aucuns t'appelleront une caricature,
Qui ne comprennent pas, amants ivres de chair,
L'élégance sans nom de l'humaine armature!
Tu réponds, grand squelette, à mon goût le plus cher!

Viens-tu troubler, avec ta puissante grimace,
La fête de la vie . . . ?[13]

I think, my friend, that we can stop here; I might pro-
duce some new specimens, but I could only regard them
as superfluous proofs in support of the principal idea
which from the beginning has controlled my work—namely,
that the most ingenious and the most patient of talents can
in no wise do duty for a taste for grandeur and the sacred
frenzy of the imagination. For some years past, people
have been amusing themselves with more than allowable
criticism of one of our dearest friends; very well, I am one
of those who can confess, without blushing, that whatever
the *skill* that is annually displayed by our sculptors, never-
theless, since the death of David,[14] I look around me in
vain for the ethereal pleasures which I have so often had
from the tumultuous, even if fragmentary, *dreams* of
Auguste Préault.

[13] The earliest published version of the opening stanzas of Bau-
delaire's *Danse Macabre*. See Appendix.
[14] David d'Angers died in 1856.

X

ENVOI

AT LAST the moment has come to utter that irrepressible *ouf!* of relief which is breathed with such joy by every simple mortal who is not devoid of spleen and has been condemned to a forced march, when at last he can throw himself into the longed-for oasis of rest. From the very beginning, I will willingly admit, the blessed characters which spell the word END have been floating before my brain, clothed in their black skins, like tiny Ethiopian dancers ready to execute the most engaging of 'character dances'. My honourable friends the artists—I speak of true artists, of those who agree with me that everything that is not perfection should hide its head, and that everything that is not sublime is useless and blameworthy; of those who know that there is an awesome profundity in the first idea that comes, and that among the innumerable methods of expressing it, there are at the most only two or three excellent ones (in this I am less strict than La Bruyère) —those artists, I mean, who are always restless and unsatisfied, like souls confined, will not take amiss certain mocking thrusts and peevish quirks which they have to suffer as often as the critic does himself. They know as well as I do that nothing is more wearisome than to have to explain what everyone ought to know already. If boredom and contempt can be regarded as emotions, they too will have found contempt and boredom the most difficult of emotions to deny—the most fatal, the most ready to hand. I impose upon myself the same harsh conditions which I should like to see everyone else impose upon himself; I never stop asking myself, 'What is the good?', and whenever I imagine that I have expounded a good argument, I ask myself 'Whom, and what, can it serve?' Amongst the numerous omissions of which I am guilty, some are deliberate; I have purposely neglected a crowd of obviously gifted artists who are too well-known to be praised, or not

unusual enough, either for good or for ill, to serve as a theme for criticism. I set myself the task of seeking Imagination throughout the Salon, and having found it but seldom, I have only had to speak of a small number of men. As for the involuntary omissions or errors which I may have committed, the Muse of Painting will surely forgive me, as being a man who, without having made extended studies, nevertheless has the love of Painting in every fibre of his being. Besides, anyone who may have some reason for complaint will find innumerable allies to avenge and console him, without counting that one of us to whom you will entrust the task of analysing next year's exhibition, and whom you will grant the same liberties as you have been kind enough to accord to me. I hope with all my heart that he may find more subjects for wonder and amazement than I have conscientiously found. The noble and excellent artists whom I was invoking a moment ago will say, as I do: 'To sum up, a great deal of technique and skill, but precious little genius!' That is what everyone says. Alas then, I agree with everyone! You see, my dear M—, it was quite unnecessary to explain what they all of them agree with us in thinking. My only consolation is that, by parading these commonplaces, I may perhaps have been able to please two or three people who will guess that I am thinking of them, and in whose number I beg you to be so kind as to include yourself.

Your very devoted collaborator and friend.

"Tell me, my heart, can this be Love?"

THE LIFE AND WORK
OF EUGÈNE DELACROIX[1]

To the Editor of the *Opinion Nationale*

SIR,

Once more and for the last time I wish to pay homage
to the genius of Eugène Delacroix, and I beg you to be
so kind as to extend the hospitality of your journal to the
following few pages in which I shall attempt to bring to-
gether, as briefly as possible, the history of his talent, the
reasons for his pre-eminence (which in my opinion is still
not sufficiently recognized) and finally a few anecdotes and
observations upon his life and his character.

I had the good fortune to be associated at a very early
age with the illustrious deceased (from the year 1845, as
far as I can remember); and this association, from which
reverence on my part and indulgence on his in no wise
excluded mutual confidence and familiarity, enabled me
to form the most accurate notions not only upon his method,
but also upon the most intimate qualities of his great soul.

You would not expect me, Sir, to carry out here a de-
tailed analysis of the works of Delacroix. Quite apart from
the fact that each of us has already performed the task in
accordance with his own powers and by gradual degrees as
the great painter revealed to the public the successive
labours of his brain, the list is such a long one that even
if only a few lines each were to be allotted to his chief
works, an analysis of this kind would fill almost a whole
volume. Let it be enough for us to confine ourselves here
to a brisk summary.

His monumental paintings are there for all to see in the

[1] This article, in the form of a long letter to the editor, was pub-
lished in the *Opinion Nationale* in three parts (2nd Sept., 14th
and 22nd Nov. 1863). Delacroix had died on 13th August 1863.
Baudelaire also used the article as a lecture in Brussels (2nd
May 1864), when he preceded it with a short passage of intro-
duction (see Crépet's ed. of *L'Art Romantique*).

'Salon du Roi'[2] and the library[3] at the Chambre des députés; in the library at the Palais du Luxembourg;[4] in the 'Galerie d'Apollon'[5] at the Louvre; and in the 'Salon de la Paix' at the Hôtel de Ville.[6] These decorations comprehend an enormous mass of allegorical, religious and historical subjects, all of them belonging to the noblest realms of the intelligence. As for his easel-pictures, his sketches, his *grisailles,* his water-colours, etc., the reckoning amounts to an approximate total of two hundred and thirty-six.

The great subject-pictures exhibited at various Salons reach the number of seventy-seven. (I am taking these figures from the catalogue which M. Théophile Silvestre has placed at the end of his excellent account of Eugène Delacroix in his *Histoire des artistes vivants.*[7])

I myself have tried more than once to draw up this enormous catalogue;[8] but my patience was always exhausted by the incredible fecundity of the man, and finally, for the sake of peace and quiet, I gave it up. If M. Théophile Silvestre has made mistakes, they can only be mistakes of omission.

I believe, Sir, that the important thing for me to do here is to search for, and to try and define, the characteristic quality of Delacroix's genius; to seek to discover in what it is that he differs from his illustrious ancestors, while equalling them; and finally to show, as far as the written word is capable of showing, the magical art with whose help he has been able to translate the *word* by means of plastic images more vivid and more appropriate than those of any other creative artist of the same profession—to discover, in short, what was the *specialty*[9] with which Provi-

2 1833–7. 3 1838–47. 4 1840–6. 5 1849–51.

6 1851–3: destroyed during the Commune.

7 Published 1856: the catalogues were by L. de Virmond.

8 Robaut (*L'Oeuvre complet de Delacroix,* 1885) lists 1968 works in all.

9 Gilman (p. 250, *n.* 27) suggests that Baudelaire's italicizing of this word may reflect Swedenborg's and Balzac's use of it to denote a state of intuitive and immediate vision of all things, both material and spiritual, 'in their original and consequential ramifications'; it would amount, therefore, to a full understanding of the *'correspondances'.*

dence had charged Eugène Delacroix in the historical development of painting.

I

WHAT is Delacroix? What role did he come into this world to play, and what duty to perform? That is the first question that we must examine. I shall be brief, and I look for immediate conclusions. Flanders has Rubens, Italy Raphael and Veronese; France has Lebrun, David and Delacroix.

A superficial mind may well be shocked, at first glance, by the coupling of these names which represent such differing qualities and methods. But a keener mental eye will see at once that they are united by a common kinship, a kind of brotherhood or cousinage which derives from their love of the great, the national, the immense and the universal—a love which has always expressed itself in the kind of painting which is called 'decorative', or in what are known as great *machines*.

Many others, no doubt, have painted great *machines*; those that I have mentioned, however, painted them in the way most suited to leave an eternal trace upon the memory of mankind. Which is the greatest of these great men who differ so much from one another? Each must decide as he pleases, according as whether his temperament urges him to prefer the prolific, radiant, almost jovial abundance of Rubens; the mild dignity and eurhythmic order of Raphael; the paradisal—one might almost say the *afternoon* colour of Veronese; the austere and strained severity of David; or the dramatic and almost literary rhetoric of Lebrun.

None of these men is replaceable; aiming, all of them, at a like goal, they yet used different means, drawn from their individual natures. Delacroix, the last to come upon the scene, expressed with an admirable vehemence and fervour what the others had translated but incompletely. To the detriment of something else, perhaps, as they too had done? It may be; but that is not the question that we have to examine.

Many others apart from myself have gone out of their

way to pontificate on the subject of the fatal consequences of an essentially personal genius; and it may also be quite possible, after all, that the finest expressions of genius, elsewhere than in Heaven—that is to say, on this poor earth, where perfection itself is imperfect—could only be secured at the price of an unavoidable sacrifice.

But doubtless, Sir, you will be asking what is this strange, mysterious quality which Delacroix, to the glory of our age, has interpreted better than anyone else. It is the invisible, the impalpable, the dream, the nerves, the *soul*; and this he has done—allow me, please, to emphasize this point—with no other means but colour and contour; he has done it better than anyone else—he has done it with the perfection of a consummate painter, with the exactitude of a subtle writer, with the eloquence of an impassioned musician. It is, moreover, one of the characteristic symptoms of the spiritual condition of our age that the arts aspire if not to take another's place, at least reciprocally to lend one another new powers.

Delacroix is the most *suggestive* of all painters; he is the painter whose works, even when chosen from among his secondary and inferior productions, set one thinking the most and summon to the memory the greatest number of poetic thoughts and sentiments which, although once known, one had believed to be for ever buried in the dark night of the past.

The achievement of Delacroix sometimes appears to me like a kind of *mnemotechny* of the grandeur and the native passion of universal man. This very special and entirely new merit, which has permitted the artist to express, simply with contour, the gesture of man, no matter how violent it may be, and with colour what one might term the atmosphere of the human drama, or the state of the creator's soul—this utterly original merit has always earned him the support of all the poets; and if it were permissible to deduce a philosophical proof from a simple material manifestation, I would ask you, Sir, to observe that amongst the crowd that assembled to pay him his last honours, you could count many more men of letters than painters. To tell the blunt truth, these latter have never perfectly understood him.

II

AND what is so very surprising in that, after all? Do we not know that the age of the Raphaels, the Michelangelos and the Leonardos—not to speak of the Reynoldses—is already long past, and that the general intellectual level of artists has singularly dropped? It would doubtless be unfair to look for philosophers, poets and scholars among the artists of the day; but it would seem legitimate to demand from them a little more interest in religion, poetry and science than in fact they show.

Outside of their studios, what do they know? what do they love? what ideas have they to express? Eugène Delacroix, however, at the same time as being a painter in love with his craft, was a man of general education; as opposed to the other artists of today, who for the most part are little more than illustrious or obscure daubers, sad specialists, old or young—mere artisans, possessing some the ability to manufacture academic figures, others fruit and others cattle. Eugène Delacroix loved and had the ability to paint everything, and knew also how to appreciate every kind of talent.

His was of all minds the most open to every sort of idea and impression; he was the most eclectic and the most impartial of voluptuaries.

A great reader, it is hardly necessary to mention. The reading of the poets left him full of sublime, swiftly-defined images—ready-made pictures, so to speak. However much he differed from his master Guérin both in method and in colour, he inherited from the great Republican and Imperial school a love of the poets and a strangely impulsive spirit of rivalry with the written word. David Guérin and Girodet kindled their minds at the brazier of Homer, Virgil, Racine and Ossian. Delacroix was the soul-stirring translator of Shakespeare, Dante, Byron and Ariosto. The resemblance is important; the difference but slight.

But let us enter a little further, if you please, into what one might call the *teaching* of the master—a teaching which,

for me, results not only from the successive contemplation of all his works, and from the simultaneous contemplation of certain of them (as we had the opportunity of enjoying at the *Exposition Universelle*[1] of 1855), but also from many a conversation that I had with him.

III

DELACROIX was passionately in love with passion, and coldly determined to seek the means of expressing it in the most visible way. In this duality of nature—let us observe in passing—we find the two signs which mark the most substantial geniuses who are scarce made to please those timorous, easily-satisfied souls who find sufficient nourishment in flabby, soft and imperfect works. An immense passion, reinforced with a formidable will—such was the man.

Now he used continually to say:

'Since I consider the impression transmitted to the artist by nature as the most important thing of all to translate, is it not essential that he should be armed in advance with all the most rapid means of translation?'

It is evident that in his eyes the imagination was the most precious gift, the most important faculty, but that this faculty remained impotent and sterile if it was not served by a resourceful skill which could follow it in its restless and tyrannical whims. He certainly had no need to stir the fire of his always-incandescent imagination; but the day was never long enough for his study of the material means of expression.

It is this never-ceasing preoccupation that seems to explain his endless investigations into colour and the quality of colours, his lively interest in matters of chemistry, and his conversations with manufacturers of colours. In that respect he comes close to Leonardo da Vinci, who was no less a victim of the same obsessions.

In spite of his admiration for the fiery phenomena of life, never will Eugène Delacroix be confounded among that

[1] See pp. 210–9 above.

herd of vulgar artists and scribblers whose myopic intelligence takes shelter behind the vague and obscure word 'realism'. The first time that I saw M. Delacroix—it was in 1845, I think (how the years slip by, swift and greedy!)— we chatted much about commonplaces—that is to say, about the vastest and yet the simplest questions; about Nature, for example. Here, Sir, I must ask your permission to quote *myself*, for a paraphrase would not be the same thing as the words which I wrote on a former occasion, almost at the dictation of the master:[1]

'Nature is but a dictionary, he kept on repeating. Properly to understand the extent of meaning implied in this sentence, you should consider the numerous ordinary usages of a dictionary. In it you look for the meaning of words, their genealogy and their etymology—in brief, you extract from it all the elements that compose a sentence or a narrative; but no one has ever thought of his dictionary as a *composition*, in the poetic sense of the word. Painters who are obedient to the imagination seek in their dictionary the elements which suit with their conception; in adjusting those elements, however, with more or less of art, they confer upon them a totally new physiognomy. But those who have no imagination just copy the dictionary. The result is a great vice, the vice of banality, to which those painters are particularly prone whose specialty brings them closer to what is called inanimate nature—landscape-painters, for example, who generally consider it a triumph if they can contrive not to show their personalities. By dint of contemplating and copying, they forget to feel and think.

'For this great painter, however, no element of art, of which one man takes this and another that as the most important, was—I should rather say, *is*—anything but the humblest servant of a unique and superior faculty. If a very neat execution is called for, that is so that the language of the dream may be translated as neatly as possible; if it should be very rapid, that is lest anything

[1] The following two passages are quoted from Baudelaire's *Salon de 1859;* they contain a few minor verbal discrepancies.

may be lost of the extraordinary vividness which accompanied its conception; if the artist's attention should even be directed to something so humble as the material cleanliness of his tools, that is easily intelligible, seeing that every precaution must be taken to make his execution both deft and unerring.'

I might mention in passing that never have I seen a palette so meticulously and delicately prepared as that of Delacroix. It was like an expertly matched bouquet of flowers.

'With such a method, which is essentially logical, all the figures, their relative disposition, the landscape or interior which provides them with horizon or background, their garments—everything, in fact, must serve to illuminate the general idea, must wear its original colour, its livery, so to speak. Just as a dream inhabits its own proper, coloured atmosphere, so a conception which has become a composition needs to move within a coloured setting which is peculiar to itself. Obviously a particular tone is allotted to whichever part of a picture is to become the key and to govern the others. Everyone knows that yellow, orange and red inspire and express the ideas of joy, richness, glory and love; but there are thousands of different yellow or red atmospheres, and all the other colours will be affected logically and to a proportionate degree by the atmosphere which dominates. In certain of its aspects the art of the colourist has an evident affinity with mathematics and music.

'And yet its most delicate operations are performed by means of a sentiment or perception, to which long practice has given an unqualifiable sureness. We can see that this great law of general harmony condemns many instances of dazzling or raw colour, even in the work of the most illustrious painters. There are paintings by Rubens which not only make one think of a coloured firework, but even of several fireworks set off on the same platform. It is obvious that the larger a picture, the broader must be its *touch;* but it is better that the individual touches should not be materially fused, for they will fuse naturally at a distance determined by the

law of sympathy which has brought them together. Colour will thus achieve a greater energy and freshness.

'A good picture, which is a faithful equivalent of the dream which has begotten it, should be brought into being like a world. Just as the creation, as we see it, is the result of several creations, in which the preceding ones are always completed by the following, so a harmoniously-conducted picture consists of a series of pictures superimposed on one another, each new layer conferring greater reality upon the dream and raising it by one degree towards perfection. On the other hand, I remember having seen in the studios of Paul Delaroche and Horace Vernet huge pictures, not sketched but actually begun—that is to say, with certain passages completely finished, while others were only indicated with a black or a white outline. You might compare this kind of work to a piece of purely manual labour—so much space to be covered in a given time—or to a long road divided into a great number of stages. As soon as each stage is reached, it is finished with; and when the whole road has been run, the artist is delivered of his picture.

'It is clear that all these rules are more or less modifiable in accordance with the varying temperaments of artists. Nevertheless I am convinced that what I have described is the surest method for men of rich imagination. Consequently, if an artist's divergences from the method in question are too great, there is evidence that an abnormal and undue importance is being set upon some secondary element of art.

'I have no fear that anyone may consider it absurd to suppose a single method to be applicable by a crowd of different individuals. For it is obvious that systems of rhetoric or prosody are no arbitrarily invented tyrannies, but rather they are collections of rules demanded by the very constitution of the spiritual being. And systems of prosody and rhetoric have never yet prevented originality from clearly emerging; the contrary—namely, that they have assisted the birth of originality—would be infinitely more true.

'To be brief, I must pass over a whole crowd of corol-
laries resulting from my principal formula in which is
contained, so to speak, the entire formulary of the true
aesthetic, and which may be expressed thus: The whole
visible universe is but a store-house of images and signs
to which the imagination will give a relative place and
value; it is a sort of pasture which the imagination must
digest and transform. All the faculties of the human soul
must be subordinated to the imagination, which puts
them in requisition all at once. Just as a good knowledge
of the dictionary does not necessarily imply a knowledge
of the art of composition, and just as the art of compo-
sition does not itself imply a *universal* imagination, in
the same way a *good* painter need not be a *great* painter.
But a great painter is perforce a good painter, because
the universal imagination embraces the understanding
of all means of expression and the desire to acquire
them.

'As a result of the ideas which I have just been making
as clear as I have been able (but there are still so many
things that I should have mentioned, particularly con-
cerning the concordant aspects of all the arts, and their
similarities in method!), it is clear that the vast family
of artists—that is to say, of men who have devoted them-
selves to the expression of beauty—can be divided into
two quite distinct camps. There are those who call them-
selves "realists"—a word with a double meaning, whose
sense has not been properly defined, and so, in order
the better to characterize their error, I propose to call
them "positivists"; and *they* say, "I want to represent
things as they are, or rather as they would be, suppos-
ing that I did not exist." In other words, the universe
without man. The others, however—the "imaginatives"—
say, "I want to illuminate things with my mind, and to
project their reflection upon other minds." Although
these two absolutely contrary methods could magnify
or diminish any subject, from a religious scene to the
most modest landscape, nevertheless the man of imagi-
nation has generally tended to express himself in reli-
gious painting and in fantasy, while landscape and the

type of painting called "genre" would appear to offer enormous opportunities to those whose minds are lazy and excitable only with difficulty . . .[2]

'The imagination of Delacroix! Never has it flinched before the arduous peaks of religion! The heavens belong to it, no less than hell, war, Olympus and love. In him you have the model of the painter-poet. He is indeed one of the rare elect, and the scope of his mind embraces religion in its domain. His imagination blazes with every flame and every shade of crimson, like the banks of glowing candles before a shrine. All that there is of anguish in the Passion impassions him; all that there is of splendour in the Church casts its glory upon him. On his inspired canvases he pours blood, light and darkness in turn. I believe that he would willingly bestow his own natural magnificence upon the majesties of the Gospel itself, out of superabundance.

'I remember seeing a little Annunciation by Delacroix in which the angel visiting Mary was not alone, but was escorted in ceremony by two other angels, and the effect of this celestial retinue was powerful and touching. One of his youthful pictures, the *Christ in the Garden of Olives* ("O my Father, if it be possible, let this cup pass from me") positively melts with feminine sensibility and poetic unction. Anguish and Splendour, which ring forth so sublimely in religion, are never without an echo in his mind.'[3]

And more recently still, when writing on the subject of the chapel of the Holy Angels at Saint-Sulpice (*Heliodorus* and *Jacob and the Angel*), his last great labour, and one so stupidly criticized, I said:[4]

'Never, not even in the *Justice of Trajan*, or in the *Entry of the Crusaders*, has Delacroix displayed a palette

[2] See pp. 238–42 above.
[3] See pp. 246–7 above.
[4] The following passage is taken from an article published in the *Revue Fantaisiste*, 15th Sept. 1861. The remainder of the article —little more than a description of the paintings—was published in *L'Art Romantique* as 'Peintures murales d'Eugène Delacroix à Saint-Sulpice.'

more splendidly or more scientifically supernatural; never a draughtsmanship more *deliberately* epic. I know very well that some people—bricklayers no doubt, or possibly architects—have uttered the word "decadence" in connection with this last work. This is the moment to recall that the great masters, whether poets or painters, Hugo or Delacroix, are always several years ahead of their timid admirers.

'In relation to genius, the public is like a slow-running clock. Who among the ranks of the discerning does not understand that the master's very first picture contained all his others in embryo? But that he should be ceaselessly perfecting and diligently sharpening his natural gifts, that he should extract new effects from them and should himself drive his nature to its utmost limits—that is inevitable, foredoomed and worthy of praise. The principal characteristic of Delacroix's genius is precisely the fact that he knows not decadence; he only displays progress. The only thing is that his original qualities were so forceful and so rich, and they have left such a powerful impression upon even the most commonplace of minds, that day-to-day progress is imperceptible for the majority; it is only the dialecticians of art that can discern it clearly.

'I spoke a moment ago of the remarks of certain *bricklayers*.[5] By this word I wish to characterize that class of heavy and boorish spirits (their number is legion) who appraise objects solely by their contour, or worse still, by their three dimensions, length, breadth and height—for all the world like savages and rustics. I have often heard people of that kind laying down a hierarchy of qualities which to me was absolutely unintelligible; I have heard them declare, for example, that the faculty that enables one man to produce an exact contour, or another a contour of a supernatural beauty, is superior to the faculty whose skill it is to make an enchanting assemblage of *colours*.[6] According to those people, colour has no power

[5] The French word *maçon* is regularly used in such a figurative sense, to denote crass stupidity of one kind or another.

[6] Although the text as originally printed in the *Revue Fantaisiste*

to dream, to think, or to speak. It would seem that when I contemplate the works of one of those men who are specifically called "colourists", I am giving myself up to a pleasure whose nature is far from a noble one; they would be delighted to call me a "materialist", reserving for themselves the aristocratic title of "spiritualists".[7]

'It seems not to have occurred to those superficial minds that the two faculties can never be entirely separated, and that they are both of them the result of an original seed that has been carefully cultivated. External nature does nothing more than provide the artist with a constantly-renewed opportunity of cultivating that seed; it is nothing but an incoherent heap of raw materials which the artist is invited to group together and put in order—a stimulant, a kind of alarum for the slumbering faculties. Strictly speaking there is neither line nor colour in nature. It is man that creates line and colour. They are twin abstractions which derive their equal status from their common origin.

'A born draughtsman (I am thinking of him as a child) observes in nature, whether at rest or in motion, certain undulations from which he derives a certain thrill of pleasure, and which he amuses himself in fixing by means of lines on paper, exaggerating or moderating their inflexions at his will. He learns thus to achieve stylishness, elegance and character in drawing. But now let us imagine a child who is destined to excel in that department of art which is called colour; it is the collision or the happy marriage of two tones, and his own pleasure resulting therefrom, that will lead him towards the infinite science of tonal combinations. In neither case has nature been other than a pure *excitant*.

'Line and colour both of them have the power to set one thinking and dreaming; the pleasures which spring from them are of different natures, but of a perfect equality and absolutely independent of the subject of the picture.

reads 'couleurs', which is evidently correct in the context, all editions of *L'Art Romantique* have contained the obvious misprint 'contours' at this point.

[7] In the philosophical, not the mediumistic sense.

'A picture by Delacroix will already have quickened you with a thrill of supernatural pleasure even if it be situated too far away for you to be able to judge of its linear graces or the more or less dramatic quality of its subject. You feel as though a magical atmosphere has advanced towards you and already envelops you. This impression, which combines gloom with sweetness, light with tranquillity—this impression, which has taken its place once and for all in your memory, is certain proof of the true, the perfect colourist. And when you come closer and analyse the subject, nothing will be deducted from, or added to, that original pleasure, for its source lies elsewhere and far away from any material thought.

'Let me reverse my example. A well-drawn figure fills you with a pleasure which is absolutely divorced from its subject. Whether voluptuous or awe-inspiring, this figure will owe its entire charm to the arabesque which it cuts in space. So long as it is skilfully drawn, there is nothing—from the limbs of a martyr who is being flayed alive, to the body of a swooning nymph—that does not admit of a kind of pleasure in whose elements the subject-matter plays no part. If it is otherwise with you, I shall be forced to believe that you are either a butcher or a rake.

'But alas! what is the good of continually repeating these idle truths?'

But perhaps, Sir, your readers will set much less store upon all this rhetoric than upon the details which I myself am impatient to give them concerning the person and the habits of our late-lamented genius.

IV

IT IS Eugène Delacroix's writings[1] above all that reveal that duality of nature which I have mentioned. I need hardly

[1] The articles mentioned below by Baudelaire are included in the two volumes of *Oeuvres Littéraires d'Eugène Delacroix* (Paris 1923).

remind you, Sir, that many people were astonished at the sagacity of his written opinions and at the moderation of his style, some finding this a matter for regret, and others for approval. The *Variations du Beau*, the studies on Poussin, Prud'hon and Charlet, and other pieces published either in *L'Artiste* (whose proprietor at that time was M. Ricourt) or in the *Revue des Deux Mondes*, only go to confirm that two-sidedness of great artists which drives them, as critics, to praise and to analyse more zestfully those qualities which, in their capacity as creators, they need the most, and which form a kind of antithesis to those they already possess in superabundance. If Eugène Delacroix had praised and magnified the qualities which we admire pre-eminently in him—his violence and abruptness in gesture, his turbulence of composition and the magic of his colour—that would indeed have been a matter for astonishment. Why look for what one already has almost to excess? and how can one fail to praise what seems rarer and more difficult to acquire? You will always observe the same phenomenon occurring with creative geniuses, be they painters or writers, whensoever they apply their faculties to criticism. At the time of the great struggle between the two schools, the Classic and the Romantic, simple souls were amazed to hear Eugène Delacroix ceaselessly extolling Racine, La Fontaine and Boileau. I could name a poet, by nature always stormy and restless, whom a line of Malherbe, with its balanced and symmetrical melody, will throw into long ecstasies.

Nevertheless, however judicious, however sound, however compact of expression and intention we find the great painter's literary fragments, it would be absurd to suppose that they were written easily or with the bold assurance of his brush. His feeling of confidence that he was *writing* what he really thought about a canvas was always balanced by his concern that he was not able to *paint* his thoughts upon the paper. 'The pen,' he used often to say, 'is not my tool. I am conscious of the justness of my thought, but the need for order, to which I am obliged to submit, I find quite terrifying. Would you believe it, but the necessity of writing a page gives me a sick headache!' It is this awkwardness,

which results from lack of practice, that may perhaps explain certain slightly threadbare forms of words—outworn clichés, even—which too often escaped this naturally distinguished pen.

The most manifest characteristic of Delacroix's style is its concision and a kind of unobtrusive intensity—the customary result of a concentration of the entire mental powers upon a given point. 'The hero is he who is immovably centred', says the transatlantic moralist, Emerson,[2] who, in spite of his reputation as the leader of the wearisome Bostonian school, has nevertheless a certain flavour of Seneca about him, which effectively stimulates meditation. 'The hero is he who is immovably centred'. But this maxim, which the leader of American *Transcendentalism* applies to the conduct of life and the sphere of business, can equally well be applied to the sphere of poetry and art. You might equally well say, 'The literary hero, i.e. the true writer, is he who is immovably centred'. It will therefore hardly seem surprising to you, Sir, when I tell you that Delacroix had a very marked sympathy for concise and concentrated writers—for writers whose simple, unadorned prose seems to imitate the swift movements of thought, and whose sentences are like gestures—Montesquieu, for example. Let me offer you a curious example of this pregnant and poetic brevity. Like me, you must recently have read a very admirable and interesting study by M. Paul de Saint-Victor on the ceiling of the Galerie d'Apollon. It appeared in *La Presse*.[3] The various different conceptions of the flood, the way in which the legends relating to the flood should be interpreted, the moral significance of the episodes and actions which make up the ensemble of that wonderful picture—everything was there; and the picture itself was minutely described in that delightful style, as witty as it is highly-coloured, of which the author has already shown us so many samples. And yet all this will leave no more than a shadowy phantom in the memory—like something dimly seen through a telescope. Now compare that vast

[2] In the *Conduct of Life,* 'Considerations by the Way' (*Prose Works,* Boston 1870, vol. II, p. 463).

[3] 13th Sept. 1863.

essay with the following few lines which, in my opinion,
are much more forceful and much better adapted to con-
jure up a picture, even assuming that the picture which
they summarize did not already exist. I am simply copying
the programme which M. Delacroix distributed to his
friends when he invited them to inspect the work in ques-
tion:

APOLLO VICTORIOUS OVER THE SERPENT PYTHON.
'Mounted upon his chariot, the god has already shot a
portion of his arrows; his sister Diana is flying at his heels
and holding his quiver out to him. Already transfixed by
the shafts of the god of warmth and life, the bloody
monster writhes as it breathes forth the last remnants
of its life and impotent rage in a flaming cloud. The
waters of the flood are beginning to run dry, leaving the
bodies of men and animals upon the mountain-tops, or
sweeping them away with it. The gods are wrathful to
see the earth abandoned to misshapen monsters, foul
products of the primeval slime. Like Apollo, they have
taken up arms; Minerva and Mercury leap forth to their
destruction, until the time comes for eternal Wisdom to
repeople the solitude of the universe. Hercules is crush-
ing them with his club; Vulcan, the god of fire, is driving
the night and the foul mists before him, while Boreas
and the Zephyrs dry up the waters with their breath and
finally dispel the clouds. The nymphs of the rivers and
the streams have regained their reedy bed and their urn,
still soiled by filth and débris. A few of the more timid
divinities are standing aside and watching this combat
between the gods and the elements. Meanwhile from
the summit of the heavens Victory is flying down to
crown Apollo the conqueror, and Iris, the messenger
of the gods, is unfolding her veil in the airs—a symbol of
the triumph of light over darkness and the revolt of the
waters.'

I know that the reader will be obliged to use his imagina-
tion a great deal—to collaborate, so to speak, with the
author of the note. But do you really think, Sir, that my
admiration for the painter is making me see visions in this

matter? Tell me, am I totally mistaken in pretending to discover here the evidence of aristocratic habits acquired in good reading, and of that rectitude of thought which has enabled men of rank, soldiers, adventurers, or even simple courtiers, to write—sometimes even to *dash off*—very excellent books which even we, who are writers by trade, are constrained to admire?

V

EUGÈNE DELACROIX was a curious mixture of scepticism, politeness, dandyism, burning determination, craftiness, despotism, and finally of a sort of personal kindness and tempered warmth which always accompanies genius. His father belonged to that race of strong men of whom we knew the last in our childhood—half of them fervent apostles of Jean-Jacques, and the other half resolute disciples of Voltaire, though they all collaborated with an equal zeal in the French Revolution, and their survivors, whether Jacobins or Cordeliers, all rallied with a perfect integrity (it is important to note) to the aims of Bonaparte.

Eugène Delacroix never lost the traces of his revolutionary origin. It may be said of him, as of Stendhal, that he had a great dread of being made a fool of.[1] Sceptical and aristocratic, he only knew passion and the supernatural through his forced intimacy with the world of dreams. A hater of the masses, he really only thought of them as iconoclasts, and the acts of violence perpetrated upon several of his works in 1848[2] were ill-suited to convert him to the political sentimentalism of our times. There was even something of Victor Jacquemont[3] about him, as regards style,

[1] See p. 244 above.
[2] His *Richelieu disant la Messe* was destroyed in the Palais-Royal, and his *Corps de garde marocain* was somewhat damaged at the Tuileries.
[3] The botanist and traveller, who visited America and India. He was well known through the two volumes of his correspondence which were published in 1834, two years after his death. See David Stacton, *A Ride on a Tiger* (London 1954).

manners and opinions. I know that the comparison is just
a little offensive, and therefore I should only wish it to be
applied with an extreme discretion; for there is a touch
of the rebellious bourgeois wit in Jacquemont—a kind of
churlish sarcasm which is just as likely to mystify the min-
isters of Brahma as those of Jesus Christ, while Delacroix,
cautioned by the *taste* which is always inherent in genius,
could never fall into such vulgar crudities. My comparison
only relates therefore to the sense of prudence and the
sobriety which characterized them both. In the same way,
the hereditary marks which the 18th century had left upon
his nature seemed to have been borrowed above all from
that class which is just as far removed from the utopians as
from the fanatics—I mean from the class of the polished
sceptics, the victors and the survivors, who, generally speak-
ing, stemmed more from Voltaire than from Jean-Jacques.
And so, at first glance Eugène Delacroix simply gave the
impression of an *enlightened* man, in the honorable ac-
ceptance of the word—of a perfect *gentleman*,[4] with neither
prejudices nor passions. It was only by seeking his company
more assiduously that one could penetrate beneath the
varnish, and guess at the hidden corners of his soul. A man
to whom one could compare him more justly, both in his
outward appearance and in his manners, would be M.
Mérimée.[5] There we find the same apparent, slightly af-
fected, coldness, the same icy mantle which cloaked a bash-
ful sensitivity and a burning passion for the good and the
beautiful; beneath the same hypocritical pretence of ego-
tism, we find the same devotion to his private friends and
his pet ideas.

There was much of the *savage* in Eugène Delacroix—this
was in fact the most precious part of his soul, the part which
was entirely dedicated to the painting of his dreams and
to the worship of his art. There was also much of the man
of the world; that part was destined to disguise and excuse
the other. It was, I think, one of the great concerns of his
life to conceal the rages of his heart and not to have the
seeming of a man of genius. His spirit of dominance, which

[4] This word is used in the original.

[5] Baudelaire's admiration for Mérimée was not reciprocated.

was quite legitimate and even a part of his destiny, had almost entirely disappeared beneath a thousand kindnesses. You might have called him a volcanic crater artistically concealed behind bouquets of flowers.

Another feature of resemblance with Stendhal was his propensity for simple formulas, brief maxims for the proper conduct of life. Like all men whose passion for method is all the more intense as their ardent and sensitive temperaments seem to deflect them from it, Delacroix loved to construct those little catechisms of practical morality which the thoughtless and the idle (who practise nothing) would scornfully attribute to M. de la Palisse,[6] but which genius does not despise, because genius is allied with simplicity— I mean sound, strong, simple and firm maxims, which serve as buckler and cuirass to the man whom the fatality of his genius hurls into an endless battle.

Need I tell you that the same spirit of inflexible and contemptuous wisdom inspired M. Delacroix's opinions in political matters also? He believed that nothing changes, although everything appears to change, and that certain climacteric moments in the history of the nations will invariably bring with them analogous phenomena. On the whole, his thinking in matters of this kind came very close (particularly in its attitude of cold and sorrowful resignation) to the thinking of a historian of whom I for my part have a quite special respect, and whom you, Sir, who are so perfectly familiar with these arguments, and know how to assess talent even when it contradicts you, must have felt constrained to admire more than once, I feel sure. I am referring to M. Ferrari,[7] the subtle and learned author of the *Histoire de la raison d'Etat*. And so the speaker who, in M. Delacroix's presence, gave way to childish utopian enthusiasms had very soon to suffer the effect of his bitter laugh, shot through with a sarcastic pity; and if anyone was imprudent enough in his company to launch forth the great chimera of modern times, the monster-balloon of per-

[6] The phrase 'une vérité de la Palisse' means a stale truism.

[7] Giuseppe Ferrari (1811–76), philosopher, politician, and editor of Vico. His *Histoire de la raison d'Etat* was published in Paris in 1860.

fectibility and indefinite progress, he would be swift to ask, 'Where then are your Pheidiases? where are your Raphaels?'

Be assured, however, that this gruff good sense did not divest M. Delacroix of any of his graces. This zest of incredulity, and this refusal to be taken in, seasoned his conversation—already so poetic and so colourful—like a dash of Byronic salt. He owed also to himself, far more than to his long familiarity with the world of society—to himself, that is to say to his genius and the consciousness of his genius—a sureness, a marvellous ease of manner, combined with a politeness which, like a prism, admitted every nuance, from the most cordial good nature to the most irreproachable rudeness. He possessed quite twenty different ways of uttering the words 'mon cher Monsieur', which, for a practised ear, represented an interesting range of sentiments. For finally it must be said—since to me this seems but one more reason for praise—that Eugène Delacroix, for all that he was a man of genius, or *because* he was a man of *complete* genius, had much of the dandy about him. He himself used to admit that in his youth he had thrown himself with delight into the most material vanities of dandyism, and he used to tell with a smile, but not without a certain touch of conceit, how, with the collaboration of his friend Bonington, he had laboured energetically to introduce a taste for English cut in clothes and shoes among the youth of fashion. I take it that this will not seem to you an idle detail, for there is no such thing as a superfluous memory when one has the nature of certain men to paint.

I have told you that what most struck the attentive observer was the *natural* part of Delacroix's soul, in spite of the softening veil of a civilized refinement. He was all energy, but energy which sprang from the nerves and from the will—for physically he was frail and delicate. The tiger intent upon his prey has eyes less bright and muscles less impatiently a-quiver than could be observed when the whole spiritual being of our great painter was hurled upon an idea or was struggling to possess itself of a dream. Even the physical character of his countenance, his Peruvian or

Malay-like colouring, his great black eyes (which, however, the blinkings of concentration made to appear smaller, so that they seemed to do no more than *sip* at the light), his abundant and glossy hair, his stubborn brow, his tight lips, to which an unceasing tension of will gave an expression of cruelty—his whole being, in short, suggested the idea of an exotic origin. More than once, when looking at him, I have found myself thinking of those ancient rulers of Mexico, of Montezuma, whose hand, with sacrificial skill, could immolate three thousand human creatures in a single day upon the pyramidal altar of the Sun, or perhaps of some oriental potentate who, amid the splendours of the most brilliant of feasts, betrays in the depths of his eyes a kind of unsatisfied craving and an inscrutable nostalgia—something like the memory and the regret of things not known. I would ask you to observe too that even the general colour of Delacroix's pictures has something of the colour proper to oriental landscapes and interiors, and that it produces a somewhat similar impression to that which is experienced in tropical lands by a sensitive eye; I mean that there, in spite of the intensity of local tones, the immense diffusion of light creates a general effect which is almost crepuscular. The *morality* of his works—if it is at all permissible to speak of ethics in painting—is also visibly marked with Molochism. His works contain nothing but devastation, massacres, conflagrations; everything bears witness against the eternal and incorrigible barbarity of man. Burnt and smoking cities, slaughtered victims, ravished women, the very children cast beneath the hooves of horses or menaced by the dagger of a distracted mother—the whole body of this painter's works, I say, is like a terrible hymn composed in honour of destiny and irremediable anguish. Occasionally he found it possible to devote his brush to the expression of tender and voluptuous feelings—for certainly he was not lacking in tenderness; but even into these works an incurable bitterness was infused in strong measure, and carelessness and joy—the usual companions of simple pleasure—were absent from them. Once only, I believe, did he make an experiment in the role of clown or comedian, and as though he had

guessed that this was both beyond and below his nature, he never more returned to it.[8]

VI

I know several people who have a right to say 'Odi profanum vulgus'; but which among them can triumphantly add 'et arceo'? Too much hand-shaking tends to cheapen the character. But if ever a man had an *ivory tower*, well protected by locks and bolts, that man was Eugène Delacroix. And who has ever had a greater love for his *ivory tower*—that is, for his privacy? He would even, I believe, have armed it with artillery and transported it bodily into a forest or to the top of an inaccessible rock! Who has had a greater love for the *home*[1]—both sanctuary and den? As others seek privacy for their debauches, he sought privacy for inspiration, and once he had gained it, he would give himself up to veritable drunken orgies of work. 'The one prudence in life is concentration; the one evil is dissipation,' says the American philosopher whom we have already quoted.[2]

M. Delacroix might almost have written that maxim; but certainly he austerely practised it. He was too much a man of the world not to scorn the world; and the efforts to which he went in order not to be too visibly *himself* drove him naturally to prefer our society. The word 'our' is not only intended to imply the humble author of these lines, but several others as well, young or old, journalists, poets and musicians, in whose company he could freely relax and be himself.

In his delightful study on Chopin, Liszt puts Delacroix among the poet-musician's most assiduous visitors, and tells how he loved to fall into deep reverie at the strains of that tenuous and impassioned music which is like a brilliant bird fluttering above the horrors of an abyss.

[8] Delacroix published a few lithographic caricatures in *Le Miroir* in 1821.

[1] This word is used in the original.

[2] In the *Conduct of Life*, 'Power' (p. 353).

That is how it came about that, thanks to the sincerity of our admiration, we were able, though still very young, to penetrate the fortifications of that studio where, in spite of the rigours of our climate, an equatorial temperature prevailed, and where the eye was immediately struck by a sober solemnity and by the classic austerity of the old school. We had seen such studios in our childhood, belonging to the late rivals of David—those touching heroes long since departed. One felt instinctively that this retreat could not be the habitation of a frivolous mind, titillated by a thousand incoherent fancies.

There were no rusty panoplies to be seen there, not a single Malayan *kris,* no ancient Gothic scrap-iron, no jewellery, no old clothes, no bric-à-brac, nothing of what indicts its owner of a taste for toys and the desultory wanderings of childish daydreaming. A marvellous portrait by Jordaens, which he had unearthed somewhere or other, and several studies and copies, made by the master himself, sufficed to decorate that vast studio, in which a softened and subdued light illumined self-communion.

These copies will probably be seen at the sale of Delacroix's drawings and pictures which is fixed, I am told, for next January.[3] He had two very distinct manners of copying. The first, which was broad and free, was a mixture of fidelity and betrayal of the model, and into this he put much of himself. The result of this method was a fascinating mongrel-compound which threw the mind into a state of delightful uncertainty. It is in that paradoxical light that I remember a large copy of Rubens' *Miracles of St. Benedict.*[4] In his other manner Delacroix made himself the humblest and most obedient slave of his model, and he achieved an exactness of imitation of which those who have not seen these miracles may well be incredulous. Such, for example, are the copies which he made after two heads by Raphael[5] in the Louvre—copies in which expression, style and manner are imitated with such a perfect sim-

[3] In fact it took place in February, 1864.
[4] Now in the Brussels Museum.
[5] Robaut lists three such copies; Nos. 1925-7.

plicity that one could reciprocally and in turn mistake the originals for the translations.

After a luncheon lighter than an Arab's, and with his palette arranged with the meticulous care of a florist or a cloth-merchant, Delacroix would set himself to grapple with the interrupted idea; but before launching out into his stormy task, he often experienced those feelings of languor, fear and prostration which make one think of the Pythoness fleeing the god, or which remind one of Jean-Jacques Rousseau dilly-dallying, rummaging among his papers and turning over his books for an hour before attacking paper with pen. But as soon as the artist's special magic had started to work, he never stopped until overcome by physical fatigue.

One day, when we happened to be talking about that question which always has such an interest for artists and writers—I mean, about the *hygienics* of work and the conduct of life—he said to me:

'Formerly, in my youth, I was unable to get down to work unless I had the promise of some pleasure for the evening—some music, dancing, or any other conceivable diversion. But today I have ceased to be like a schoolboy, and I can work without stopping and without any hope of reward. And then (he added), if only you knew how unremitting work makes one indulgent and easy to satisfy where pleasures are concerned! The man who has well filled his day will be prepared to find a sufficiency of wit even in the local postman, and will be quite content to spend his evening playing cards with him!'

This remark made me think of Machiavelli playing at dice with the peasants. Now one day (a Sunday it was) I caught sight of Delacroix at the Louvre in the company of his old servant,[6] she who so devotedly looked after and cared for him for thirty years; and he, the elegant, the exquisite, the erudite, was not too proud to point out and to explain the mysteries of Assyrian sculpture to that excellent woman, who, moreover, was listening to him with an artless concentration. The memory of Machiavelli and

[6] There is a portrait by Delacroix of his servant, Jenny le Guillou, in the Louvre; see *Journal*, pl. 28.

of our former conversation leapt immediately into my mind.

The truth is that during his latter years everything that one normally calls pleasure had vanished from his life, having all been replaced by a single harsh, exacting, terrible pleasure, namely *work*, which by that time was not merely a passion but might properly have been called a rage.

After having dedicated the hours of the day to painting, either in his studio or upon the scaffolding whither he was summoned by his great decorative tasks, Delacroix found strength yet remaining in his love of art, and he would have judged that day ill-filled if the evening hours had not been employed at the fire-side, by lamp-light, in drawing, in covering paper with dreams, ideas, or figures half-glimpsed amid the random accidents of life, and sometimes in copying drawings by other artists whose temperament was as far as possible removed from his own; for he had a passion for notes, for sketches, and he gave himself up to it wherever he happened to be. For quite a long time he made a habit of drawing at the house of friends to whom he went to spend his evenings. That is how it comes about that M. Villot[7] possesses a considerable quantity of drawings from that fertile pen.

He once said to a young man of my acquaintance: 'If you have not sufficient skill to make a sketch of a man throwing himself out of a window, in the time that it takes him to fall from the fourth floor to the ground, you will never be capable of producing great *machines*.' This enormous hyperbole seems to me to contain the major concern of his whole life, which was, as is well known, to achieve an execution quick and sure enough to prevent the smallest particle of the intensity of action or idea from evaporating.

Delacroix was, as many others have been in a position to observe, a man of conversation. But the humorous side of it is that he was as frightened of conversation as he was of a debauch, a dissipation in which he ran the risk of wasting his strength. When you entered into his presence he began by saying:

[7] Delacroix's Journals contain many references to his friend Frédéric Villot.

'I think perhaps that we had better not talk this morning, don't you? or only a very, very little.'

And then he would chatter away for three hours! His talk was brilliant and subtle, but full of facts, memories and anecdotes—in short, 'the word that nourisheth'.

When he was roused by contradiction, he drew back momentarily, and instead of a frontal assault upon his adversary (a thing which runs the risk of introducing the brutalities of the hustings into the skirmishes of the drawing-room), he played for some time with him, and then returned to the attack with unexpected arguments or facts. It was indeed the conversation of a man who loved a tussle, but was the slave of courtesy, shrewd, giving way on purpose, and full of sudden feints and attacks.

In the intimacy of his studio he freely relaxed so far as to deliver his opinions upon his contemporary painters, and it was on these occasions that we often had to admire that special forbearance of genius which derives perhaps from a particular kind of simplicity or of readiness to appreciate.

He had an astonishing weakness for Decamps, who today has fallen very low, but who doubtless was still enthroned in his mind through the power of memory. And the same for Charlet. He once sent for me to come and see him on purpose to rap me sharply over the knuckles about a disrespectful article[8] that I had perpetrated on the subject of that spoiled child of chauvinism. In vain did I try to explain to him that it was not the Charlet of the early days that I was censuring, but the Charlet of the decadence—not the noble historian of the old campaigners, but the tavern-wit. But I never managed to win my pardon.

He admired Ingres in certain of his aspects, and assuredly he must have had great critical stamina to admire by reason what he can only have rejected by temperament. He even carefully copied some photographs which had been made of a few of those meticulous pencil-portraits in which we see the relentless and searching talent of M. Ingres at its best, for he is all the more resourceful as he is the more cramped for space.

Horace Vernet's detestable colour did not prevent him

[8] See pp. 156–60 above.

from feeling the personal potentiality with which most of
his pictures are charged, and he hit upon some amazing
expressions in order to praise their scintillation and their
indefatigable passion. His admiration for Meissonier went
a little too far. He had appropriated, almost by violence,
the drawings which had been used in the preparation of
La Barricade,[9] the best picture of an artist whose talent,
nevertheless, finds far more energetic expression with the
simple pencil than with the brush. Of Meissonier he often
used to say, as though anxiously dreaming of the future,
'After all, he is the most certain of us all to live!' Is it not
strange to see the author of such great works showing some-
thing very like jealousy of the man who only excels in small
ones?

The only man whose name had the power to wring an
abusive word or two from those aristocratic lips was Paul
Delaroche. In that man's works there was obviously not a
single extenuating circumstance to be found, and he never
rid himself of the memory of the distress which had been
caused him by all that sour and muddy painting, executed
with 'ink and boot-polish', as Théophile Gautier once ob-
served in an unusual access of independence.

But his favourite choice as his travelling-companion on
vast *exiles* of talk was the man who resembled him least of
all in talent as in ideas, his veritable opposite pole—a man
who has not yet received all the justice which is his due,
and whose brain, although as fog-ridden as the fuliginous
sky of his native city, contains a whole host of admirable
things. I am describing M. Paul Chenavard.

The abstruse theories of the painter-philosopher of Lyons
made Delacroix smile; and that doctrinaire pedagogue held
the sensuous pleasures of pure painting to be frivolous, if
not blameworthy things. But however remote they may
have been from one another, or precisely because of that
remoteness, they loved to set course for one another, until,
like two vessels secured by grappling-irons, they could no
longer part company. Both of them, moreover, being highly
educated and endowed with a remarkable sense of socia-
bility, met together on the common ground of erudition.

[9] Now in the Louvre; see pl. 47.

It is well known that generally speaking this is not the quality for which artists are conspicuous.

Chenavard was thus a precious resource for Delacroix. It was a real pleasure to watch them set to in innocent struggle, the words of the one marching ponderously like an elephant in full panoply of war, and those of the other quivering like a fencing-foil, equally keen and flexible. During the last hours of his life our great painter expressed the desire to shake the hand of his friendly sparring-partner once more. But he was far from Paris at that time.

VII

SENTIMENTAL and affected women will perhaps be shocked to learn that, like Michelangelo (may I remind you that one of his sonnets ends with the words 'Sculpture! divine Sculpture! thou art my only love!'), Delacroix had made painting his unique muse, his exclusive mistress, his sole and sufficient pleasure.

No doubt he had loved woman greatly in the troubled hours of his youth. Who among us has not sacrificed too much to that formidable idol? And who does not know that it is precisely those that have served her the best that complain of her the most? But a long time before his death he had already excluded woman from his life. Had he been a Mohammedan, he would not perhaps have gone so far as to drive her out of his mosques, but he would have been amazed to see her entering them, not being quite able to understand what sort of converse she could have with Allah.

In this question, as in many others, the oriental idea dominated him keenly and tyrannically. He regarded woman as an object of art, delightful and well suited to excite the mind, but disobedient and disturbing once one throws open the door of one's heart to her, and gluttonously devouring of time and strength.

I remember that once we were in a public place, when I pointed out to him the face of a woman marked with an original beauty and a melancholy character; he was very anxious to be appreciative, but instead, to be self-consistent,

he asked with his little laugh, 'How on earth could a woman be melancholy?', doubtless insinuating thereby that, when it comes to understanding the sentiment of melancholia, woman is lacking in some essential ingredient.

This, unfortunately, is a highly insulting theory, and I certainly would not want to advocate defamatory opinions upon a sex which has often exhibited glowing virtues. But you will surely allow that it is a *prudential* theory; and further, that talent could not be too well armed with prudence in a world that is full of ambushes, and that the man of genius is privileged to hold certain doctrines (so long as they are not subversive of order) which would rightly scandalize us in a mere citizen or a simple family man.

At the risk of casting a shadow upon his memory in the estimation of elegiac souls, perhaps I ought to add that neither did he show any affectionate partiality for childhood. He never thought of children except with jam-smeared hands (a thing that dirties canvas and paper), or beating a drum (a thing that interrupts meditation), or as incendiaries and animally dangerous creatures like monkeys.

'I remember very well (he used to say sometimes) that when I was a child, *I was a monster*. The understanding of duty is only acquired very slowly, and it is by nothing less than by pain, chastisement and the progressive exercise of reason that man can gradually diminish his natural wickedness.'

Thus, by the road of simple good sense he reverted towards the Catholic idea. For it is true to say that, generally speaking, the child, in relation to the man, is much closer to original sin.

VIII

You would have thought that Delacroix had reserved his entire sensibility, which was manly and deep, for the austere sentiment of friendship. There are people who become easily attached to the first comer; others reserve the

use of the divine faculty for great occasions. If he had no
love of being bothered over trifles, the famous man about
whom I am now talking to you with so much pleasure
knew how to be a courageous and zealous ally when im-
portant matters were in question. Those who knew him
well have had many an opportunity of appreciating his
positively English loyalty, punctiliousness and stability in
social relations. If he was exacting to others, he was no
less severe upon himself.

It is sad and distressing to me to have to say a few words
about certain accusations that have been brought against
Eugène Delacroix. I have heard people taxing him with
egotism and even with avarice. I would ask you to observe,
Sir, that this reproach is always directed by the countless
tribe of commonplace souls against those that endeavour
to bestow their generosity with as much care as their friend-
ship.

Delacroix was very economical; for him it was the only
way of being, on occasion, very generous. I could prove
this with several examples, but I would hesitate to do so
without having been authorized by him, any more than
by those who have had good reason to thank him.

Please observe too that for many a long year his paintings
sold very badly, and that his decorative works ate up
almost the whole of his salary, when he did not actually
have to dip into his own purse. He gave innumerable
proofs of his scorn for money when needy artists revealed
a desire to possess one of his works. Then, like those liberal
and generous-minded doctors who sometimes expect to be
paid for their professional services, and sometimes give
them free, he would give away his pictures, or part with
them at a nominal price.

Finally, Sir, we must remember that the superior man,
more than any other, is obliged to have an eye to his per-
sonal defences. It might be said that the whole of society
is at war with him. We have had more than one opportunity
of confirming this. His courtesy is called coldness; his
irony, however much he may have softened it, is interpreted
as spitefulness; and his economy, as avarice. But if, on the
other hand, the poor creature turns out to be improvident,

society will say, 'Quite right too! His penury is a punish-
ment for his prodigality.'

I am able to assert that, so far as money and economy
were concerned, Delacroix completely shared the opinion
of Stendhal—an opinion which reconciles greatness and
prudence.

'The sensible man,' said Stendhal, 'must devote himself
to acquiring what is strictly necessary to him in order not
to be dependent upon anyone (in Stendhal's time, this
meant an income of 6,000 francs);[1] but if, once he has
achieved this security, he wastes his time increasing his
fortune, he is a scoundrel.'

Pursuit of the essential, and scorn of the superfluous—
that is the conduct of a wise man and a Stoic.

One of our painter's greatest concerns during his last
years was the judgment of posterity and the uncertain
durability of his works. One moment his ever-sensitive
imagination would take fire at the idea of an immortal
glory, and then he would speak with bitterness of the
fragility of canvases and colours. At other times he would
enviously cite the old masters who almost all of them had
the good fortune to be translated by skilful engravers
whose needle or burin had learnt to adapt itself to the
nature of their talent, and he keenly regretted that he had
not found his own translator. This friability of the painted
work, as compared with the stability of the printed work,
was one of his habitual themes of conversation.

When this man, who was so frail and so stubborn, so
highly-strung and so courageous; this man, who was unique
in the history of European art; the sickly and sensitive
artist who never ceased to dream of covering walls with his
grandiose conceptions—when this man, I say, was carried
off by one of those inflammations of the lung, of which, it
seems, he had a convulsive foreboding, we all of us felt
something approximating to that depression of soul, that
sensation of growing solitude which the death of Chateau-
briand and that of Balzac had already made familiar to us
—a sensation which was quite recently renewed by the

[1] See Stendhal *De l'Amour* (Lévy edition) p. 193.

death of Alfred de Vigny.[2] A great national sorrow brings with it a lowering of general vitality; a clouding of the intellect which is like an eclipse of the sun; a momentary imitation of the end of the world.

I believe however that this impression is chiefly confined to those proud anchorites who can only make themselves a family by means of intellectual relations. As for the rest of the community, it is only gradually that they most of them learn to realize the full extent of their country's loss in losing its great man, and to appreciate what an empty space he has left behind him. And yet it is only right to warn them.

I thank you, Sir, with all my heart for having been so kind as to allow me to say freely all that was suggested to my mind by the memory of one of the rare geniuses of our unhappy age—an age at once so poor and so rich, an age at times too exacting, at times too indulgent—and too often unjust.

[2] Chateaubriand had died in 1848, Balzac in 1850, and Vigny only a few months before Delacroix.

APPENDIX

TRANSLATIONS OF LINES AND PASSAGES
OF VERSE IN THE TEXT

Pages 211–2. Noble creatures are sometimes born under the
sun; earthly epitomes of all that one dreams of—bodies
of iron, hearts of flame, glorious spirits. God seems to
produce them so as to prove Himself; He takes a softer
clay to mould them, and often spends a century in bring-
ing them to perfection. Like a sculptor, He places the
print of His thumb on their brows, which shine with the
glory of the heavens; their fiery haloes burgeon in rays
of gold.

Calm or radiant they go their way, never for a mo-
ment abandoning their solemn gait, with the motionless
eye and the bearing of the gods . . . Give them but
one day, or give them a hundred years, tumult or tran-
quillity, the palette or the sword: they will fulfil their
shining destinies. Their strange existence is the reality
of the dream; they will carry out your ideal plan, as a
clever sculptor carries out a pupil's sketch. Through the
triumphal arch which you have built in dreams, your
unknown desires will ride behind them on their steeds
. . . Of such men each nation can count five or six, five
or six at the most, in prosperous ages, ever-living sym-
bols of which legends are made.

Page 214. And once left, the picture torments and follows
us.

Page 271. The bad taste of the age in this matter frightens
me.

Page 287. Gloomy Isis, covered with a veil! Spider with an
immense web in which the Nations are caught! Foun-
tain beset with urns! Breast ever-flowing with milk,

whither the generations of mankind come to receive the food of ideas! . . . City tempest-wrapped!

Page 301. The charms of horror only thrill the strong!

Pages 301–2. As proud of her noble stature as if she were alive, with her huge bouquet, her handkerchief and her gloves, she has the nonchalance and the unconcern of a skinny coquette with extravagant airs. Did you ever see a slimmer figure among the dancers? Her gown, billowing out in its regal abundance, cascades upon a dry foot which is pinched by a tasselled shoe, as pretty as a flower. The frill which plays about her shoulder-blades, like a wanton brook foaming against a rock, chastely shields those funereal charms which she is so anxious to hide from stupid jeerers. Her deep eyes are wells of darkness and shadow, and her skull, tastefully crowned with flowers, sways slackly on her slender spine—Oh spell of nothingness, madly bedecked! Some will call you a caricature— those whose drunken love of the flesh does not allow them to understand the nameless elegance of the body's scaffolding. Huge skeleton, you echo my dearest taste! . . . Do you come to disturb the festival of life, with your awesome grimace?

NOTES ON THE ILLUSTRATIONS

NOTES ON THE ILLUSTRATIONS

The Illustrations have been arranged according to the following over-all design: 1. Illustrations to the Introduction (Nos. 1–11); 2. A series of identified works from the Salons of 1845, 1846, and 1859 (excluding Delacroix) (Nos. 12–41); 3. A few works from other Salons which are mentioned by Baudelaire; typical works by artists whom he discusses but who do not figure in the first series; prints and sculptures (Nos. 42–58); 4. Works by Ingres and Delacroix (Nos. 59–71); and 5. Caricatures (Nos. 72–9).

Unless otherwise stated, the medium is oil.

1. CHARLES BAUDELAIRE (1821–67): SELF-PORTRAIT, c.1860 Pen and red chalk.
 Lausanne, M. Armand Godoy
 One of a series of self-portrait drawings which may have been intended (but were not used) for the second edition of the *Fleurs du mal* (1861). According to Baudelaire's friend and publisher, Poulet-Malassis, this was the best of the group. See *Dessins de Baudelaire* (Paris, 1927).

2. BAUDELAIRE's 'SALON DE 1846': Title-page
 London, British Museum
 Baudelaire's mother was born Caroline Archimbault-Dufays, and his first works were published under the composite name 'Baudelaire Dufays'.

3. GAVARNI (1804–66): THE ARTIST AND HIS CRITIC
 Lithograph, from *Le Charivari*. See p. 41.
 London, Victoria and Albert Museum

4. OCTAVE TASSAERT (1800–74): 'DON'T PLAY THE HEARTLESS ONE!'
 Lithograph, from the series 'Les Amants et les Epoux'. See p. 71.
 Paris, Bibliothèque Nationale

5. ÉTIENNE CARJAT (1828–1906): PHOTOGRAPH OF BAU-
 DELAIRE, c.1863

6. EDOUARD MANET (1832–83): PORTRAIT OF BAUDE-
 LAIRE, 1862
 Etching (Guérin 31).
 London, Private Collection
 Taken from the figure of Baudelaire in Manet's *La
 Musique aux Tuileries,* and published in Charles
 Asselineau's *Charles Baudelaire et son oeuvre* (1869).

7. EUGÈNE LAMI (1800–90): PORTRAIT OF DELACROIX
 Water-colour, after a pastel by Eugène Giraud.
 France, Private Collection

8. THE INGRES GALLERY AT THE EXPOSITION UNIVER-
 SELLE, 1855
 Contemporary photograph. See pp. 204–5.
 London, Victoria and Albert Museum
 The large circular painting in the centre is the *Apoth-
 eosis of Napoleon.* To the left can be seen the *Joan of
 Arc,* the *Grande Odalisque,* the *Venus Anadyomene*
 and the portrait of Mme. Gonse: below, the *Muse de
 Cherubini* and the portrait of M. Bertin the elder: to
 the right, the *Bather of Valpinçon, Christ giving the
 keys to St. Peter, Oedipus and the Sphinx,* and, at
 the top, three cartoons for stained glass.

9. HONORÉ DAUMIER (1808–79): THE SALON OF 1859
 Lithograph (Deltiel 3138) from the series 'L'Ex-
 position de 1859'.
 London, Victoria and Albert Museum
 The following is a translation of the caption:—
 —Just look how they have 'skied' my picture!
 —Why, my dear fellow—aren't you pleased? But you
 ought to be enchanted to see that they have hung
 your little things well above those of Meissonier!

10. BAUDELAIRE: PORTRAIT OF DAUMIER, 1856
 Pen and wash.
 Lausanne, M. Armand Godoy

11. GUSTAVE COURBET (1819–77): PORTRAIT OF BAUDE-
LAIRE
Montpellier, Musée Fabre
According to Champfleury (*Souvenirs et portraits de
jeunesse*, 1872, p. 135), Courbet found Baudelaire a
difficult subject. 'I don't know how to finish Baude-
laire's portrait,' he said: 'his face changes every day.'
'It is true,' added Champfleury, 'that Baudelaire had
the ability to alter his appearance like an escaped con-
vict seeking to evade recapture. Sometimes his hair
would hang over his collar in graceful perfumed ring-
lets: the next day his bare scalp would have a bluish
tint owing to the barber's razor. One morning he
would appear smiling with a large bouquet in his hand
. . . two days later, with hanging head and bent
shoulders, he might have been taken for a Carthusian
friar digging his own grave.'

12. WILLIAM HAUSSOULLIER (1818–91): THE FOUNTAIN
OF YOUTH
Salon of 1845 (*La Fontaine de jouvence*). See pp. 8–
11.
London, Mr. Graham Reynolds
This painting was lot 107 at Christies, 17 Dec. 1937.
It is dated 1843, and measures 51 by 72 in. Its inter-
mediate history is unknown.

13. HAUSSOULLIER: THE FOUNTAIN OF YOUTH (detail)

14. ADRIEN GUIGNET (1816–54): JOSEPH INTERPRETING
THE DREAMS OF PHARAOH
Salon of 1845 (*Joseph expliquant les songes du
Pharaon*).
See p. 27.
Rouen, Musée des Beaux-Arts

15. HORACE VERNET (1789–1863): THE CAPTURE OF THE
SMALA (detail)
Salon of 1845 (*La prise de la smalah d'Abd-el-Kader*).
See pp. 7–8.

Versailles, Musée

The capture of the *smalah*—or encampment—of the
Emir Abd-el-Kader by the French forces under the
duc d'Aumale took place in 1843 and was one of the
most picturesque episodes in the North African cam-
paign. This was Horace Vernet's largest composition
the present detail representing only about a quarter of
the complete picture.

16. LOUIS JANMOT (1814–92): FLOWERS OF THE FIELD
Salon of 1845 (Fleurs des champs). See p. 20.
Lyon, Musée des Beaux-Arts

17. THÉODORE CHASSÉRIAU (1819–56): THE CALIPH OF
CONSTANTINE WITH HIS BODYGUARD
Salon of 1845 (Le Kalifat de Constantine suivi de so
escorte). See p. 16.
Versailles, Musée
Ali-ben-Hamet, Caliph of Constantine, had recently
paid a lengthy visit to Paris.

18. LOUIS DE PLANET (1814–75): THE VISION OF SAIN
TERESA
Salon of 1845 (La Vision de sainte Thérèse). See pp
17–8.
France, Private Collection
See also Louis de Planet, *Souvenirs de travaux d
peinture avec M. Eugène Delacroix* (Paris, 1929)
pp. 80–4.

19. GUSTAVE LASSALE-BORDES (1814–c.1868): TH
DEATH OF CLEOPATRA
Salon of 1846 (La Mort de Cléopâtre). See pp. 68–
Autun, Musée Municipal
Like Louis de Planet and Léger Chérelle, Lassal
Bordes was one of Delacroix's assistants in his decor
tive works.

20. JEAN-BAPTISTE-CAMILLE COROT (1796–1875):
HOMER AND THE SHEPHERDS
Salon of 1845 (Homère et les bergers). See p. 29.
Saint-Lô, Musée

21. COROT: LANDSCAPE—THE FOREST OF FONTAINEBLEAU
Salon of 1846 (Vue prise dans la forêt de Fontaine-
bleau).
See pp. 113–4.
Boston, Museum of Fine Arts

22. PAUL CHENAVARD (1807–95): DANTE'S INFERNO
Salon of 1846 (L'Enfer de Dante). See p. 109.
Montpellier, Musée Fabre
On Baudelaire's opinion of Chenavard, see also Joseph
C. Sloane's article 'Baudelaire, Chenavard, and "Philo-
sophic Art"', in the *Journal of Aesthetics and Art
Criticism*, vol. XIII, No. 3, March 1955. Prof. Sloane's
identification of a portrait-drawing of Baudelaire by
Chenavard does not however seem to be entirely con-
vincing.

23. ARY SCHEFFER (1795–1858): ST. AUGUSTINE AND
ST. MONICA
Salon of 1846 (Saint Augustin et sainte Monique).
See p. 105.
London, Tate Gallery
This is in fact a replica of the Salon picture, which
was formerly in the collection of Queen Marie Amélie.

24. ALEXANDRE-GABRIEL DECAMPS (1803–60): SOUVENIR
OF TURKEY IN ASIA
Salon of 1846 (Souvenir de la Turquie d'Asie). See
p. 78.
Chantilly, Musée Condé
It is presumably of this picture that Baudelaire ob-
serves that the ducks have been given a 'slab of stone
to swim on'.

25. DECAMPS: TURKISH LANDSCAPE
 Salon of 1846 (Paysage turc). See p. 78.
 Amsterdam, Fodor Museum

26. JOSEPH LIÈS (1821–65): THE EVILS OF WAR
 Salon of 1859 (Les Maux de la guerre). See pp.
 269–70.
 Brussels, Musée d'Art Moderne

27. ALPHONSE LEGROS (1837–1911): THE ANGELUS
 Salon of 1859 (L'Angélus). See pp. 243–5.
 Cheltenham, Mr. Asa Lingard

28. AMAND-DÉSIRÉ GAUTIER (1825–94): SISTERS OF
 MERCY
 Salon of 1859 (Les Soeurs de charité). See pp. 245–6.
 Lille, Musée des Beaux-Arts

29. NICOLAS-FRANÇOIS CHIFFLART (1825–1901): FAUST
 AT THE SABBATH (detail)
 Salon of 1859 (Faust au sabbat). See p. 267.
 London, Victoria and Albert Museum
 The reproduction is taken from A. Bahuet's lithograph
 after Chifflart's drawing, whose present whereabouts is
 not known.

30. PAUL BAUDRY (1828–86): THE PENITENT MAGDALEN
 Salon of 1859 (La Madeleine pénitente). See p. 265.
 Nantes, Musée des Beaux-Arts

31. PAUL FLANDRIN (1811–1902): LANDSCAPE
 Salon of 1859 (Paysage).
 Montauban, Musée Ingres
 Although Baudelaire did not write about Paul Flandrin
 at the Salon of 1859, he gave him a paragraph in
 1845 (p. 31), and in 1846 devoted two pages to an
 attack on 'Historical Landscape', of which this pic-
 ture is a good example (pp. 112–3).

32. ERNEST HÉBERT (1817–1908): PEASANT WOMEN OF
 CERVARO
 Salon of 1859 (Les Cervarolles). See p. 264.
 Paris, Musée du Louvre

33. CHARLES DAUBIGNY (1817–78): LANDSCAPE BY THE
 RIVER OISE
 Salon of 1859 (Les Bords de l'Oise). See p. 280.
 Bordeaux, Musée de Peinture

34. CHARLES LE ROUX (1814–95): WATER-MEADOWS AT
 CORSEPT, ON THE MOUTH OF THE LOIRE
 Salon of 1859 (Prairies et marais de Corsept, à l'em-
 bouchure de la Loire, au mois d'août). See p. 280.
 Paris, Musée du Louvre
 The figures are by Corot.

35. THÉODORE ROUSSEAU (1812–67): THE GORGES
 D'APREMONT, FONTAINEBLEAU
 Salon of 1859 (Les Gorges d'Apremont). See pp.
 281–2.
 Princeton, Mrs F. J. Mather, Jr.

36. ROUSSEAU: THE FOREST OF FONTAINEBLEAU—MORNING
 Salon of 1850–1 (Lisière de forêt—effet de matin).
 London, Wallace Collection.
 A larger picture representing the same scene at sunset
 (now in the Louvre), and exhibited at the same Salon,
 had been commissioned in 1848 by the State. This
 marked the beginning of Rousseau's official recog-
 nition.

37. JEAN-FRANÇOIS MILLET (1814–75): THE COWGIRL
 Salon of 1859 (Femme faisant paître sa vache). See
 pp. 280–1.
 Bourg-en-Bresse, Musée de l'Ain

38. MILLET: THE ANGELUS
 Paris, Musée du Louvre

Although painted in 1858–9, at about the same time as the *Cowgirl*, this picture was not exhibited until the *Exposition Universelle* of 1867.

39. EUGÈNE BOUDIN (1824–98): SKY-STUDY
Pastel. See pp. 285–6.
London, O'Hana Gallery
This pastel, which is not however inscribed, is similar in style to others which have been referred to Baudelaire's description in the *Salon of 1859*.

40. COROT: MACBETH AND THE WITCHES
Salon of 1859 (Macbeth, paysage). See pp. 281–3.
London, Wallace Collection
In the original sketch for this picture, Macbeth was alone and unmounted. The Shakespearian subject shows Corot's orthodox Romantic sympathies.

41. CONSTANT TROYON (1810–65): THE RETURN TO THE FARM
Salon of 1859 (Le Retour à la ferme). See p. 281.
Paris, Musée du Louvre

42. CHARLES GLEYRE (1806–74): EVENING
Salon of 1843 (Le Soir). See pp. 18–9.
Paris, Musée du Louvre
This picture achieved a great popular success, and was engraved under the title *Les Illusions perdues*. Clément (*Gleyre*, 1886 edition, p. 98) gives a long quotation from Gleyre's Journal, in which he describes the 'vision' he had in March 1835 beside the Nile, which gave rise to the picture. The seated man in the foreground represents the poetic hero who sadly watches his youthful illusions pass away from him.

43. JEAN-LÉON GÉRÔME (1824–1904): THE COCK-FIGHT
Salon of 1847 (Jeunes Grecs faisant battre des coqs).
See p. 256.
Paris, Musée du Louvre

This was Gérôme's first exhibit at the Salon; it earned him the title of the 'Master of the Neo-Greeks' (see pp. 253 ff.).

44. FRANÇOIS-MARIUS GRANET (1775–1849): THE INTERROGATION OF SAVONAROLA
Lyon, Musée des Beaux-Arts
Although Granet exhibited an *Interrogatoire de Savonarole* at the Salon of 1846, it cannot be identified with the present version, which had already entered the Lyon Museum in the previous year. On Granet's colour, see pp. 97 and 101.

45. HIPPOLYTE FLANDRIN (1809–64): PORTRAIT OF MME. VINET
Dated 1840.
Paris, Musée du Louvre
A characteristic example of the Ingres-school portrait, on which see pp. 93–5 and 275–6.

46. GUSTAVE RICARD (1823–73): PORTRAIT OF A GIRL
Lyon, Musée des Beaux-Arts
On Ricard, see pp. 277–8.

47. ERNEST MEISSONIER (1815–91): THE BARRICADE
Salon of 1850–1 (Souvenir de guerre civile). See p. 333.
Paris, Musée du Louvre
The scene is set in the rue de la Mortellerie, Paris, which no longer exists. On Meissonier, see particularly p. 27.

48. MEISSONIER: A PAINTER SHOWING HIS DRAWINGS
Salon of 1850–1 (Un peintre montrant ses dessins).
London, Wallace Collection
Among the pictures on the wall in the background is a self-portrait and a sketch for Meissonier's unfinished *Samson slaying the Philistines*.

49. NARCISSE DIAZ (1807–76): LOVE'S OFFSPRING
 Dated 1847.
 London, Tate Gallery
 On Diaz, see particularly pp. 80–1 and 265–6.

50. DIAZ: STUDY OF TREES
 New York, Metropolitan Museum of Art

51. THÉODORE CARUELLE D'ALIGNY (1798–1871): THE
 ACROPOLIS, ATHENS
 Salon of 1846. Etching. See pp. 113–4.
 London, Victoria and Albert Museum
 No. 5 in Aligny's *Vues des sites les plus célèbres de la
 Grèce Antique*, Paris, 1845.

52. GEORGE CATLIN (1796–1872): BUFFALO-HUNT UNDER
 THE WOLF-SKIN MASK
 Washington, Smithsonian Institution
 Probably painted in 1832, on the plains of the Upper
 Missouri.
 On Catlin, see particularly pp. 72–3.

53. GEORGE CATLIN: MAH-TO-HE-HA, THE OLD BEAR
 Washington, Smithsonian Institution
 Painted in 1832, among the Mandan farmers of the
 Upper Missouri river. The sitter was described by
 Catlin as 'A very distinguished brave; but here repre-
 sented in the character of a Medicine Man or Doctor,
 with his medicine or mystery pipes in his hands, and
 foxes' tails tied to his heels, prepared to make his last
 visit to his patient, to cure him, if possible, by hocus
 pocus and magic'.

54. CHARLES MÉRYON (1821–68): THE CLOCK TOWER,
 PARIS
 Etching, 1852.
 London, Victoria and Albert Museum
 No. 28 in Delteil and Wright, *Catalogue raisonné of
 the etchings of Charles Méryon*, 1924. On Méryon, see
 pp. 286–8.

55. P.-J. DAVID D'ANGERS (1788–1856): CHILD WITH A BUNCH OF GRAPES
Salon of 1845 (L'Enfant à la grappe). Marble. See p. 35.
Paris, Musée du Louvre

56. JAMES PRADIER (1792–1852): THE FRIVOLOUS MUSE
Salon of 1846 (La Poésie légère). Marble. See p. 122.
Nîmes, Musée des Beaux-Arts

57. AUGUSTE CLÉSINGER (1814–83): BUST OF MADAME SABATIER
Marble, 1847.
Paris, Musée du Louvre
Baudelaire's 'Vénus blanche', and called by Gautier 'la Présidente', Apollonie Sabatier became a celebrated literary and artistic hostess in the 1850s. Whether she was Baudelaire's mistress in the strict sense of the word is still uncertain, but he is known to have addressed anonymous love-letters to her, and a group of poems in the *Fleurs du mal* refers to her. On Clésinger's sculptures, see pp. 293–4.

58. ERNEST CHRISTOPHE (1827–92): 'DANSE MACABRE'
Terracotta (?), 1859. See pp. 300–2.
Present whereabouts unknown
This *maquette*, which was the source of Baudelaire's poem of the same name, was in 1917 in the collection of Comte Robert de Montesquiou, when it was reproduced as frontispiece to *Le Cinquantenaire de Charles Baudelaire* (Paris, Maison du Livre). In the course of the publication of Baudelaire's articles on the Salon of 1859, Christophe wrote to him hoping that he would not be forgotten when it came to the section on sculpture. Christophe married Bébé, the younger sister of Mme. Sabatier.

59. J.-A.-D. INGRES (1780–1867): CHERUBINI AND HIS MUSE

Dated 1842 (La Muse de Cherubini). See p. 87.
Paris, Musée du Louvre
The composer Cherubini died in Paris in 1842.

60. INGRES: THE COMTESSE D'HAUSSONVILLE
Dated 1845. See p. 88.
New York, Frick Collection

61. INGRES: APOTHEOSIS OF HOMER
Dated 1827. See pp. 61 and 87.
Paris, Musée du Louvre

62. INGRES: THE 'GRANDE ODALISQUE'
Dated 1814. See pp. 70 note, and 88.
Paris, Musée du Louvre

63. EUGÈNE DELACROIX (1798–1863): DANTE AND VIRGIL
Salon of 1822 (Dante et Virgile conduits par
Phlégias). See pp. 51–2 and 212.
Paris, Musée du Louvre

64. DELACROIX: WOMEN OF ALGIERS
Salon of 1834 (Femmes d'Alger dans leur apparte-
ment).
See pp. 54 and 66.
Paris, Musée du Louvre
Among Baudelaire's pictures was a copy of the
Femmes d'Alger by Emile Deroy.

65. DELACROIX: HAMLET AND THE GRAVEDIGGER
Salon of 1839 (Hamlet et Horatio au cimetière). See
pp. 65–6 and 214.
Paris, Musée du Louvre

66. DELACROIX: ROMEO AND JULIET
Salon of 1846 (Les Adieux de Roméo et Juliette). See
pp. 64–5 and 214.
Formerly with Messrs. Bernheim-Jeune, Paris

67. DELACROIX: THE SULTAN OF MOROCCO WITH HIS
BODYGUARD
Salon of 1845 (Muley Abd-err-Rahman, sultan de
Maroc, sortant de son palais de Mequinez). See
p. 7.
Toulouse, Musée des Augustins
A later version is reproduced *Journal*, pl. 67.

68. DELACROIX: THE LAST WORDS OF MARCUS AURELIUS
Salon of 1845 (Dernières paroles de l'empereur Marc-
Aurèle). See pp. 4–6.
Lyon, Musée des Beaux-Arts

69. DELACROIX: THE SIBYL WITH THE GOLDEN BOUGH
Salon of 1845 (Une Sibylle qui montre le rameau
d'or). See p. 7.
Formerly in the collection of M. Bessonneau
The reference is to the sixth book of the Aeneid, in
which Aeneas consults the Cumaean Sibyl and is told
that he must find the golden bough before he can
speak with his father, Anchises, in Hades.

70. DELACROIX: OVID IN EXILE AMONG THE SCYTHIANS
Salon of 1859 (Ovide en exil chez les Scythes). See
pp. 250 and 252.
Private Collection

71. DELACROIX: THE ASCENT TO CALVARY
Salon of 1859 (La Montée au Calvaire). See p. 250.
Metz, Musée Central

72. CHARLES-JOSEPH TRAVIÈS (1804–59): LIARD—THE
PHILOSOPHER TRAMP
Lithograph (Liard—chiffonnier philosophe). See
p. 176.
London, Victoria and Albert Museum
Published in *Le Charivari*: Béraldi, *Le Graveur du
XIXe siècle*, vol. XII (1892), p. 151, No. 4.

73. GAVARNI (1804–66): AFTER THE BALL
Lithograph (unpublished)
Paris, Bibliothèque Nationale
A posthumous work, No. 2691 in Armelhaut and
Bocher's *Oeuvre de Gavarni*, 1873. The two girls are
dressed in the costume of 'débardeurs'. On Gavarni,
see pp. 173–4.

74. EDMÉ-JEAN PIGAL (1798–1872): 'THE OTHER FOOT,
SIR, PLEASE!'
Lithograph ('L'aut' pied, not' maître')
London, Victoria and Albert Museum
No. 7 of the series, 'Miroir de Paris', published in *Le
Charivari*. On Pigal, see pp. 155–6.

75. HONORÉ DAUMIER (1808–79): ROBERT MACAIRE—
BARRISTER
Lithograph (Delteil 362). See p. 168.
Private Collection
No. 9 of the series, 'Caricaturana'. The following is a
translation of the caption:—
'My dear Bertrand, give me a hundred crowns and I'll
have you acquitted on the spot!'—'I haven't got a
shilling.'—'Very well, a hundred *francs!*'—'I haven't got
a penny.'—'Haven't you got *ten* francs?'—'Not a far-
thing.'—'Then give me your shoes, and I'll plead ex-
tenuating circumstances.' On Daumier, see particu-
larly pp. 160–70.

76. DAUMIER: DIDO AND AENEAS
Lithograph (Delteil 939). See pp. 168–9.
Private Collection
No. 15 of the series, 'Histoire Ancienne'. The follow-
ing is a translation of the caption, which is a comic
adaptation from Virgil:—
A protective fog obscured the heavens; and as they
both happened to have come out without their um-
brellas, Aeneas guided his lady-friend into a dim
grotto, there on this fine day to crown his passion.

77. WILLIAM HOGARTH (1697–1764): THE REWARD OF
CRUELTY
Engraving. See pp. 179–80.
London, Victoria and Albert Museum
No. 4 of the series, 'The Four Stages of Cruelty'
(1751).

78. FRANCISCO GOYA (1746–1828): WHO WOULD HAVE
BELIEVED IT?
Aquatint (Quien lo creyera!). See p. 184.
London, Victoria and Albert Museum
No. 62 of *Los Caprichos*. On Goya, see pp. 182–6.

79. BARTOLOMEO PINELLI (1781–1835): ROMAN CARNI-
VAL
Water-colour, dated 1806.
London, Victoria and Albert Museum
On Pinelli, see pp. 187–8.

NOTES ON THE VIGNETTES

The vignettes in the text are as follows:—

INDEX

INDEX

ANCHOR BOOKS